The Late Richard Dadd

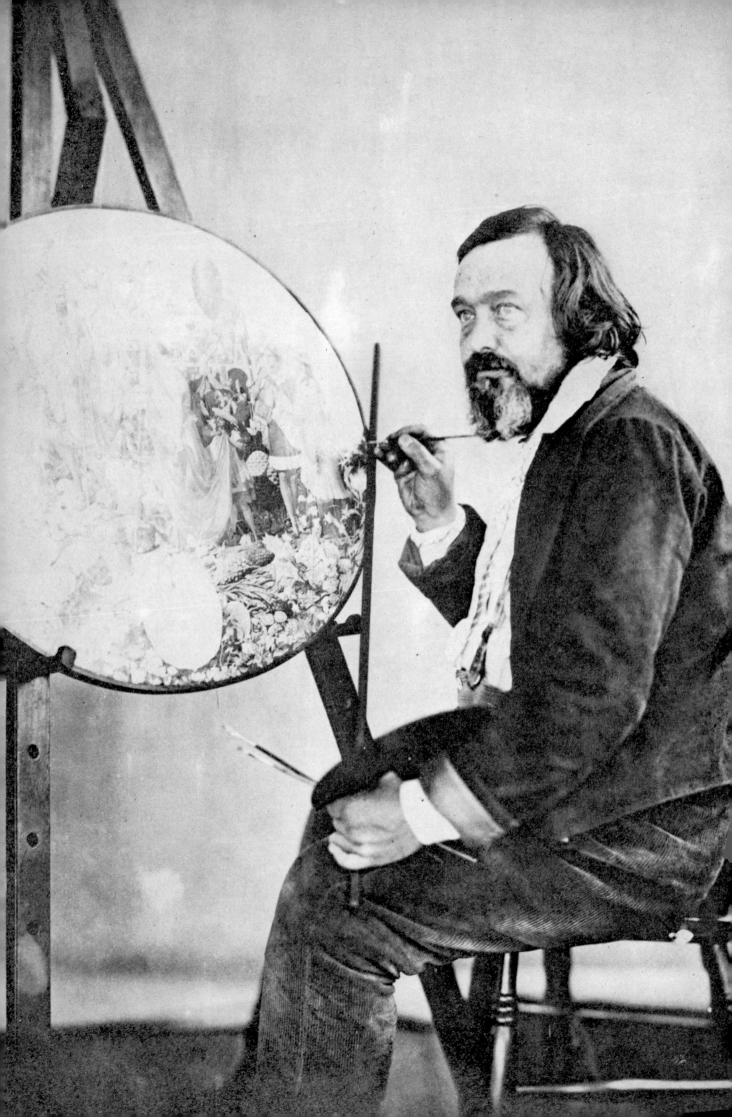

PATRICIA ALLDERIDGE

The Late RICHARD DADD

1817-1886

'. . . for, although the grave has not actually closed over him, he must be classed among the dead.' *Art Union*, 1843

THE TATE GALLERY

Exhibition Tour under the auspices of the Arts Council:

Ferens Art Gallery, Hull 21 September–20 October 1974
Municipal Art Gallery, Wolverhampton 26 October–24 November 1974
City Art Gallery, Bristol 30 November 1974–5 January 1975

Exclusively distributed in France and Italy by Idea Books
24 rue du 4 Septembre, Paris (2e) and Via Cappuccio 21, 20123 Milan

ISBN 0 900874 79 1 cloth 0 900874 78 3 paper
Published by order of the Trustees 1974
for the exhibition of 19 June–18 August 1974
Copyright © 1974 The Tate Gallery
Designed and published by the Tate Gallery Publications Department,
Millbank, London SW1P 4RG
Blocks by Augustan Engravers
Printed in Great Britain by Balding & Mansell Ltd, Wisbech, Cambs

Contents

Cover/Jacket
Bacchanalian Scene, 1862
(catalogue No.184)

Frontispiece
Richard Dadd painting
at Bethlem Hospital, *c.*1856
(*see* catalogue No.172)

Foreword

Richard Dadd is mainly known today as the artist of 'The Fairy Feller's Master-Stroke' in the Tate Gallery and as the man who murdered his father and was, as a result confined to Bethlem Hospital for life.

With this exhibition we are showing for the first time the whole range of Dadd's work in all its variety. Included is almost every known painting and drawing that can be traced. For this we are indebted to Patricia Allderidge, Archivist to The Bethlem Royal Hospital and The Maudsley Hospital, who has been researching into Dadd's work for several years and has discovered much new material. She has selected the works and written the catalogue which contains entries on all Dadd's recorded work, much of which is now lost.

We are very grateful to all collectors both private and public who responded most enthusiastically to our requests for loans, and in particular to the Board of Governors of The Bethlem Royal Hospital and The Maudsley Hospital and to Broadmoor Hospital.

After the Tate showing, the exhibition is to be shown in three other places under the auspices of the Arts Council: Ferens Art Gallery Hull, Municipal Art Gallery Wolverhampton and Bristol City Art Gallery.

Norman Reid, Director

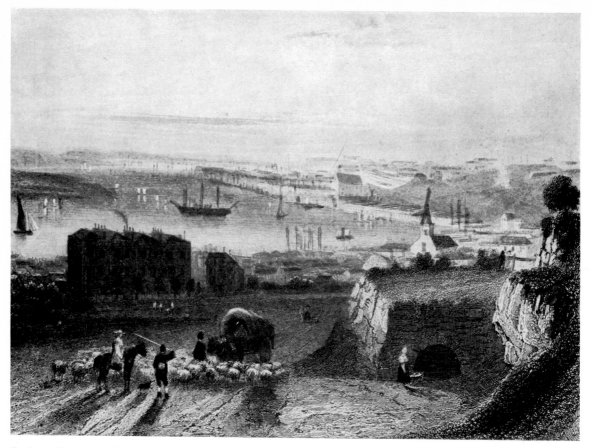

Chatham, Kent, from the south *c.*1830

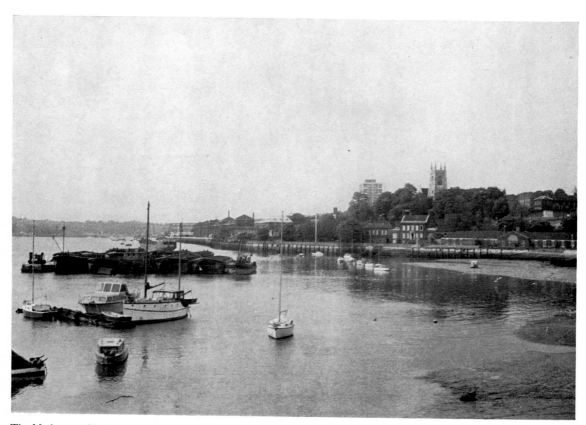

The Medway at Chatham, from the Sun Pier (*see* No. 166)

The Late Richard Dadd: his Life

'THE LATE RICHARD DADD. Alas! we must so preface the name of a youth of genius that promised to do honour to the world; for, although the grave has not actually closed over him, he must be classed among the dead.'[1]

Art Union, 1843

The 'obituary' notice which began with these words was written in 1843, when Richard Dadd was twenty-six years old, and if the writer had been asked to revise it at any time during the next forty-three years he would probably have made few alterations. To the world in general, Dadd remained in oblivion from the moment when his name passed from the sensational headlines of the press, after the insane killing of his father; and although interest in him was never altogether extinguished, there was more curiosity that he still existed at all, than recognition that he still existed as a painter.

Some of the work produced during his confinement at Bethlem Hospital and Broadmoor was known outside the hospitals during his lifetime, but the idea that this would one day be considered the most important period of his working life, would have seemed as bizarre as many of his pictures then appeared to those who saw them. In more recent times the position has been reversed, and Dadd is known chiefly as a 'mad' painter. It is even suggested that madness liberated some latent talent which had not previously been apparent, enabling him to produce one great painting, 'The Fairy Feller's Master-Stroke' (the only picture by which he is widely known).

It is hoped that this exhibition will show amongst other things that he was already, before insanity overtook him, an artist of rare perception whose future as an imaginative painter was assured; and that insanity should only be regarded as one of the many influences contributing to his lifelong artistic development, affecting it through the revolutionary change in the pattern of his daily life, as well as the alteration in his personality and any possible intensification of vision, which it brought about. One purpose will have been achieved if it dispels the view of him as a painter who, under the influence of madness, produced one major work and little else of any worth.

The title has been chosen to emphasise the fact that much of the work shown here emerged into the world, as it were, from beyond the grave, painted in conditions of isolation which can rarely have been paralleled in the life of any other artist. It also draws attention to one of the most important elements in Dadd's personality; the total commitment to, and understanding of, his own creative power, which enabled him to keep on working and to grow and develop in this isolation, knowing that he could never win any more recognition or response from the world outside his asylum than if he had been literally dead.

Chatham[2] Richard Dadd was born on 1 August 1817 in the Medway town of Chatham, where his family had been established for several generations and where they spread over a wide social spectrum. His paternal grandfather Stephen had made a successful career in the Royal Naval Dockyard, moving in succession from Chatham to the Sheerness and Plymouth yards, and back to Chatham where he ended his sixty years of service as timbermaster (*see also* No. 240).

The dockyard was a major social and industrial influence in the area, and many members of the Dadd family had been, and still were, employed there. The military establishments for protecting the yard gave the town much of its distinctive character, as well as a closer communication with London than would usually be found in a small provincial town. Its martial aspect, with sentries and fortifications, street-posts made of old cannon, ramparts and palisades sliced through by roads, was to be recalled by Dadd many years later in the glimpses of Chatham which can be seen in the background to some of his drawings.

Richard Dadd's father Robert (see also No. 241) was born c.1789 in Brompton, a new village divided between the parishes of Chatham and neighbouring Gillingham, which had sprung up to house the dockyard workers. After serving his apprenticeship he set up as an apothecary and chemist in the High Street, and around the same time, on 5 November 1812, he married Mary Ann the daughter of Richard Martin of Gillingham. The Martins were another local family of substance and respectability: at least two of them practised as surgeons in Chatham, and Mary Ann's brother Charles was long established as a chemist across the river in Strood.

The first son, Robert, was born in 1813. Richard was the fourth of seven children, the others being Mary Ann, born 1814; Stephen, born 1816; Sarah Rebecca, born 1819; Maria Elizabeth, born 1821; and George William, born 1822. Of these seven, four were to die insane. Their mother died in 1824 at the age of thirty-four, but it has not been possible to discover the cause of her death or any further information about her.

Robert Dadd soon married again, his second marriage even shorter lived than the first. Sophia Oakes Dadd, about whom still less is known than about her predecessor, died in 1830 aged twenty-eight after adding two more sons to the family; Arthur John, born late 1826 or early 1827, and John Alfred, born 1828. After this the eldest daughter Mary Ann, now nearly sixteen, took charge of the household.

Robert Dadd was popular and respected in Chatham, playing a leading role in the town's intellectual life. He was well-known as a geologist, and when the Chatham and Rochester Literary and Philosophical Institution was founded in 1827, became the first curator of its museum which he built up virtually single-handed.[3] He was involved in setting up and managing a number of educational concerns for both children and adults, such as the Commercial and Mathematical School of which he was a founding proprietor and treasurer:[3] he was himself a good lecturer on both chemistry and geology, and was politically active in the Reform movement. He was also successful in his chemist's business, and added to it in the 1820s the agency of the Hope Fire Office.

The cultural atmosphere in which this large family grew up must have been stimulating, and those members for whom there is any evidence on the subject all show themselves to have been intelligent, literate and relatively liberal in outlook. The eldest son, Robert, also provides some retrospective evidence to suggest that their childhood was happy despite the double loss of both mother and stepmother. Some thirty years later he was to write in a letter to one of his brothers: 'I call to mind that childhood the brightest period of our brief span here below soon passes away . . . A happy childhood is the principle ingredient in a good home education'; and elsewhere he wrote of pleasing, though sometimes melancholy, recollections of Chatham, which he often revisited.[4]

From 1827 to 1831 Richard Dadd attended the grammar school at Rochester, a foundation of Henry VIII known as The King's School. The school's educational standard is said to have been at its lowest ebb at this time,

but it was enough to introduce the child to the classics, and sow in him the seeds of a lifelong devotion which found him still with a *Juvenal* in his hand at the age of sixty, and after thirty-three years in an asylum. At some stage he acquired an equally profound love of English literature, though this may have taken root at home where it was shared with other members of the family.

He began to draw seriously when he was about thirteen, that is, at about the time when he left school. There is little evidence as to his early training; but among his father's associates in the field of education was William Dadson, whose drawing academy was in Chatham High Street not far from the Golden Mortar sign of Robert Dadd's shop. Dadson has left little to posterity beyond a volume of rather woolly lithographs published at his own expense in 1824, predictably called *Sketches of the Picturesque, in Rochester and its Vicinity*; but he did exhibit three landscapes at the Society of British Artists, in the year in which the Dadds had moved to live a few doors from the Society's gallery in London. As a friend of the family and the only drawing master in the vicinity, there is a strong probability that he was one of Dadd's first teachers, and responsible for the thorough grounding in landscape drawing which Dadd so evidently received.

Chatham and Rochester offered a rich supply of subjects, and Rochester castle in particular is a recurrent theme in the background of the Bethlem pictures; and, although little has yet been traced of these earliest drawings, it is obvious from later work that Dadd must have made many studies of the Medway and its shipping. He is recorded as having spent much time sketching in the countryside of Kent, which was then inspiring Samuel Palmer in not far distant Shoreham, and a favourite haunt was Lord Darnley's estate of Cobham Park, about five miles west of Rochester. Here he became well known to the servants, with whom he was popular because of his pleasant manners. His visits to the house itself, which was open once a week, must have been largely for the sake of its fine collection of pictures which included works by Rubens, Guido Reni, Salvator Rosa, Reynolds, Jordaens, Titian and Tintoretto. At this time the opportunity to study paintings at first hand outside London was dependent on gaining access to such private collections.

Little of his work has survived from the period before he began his more advanced training, but what there is points to his having been adequately taught. A small watercolour portrait (No. 3) painted when he was fifteen, shows a mature sensitivity in the handling of both figure and landscape background, as well as the suggestion that he was already learning the technique of miniature painting. It is uncertain whether he had any instruction beyond what was available locally, but he had every encouragement from his father and the rest of the family, all of whom recognised that his talent was something out of the ordinary.

London and the Academy Schools

In 1834 the whole family moved to London.[5] Since Richard was by now seventeen, and in any case London was only thirty miles from Chatham, this can hardly have been just to look after his welfare; but his interests probably influenced the decision. Robert Dadd now gave up chemistry, buying the business of a carver, bronzist and watergilder. There was at least one precedent for this occupation in the family, Isaac John Dadd (whose relationship to Robert Dadd is uncertain) having practised as a carver and gilder in Chatham for several years according to the local directories; and the second son, Stephen, took it up and became his father's partner in the London business.

The family settled at 15 Suffolk Street, Pall Mall East, a new and extremely reputable street designed by Nash at the back of the Haymarket, which was also Robert Dadd's business premises. As well as carving and gilding, and

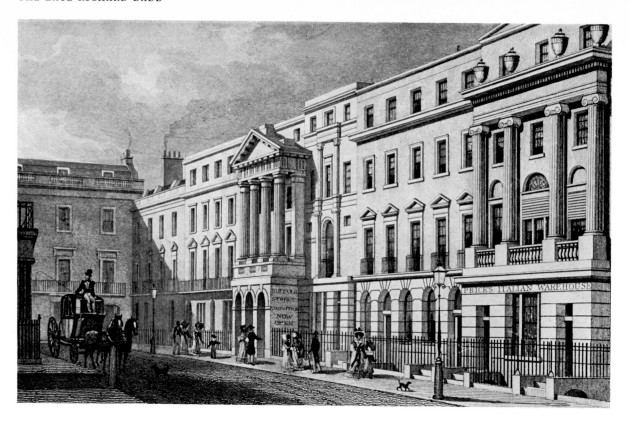

presumably frame making, he engaged in the restoration of ormolu and in making oil for artists. The concern flourished, and he is said to have acquired court patronage.

Suffolk Street, Pall Mall East, 1829 (No. 15 is in the far corner)

This new occupation may have introduced him into artistic circles, or perhaps previous friendships had influenced him, in changing to a pursuit more closely connected with the art world. It is not known when the various relationships were formed, but within a short time of coming to London he was associating freely with a number of men who could also have been very helpful to his son. Early on he became a close friend of the painter David Roberts, visiting Scotland with him in 1841;[6] and by 1837 Clarkson Stanfield was known, at least, to the family. Another friend was the Liverpool miniaturist John Turmeau (see also No. 242) and, since he painted Robert Dadd's portrait as early as 1836, there is a possibility that he might have been connected with Dadd's early skill in miniature painting, for which he showed a predilection throughout his life. However, Dadd's style in a number of small watercolour portraits of around 1838 is quite different from that of Turmeau and, at the moment, there is nothing beyond the coincidence of Turmeau's friendship with Robert Dadd to link the two.

Other Liverpool people followed Dadd's career with interest. His father was an acquaintance, if nothing more, of the Liverpool collector Joseph Mayer, and had a closer intimacy with William Clements, a wood-engraver from the same city who was by now London based as a printseller and freelance reporter on the arts, and as Mayer's agent for buying pictures. Another member of the Clements–Dadd circle and firm friend of the family was Henri Josi, a printseller who became Keeper of Prints and Drawings at the British Museum in 1836.[7]

Such teaching as Dadd may have received during the early years in London must have been casual, for he did not formally enter the studio of any painter, nor the famous drawing school of Henry Sass, seed-bed of much academic success. But since entry to the Royal Academy Schools, his ultimate goal, depended on ability to draw from the antique, he spent a period preparing for

this ordeal by drawing at the other well-established probationary school, the British Museum. According to the *Art Union* this exercise, being quite unsupervised, could be not only imprudent but positively dangerous: 'the idleness, the irrecoverable waste of time, and the fatal acquirement of a vicious or incorrect style of drawing is perfect ruin in after life. . .':[8] but he survived these corrupting tendencies and in January 1837 was admitted as a probationer to the Academy Schools, on the recommendation of Clarkson Stanfield. He was admitted as a full student in December of the same year.[9]

The Academy was just then moving from Somerset House to its share in the new National Gallery building, a few steps round the corner from Suffolk Street. The training, inviolate and inviolable since the days of Sir Joshua Reynolds himself, taught 'an implicit obedience to the rules of art', and began with another spell of drawing from the antique until the student was considered fit for admission to the life class, which was held in the small round room known as 'the pepper box' at the top of the east wing. The seductions of brush and paint were to be resisted as long as possible, and were reserved for copying old masters borrowed from Dulwich College and, after 1837, those in the National Gallery.

The 'visitors' in the various schools were members of the Academy who attended classes in rotation, their duty, though not necessarily their practice, being to 'examine the performances of the Students . . . endeavour to form their taste, and turn their attention towards that branch of the Arts for which they shall seem to have the aptest disposition'. During Dadd's time the visitors included Maclise, Mulready, Etty and Stanfield, all of whom can be seen to have had some influence on his work; also Landseer and Turner, who cannot.[9] In addition, the professors of painting, perspective and anatomy were each supposed to deliver six lectures a year, although Turner, then the professor of perspective, had not been heard for many years.

The professor of painting was Henry Howard, who seems to be the rather unexpected source for Dadd's first interest in imaginative painting. Howard was an indefatigable painter of fairy and poetic subjects, though their quality is now largely open to speculation as most of them seem to have disappeared, probably self-destroyed through the progressively corrosive action over the years of bitumen glazes. His titles include 'Fairies on the Sea Shore', 'Sleeping Titania', 'The Moon Unveiling her Light', 'The Contention of Oberon and Titania' (surviving, but only as a blistered wreck), and a scene from 'Manfred', all of which are suggestive in view of Dadd's later choice of subjects. In the first of a largely unoriginal series of lectures, he tried to inspire his students with the ideal of a close association between poetry and painting, and issued the challenge that 'The genius of the painter, like that of the poet, may ever call forth new species of beings – an Ariel, a Caliban, or the Midsummer Fairies . . . may lift us out of this "visible diurnal sphere", and "lap us in Elysium".'[10] Whether by coincidence or as a direct result, Dadd certainly responded to this call.

The Clique In 1837 the two young men who were to become most nearly associated with Dadd entered the Schools with him, John Phillip and William Powell Frith. Frith, his closest friend, is one of the few among their contemporaries to leave any substantial account of him. There is a generosity in his tribute of forty years later to his friend's far greater talent, which has nothing to do with that talent's never having been a rival to his own: 'Dadd was my superior in all respects; he drew infinitely better than I did . . . I can truly say, from a thorough knowledge of Dadd's character, that a nobler being, and one more free from the common failings of humanity, never breathed.[11] Elsewhere he spoke of him as 'a man of genius that would assuredly have placed him high

in the first rank of painters . . . one of the noblest natures and brightest minds that ever existed'.[12]

John Phillip, Dadd's future brother-in-law, stayed only about three years at the Academy before going back to Aberdeen to practise as a portrait painter, but he came to London again in 1846. It is likely to have been at about this time or soon after that he married the youngest of the Dadd daughters, Maria Elizabeth. Their marriage cannot have been untroubled for long, and within a few years she was probably already showing signs of insanity (see also No. 247). Phillip himself was not strong, and seems to have been highly strung.

One of Frith's daughters in her reminiscences of childhood, gives a casual but terrifying glimpse of these two driving each other to distraction during the final unhappy stages of their relationship: 'He could never tolerate the least amount of movement, and I can see now how he turned round on his wife with a snap and a snarl which nearly frightened her into fits because she would sit just behind him while he was painting, drawing her needle in and out of some very stiff material which creaked in the most horrible manner possible. I hated the noise too, but I would rather have put up with it than been as alarmed as I was at his sudden rage. Poor lady! She was even then on the borderland . . .'[13]

At around the same time she was noticed to be 'very distraught and peculiar' by Mrs E. M. Ward, at a ball at the Ward's house. A short while later she is said to have tried to strangle her youngest child[14] and in 1863 she was admitted to an asylum in Aberdeen, where she lived until 1893. Phillip was broken up by this second calamity (for by now his close friend Dadd was also insane), and he himself lived for only four years after it.

Augustus Egg was already a student at the Academy when Dadd, Frith and Phillip arrived, and Henry Nelson O'Neil, although exactly the same age as Dadd, had been there for four years. Alfred Elmore, a little older, had been admitted in 1832. These six were to form the nucleus of a loosely knit group of young painters who were drawn together by mutual liking as well as by common aspirations, by determination to further the cause of their profession as well as their own careers, and by high idealism as well as high spirits.

Edward Matthew Ward was drawn in when he arrived home from Rome in 1838; and Thomas Joy, though somewhat older, was another member of the circle, probably introduced by his former pupil John Phillip. William Bell Scott was associated with them, perhaps not so closely as he would have liked, to judge from his sour tone: 'It is impossible to say that this society was exhilarating or even amusing; apart from "the shop" indeed – and in professional questions reticence was rather too visible – conversation could scarcely be said to exist. It was a society of rivals . . .'[15] This can be set against the view of an insider, Frith, who saw them as 'a band of followers full of the spirit of emulation, love for our art and one another', meeting together constantly but showing neither jealousy nor unthinking mutual admiration, and criticising and abusing each other's works whenever they thought they deserved chastisement:[12] or Dadd, writing to Frith from the Middle East: 'How many times I have thought over the "clique", with all its associations of fun and frolic mixed – certainly with a big grain of folly, I need not assure you.'[11]

'The Clique' was the name attached to the sketching club formed by these young men. John Imray's 'A Reminiscence of Sixty Years ago' published in the *Art Journal* in 1898 is the main source of information about it, but taken in isolation, his recollections seem to show a more limited membership than is suggested by the scattered references of others who were involved. He ties it

down to Frith, Egg, Dadd, Phillip and O'Neil, while Frith includes Elmore, Ward and 'some others':[12] but in any case, the vagueness of the name suited the vagueness of the constitution, and visitors were always welcomed to the meetings as well as members.

Weekly meetings were held in Dadd's rooms, at any rate from the time around 1840 when he lodged, with a friend who was a clerk in the City, at 66 Great Queen Street. As with the more senior Sketching Society, on which it was doubtless modelled, subjects for illustration were chosen at each meeting, and the spirit of healthy criticism noted by Frith was exercised by an adjudication on the week's best performance. One of the visitors, frequently Imray, acted as judge, and Dadd's drawing generally won: the subjects, chiefly literary with a preponderance from Byron and Shakespeare, were especially well suited to his taste. Also like the Sketching Society, they worked only in monochrome, and rounded off the evening with bread and cheese and beer. Friends and members of the club would also sit to Dadd for character portraits which gradually covered the walls of his studio: the portrait of Augustus Egg in civil war costume (No. 46) is presumably one of these, and the drawing of John Phillip as 'Glorious Jock' (No. 25) a sketch of another. Others recorded include a man with an oriental look portrayed as a Pasha, a thin one with 'a lean and hungry look' as Cassius, and one who made verses as a poet, 'his eye in a fine frenzy rolling'.

William Bell Scott has also recorded the meeting of a group which he calls, probably facetiously, 'the malcontents'[15] and which has recently become wrongly identified with the Clique. Their aim was to try and find new ways to bring the work of younger painters, not yet established, before the public in the face of monopoly by the academicians. A committee chaired by Dadd was formed in 1841, and Frith, Egg and a number of landscape painters were also involved. A report about a new exhibition was actually produced and a meeting called to consider it, but there the matter seems to have rested. As Bell Scott remarked, every year 'such attempts to organise new exhibiting societies were constantly being made by young men struggling to get their innings before their time.'

At the centre of his circle, Dadd stood out as one of the most attractive as well as the most talented and was admired by seniors and contemporaries alike. 'His personal appearance was in his favour,' recalled S. C. Hall many years later; 'He was somewhat tall, with good and expressive features, and gentlemanly demeanour. His career afforded sure promise of a great future'.[16] He was about 5 ft 8 in tall, with dark brown hair, thick dark eyebrows and a sallow complexion. His eyes were blue, variously described as 'light', and 'fine and dark'; 'at one moment almost wild with the varied lights of mirth and fancy, and then so deep and solemn in their thoughtfulness'.[17] Someone who knew him well, writing in the immediate aftermath of his father's death, is lavish in his praise: 'a person more invariably gentle, kind, considerate, and affectionate, did not exist. He was emphatically one who could not deliberately injure a fly . . . his full rich voice, as full of music as a joy-bell, and his sportive humour, exciting innocent mirth . . . he was satisfied with small praise for himself, but ready and lavish of his praise of others. . .'[17] Another spoke of 'one of the kindest and the best, as well as the most gifted, of the children of genius it has ever been our lot to know', and of his attention and diligence, his astonishing industry, close observation, untiring energy and enthusiastic love of his profession.[17]

Early progress Dadd's ability as a draughtsman was evident from an early age, and at the Academy Schools he won three silver medals.[18] Several silver medals were awarded each year in the various schools and only an occasional gold, so this

does not necessarily mean that silver represented the year's runner up. In 1839 he received the second medal for copying in the school of painting, and in the life class the third medal for the fourth best drawing. This happened because Henry Le Jeune was debarred from receiving the third award, having won a higher one the year before. Le Jeune also won the first medal, above Dadd, for copying in the painting school that year, and had had a phenomenal success in this line since his first entry to the Schools at the age of fifteen. A study of the popular pictures of Le Jeune's maturity, such as 'Little Red Riding Hood', 'Little Bo Peep' and 'The Wounded Robin', might help to set medal winning in its proper perspective; nevertheless it must be recorded that in 1840 Dadd won outright the medal for the best drawing in the life class.

Dadd began exhibiting during his first student year at the Society of British Artists, whose galleries were almost next door in Suffolk Street. Bryan[19] describes his contribution of 1837 as 'Head of a Man', though his biographer in the *Art Union* recalls his first work for the Suffolk Street Galleries as 'His Brother's Dog'; but perhaps the inadequacy lies in the record rather than in Dadd's drawing. The following year at the same exhibition he showed two scenes from the Plymouth region and a 'Coast Scene, Hastings' (Nos. 14 to 16), all untraced. In 1838 he also started a series of lively little watercolour portraits of members of his family and friends, most of which remained in the possession of the various families.

In 1839 he first exhibited at the British Institution in Pall Mall. According to the *Art Union* this gallery was beginning to lose sight of its founding aim, to sell works not fortunate enough to find a purchaser elsewhere, and its exhibitions were always a pleasure.[20] According to William Bell Scott, it was run by a body of superannuated private subscribers whose flagging interest left it dominated by an unscrupulous keeper whose main aim was to get custom for his frame-maker son.[15] Either way, it provided an opportunity for young artists to be seen. He also had a 'Study of a Head' accepted by the Academy and made his first sale with a scene from 'Don Quixote' (No. 29), bought out of the Suffolk Street Galleries by the Irish actor W. Tyrone Power.

The 'Don Quixote' marks a stage in an inevitable progression. Scenes from the works of popular novelists and dramatists were an acceptable variant of the more sublime but less saleable forms of history painting; and over the next two years Dadd was to try his hand at both types with scenes from *As You Like It* and *Hamlet* (Nos. 37, 38), as well as some unpromising sounding titles such as 'Alfred the Great in Disguise of a Peasant, Reflecting on the Misfortunes of his Country' (No. 36), shown at the Academy in 1840, and 'Elgiva the Queen of Edwy in Banishment' (No. 40), shown at Manchester the same year. The rest of his circle were all exhibiting illustrative works from similar sources, and on the whole received slightly more, if still sparse, critical attention; but Dadd's 'Alfred' attracted a favourable notice in the *Art Union*, whose critic found in it much to give promise for the future and 'proofs of a reflective mind.'[21]

By now he was showing a clear preference for scenes from Shakespeare in his literary work, and in 1841 discovered his true *métier* in the most fanciful of the plays *A Midsummer Night's Dream*. This year he showed 'Titania Sleeping' (No. 57) at the Academy and 'Puck' (No. 58) its companion picture at Suffolk Street, both of which were bought by the dealer Henry Farrer. In these two brilliant, luminous, works he had obviously found the outlet for a most powerful poetic imagination, and they aroused a good deal of admiration and were well reviewed. There is nothing experimental about them and he must already have been working this rich vein of fantasy for some time, but

as the first surviving examples, they are the more astonishing for appearing to arrive unheralded and fully developed.

He had not completely abandoned the earlier subjects, and also exhibited 'When I Speak, Let no Dog Bark' (No. 63) at Suffolk Street in 1841, but two other exhibits of the same year were 'Fairies Assembling at Sunset' (No. 65) shown at Manchester, and 'Ever Let the Fancy Roam' (No. 64) at the British Institution. These show that his inclination was leading towards purely imaginative work. The following year, 1842, he sent another fairy picture to the Academy, a scene from *The Tempest*: 'Come unto These Yellow Sands' (No. 68), which was described as one of the attractions of the exhibition and which drew from one critic the view that 'the artist must be some kind of a cousin to the muse Thalia'.[22] Without the surviving evidence of the major fairy paintings and some smaller sketches, Dadd might be suspected of having begun to cash in on a line which had caught the public fancy, but the electric excitement and sense of involvement which is communicated in these pictures forestalls any such suggestion, and it is clear that he had found a mode of expression in which he felt able to commit himself totally.

In the spring of 1842 he was commissioned to illustrate 'The Ballad of Robin Goodfellow' for S. C. Hall's forthcoming *Book of British Ballads* (No. 69). Hall, very conscious of his potential as a patron of young talent, held *soirées* during the production of the book at which the artists would gather round while he read aloud each ballad and allotted it to its illustrator. 'They were', as he said himself, 'brilliant evenings when so many young artists – all of rare promise – assembled at The Rosery . . .'[16] Among those who took part were Frith, E. M. Ward, William Bell Scott, John Tenniel and Kenny Meadows.

Dadd drew directly on the wood, showing aptitude for the technique and producing inventive illustrations which were, appropriately, in a more whimsical mood than that of the paintings. He had for some time been interested in engraving and book illustration and in 1840 had designed and etched the title-page for a small volume *The Kentish Coronal* (No. 51), edited by a Chatham friend and relative H. G. Adams. He had also made a slightly more confident etching of his own self-portrait (No. 53), and a fairy piece, 'Water Nymphs' (No. 66). The latter was given by his father to William Clements who, as a wood-engraver turned printseller, must have taken some interest in this aspect of his development.

At around the time of the *Book of British Ballads* he became a founder member of the Painters' Etching Society, together with Frith, O'Neil, Scott, Ward, Joy, Egg, J. B. Pyne and about a dozen others.[23] Another venture with which Hall was associated, this was founded 'to cultivate for mutual improvement, and public advantage, a too much neglected branch of Art'. The first work chosen for illustration was an edition of Gray's *Poems*, though this was never produced, and although Dadd did not play any part in the Society's eventual publications, he did etch at least one design for the 'Elegy in a Country Churchyard' (No. 70).

Somewhat earlier he had received a more substantial commission, the decoration of 26 Grosvenor Square for Lord Foley. The subjects, which he is said by John Imray to have chosen himself, were from Tasso's 'Jerusalem Delivered' and Byron's 'Manfred' (No. 67). The latter, which attracted a number of artists including John Martin, is a particularly significant choice: described by Byron himself (though Dadd could not have known this) as 'a sort of mad Drama . . . a Bedlam tragedy',[24] this demon haunted poem must have already exercised a strong fascination for him, about a year before persecution by evil spirits was to become a dominating experience in his own life. Manfred's description of his torments is poignantly prophetic:

'My solitude is solitude no more,
But peopled with the Furies.
. . .
 I have pray'd
For madness as a blessing.'

The work seems to have been a series of panels, of which none has so far been traced although some at least were probably moved from the house and dispersed. They were regarded by contemporaries as being among his finest productions, and one writer said that there were more than a hundred which, if anything like true, would account for the relatively few pictures exhibited during this period. His only work for the Academy exhibition of 1842 was the scene from *The Tempest*, which was later sent to Birmingham; and in this same year he received another commission which was to take him out of the country for ten months.

Dadd's new patron, Sir Thomas Phillips, was a South Wales solicitor and former mayor of Newport who had been wounded by chartists amidst a blaze of publicity, and subsequently knighted for his part in quelling the riot (*see* also No. 251). Then aged forty-one, he was about to make an extended grand tour before settling down to a new career as a barrister in London, and had decided to take a young artist with him to make drawings. In another age he would have taken a camera; probably several, and a tape recorder too, for he was conscientious in everything and particularly in the serious business of tourism.

He may have had some wish, too, to make his mark as a patron of the arts: something which was already being achieved by his younger brother Benjamin, whose wife had made their Wimpole Street drawing room into a meeting place for artists and literary men.[25] It could have been here that Phillips first met David Roberts: at any rate, since his journey was to take in a large area of the Middle East he turned for advice to Roberts, who was an experienced Middle Eastern traveller. As a travelling companion Roberts recommended Dadd, not, as Frith said, because of his friendship with Dadd's father, but for 'the knowledge that the young artist's powers as a draughtsman, and his amiable qualities as a man, would render him as charming in companionship as he would be efficient as an artist'.[11] It was from this journey that Dadd returned insane.

Dadd and Phillips crossed to Ostend on 16 July 1842, to begin a journey **Travel**[26] which would have knocked out any but the strongest constitution before the halfway point. The first month carried them to Ancona by rail, diligence, caliche, steamboat, foot, horse, char-à-banc, rowing boat, mule and vettura, taking in *en route* about three hundred miles of the Rhine, Lake Maggiore in a thunderstorm, and everything of pictorial, architectural, sculptural, scenic and historical/anecdotal interest in North Italy recommended in the guidebooks. Even Sir Thomas (who had 'done' Switzerland before) admitted to 'two hard days work' racing up and down the Bernese Alps, when they travelled eighty-five miles of which thirty were on horseback. It is small wonder that neither Dadd's sketchbook nor any other known contemporary drawing, records this part of the trip; though there is evidence of the lasting impression which it made on him, in the rocky precipices and turreted castles set on vertiginous heights in some of his later drawings.

In Venice he was particularly impressed by the paintings of Veronese and Tintoretto, writing of them to David Roberts as 'the most marvellous things imaginable in respect of execution and colour', and again later commenting that 'The pure daylight of Paul Veronese, and surpassing brilliancy of colour, show clearly enough that lightness of effect depends on the artist and not the

material; and to speak truly, I have seen no frescoes possessing such luminous power as his works'.[27] At Bologna he had preferred Guido Reni above all else, and was convinced by everything he saw, of the vast superiority of oil over fresco 'whether considered as to design, expression, truth to nature, colour, or durability'.[27]

From Ancona they crossed, touching at Corfu, to Patras, and spent a week riding round the antiquities of the Peloponnese followed by a week in Athens and its environs. At Delphi they drank the waters of the Castalian fountain, now, according to Dadd, filled with frogs and watercresses rather than inspiration; at Athens they saw the burial of a bishop; and everywhere he noticed the contrast between the barren beauty of the country, and the misery of its people.

Dadd's surviving sketchbook (No. 73) begins in Greece, and in the drawings of figures and heads in particular, there can be seen something of the exhilaration with which he responded throughout the journey to every new spectacle, 'eyes and mouth wide open, swallowing, with insatiable appetite the everlasting succession of picturesque characters'.[28] He was also very sensibly stocking up with the popular tourist subjects; but a description to David Roberts of life on Corfu shows the sort of scene which gave him most satisfaction: 'it seemed a large assortment, or menagerie, of pompous ruffians, splendid savages, grubby finery, wild costume . . . I never saw such an assemblage of deliciously-villainous faces: they grinned, glowered, and exhibited every variety of curiosity. Oh, such expression! Oh, such heads! enough to turn the brain of an artist'.[27] Throughout his letters, it is the lamp-lit cowled faces of the monks of St Anthony, the barbaric blackbearded splendour of a Syrian sheik, the turbulent crowds in the bazaars, the untutored dignity of the water-carrying women, which stir his greatest enthusiasm; though he writes with more formal interest too of the classical and other antiquities which they visited.

From Greece they sailed to Smyrna, and travelled up the coast by steamer for a two-week stay in Constantinople, returning by the same route: and on 1 October they left Smyrna again with a cavalcade of eight horses, to ride down the coast road to Bodrum, the ancient Halicarnassus. This last was a diversion. Phillips had been asked by Sir Stratford Canning (later Lord Stratford de Redcliffe), then ambassador to Turkey, to visit the castle of St Peter at Bodrum and report on the state of the marble fragments from the tomb of Mausolus which were built into the walls (*see* No. 80). Armed with a letter and an escort from the Pasha of Aydin, they set forth to become, in Sir Thomas's estimation, the first Franks that century to set foot inside the forbidden fortress.

Clearly delighted with the mission, Phillips wrote to his brother with relish about 'diplomatic security' and the importance of strict secrecy: Dadd wrote casually of the venture to David Roberts with such lack of caveat and proviso, that the letter was passed on to the *Art Union* for publication. But his indiscretion does not seem to have harmed the delicate negotiations, and the marbles of the Mausoleum can now be seen in the British Museum, where they were brought in 1846. In the event, the fortress was to remain undefiled by Frankish footsteps for a few more years, and only permission to sketch the four bas-reliefs in the outer face of the wall could be obtained. Dadd's drawings were forwarded to Canning with a letter from Sir Thomas urging him to 'leave no step untried to obtain them for the British Museum'. Dadd himself thought them 'the finest works in bas-relief in marble that I have seen, after the marbles of the Parthenon', with 'all the energy and spirit of Greek Art in its highest perfection'; and besides some sketches in the surviving book he must have made others which he had with him in Bethlem, for he later used

a group from this frieze in the watercolour 'Dymphna Martyr' (No. 105). He must have recalled all these events again, too, when he worked up another sketch into the watercolour 'Street Scene in Boudroon. The Birthplace of Herodotus' (No. 171), sixteen years later.

From Bodrum they proceeded by various forms of transport to Lycia, an area to be worked over more thoroughly the following year by William James Müller, who wrote: 'There is little, unfortunately, in the remains of the buildings or temples that may be termed *sketchable* . . . Cyclopean walls, with Roman ones built upon them, do not exactly suit the artist's folio: yet there may be one . . . a *landscape painter* I mean – one who would delight in Nature in her wild moods, her savage beauties – let him accompany me to Pinara'.[29] Dadd did delight in just such moods, and wrote to Roberts: 'The sight of their enormous ruins is remarkable for the romantic and grand', and 'The plain and mountains about the city [Macri] are exquisitely beautiful; and the Masicyths range of snow mountains, when first we caught sight of it, was enough to make one leap out of one's skin . . . the sight of their bald summits, glowing and gleaming in the setting sun, would wake all the artist in you, or indeed in anybody with the least love of nature'.[30]

Crossing from Asia Minor, they waited at Rhodes for four days for a steamer (*see* 'View in the Island of Rhodes', No. 100). After touching at Cyprus the boat docked at Beirut early on 28 October, and the following morning they set off again up the coast for Tripoli. This was very much the pattern of their journeying from now on; and for Dadd in his sketching there was constant need to adapt to changing environments, to capture fresh atmosphere and new ways of life, never having time to absorb one scene before moving on to the next.

After Beirut the journey became physically as well as mentally more wearing than ever. Travelling on horses and mules which had 'the habit of tripping and lying down in a remarkably developed state', they abandoned the last inn in Syria or Palestine for dependence on the hospitality of the country, which might mean anything from the relative comfort of a Maronite convent to the mud floor of a peasant hut. The stages were long, the pace unrelenting, and the conditions exhausting. Ascending the Lebanon range to the Cedars they experienced a drop in temperature from 90° to 50° in an hour and a half, followed by several hours riding through a snowstorm during the descent to the Baquaar. Tripoli to Damascus took only four days including the exploration of Baalbec, which Sir Thomas found imposing but disappointing, and Dadd found 'glorious' – but he particularly lamented that their mode of travel left little opportunity to sketch, since the light was nearly always gone by the time they stopped and, as he had complained in Asia Minor, 'a body can't very well sketch riding on horseback'[30].

The sight of Damascus as they descended from Anti-Lebanon must have looked, as it did to the prophet Mohammed, like Paradise: but they rested there only five days and were off again, enduring 'all sorts of filth and inconvenience to see an infernally rocky country that won't grow anything but big stones', as Dadd wrote to Frith in a moment of disillusion, though he was really enraptured by the people and villages in 'this emporium of artistic wealth'.[11] In less than two weeks they toured Mount Hermon, Tiberias, Cana, Nazareth, Mount Tabor, Carmel, Caesarea, Jaffa, and Lod, finishing up at Jerusalem only to set out the following day to visit the Jordan and the Dead Sea, on a trip which brought them back across the wilderness of Engaddi by moonlight. At Jericho they were surrounded by a band of armed arab tribesmen who galloped up with wild gesticulations and brandishing spears, led by a sheik 'whose black grizzly beard would make capital brushes',[11] who conducted them to his village and bargained with their escort for a ransom. There seems

to be something of this episode recalled in 'The Flight out of Egypt' (No. 104), in the group of horsemen armed with tufted lances who have just ridden up on the left-hand side.

At Smyrna they had met the officers of the Survey ship *Beacon*, who now caught up again and joined in the visit to the Dead Sea. Through the captain they were given a passage on a sister ship, the *Hecate*, from Jaffa to Alexandria, sparing the long trek across the desert which had been planned, and arrived on 28 November. After quarantine they moved on to Cairo and made an excursion to the pyramids of Giza, to be conducted round by the group led by Dr Lepsius and including Joseph Bonomi which was currently exploring there. In Cairo they also met the painter J. F. Lewis, one of the first recorded sightings of this brilliant lotus-eater, whose life as an oriental nobleman Thackeray was to describe two years later.[31] Phillips reported only that 'he has not been very usefully employed hitherto'.

Even Sir Thomas had had enough of rough living by this time, and hired a boat with a crew of sixteen from the English consul at Cairo in which they journeyed in luxury up the Nile to Thebes, breakfasting daily on fresh eggs and dining on plum pudding on Christmas Day. Each day Dadd sketched, while Sir Thomas went on shore and tried to shoot crocodiles. They visited Dendara and other sites on the way, and spent a week at Thebes visiting all the temples and palaces in the area. The feelings of awe which Dadd experienced here must have strongly influenced the direction of his thoughts at this critical time, helping to contribute the element of Egyptian religion which later became entrenched in his delusional beliefs: 'At Carnac I was more astonished than even at the Pyramids. . . . the mind is at once impressed with the idea of immense size and eternal strength . . .';[28] feelings which were apparently not diminished by discovering David Roberts's name scratched on both sides of one of the propylaea.

Another lasting impression must have been left by an incident at Thebes which occurred when the boat was moored close to the temples of Luxor, looming supernaturally huge under a brilliant moon. Aroused by a strange low chant which rose and fell, slowly increasing in vehemence, Phillips and Dadd went on deck to find the boat's Egyptian and Nubian crew holding hands in a circle in the empty desert, writhing and chanting in growing frenzy while one of them intoned passages from the Koran, until several sank foaming at the mouth and senseless on the sand.[32] The effect of a scene such as this, on a sensibility which had created 'Come unto these Yellow Sands' only a few months before, is a refinement which only the cruelty of chance could have brought about.

It was during this whole Egyptian period that Dadd experienced the first symptoms of the illness which was to destroy his reason. Later, he was said to have suffered sunstroke one intensely hot day but to have recovered; and perhaps an attack of sunstroke did help to trigger off the latent disorder which would, almost certainly, have been set in motion by something else if not by the hectic excitement of this journey. It is equally probable that what was taken for sunstroke, was an early episode in the illness; particularly since he had already written to Frith before reaching Egypt of having often 'lain down at night with my imagination so full of wild vagaries that I have really and truly doubted of my own sanity'.[11]

Again on the way home he was to acknowledge an inexplicable feeling of unease, during the passage from Alexandria to Malta: 'I never passed six more miserable days. I scarcely know – perhaps I should say that I am perfectly ignorant of–the cause of the nervous depression that I experienced . . .'[28] What he left out of this letter to David Roberts was that he was already fighting off the terrors of approaching insanity.

THE LATE RICHARD DADD

Throughout the return journey up the west coast of Italy, Dadd suffered increasingly from delusions that he was being pursued by spirits, which appeared to him in different disguises; as an old lady in the Vatican galleries, as a priest pretending that he could not understand English, as Sir Thomas Phillips himself on board the steamer from Alexandria, playing at cards for the captain's soul.[33] Extreme hostility to Sir Thomas later became more marked; but although his behaviour and attitude after the 'sunstroke' must occasionally have given concern, there was nothing sufficiently disturbing to cause any change of plan, and they spent nearly three weeks in the vicinity of Naples and a month in Rome.

While in Rome they visited the studio of Overbeck and perhaps some other of the Nazarenes, and Phillips wrote of their work to his brother with all the enthusiasm of a recent convert; but Dadd's views are not recorded. In Rome, too, Dadd was first overtaken by one of the irrational impulses which were to dominate the rest of his life, this time an urge to attack the Pope on one of his public appearances, which he resisted only because the Pope was so well protected.[34] During the last stage of the homeward journey towards the end of May 1843, his self-control seems to have failed completely, and he showed 'symptoms of aberration of mind' (no more is said) which made Sir Thomas seek medical advice. Dadd left him in Paris, and fled precipitately home to London.

It was soon obvious to his family and friends that Dadd was insane. His method of arrival, having posted home alone from Paris in such haste that all his money was used up, would have aroused some comment, and Sir Thomas soon followed with more details. So far as his companions could see, his insanity showed itself in a complete change of character: he was now watchful and suspicious, increasingly reserved and gloomy, and showed 'a degree of shrewdness and sharpness about little things utterly foreign to his former character'.[35] His actions became unpredictable and occasionally violent, and he seemed to believe that he was being watched: once he rushed away alone while a friend prepared to accompany him home;[36] another time he shut himself in his room and waved a knife under the door at visitors;[37] he is said to have cut a birthmark from his forehead, saying it was planted there by the devil.[38] He obviously saw and heard things which did not exist, and though he did not speak much of this, he let slip to a close friend that he was haunted by evil spirits, and was himself searching for the devil.

Delusion

Dadd's own experience during this period was one of increasing domination by external powers, whose authority he could not resist, even while still recognising that other people would take them for symptoms of insanity. He believed himself persecuted by the devil's minions, but also, prompted by the voices of these outside powers, he began to believe in his own mission to rid the whole world of the devil: and intertwined amongst many vague and confused ideas was a strong element of Egyptian mythology.

He later wrote for Dr Wood, the apothecary of Bethlem Hospital, a typically abstruse sounding account of the notions occupying him at this time: 'On my return from travel, I was roused to a consideration of subjects which I had previously never dreamed of, or thought about, connected with self; and I had such ideas that, had I spoken of them openly, I must, if answered in the world's fashion, have been told I was unreasonable. I concealed, of course, these secret admonitions. I knew not whence they came, although I could not question their propriety, nor could I separate myself from what appeared my fate. My religious opinions varied and do vary from the vulgar; I was inclined to fall in with the views of the ancients, and to regard the substitution of modern ideas thereon as not for the better. These and the like, coupled

with the idea of a descent from the Egyptian god Osiris . . .'.[38] 'These and the like', were to occupy him for the rest of his life; and the persuasion that he was subject to the arbitrary will of Osiris was still central to Dadd's belief when he was questioned about it more than thirty years later in Broadmoor.[33]

The Egyptian content of his delusions is not surprising, nor, indeed, his whole obsession with Middle Eastern subject matter for the rest of his life, considering the powerful stimuli to which he had been exposed just when his mind was particularly receptive. The illness which caused his mental disorder, whatever it may have been (and it is not now diagnosable), contained a strong element of hereditary predisposition; so that whether its onset during this tour was mere coincidence or not, his receptivity had probably become abnormally intensified long before anything was really apparent even to himself. During the whole journey there had been a continuous bombardment of bewildering new sensations as well as much physical exhaustion; and he had often been involved in everyday incidents of great excitement, as well as watching others, such as the one at Thebes already described, the dancing dervishes in Turkey, a funeral procession at Damascus with its following of wailing women, and other scenes of mass fervour.

By the time the illness began to take a real grip he had become feverishly sensitive to external impressions, and wrote of wandering about Cairo with 'the most unaccountable impulses, that would not let me stop to sketch, but were constantly prompting me on, to drink in, with greedy enjoyment, the stream of new sensations'.[28] At the same time he was reading about the customs and religion of ancient Egypt, and feeling at first hand the mystery and awe of the monuments; so that as confusion gradually began to overtake his mind, images and stories from Egyptian mythology became inextricably bound up with his thinking.

He continued working, however, throughout this critical period, sending a cartoon for the competition to decorate the new Palace of Westminster which he had begun immediately on arriving home, and completed within two days (see No. 89). The painting which he sent to the Liverpool Academy that year as 'Group of Water Carriers . . . near Mount Carmel' (No. 91) ranks among his finest, but the cartoon was regarded as evidence of a disordered mind on the grounds that the dragon, just slain by St George, had an inordinately long tail. Another work from this period, a watercolour 'Dead Camel' (No. 94), now lost, is described as 'a ghastly little invention of desert-horror, framed in by demons such as his distempered brain alone could devise'.[39] Many of his contemporaries, however, saw no sign of insanity in his work, and some saw none in his life either, though all had heard the stories.

During the period of June to August, as the crisis approached, the turmoil of his thoughts resulted in increasingly bizarre behaviour and more frequent lapses of self-control. His landlady at 71 Newman Street, where he had taken lodgings on returning home, became positively afraid of him, and his old friend E. M. Ward reported that 'he's been behaving in such an odd way lately that I hardly liked having him in my studio'.[40] When his room was searched after he had left it was found to contain nearly three hundred eggs, the carpet covered in shells, and quantities of ale, this having been his exclusive diet for some time.[41] There were also found a number of drawings of his friends, all shown with their throats cut.

His father resolutely maintained that nothing was wrong except the after-effects of sunstroke, which would pass with rest and quiet, and this despite the fact that his younger son George was at the same time showing signs of mental disorder: but finally he was prevailed on to consult Dr Alexander Sutherland of St Luke's Hospital, one of the leading 'mad doctors' of the day. Sutherland advised that Richard was no longer responsible for his actions and

should be put under restraint; but Robert Dadd, who was devotedly attached to his son and had never known anything but reciprocal affection from him, determined to care for him himself.

One or possibly two days after the consultation with Sutherland, on Monday, 28 August, Dadd called on his father asking him to go down into the country. He insisted that they should go to his favourite old haunt of Cobham, and promised to 'unburden his mind' when they got there. After they had set off one of the sisters, probably Mary Ann, had a premonition of disaster and wrote to her brother Stephen, who was staying at Strood to watch the Chatham manoeuvres, that Richard had gone to Cobham with his father, that he was much worse, and that she feared him to be dangerous. By the time this letter was received, its truth was all too apparent. After resting and eating at the Ship Inn and engaging beds in the village, the two had gone out together for a walk in Cobham Park, and not far from the road Richard had killed his father with a spring knife which he had brought with him expressly for the purpose.[42]

Aftermath[42]

There is no doubt that the killing was premeditated, as Dadd himself explained in the paper written for Dr Wood and quoted before: '. . . These and the like, coupled with the idea of a descent from the Egyptian god Osiris, induced me to put a period to the existence of him whom I had always regarded as a parent, but whom the secret admonishings I had, counselled me was the author of the ruin of my race. I inveigled him, by false pretences, into Cobham Park, and slew him with a knife, with which I stabbed him, after having vainly endeavoured to cut his throat'.[38] This version tallies with the findings of the inquest, as also with the account which he gave shortly after his arrest. In his deluded state Dadd believed that his father was the devil, and his own mission as an envoy of god (or more probably, of Osiris) was to 'exterminate the men most possessed with the demon'. He may have been spared the ultimate agony of ever knowing whom he had really killed, and certainly at this time he had no continuous recognition of his father's identity, and little enough of anyone else's, including his own.

He did, however, know that he had acted against society's conventions; and having previously equipped himself with a passport, promptly made his way to France, hiring a boat at Dover for £10. Meanwhile his stunned family received another blow, for two days later the younger son George (*see* No. 41) returned home destitute and in a similar state of derangement.[43] He was sent to Kensington House Asylum, and from there transferred to Bethlem Hospital where he remained until his death in 1868.

The case received sensational, though mainly sympathetic, coverage in the newspapers, and for the next fortnight they speculated freely as to Dadd's whereabouts. Various friends of the family such as Clements and Josi, as well as relatives from Chatham, helped in the search; Clements, astute journalist that he was, also furnishing some of the more accurate progress reports to the papers.[44] In fact, Dadd had been arrested in France on the night of 30 August after failing to resist another impulse. He was (so he told Dr Charles Hood later) on his way to kill the emperor of Austria: but while travelling in a diligence through the forest of Valance he was inspired to attack his fellow passenger, a complete stranger. This remarkably tolerant man seems to have allowed Dadd to play with his cravat and collar for a quarter of an hour, merely requesting him to have done with it: but when Dadd produced 'an excellent English razor' and set about cutting his throat, *sang froid* deserted him and he managed eventually to overcome his attacker. On being arrested Dadd promptly identified himself and began to recount his recent activities at Cobham, at the same time handing over all his money for his latest victim's welfare.

From *The Kentish Independent*, 9 September 1843
Left
Supplement to the newspaper with portraits of Richard
Dadd (right) and his father, and the 'Scene of the Murder'
Below, announcement of the supplement

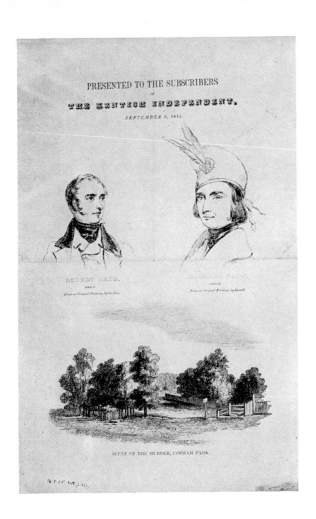

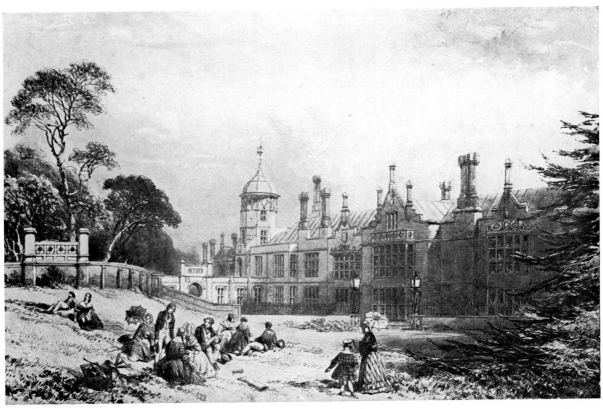

Cobham Hall, the north front, with a sketching party in the foreground, October 1843

Under French law he was committed to an asylum without trial on being certified insane, and after a brief stay at Melun, was removed in stages via Brie, St Denis and Luzarches to Clermont.[45] Here his family would have liked him to stay. They arranged for special food to be sent to him, and also a supply of pencils, paint and canvas, but he ignored the latter and appeared to have no recollection of his former life. The governor reported that 'his mind is an utter and irreclaimable blank', and that his sole occupation was to stand in the courtyard gazing at the sun, 'which he calls his father':[46] though who can say what thoughts were really passing through his head.

The Home Secretary, though sympathetic, was too conscious of the dangers of precedent to allow Dadd to remain perpetually in France; and in 1844 he was extradited and brought to England just before the court proceedings, thus avoiding a long detention in prison. Arriving on 28 July he appeared before the magistrates at Rochester the following morning, and was remanded to Maidstone gaol. A week later he appeared again and was committed to the next assizes, but these were mere formalities and it was never intended that he should stand trial.

His two appearances had left no one in doubt as to his state of mind; for although at times he seemed to take a rational interest in the proceedings, and made several small corrections to witnesses' evidence, at others he became wildly excited and incoherent, laughing and exclaiming, and calling out to people in the court as well as to some who were not. Once he became so disturbed during an exchange with some invisible disputant that he had to be taken out, but on returning to be asked formally by the chairman whether there was any reason why he should not be committed for trial, he replied pleasantly enough 'No, oh no, of course not'. Physically, he appeared well and handsome. He had grown a moustache and long beard, dark as his hair, and wore a large blue military style cloak: but beneath the cloak, his hands were shackled.[47]

He remained in Maidstone gaol for another fortnight, alternating between fits of frenzied violence, and intervals when he was so mild and amenable that he was allowed into the prison yard. At length, on 22 August 1844, he was removed and admitted to the criminal lunatic department of Bethlem Hospital, under an Act of 1840 which enabled the Home Secretary to transfer any prisoner to an asylum on receiving proper certification of his insanity.[48]

The Bethlem of 1844 had come some way since the days when 'Bedlam' was **Bethlem**[49] factually, as well as linguistically synonymous with 'chaos'. Since 1815 it had been housed at St George's Fields, Southwark, in the building of which the central part is now the Imperial War Museum; and many improvements had been incorporated into the new building, and many more had been introduced later. Indiscriminate visiting to 'view the lunatics' had been abolished as long ago as 1770, and the use of iron manacles had practically ceased by the 1830s. Dadd was admitted from prison in a strait-waistcoat, but was never again subjected to any sort of physical restraint of this kind.

By the 1840s attempts were being made to provide more occupation and entertainment for the patients: workshops had been built, books and periodicals circulated in the wards, and a ballroom and billiards room had been added in 1838. But any similar progress was severely restricted in the criminal department, where Dadd was confined, which was accommodated in two blocks, one each for men and women, at the back of the main hospital and had no communication with the other departments. The ultimate authority for its control was the Home Secretary, though it was managed and staffed by the hospital. All expenses, including maintenance of the patients and salaries of the staff were paid by the government. It was, in fact, the country's state

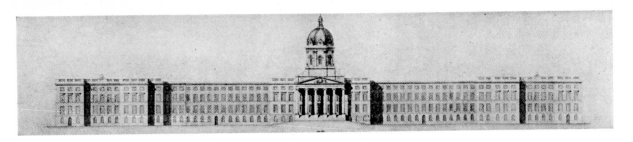

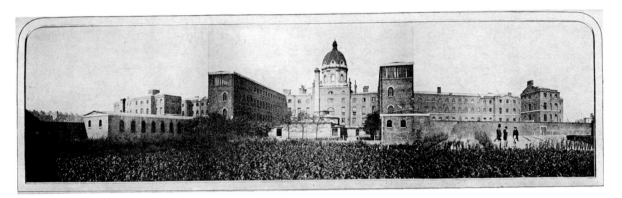

Bethlem Hospital, Southwark, front and back views. The lower picture shows the male criminal block
(far left, immediately behind the wing projecting from the building)

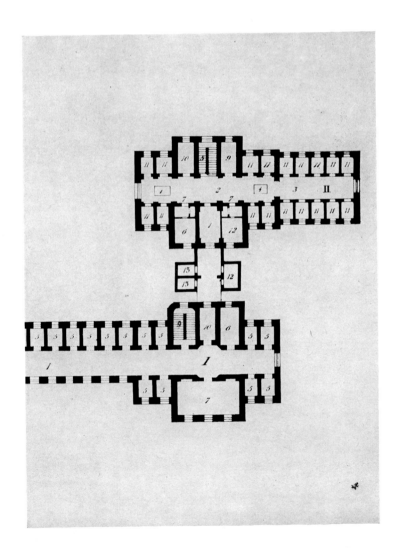

Bethlem Hospital, plan and description of
the male criminal block from the Charity
Commissioners' *Report*, 1840

Basement
1. Passage from the main building.
2. Gallery, with bed-rooms on each side.
3. Addition recently made to it.
4. Dining tables.
5. Staircase.
6. Pump and engine room.
7. Sink and water-closet.
9. Keeper's room.
10. Large sleeping-room.
11. Ordinary sleeping-rooms.
12. Sleeping-room, with water-closet
contiguous.

The next floor contains a bath room. In
other respects the arrangement of the upper
stories is nearly similar to that of the base-
ment.

The galleries are lighted by windows at
each end.

Several portions of this wing are divided
(by means of iron rods or wires) into cages,
communicating with the adjacent sleeping-
rooms, by which means patients can be
separated from each other without being
locked up in their sleeping-rooms.

criminal lunatic asylum, which had been joined on to Bethlem Hospital for convenience in 1816; and as such it was doomed to share the increasingly enlightened attitude of a hospital, with the restrictive conditions of an institution designed as though it were a prison.

The male criminal wing consisted of a basement and three stories, all with the same lay-out. A gallery about a hundred feet long, lit only by a small window at each end laden with heavy, black-painted iron bars, served as a day room. Eighteen individual sleeping rooms opened off it on both sides, small cells just under eight by ten feet, with windows designed to admit air rather than light. There was little else, besides a keeper's room, W.C.s and wash-places. The patients were locked into their rooms at night, but except when they were taken down into the exercise yards, their days were spent herded together in the gallery, where the dining tables were also set up.

The building was always overcrowded, and there was little scope for classification, so that the educated and refined, whose derangement had prompted a single criminal act, must be kept in close proximity with the hardened and degraded, whose whole career might have been one of crime until insanity had (perhaps mercifully) overtaken them. Several parts of the galleries were divided off by iron rods into areas communicating with the adjacent sleeping rooms; but the effect of this, the only means of separating patients without locking them into their rooms, was to produce cages 'more like those which enclose the fiercer carnivora at the Zoological Gardens than anything we have elsewhere seen employed for the detention of afflicted humanity. . .'[50]

Because the patients could not be moved from this wing it was difficult to provide any occupation for them, though two looms had recently been set up. Every encouragement was given to them to occupy themselves, however, and reading, chess, knitting and handicrafts of all kinds were practised at the time of Dadd's arrival, with fives and foot racing the most popular entertainment in the exercise yard. Any inclination on his part to take up painting again, therefore, would be supported by the staff (though not necessarily by all his fellow patients).

The person most likely to show interest in him as a painter was Dr Edward Thomas Monro, the physician in charge of his case. Monro was the son of Dr Thomas Monro (also visiting physician to Bethlem as his father and grandfather had been before), whose patronage of young artists at the turn of the century has left the name of 'Monro School' associated with the group of watercolourists who came to draw and learn from works in his collection. Edward Thomas Monro had been brought up in a house frequented by Turner and Girtin, Linnel, Hunt and Cotman, amongst others, and whose walls were lined with the works of many masters ancient and modern. He had played cricket with de Wint and gone to Easter balls with the Hoppners; his father was a talented draughtsman, his brother a brilliant one, and he had sketched a little himself in his youth; so he cannot have been indifferent to art. Unfortunately, he was indifferent to record keeping, and it can only be surmised how far he was responsible for Dadd's return to work.

Within a year, he certainly had returned; and amidst the desolation and crudity of these surroundings and the oppression of his own tormented mind, he began to produce again the works of incredible delicacy and beauty, which were now all that remained of a world which had disintegrated around him and could never be rebuilt. Whatever the motive that set him working again — a means of escape, perhaps, from the endlessly blank vista of the years ahead — a total commitment to his own creative power as an artist reasserted itself at once, and was to sustain him for the next forty years. It was a commitment as necessary to his own survival, as to his painting, and Dadd survived as a person throughout these terrible years because he survived as a painter. Never,

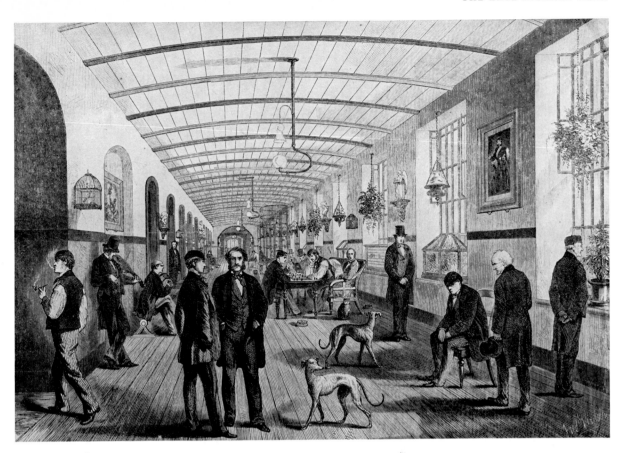

Bethlem Hospital, ward of the type to which Dadd was moved in 1857

on the evidence of his work, did he draw or paint merely to pass the time, and there can be little doubt that for the rest of his life he lived and worked as a dedicated artist, who had never abandoned his profession.

His first work was in watercolour and consisted chiefly of landscapes and eastern scenes, remembered or worked up from the sketchbook which some-one must have brought to him, and which contained drawings from his Middle Eastern trip. They are described as exhibiting 'all the power, fancy, and judgment for which his works were eminent previous to his insanity', though two or three were said to 'indicate the state of his mind', and some had descriptions on the back in strangely mingled French and English.[51] Little seems to have survived from these early drawings, but 'View in the Island of Rhodes' (No. 100) and 'Bethlehem' (No. 101) may have been amongst them.

A small oil on panel also dates from the first year, the 'Caravanserai at Mylasa' (No. 97), and he may have gone on working over his Middle Eastern material in a relatively straightforward manner for several years. 'The Flight out of Egypt' (No. 104) of 1849 could hardly, perhaps, be called straightforward, but the components of this complex and confusing composition are clearly taken from the sketchbook, and are transcribed fairly literally within their fantastic context. In a sense, of course, all his pictures after 1844 come from the same source, that is, from memory or directly from the sketchbook; but the development of his imaginative work over the years creates a clear distinction between the remoteness of the later eastern scenes, and such realistic works as the 'Caravanserai'.

Whether he did not produce much during the first eight years, or whether it was not preserved or has not yet come to light, there were certainly changes in the hospital around 1853 which seem to be reflected in both the quantity and content of his work. In the previous year the management had been radically altered following a critical inquiry by the Commissioners in Lunacy,[52] and for the first time in six hundred years a resident physician superintendent took

charge, replacing the visiting physicians who had become increasingly negligent over the years. Now the hospital was to be controlled by one person, devoting his full time and attention to every aspect of the patients' welfare.

The man appointed to carry out the reforms was one of the most outstanding in Bethlem's history, Dr William Charles Hood. Appointed at the age of twenty-eight, a man of vision and industry, of compassion, culture and commonsense, he opened the new regime almost symbolically by enlarging the windows throughout the hospital, and within a few years had furnished every ward with an aviary of singing birds as well as flowers, pictures, statuary, books and all the accompaniments of civilisation which could hope to distract and soothe the alienated mind.

Hood was not alone, sharing both work and outlook with the new steward George Henry Haydon, who was little older than himself. But even Hood and Haydon could make small impression on the physical conditions in the criminal department, because of the overcrowding and unalterably prison-like construction of the building: and until a further change in 1857, their chief effect on Dadd was through the changed attitude all over the hospital, the possibility of conversation with men of similar background fresh from the outside world, and with Hood, perhaps, some sort of relationship as near as he would ever come again to friendship. In writing up Dadd's casenotes in 1854 Hood spoke of him as being, despite his still deluded state and often unpleasant behaviour, able to be 'a very sensible and agreeable companion, and shew in conversation, a mind once well educated and thoroughly informed in all the particulars of his profession in which he still shines . . .':[34] it is doubtful whether Dr Monro would have used the word 'companion' in speaking of a patient. Hood's genuine admiration for his work is borne out by the fact that he eventually owned thirty three examples of it, some of them among the finest.[53]

In 1851 and 1852 Dadd had produced a few watercolour figure compositions, such as 'Dymphna Martyr', 'Polyphemus' and 'Robin Hood' (Nos. 105-7), the former especially interesting for its choice of subject. In 1853 he began the series 'Sketch to Illustrate the Passions', of which nearly thirty survive, and more are recorded; and since Hood owned at least sixteen of them it is possible that he had in some way initiated the subject, or at any rate encouraged its progress. There is considerable violence and tension in some of these and in other watercolour sketches of the same period, and they seem almost to be used as a vehicle to channel his aggression, which is far less evident in the oil paintings. Of the oils, 'Oberon and Titania' (No. 172) and 'The Fairy Feller's Master-stroke' (No. 190), the two masterpieces of his maturity, are dedicated to Hood and Haydon respectively. They appear to represent his only return to fairy painting after his confinement, and the first occupied him for four years and the second for up to possibly nine. The only other oils known from the 1850s are 'Saul and David' (No. 123) and the 'Portrait of a Young Man' (No. 112), which are both works of outstanding quality and originality.

The 'Passions' series continued for several years and then, again to judge by survivals, came another change, and Dadd seems to have left figure drawing for a while to return to landscape. Now it is the landscape of one who has been confined within high walls for thirteen years; visionary and intense, based on material from the sketchbook, but moving gradually farther from it into the inner reaches of imagination. This style is epitomised at Bethlem in 'Port Stragglin' (No. 181), and later at Broadmoor in 'Tlos in Lycia' (No. 215).

At around this time there came an improvement in his physical circumstances. In 1857 an ordinary ward in the hospital was converted to the use of

forty of 'the better class' of criminal patients, adapted as to security and isolation, but otherwise retaining its former character with flowers and birds, pictures and statues. There was also a billiard table, and the government laid out £100 for the purchase of a library. Dadd was undoubtedly among those moved, for W. M. Rossetti, who visited the hospital in 1863, saw him in a 'large airy room',[54] a description which could by no stretch of the imagination be applied to any part of the criminal department. In these, more pleasant, surroundings he seems to have found peace to develop the gentle watercolour landscapes and seascapes, with their pale dreamlike quality; but half a dozen fine and powerful oils, in completely different mood, also date from this period.

Broadmoor[55] For many years there had been plans to build a new and much larger state criminal asylum in Berkshire, and when Broadmoor Hospital was finally completed all the Bethlem criminal patients were transferred there. Dadd left London by the Great Western Railway on 23 July 1864, to his first sight in twenty years of the countryside which had once been so important to his work.

After the strict confinement of Bethlem the move to the new hospital must have seemed almost like release, for Broadmoor had been deliberately designed to allow as much freedom of movement as possible within the outer perimeter. Terraces at the back helped to disguise the harsh reality of prison walls, and gave on to a magnificent sweep of wooded uplands to replace the monotonous brick and sky of the Bethlem exercise yards. Laurels and rhododendrons were planted to soften the outline of iron railings. Inside and out there were facilities for recreation and employment, and life was no longer divided exclusively between one tiny cell, one crowded gallery and a bleak yard.

These changed conditions do not seem to have produced much outward change, however, in Dadd's work, which by now was almost entirely the product of imagination; and without any break in continuity he went on with the fragile and mystical little watercolours of his late period at Bethlem. These were interspersed with a few oils, but the two which have survived are so different from each other in character that it is impossible to speculate on the rest. One is the vivid and naturalistic portrait of Dr Orange (No. 207), the other 'Wandering Musicians' (No. 211), which is nearer in spirit to the late watercolours than any other of his known paintings and was in fact duplicated in watercolour.

His major work at Broadmoor is now largely destroyed, the decoration of the theatre in 1874 with murals, an elaborate drop-curtain (*see* No. 199) and other scenery; and the panels from the front of the stage are the only surviving remnants (Nos. 200 to 205). It is a remarkable testimony to his own survival that at this time in his life, after thirty years of complete seclusion and narrow restriction, he was able to open out again to all the techniques and media of his youth: and even, indeed, to experiment confidently with new ones, as shown by his decorated glass panels (Nos. 217 to 227), and recorded in his willingness to turn out Christmas decorations, lantern slides, and anything else that might be required.[33]

At Broadmoor too, he continued to pursue the other activities which had always helped to fill up his non-working hours. He was a skilled violinist, and would play by the hour his own variations on tunes learnt in childhood: he read classical history and literature, and English poetry; and must have seized whatever he could get hold of in the journalism of his profession, for he was always eager to learn of new developments in the art world, new techniques invented, new pictures exhibited, new R.A.s elected.[33]

Dadd never fully recovered his sanity, though his intellectual powers were

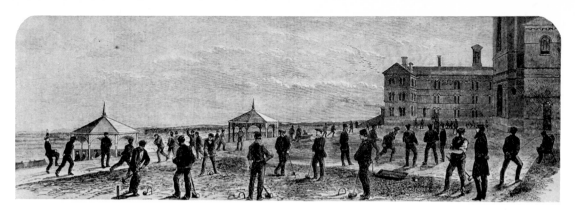

Broadmoor Hospital, the terrace, from the *Illustrated London News*, 1867

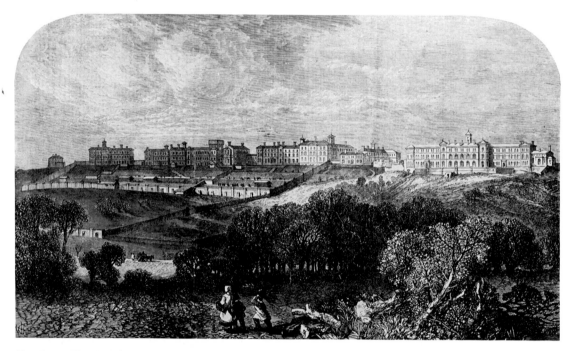

Broadmoor Hospital, from the *Illustrated London News*, 1867

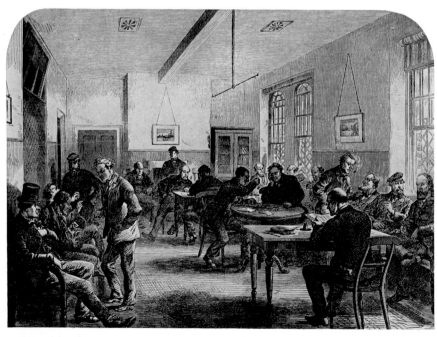

Broadmoor Hospital, day-room for male patients, from the *Illustrated London News*, 1867

left practically untouched, and there must have been a considerable remission in his worst symptoms, after his return from France and before he began painting again. But during most of the time at Bethlem he was always liable to sudden, if infrequent, outbursts of violence; he would make unprovoked attacks on his neighbours, and apologise afterwards; and his behaviour and conversation were often uncontrolled and disagreeable.[34] His apparently irrational 'impulses' all stemmed from the same source, the feeling of being controlled by Osiris and other spirits, and this belief remained paramount all his life: but by the time he had reached Broadmoor it was becoming less openly obvious, and although he would talk about it when questioned, he was able to speak with something of the detachment of one resigned to being mis-understood.

Whether he ever achieved any lasting inward peace cannot be certain: a visitor writing in 1877 spoke of him still oppressed 'by thick-coming horrors and portentous visions–meditative, gloomy, abstracted', but he did achieve the appearance of tranquillity in his outward life. The same writer describes 'a recluse doing the honours of his modest unpretending abode; a pleasant-visaged old man with a long and flowing snow-white beard, with mild blue eyes that beam benignly through spectacles when in conversation, or turn up when in reverie till their pupils are nearly lost to sight. He is dressed with extreme simplicity in gray "dittoes"; his manner is unassuming, but impressive and perfectly courteous; his utterance slow, not as though ideas were lacking, but as if he wished to weigh carefully his words before he spoke them'.[33]

The writer might also have remarked that the old man with the snow-white beard was prematurely aged, since he was only just sixty at the time and his family, barring the effects of insanity and murder, tended to be long-lived and robust. He lived, however, for another nine years, continuing to work in watercolour until at least 1883 and undertaking another large mural (No. 214), this time in the house of the superintendent Dr Orange, whose portrait he had already painted.

Towards the end of 1885 he became dangerously ill with consumption. By now there were few left to remember him; his sister and half-brother, Mary Ann and John Alfred, were living in America, and the descendants of his other brothers and sister can hardly be blamed for trying to shut out the many tragedies of the previous generation. The only person to be informed of his illness was Elizabeth Langley, a friend of their youth whose sister had married Dadd's brother Robert, and whose portrait, together with that of her husband Joel Langley, he had painted several times (Nos. 8, 18, 19 etc.). Mrs Langley had previously written to the hospital on her sister's behalf, to ask after him, and was also the first person to receive the news when he died a month later, on 8 January 1886.[56]

Dadd was buried in the peaceful little cemetery at Broadmoor, towards the bottom of a hill which slopes down amongst scattered trees.[57] From America his sister Mary Ann wrote an epitaph which echoes the *Art Union*'s 'obituary' of forty-two years earlier: 'I am truly thankful to know him at rest, it is less grief to me, that it was to think of him in the changed condition in which he has lived for many years past, his life has been to me a living death . . .'[58]

The outside world Several of Dadd's contemporaries have left, in their memoirs and other works, glimpses of his life in Bethlem and Broadmoor, though not many could be classed as visitors to him personally. During his own lifetime he was to become a creature of another world, to be seen and commented on as a curiosity, but scarcely to be spoken to as a human being.

In the early days of confinement, however, he did have a few visitors. An

article in the *Art Union* of May 1845 describes how one of his former artist acquaintances 'happened to be passing through the ward, with a portfolio under his arm', though actually intending to avoid recognition. Dadd accosted him with the rather disconcerting question, 'What brings you here; have you killed anybody?', and then engaged in a long and technical discussion about the contents of his portfolio.[59] Unlikely though this encounter may sound, with its picture of casual strolling in and out of the criminal wards, the artist was probably a man called Gow, who made many drawings of asylum patients for works on the physiognomy of mental disease.

A more deliberately social call by one of his most intimate friends is recorded in the same article, but on this occasion Dadd refused to see him; and on being told that one of his friends had come, simply shrugged his shoulders and turned away muttering 'Friends!' Such rebuffs probably helped to discourage future attempts.

Another episode is recounted by Frith in his autobiography, which undoubtedly relates to Gow. The patient concerned is not identified as Dadd but as a Frenchman, formerly an art student in Paris, but one cannot tell whether Frith was tactfully disguising his friend's identity or whether he had heard or recollected a garbled version of the story, and did not himself recognise the participant. Dadd may have sometimes tried to pass himself off as a Frenchman during these early years. This time (or it may have been the occasion previously recounted) Gow turned up in the middle of lunch. Dadd, after complaining about the lack of suitable models among his mad companions, suddenly seized his neighbour by the back of the neck, twisted round his head and exclaimed, 'what could any artist make of such an ugly fellow as this?' He then took Gow to see one of his paintings and extolled its merits with French volubility, but on perceiving a fly stuck to the paint and identifying it as the devil in one of his disguises, became excited and distraught.[60]

The occasions when Dadd could meet former friends and acquaintances and discuss art with them on equal terms were, inevitably, to become less frequent, though there is little on record at all about this aspect of his life. But by 1848 the *Art Union* could show an interest in his pictures, without offering any news about his welfare or the circumstances of his life in Bethlem, except to reiterate its earlier conclusion that his earthly life was over. The short account ends with the prophetic words: 'How singular these outpourings of disease and mind [*sic*] will be to future collectors': but the inference is that this will be on the grounds of curiosity rather than artistic value.[61]

Casual visitors, those who came to see the hospital out of professional or sometimes journalistic interest, would usually remark on the more famous patients in the criminal department, and Dadd was generally included in the list. Some, however, came with the deliberate intention of seeing him, among them William Michael Rossetti who, having done so, could find nothing better to say than that 'his aspect was in no way impressive or peculiar; he seemed perfectly composed, but with an undercurrent of sullenness,' and that 'The Good Samaritan', on the staircase, showed adequate but ordinary artistic knowledge and none of his former superior talent.[54] It is striking that anyone so closely associated with the Pre-Raphaelites could have stared at Dadd, while failing to find out that 'The Fairy Feller's Master-Stroke' was in the same building.

Another, more percipient visitor was the elusive 'EWB', one-time owner of 'Songe de la Fantasie' (No. 192). He saw Dadd at work on 'Saul and David' in 1854, and was later given his own drawing by the superintendent of Broadmoor, but there is no indication that he made any contact with Dadd himself. The only recorded encounter of any substance is a long interview in Broadmoor (part of it already quoted), published in *The World* of 26 December 1877.[33]

The author is unidentified, but seems to have been either an art journalist, or someone else moving among artists who knew how to use a good scoop. He was clearly acquainted with Frith or his circle, using material which could only have come via Frith and which was not to be published for another ten years. This man seems, despite his somewhat dramatic presentation, to have approached Dadd as a painter, to have discussed his work with him, and to have had some understanding of Dadd's own view of himself throughout the years of his incarceration. His summing up is probably the most sympathetic assessment of Dadd to be made during his lifetime: 'Art is thus his mistress still . . . it is to his beloved brush that he clings, and wields continuously, with that enthusiasm and unwearying ardour the true painter alone can know. Many works will live after him, the product of these thirty-odd years of absolute seclusion – melancholy monuments of a genius so early shipwrecked, but which never went actually to ruin.'

Besides those who actually visited the two hospitals there were others who knew and sometimes admired Dadd's work, and a certain amount of it was always in circulation. From the few pictures which can be traced back to an early provenance, it is clear that Dadd gave some to members of the hospital staff, and it must be presumed that they passed them on to others outside. G.H. Haydon, the steward, is known to have given away the painting of 'Pope's House' (No. 189) and 'A Dream of Fancy' (No. 174), the latter to Myles Birket Foster. The Bethlem authorities objected to this in principle, as shown in a reply from the Treasurer to a former physician, Sir Alexander Morison, who in 1856 sent £5 to Dadd and asked for some drawings: 'I am also sorry we must not allow any more of Dadd's drawings to leave the hospital. So long as they remain in hands such as yours no objection can be made but it is possible they may at some future time find their way into the market, a result which might lead to much inconvenience.'[62]

He was, of course, quite right, and thirty-three found their way into the market at the sale of Sir Charles Hood's property alone, after his death in 1870. The lack of watercolours up to 1852 suggests a possibility that the two visiting physicians, Monro and Morison, who left when Hood took over in 1853, might have collected most of them before this period and that in some way their collections have been lost; but this is mere speculation.

At the Hood sale over half the works were bought by dealers, but a letter from a dealer who did not buy any throws light on the limited level of interest then current. Immediately after the sale William Cox wrote to the Birmingham collector, Joseph Gillott: '. . . as Commerce I dare not buy the Dadd drawings altho as quaint and interesting productions I imagine that you might have liked to have them if you could have seen them, but I must be prudent with my very heavy stock & consequent limited means . . .'[63] The watercolours fetched sums between £5 for 'A Seapiece' and 36 gns for (surprisingly) 'The Grotto of Pan', with 'The Pilot Boat', more understandably the second highest at 24½ gns. The 'Passions' drawings mostly sold at around £10, though 'Patriotism' and 'Splendour and Wealth' made 21 gns and 20½ gns respectively. Of the oils, 'Saul and David' was sold for 19 gns, and 'Oberon and Titania' for 136 gns.[53]

John Forster, the friend and biographer of Dickens, bought one drawing, 'Patriotism' (No. 165), and left an unsuccessful bid for another. Forster may have had his interest in Dadd strengthened by Dickens himself, to whom the coincidence of their both having lived in Chatham at the same time as children must have added spice to the story. When taking friends for walks in Cobham Park, Dickens would sometimes stop and re-enact for them the scene of the murder *in situ*, and with customary dramatic vigour.[64] Frith, Egg and Maclise were all members of the same circle, and no doubt the details were common

property among them. Forster, moreover, had opportunities to see Dadd when visiting Bethlem in his capacity as Secretary to the Commissioners in Lunacy, and later as a Commissioner.

Pictures which came out of Broadmoor were also passed around, and Frederick Goodall recollected having seen some drawings, including 'The Crooked Path' (No. 196), at a meeting of the Chalcographic Society sometime after 1866.[65] He thought they showed 'that the poor fellow had retained some part of his artistic knowledge, but mixed up with curious freaks of fancy', and although it would not be fair to judge the taste of the entire art world by that of Frederick Goodall, it seems to have been a common opinion that the element of fantasy in Dadd's pictures marred rather than enhanced them. This may have been due to genuine lack of appreciation, but also partly to a tendency to pass over much of his work without really looking at it, because it was known to be from the hand of a madman. Many of the qualities which, from another painter, would have been praised as evidence of a fine imagination, were liable to be identified as symptoms of insanity; an approach which has had some currency until very recently.

Few of Dadd's pictures produced after his insanity were publicly exhibited during his lifetime, but when it did happen there was no attempt to conceal his name or the details of his story. At the Manchester *Art Treasures* exhibition of 1857, three of his oil paintings and three watercolours were exhibited, and the *Manchester Guardian*'s reviewer devoted quite a lot of space to considering them in relation to the painter's insanity. In dealing with the watercolours ('Dead Camel', 'Vale of Rocks', and 'Artist's Halt in the Desert'), he went against the general run of criticism in suggesting that Dadd and Blake might be classed together as 'examples of painters in whom a disordered brain rather aided than impeded the workings of a fertile and original fancy', and added, 'Do not be deterred by the strangeness of Blake's work, or the sadness of Dadd's, from looking closely into both.'[66] The modern paintings were selected for this exhibition by Augustus Egg, who commemorated his friend with the two *Midsummer Night's Dream* pictures (Nos. 57-8) and 'Caravan Halted by the Seashore' (No. 91).

At the *Fine Art and Industrial Exhibition* at Huddersfield in 1883 Dadd was represented by a picture painted in Bethlem, 'Caravanserai at Mylasa' (No. 97), (called 'Eastern Inn Yard'), and in the catalogue is the note 'Painted in Bethlem Hospital, after he had murdered his Father'. It might be supposed, from this rather stark comment, that the compiler did not know that he was still alive. In fact, as early as 1859 he had been listed in a book called *Painting Popularly Explained* as having died insane,[67] and it is unlikely that anyone except those who had a special interest in him knew much at all about his last years, or when he died.

It has been mentioned that Dadd's family sent him special food and painting materials while he was in France, and no doubt they would have continued to provide anything that he needed in Bethlem; but it is unlikely that much was required, since the criminal patients were kept at the expense of the State. Dr Morison's proffered £5 was returned to him in 1856, on the grounds that no special indulgences could be extended to Dadd. The family, or other friends, might have supplied his materials at the beginning, but these are equally likely to have come from inside the hospital.

There is no evidence as to whether or not any of his family came to see him, though restricted visiting was allowed; but it is recorded of his brother George, after ten years in the hospital, that 'His friends seldom or never visit him'.[34]

They had, indeed, enough to contend with, and even the insanity of Maria, the wife of John Phillip, was not the last catastrophe. The second son, Stephen, also became insane, though the information about this is confined to

the fact that he had a private attendant by 1853, and by 1860 he had died in Manchester leaving a widow and three children. Robert, the eldest (*see* No. 42), seems to have remained remarkably stable amidst disasters of Greek tragedy proportions, and successfully brought up a large family with many descendants. He also kept in touch with the others, including his two half-brothers John and Arthur after they had emigrated to America (*see* No. 27), and a strong bond of affection united them all even when widely scattered. The girls led rather less satisfactory lives, moving about from post to post as governesses and companions (one was governess to Frith's children for a short time), but returning occasionally to the refuge of their brother's home: and on the whole they seem to have been contented. Mary Ann eventually went to America too, and later joined her surviving brother John at Milwaukee.[68]

It is not likely, from what is known of them, that Dadd's brothers and sisters ever deliberately rejected him; but there was little they could do for him, and their own need was to forget as much as possible of what had happened. They were harassed from time to time by the comments of visitors to Bethlem and Broadmoor, who kept alive the memories of 1843; but a suggestion that they tried to collect his work and destroy it has no known foundation. It is the sort of story which would almost inevitably be invented, in view of the scarcity of his pictures, but in fact the evidence is all to the contrary, and quite a number of his works have been carefully preserved in the family.

Artistic talent has also been preserved in the family, each generation producing one or two professional, and several competent amateur, artists. The best known is Frank Dadd, the son of Richard's brother Robert, chiefly known for his black-and-white illustrative work, but a competent watercolourist as well. His brother, Stephen Thomas, was a wood engraver, who had been apprenticed to a distant relative, John Greenaway; (the third of Robert Dadd's sons married John Greenaway's daughter Frances, the sister of Kate Greenaway the illustrator.) One of Dadd's half-brothers, Arthur, also practised as a watercolourist outside his profession of 'decorative artist', though he could find little outlet for his work in Milwaukee. Stephen Gabriel Dadd, the son of Richard's nephew Stephen Thomas, was a talented young sculptor who died in the 1914-18 war, and several other collateral descendants have been painters and art teachers.

Appendix

A group of six letters addressed to David Roberts, R.A. five of them concerning Dadd, was sold in London c.1960. Two were the letters written by Dadd from Damascus and Malta and published in the *Art Union*, October 1843; the others were written by him after his return to London, and by Stephen Dadd and Sir Thomas Phillips after the murder. (The sixth letter, from Hanafy Ishmael, Roberts's dragoman during his Middle East tour, had nothing to do with Dadd.) It has not been possible to trace them, nor was it known until after the catalogue had gone to print that they had ever been copied. Dr L. P. Senelick of the Drama Department, Tufts University, Medford, Massachusetts, has now very kindly supplied transcripts which he made from the originals before their disappearance, and the three letters which have not previously been published are given here in full from his transcripts.[69] In the *Art Union* version of Dadd's letter from Damascus, only his personal remarks to Roberts have been omitted: more is omitted from the Malta letter, chiefly a description of preparation in Cairo for the Nile trip. A letter from Roberts to S. C. Hall, editor of the *Art Union*, also discovered after the catalogue had gone to print, specifically exhorts Hall to cut out the personal references before he publishes Dadd's letters.)

Richard Dadd to David Roberts, dated 15 Suffolk Street, Pall Mall, 13 March 1843 [an error, since he did not arrive home until the end of May]

'My dear Sir| I with many thanks return you Wilkinsons 3 Vols. on Egypt;[70] I have it is true kept them an unconscienable time, but this I trust you will forgive when I tell you that they have been to me a source of deep interest & much reflexion; The manners, customs and opinions of so antique a People cannot fail to be deeply interesting to any one more especially to one of my way of thinking; I have always felt the greatest pleasure in seeking into the origin of the manner & opinions of my fellow beings, there amongst the monuments of the old Egyptians is matter for speculation indeed; here we find ourselves conversing with a people of whose antiquity no one knows the date, for after all the researches of the learned, & this "most learned *Theban*," we find ourselves set down at once amongst a People highly civilised & polished acquainted with Arts & Sciences to a degree that puts to shame our puerile notions of them & at so early a date in our chronology as to make us laugh at the extreme youth which our modern antiquarians give to our Race – at any rate these Egyptians must have been a very precocious & might[y] generation to have so soon after the general destruction of the race, built such things as the Pyramids of Ghiza. There are many other things belonging to them so extremely curious & so terribly astounding, even according to the shewing of this author, that the call upon our Faith to believe in received opinions is so great that I fear a great many will be found bankrupt in that article after reading him thus for instance he says that the Types of much of the religious ceremonial of these antique Egyptians is to be found in the Bible of Moses – does he not mean rather that Moses drew his ceremonial from their set or Type – for instance the Urim & Thummim breastplate of the high Priest, was a copy of the Breast plate of the Judges of Egypt – the Urim & Thummim means he says lights & perfections. The Judges breastplate was Justice & Truth – also the Egyptian Priest suffered none but the initiated to meddle with holy things or to enter the Sanctuary – none but the High Priest of the Jews might enter the Holy of Holies their Sanctuary. – Now Moses was a Priest at Heliopolis as also his brother Aaron & they were skilled in all the wisdom & learning of the Egyptians – & so they applied it to the Government of the People whom they led out of the Land of Egypt, etc etc
You offered to lend me St Johns Travels in that ancient Land, if it be not giving you too much trouble will you let the Bearer have them now
With respects to your Daughter & Son in Law| I remain| Dr sir| Yours faithfully| R Dadd'

Stephen Dadd to David Roberts, dated 2 September 1843

'Dear Sir.| How shall I describe to you the awful calamity the heartrending affliction which has fallen on us. My Father has fallen been cruelly murdered in Cobham Park, and we have too much reason to suppose by the hands of his Son Richard in a fit of Frantic Madness. To you who know the state of mind my poor unfortunate brother was in I need not I am sure bring forward proofs of his insanity. You are well aware of the peculiar hallucination which had possession of his mind that he was haunted by fiends. He came to his Father on Monday morning and persuaded him to go to Cobham in Kent, on the pretence that he wished to unburthen his mind to him, which he would do no where else but in the country and that he should afterwards be quite well and perfectly himself again. My poor Father in his affection for him allowed his prudence to be overruled and accompanied him alone, and thus has fallen a victim to his affection. My God to think he should fall by the hands of his Son Richard who loved him so

dearly and whom he so dearly loved, tis more than I can bear. He who was so kind so dutiful so affectionate to his parent, to think his mind should be destroyed and that he should commit this foul deed. God help us for we have need of his help. Twas only the Sunday previous to the fatal day that my dear Father went with Mr Humby[71] to Dr Sutherland who said he was not safe was not accountable for his own actions and that when that particular hallucination took possession of him he would most likely destroy anyone who was near him! Even after that on Sunday evening my poor Father did not seem to apprehend any danger and seemed to think he could do any thing with him. Richard has not been seen or heard of since with the exception that he came back to London on Tuesday morning and asked a Cousin of his about getting a passport to Paris, he also went to Mr Joys on the same errand,[72] since then he has not been seen or heard of. May God give us strength of mind to bear up under this awful visitation. It is useless to look back. I must only look forward now, and think of those who are looking to me for protection through life and comfort in this trying hour. No more happiness for us now, all is lost God help us | Yours sincerely | Stephen Dadd.'

Sir Thomas Phillips to David Roberts, dated Llanellen near Abergavenny, 10 September 1843

'My dear Sir | I really cannot drive from my mind the frightful tragedy in which our poor friend has been the wretched but unconscious actor. Gratitude for my own preservation, sorrow for the afflicting fate of the unhappy father sympathy for the bereaved & suffering family & deep commiseration for the unconscious agent of so much misery combine together & in my case the past constantly recurs. I well know the interest you so kindly took in poor Dadd & I also know the grateful feelings he cherished towards you. And his fond hopes [have] been blighted & the prospect of high & well earned distinction rudely snatched away. With you I feel that Dadds was no common mind & that in professional capabilities he had left far behind him all the

men of his own standing & position. I really knew not how to write to you until I received your letter. I wrote to Mr Stephen Dadd in reply to a letter I had received from him I stated that I was ready to bear my testimony in any way I could do so to the state of his brothers mind during the latter part of our journey I had thought frequently of Dadd of late. He had breakfasted with me a few weeks ago (the day before I left town) & I had come to see a study he had made for a picture. I left him apparently restored to his former calmness with high hopes & untamed energies. I had very recently read [illegible] life & thought there was so much good sense right feeling & sound professional criticism in all he said & did that I meant to write to Dadd to recommend the work to his notice there was much about [illegible] that seemed likely to benefit him. I was about also to offer him some suggestions for a picture & whilst these matters were present to my mind the frightful story appeared in the newspapers. In reply to your question as to what he has done for me I will tell you how matters stand. Whilst abroad he made very few drawings but interested himself with collecting materials in his sketch books for works to be thereafter executed. Knowing his principles to be strictly honorable I never recurred to the arrangement between us but meant on our return to suggest to him that he should keep the sketches & furnish me with drawings. The circumstances under which he returned prevented my alluding to the subject but the same views appear to have occurred to him & he engaged himself in making drawings for me which I left with him. These I apprehend are not numerous & I should certainly now like to possess his sketch books as well as the drawings he has made & I have so apprised his brother who says that at present his rooms are locked up.[73] I also informed his brother I would like to *purchase* a screen I saw in his room with studies from Manfred if the family desire to dispose of it.[74] Whatever arrangement may appear to you fair I would at once accede to. I estimate my payments for him at £250 or something more. Do not honored Sir let this subject give you any trouble. I hope to be in town early in Ocbr & will there see you. Believe me to be most truly yours, | Thos. Phillips'

A note on Dadd's inscriptions

Dadd seems nearly always to have signed and dated his work, using many variants all his life including 'RD', 'R.Dadd', 'R.^d Dadd', 'Rich.^d Dadd', and 'Richard Dadd'. After his admission to Bethlem he becomes obsessionally precise (or perhaps just pedantic) about giving the day of the week, as well as the month and year, on his watercolours, sometimes including the date of starting a picture as well as its completion, and occasionally adding 'A.D.'. The location is also shown in increasing detail; first the name of the hospital only, and later 'London': but the addition of 'St. George's in the Fields', which first appears in 1857 on 'Patriotism', is incorrect. Bethlem was at St George's Fields, in Southwark. Dadd himself had lived a stone's throw

from St Martin-in-the-Fields, and may have been confused by the association. His alternation between 'Bethlem' and 'Bethlehem' reflects the hospital's own indecisive attitude to its name around the mid-nineteenth century, when there was a brief attempt to shake off the centuries-old 'Bethlem' in favour of its medieval origin. On being moved to Broadmoor he uses the location 'Broadmoor. Berks.' for some time, and then seems to drop this towards the end of his life; but too few examples survive from this period to provide any definite pattern. Several of the inscriptions are mildly eccentric, and a few describe the pictures at such length as to amount almost to catalogue notes.

The Late Richard Dadd: his Work

In strictly chronological terms Dadd is the complete Victorian; but so far as most of his work is concerned he stands outside the period, and indeed almost outside time itself, untouched by all the major developments of the second half of the century. From 1843 onwards he produced only variations, increasingly idiosyncratic, on the themes which he was already handling; and his own development, marked by a progressive drive back into his inner resources to replace the ever receding stimuli of the world from which he had been cut off, proceeded, as it were, within a vacuum.

The similarities between his work and that of the Pre-Raphaelites indicate, rather than any direct influence, a temperamental affinity which might have led to an association with them if circumstances had allowed. There is evidence of Nazarene thinking in his painting, in particular in the use of light, clear colours and taut contours, and while still a student he must have absorbed other ideas too, which led a few years later to the formation of the Brotherhood; but otherwise there is little to relate his work to any movement or fashion which occurred after he had entered Bethlem. Even in relation to late-flowering neo-classicism, his own abiding interest in classical subjects is more closely connected with the illustrative tradition of his youth, than with the escape into the idealised world of Greece and Rome which it provided for many of the Victorian neo-classicists.

Comparison between isolated pictures from before his admission to Bethlem and those of several years later, has led to the suggestion of stylistic changes which might have been produced by his illness. In fact, though the present knowledge of his oeuvre is obviously incomplete, there seems to be no sudden change either in style or subject matter, and little in his later work which cannot be seen as natural development in the very unnatural conditions in which he lived. Fantasy, sometimes thought to be especially characteristic of his insane period, already shows itself to be a driving force by the early 1840s: and already it is of a different order from the fantasy which so often becomes, in the hands of Victorian painters, an anaemic substitute for Romanticism. There is a tension and edge in these early pictures which puts Dadd in a line with Blake and Fuseli, though in manner he has little in common with either; a tradition in which fantasy is an aspect or extension of reality, and not an alternative to it. It was to become, except for memory, the only reality to which he had access, and his later development reflects this situation.

Throughout his life, with a few early exceptions, Dadd worked in a tight, closely wrought miniaturist's style, with a strong emphasis on form and outline. His work is characterised by precise, sharp-focused observation, great fertility of invention, and the depiction of intricate detail with an hallucinatory exactness, achieved by a technique which is often closer to drawing with colour than to painting. When they have not subsequently been varnished, his oils often look at first sight as though they are painted in tempera or even watercolour. The sensitive handling of a rather unusual range of clear soft colours, is one of his hallmarks in both media.

He also shows an exceptional talent for conveying the sense of place within

a small compass, and some of the late seascapes have a vivid life and immediacy, even though they must depend for their details on a phenomenal visual memory. But there is about many of Dadd's pictures a far more characteristic atmosphere of trancelike stillness, as though time and motion have been arrested by the intensity of his observation; and this is nowhere more perfectly exemplified than in 'The Fairy Feller's Master-Stroke' (No. 190) and 'The Pilot Boat' (No. 173). The earliest fairy pictures do not have this static quality, and much of their drama arises from the frenzied animation of the dancers, contained within a narrowly delimited and controlled environment; but another work from the same period, 'Caravan Halted by the Sea Shore' (No. 91), has just this air of cataleptic suspense.

Often this feature is related to a flat, frieze-like composition which shows the influence of Daniel Maclise, from whom Dadd acquired many of the recurrent elements in his meticulously careful designs, especially the preoccupation with surface pattern. He must also have studied at first hand the German sources on which Maclise himself leaned heavily, particularly in the field of book illustration, and was clearly taken up with the whole fashionable interest in German art. His skill in purely decorative design is outstanding.

Like many of his contemporaries, Dadd was a fine draughtsman; but unlike many, he was not forced by the exigencies of daily life, or by misdirected enthusiasm, into styles of painting to which his abilities were unsuited. In the seclusion of Bethlem he could devote his time exclusively to adapting media and talents together, pushing both to the limits of their potential to produce pictures such as the later fairy paintings, in which there is a total interdependence of vision and technique. Though he painted in microscopic detail, his pictures never suffocate under the profusion of minutely depicted accessories which were essential to many painters of the period as well as to their patrons. He worked not only with a miniaturist's finish, but on a scale appropriate to it, and with him detail is always an integral part of the whole concept, never a superficial embellishment or needless extravagance. There is an innate sense of discipline and restraint, even where imagination is at its most fertile; and the refinement and purity of his perception is seen in the prodigal inventiveness of 'Oberon and Titania' (No. 172) as clearly as in the sweeping curves and empty sky of 'Caravan Halted by the Sea Shore'.

In subject matter there is little change in his repertoire after 1843, which throughout his life consisted basically of scenes from history and literature, landscape and shipping subjects, and a sprinkling of scenes of daily life, with the addition of the new-found Middle Eastern interest. Only portraits, from among his early subjects, seem to have dropped out; but two major portraits do survive, of which one (No. 112) is perhaps unique in the history of portraiture, and these show that lack of opportunity or inclination rather than loss of ability account for the absence of any more.

Landscape and shipping provide the most enduring link, forged in his childhood and youth beside the Medway; and the commitment to these subjects was deep enough to survive decades of the most complete deprivation imaginable, for a painter to whom the countryside and the sea had once been so important. Dadd himself described his response to landscape as romantic, in a letter to David Roberts about the scenery of Asia Minor,[30] and his literary preferences as well as his work reveal an essentially poetic temperament: but very little survives of the early landscape painting, and the obsessional precision of his style, the insistence on order and pattern, does not suggest that he would have found himself at home for long in the Romantic tradition. There is an elegiac mood about some of the later watercolour landscapes, however, which gives them a curious affinity with the work of John Robert Cozens, who had been consigned to the care of the previous Dr Monro

exactly fifty years before Dadd.

The love of nature is a powerful force, too, in the fairy paintings, which illustrate definitively the observation of Dr Jerrold Moore that: 'The fairy painters achieved an intensification of the landscape experience by the use of these sub-human miniature creatures who live entirely in the landscape, and whose consciousness represents therefore only a sensible extension of the landscape'.[75] A consistent feature of the early fairy pictures is the identification of landscape and figures: together they form the inseparable parts of a single unified microcosm, compact and self-contained, and which can be explored in minute detail. In the two later examples this exploration of nature is developed until the exact texture of an embossed or striated leaf becomes the subject of microscopic examination, and its depiction achieves an almost mystical precision.

The 'Passions' series and the other watercolour figure compositions of the 'fifties are all subjects which might have been painted outside the hospital in an earlier part of the century, and in particular they are reminiscent of the productions of the Sketching Society, on which the Clique had been modelled. The Society's themes had often been abstract ideas embodied in a single word (such as 'Desire', set by the Queen herself in 1842), and in 1839 the members had spent an evening on 'Pale Melancholy' from Collins's 'Ode to the Passions'. The manner in which this series is painted also recalls the description of Dadd's work for the Clique, which was 'in pen-and-ink outlines with thick shadow lines'.[76] Many of the pictures individually are of striking quality, though in aggregate they may appear a little monotonous. They contain some of his finest drawing, and the crisp clear outlines and delicately modulated washes of low-key colour, the highlights on broad folds of sunlit cloth picked out by swift bold strokes of shadow, have a particular appeal especially in the pictures on brown paper.

After this series has faded out there is a return to earlier interests, and increasingly from the late fifties onwards, Dadd comes to use watercolour for 'private meditation'.[77] Outside, the growing fashion was to treat it as interchangeable with oil. His later work in this medium has an exquisite delicacy and tenderness which at first glance belies the sharpness and strength of his haunting scenes: but although they are easy to overlook amongst pictures with a more robust impact, such fragile masterpieces as 'Port Stragglin', 'The Crooked Path' and 'Tlos in Lycia' (Nos. 181, 196 and 215) possess a whispered intensity which is not easy to forget, when once it has registered. In the landscape and shipping scenes of the second half of his life, we see the quintessence of Dadd's vision, each image distilled and purified by the process which Palmer described as 'being received into the soul'.[78] In these shimmering visions of the soul as well as in the more exotic fantasy of the fairy paintings, Dadd justifies the prescience of the critic who wrote of him at the age of twenty-four: 'Mr Dadd is emphatically the poet among painters.'[79]

It is inevitable to wonder what direction Dadd's path might have taken, if he had not suffered from the illness which caused his insanity; but it would be misleading to single out insanity as having more effect on his painting than as a part of his whole formative experience. A number of contemporaries recorded unequivocally that they saw evidence of madness in his pictures; and since so many have undoubtedly disappeared, it may be that some of the madder specimens were among them. In the surviving work, however, there is little which can be called wholly irrational or even very eccentric within its context; and the children wearing Elizabethan ruffs in such pictures as 'Suspense' (No. 149), and some of the incongruities of 'The Flight out of Egypt' (No. 104), are among the few examples in this category. Delusional material – Osiris, devils and the like – does not intrude into his painting.

[43]

It is almost entirely in relation to his changed personality after 1843, that any single element in Dadd's work can be positively linked to his known mental disorder. The violence expressed in the figure compositions of the 'fifties seems explicitly to result from his state of mind; and closely allied to this, there is the singular expression in the eyes of a number of the figures. Hostile, malevolent, or just suspicious, they blaze with exaggerated intensity, but are often still more disconcertingly unfocused. But although these features leave such a powerful impression that they are sometimes thought to be characteristic of all his work, they cover a relatively short chronological period, and even then the violent scenes do not predominate over the gentler compositions with which they are always interspersed.

With these obvious exceptions, the main bulk of Dadd's work offers a view of life which is gentle, sad and wistful. It is mood, rather than emotion which he expresses supremely well, a self-generating state of mind existing independently of outside agencies: and there is a lack of interaction or communication between the solemn, preoccupied characters in many of his later pictures, even to the point that their attention may be directed away from the scene in which they are participating. A blunting of emotional response often accompanies the mental state into which he had been thrown, and his own isolation in this respect is probably reflected in his work. Paradoxically, since it stems from a deficiency in his own life, this emotional detachment adds a very refreshing quality to his pictures in an age in which sentimentality was rapidly succeeding to sentiment.

It is sometimes suggested that Dadd's later work shows a heightened intensity of perception which is somehow caused by, or related to his madness. The vivid realisation of colour and texture and detail is, very obviously, an important element in his make-up, and may be associated with his illness; but it seems more likely that the same factors which gave him a predisposition to this particular form of illness, had already contributed long before insanity showed itself, to the heightened awareness which he seems always to have possessed. Shut away from all external stimuli, the complete dependence upon his inner vision must have strengthened and sharpened it; but again there is no evidence of any sudden increase or change.

Other painters, for example Blake and Fuseli, have managed to express their full imaginative power without the aid of Dadd's enforced isolation, though both showed some degree of the mental alienation which in him had become absolute: but the question of how much he himself might have achieved in other circumstances, can never of course be answered. The fire might simply have burned itself out in the struggle for survival, or his course might have followed that of Palmer, with a few years of incandescence eventually subsiding into a steady but duller glow. An association with the Pre-Raphaelites might have lent him fresh impetus, or the Middle Eastern experience, as with J. F. Lewis, might have set in train a new departure as dramatic as the one which it did in fact precipitate. There is no need to suppose that he would merely have been swamped in the wash of nineteenth-century convention: the Pre-Raphaelites themselves proved that this was not inevitable, and even John Phillip, after his discovery of Spain, showed that every road did not lead to Ramsgate Sands. One did not have to be mad, to escape the toils of Victorian genre: but it probably helped.

Catalogue

***1 Views in Cobham Park and Elsewhere**
*c.*1830–5
'sketches'
Whereabouts unknown
Art Union, October 1843: 'We fancy that in many of
his early sketches we can trace outlines of the dells and
noble trees in his favourite park of Cobham . . . where
his young genius received its inspiration.'

2 Figures in a Landscape ?1830s
Watercolour, 5¼ × 4¾ in, 13.2 × 12.0 cm
Prov: By descent in the family of the artist's
brother.
Private collection

This is probably one of Dadd's early childhood draw-
ings. It already shows two of his main interests, dra-
matic scenes and landscape.

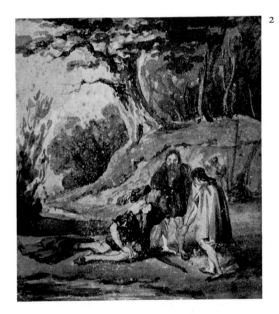
2

3 Portrait of a Girl, ?Elizabeth Langley 1832
Watercolour heightened with white,
10⅞ × 9⅞ in, 27.7 × 25.1 cm (repr. on p.49)
Inscr. bottom right: 'RD [in monogram] 1832'
Prov: Mrs E. Sloggett to 1969; by descent in the
family of the artist's brother.
Trustees of the British Museum

This portrait, which descended through the family of
Dadd's brother Robert, was identified as a portrait of
the artist's mother at the time of its acquisition by the
British Museum. When it became obvious that this
could not be so, it was presumed to be one of his
sisters. Comparison with Nos. 8 and 18 would now
suggest that the sitter may be one of the Carter sisters;
probably Elizabeth, later Elizabeth Langley, but poss-
ibly Catherine, who became Robert Dadd's wife. This
is Dadd's earliest known dated work, showing that he
had achieved considerable maturity in his portraiture
by the age of fifteen. The handling of the face and hands
also shows that he had already learnt to use the minia-
turist's technique of stippling and hatching, which he
was to employ later for many different subjects. His
feeling for landscape is seen in the brightly lit distant
view, framed between the girl's arm and the over-
hanging tree branch in a carefully constructed com-
position. The background might be a view in Cobham
Park.

4

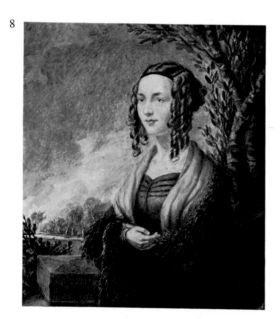

4 Portrait of a Girl, ?The Artist's Sister
?1832
Watercolour heightened with white, 9¾ × 7½ in, 25.0 × 19.1 cm
Prov: By descent in the family of the artist's brother.
Private collection

A fairly recent inscription on the back identifies the sitter as Sarah Rebecca Dadd, the second daughter, who was born 1819, but the grounds for this are not known: if any of the Dadd sisters it seems more likely to be Mary Ann, the eldest, than Rebecca. Considering them all separately, this picture has much in common with the supposed portraits of Elizabeth Langley (Nos. 8 and 18), and particularly with the girl at the bottom of the family portrait group (No. 20); but it is difficult to reconcile all five as being portraits of the same girl.

5 Landscape with Pond ?c.1832–7
Watercolour, 4⅝ × 9¾ in, 11.8 × 24.7 cm
Prov: By descent in the family of the artist's brother.
Private collection

There is nothing to indicate the date of this sketch and No. 6, but they are probably some of the early studies which Dadd made around the Chatham area.

6 Landscape with Lane ?c.1832–7
Watercolour, 4⅝ × 9¾ in, 11.8 × 24.7 cm
Prov: By descent in the family of the artist's brother.
Private collection
See notes on No. 5.

***7 Shipping** before 1837
Oil
Whereabouts unknown.

Mentioned in *The Art Union* for October 1843, 'His first picture was of shipping'.

8 Portrait of a Girl, ?Elizabeth Langley 1837
Watercolour heightened with white, 10½ × 9¾ in, 26.7 × 24.8 cm
Inscr. on stone, bottom left: 'RD' (in monogram); 'Rᵈ D 1837'
Prov: By descent in the family of Elizabeth Langley.
Mrs Campbell Logan

The sitter has always been identified by the family owning this portrait as Elizabeth (Carter) Langley (*see* No. 18); but the picture's obvious relationship with No. 3 and probably also No. 4 which have been preserved in the family of Robert Dadd jun., leaves the question open to some doubt: nor can it be certain that the sitter is the same as the girl in No. 18. The landscape background is clearly an attempt to reconstruct the one used five years before in No. 3, and if the whole picture had been reworked from the earlier version rather than being taken from life, this might account for the loss of accuracy in the likeness. Another possibility is that it might be a portrait of Robert Dadd's wife Catherine (Carter), Elizabeth Langley's sister.

9 Landscape 1837
Oil on panel, 6½ × 10¼ in, 16.5 × 26 cm
Inscr. bottom left: 'R Dad [d 18] 37' (signature
damaged)
Prov: Mrs Grace to 1948. Sotheby's 24
November 1948 (40).
York City Art Gallery

This is one of Dadd's few early landscapes to survive,
and dates from his first year at the Academy Schools.
Together with the other two which are known at pre-
sent (Nos. 10 and 11) it suggests that he may have
looked to Constable for example; and as this branch of
painting was not taught in the Schools, the landscapes
which he exhibited the following year at Suffolk Street
probably continued in the style which he was already
practising. Although his later work is generally notable
for the smooth, highly finished surface so beloved of
the nineteenth century, the much looser brushwork
and high impasto seen here is found in some of his
other early paintings, notably the portraits: the size,
however, is in keeping with an obvious preference all
his life for small-scale and miniature work. The
strength of Dadd's early feeling for landscape can be
seen throughout his work at Bethlem and Broadmoor,
sustained and intensified even after the stimulus of
actual experience had been denied him for many years.

***10 The Bridge** 1837
Oil on board, 8¼ × 11¼ in, 20.9 × 28.5 cm
Inscr. bottom right: 'R Dadd 1837'
Prov: Mrs Arthur Clifton to 1961. Agnew's.
George Leon to 1964. Sotheby's 3 June 1964 (91),
bought by Maynard Walker Gallery, New York.
Whereabouts unknown

From a photograph, this seems to be identifiable as a
companion picture to the landscape in the York City
Art Gallery (No. 9) being a view taken from the left-
hand side and looking along the stream in the opposite
direction. *See* the notes on that picture.

11 Moorland Landscape 1837
Oil on panel, 6¼ × 6¾ in, 16.0 × 17.1 cm
Inscr. bottom right: 'R D 1837'
Prov: Agnew's 1963.
Private collection

See notes on 'Landscape' (No. 9).

***12 Head of a Man** *c.*1837
? Oil
Exh: Society of British Artists 1837
Whereabouts unknown

Mentioned in Bryan's *Dictionary of Painters and En-
gravers.*

***13 His Brother's Dog** *c.*1837
Whereabouts unknown

According to the *Art Union* October 1843, 'his first
exhibited picture at the Suffolk-street Gallery was his
brother's dog', but this is not recorded in Bryan.

***14 Bickley Vale, Devon** *c.*1838
Oil, '1.3 × 1.7' (outside measurement of frame)
Exh: British Institution 1838 (57)
Whereabouts unknown

*17

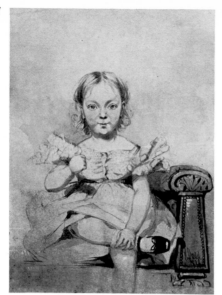

18

19

The location is presumably Bickleigh, north of Plymouth. Dadd's grandfather Stephen and his great uncle Robert and their families lived near Plymouth while working in the dockyard there, and he may have been visiting relatives still in the area when he painted this subject and 'Whitsand Bay' (No. 15).

***15 Scene in Whitsand Bay** c.1838
Oil
Exh: Society of British Artists 1838
Whereabouts unknown
Mentioned in Bryan's *Dictionary of Painters and Engravers*. This is probably Whitesand Bay, just along the coast from Plymouth, and was probably painted on the same visit as 'Bickley Vale, Devon' (No. 14).

***16 Coast Scene, Hastings** c.1838
Oil
Exh: Society of British Artists 1838
Whereabouts unknown
Mentioned in Bryan's *Dictionary of Painters and Engravers*.

***17 Child Seated in a Red Chair** 1838
Watercolour, $7\frac{1}{2} \times 5\frac{3}{8}$in, 19×13.6cm
Insc. on chair leg: 'R Dadd|1838'
Exh: *Collectors Finds*, Maynard Walker Gallery 1967
Prov: Sotheby's 7 July 1965 (36), bought by Maynard Walker Gallery.
Mr and Mrs Paul Mellon, Upperville, Virginia (not exhibited)
It is difficult to say whether this child is male or female, and there is no indication who it might be.

18 Portrait of Elizabeth Langley née Carter 1838
Watercolour heightened with white, $7\frac{3}{4} \times 5\frac{3}{4}$in, 19.7×14.6cm
Inscr. lower right: 'R Dadd|1838'
Prov: Joel Rogers to 1972; by descent in the sitter's family.
Mrs Daphne Rogers
Elizabeth, wife of Joel Langley, was the daughter of Thomas and Elizabeth Carter (*see* Nos. 34 and 35). The Carter and Dadd families seem to have been friends from childhood, and Elizabeth's sister Catherine married Robert Dadd jun. in 1843. There are other possible portraits of Elizabeth (Carter) Langley by Dadd (Nos. 3 and 8). In 1879 she wrote to Broadmoor to ask whether he was still living, and was the only person to be informed of his last illness and death in 1885–6. In returning thanks for the information, she refers to 'my poor friend Mr. Richard Dadd'.[1]

19 Portrait of Joel Langley 1838
Watercolour heightened with white, $7\frac{3}{4} \times 5\frac{3}{4}$in, 19.7×14.6cm
Inscr. right-hand side, on coat: 'Rd Dadd 1838'
Prov: Joel Rogers to 1972; by descent in the sitter's family.
Mrs Daphne Rogers
Joel Langley married Elizabeth, one of the daughters of Thomas and Elizabeth Carter. Little is known about him, but he was concerned in his father-in-law's ship-

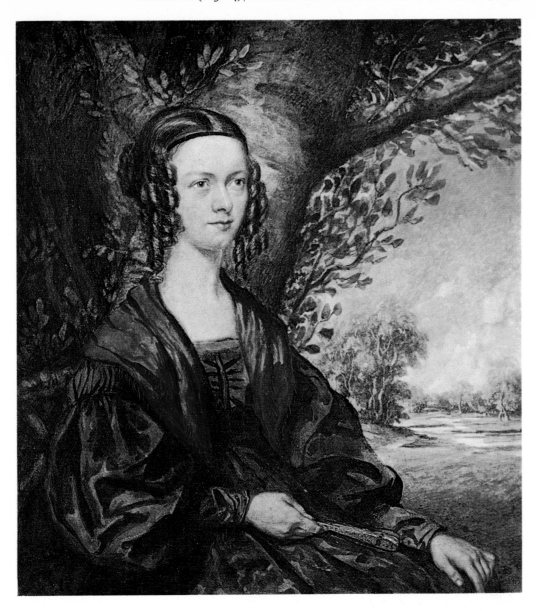

3 Entry on p. 45

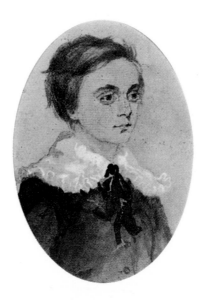

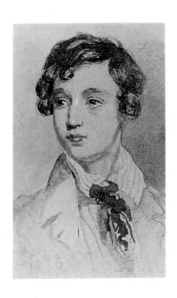

41 Entry on p. 54

27 Entry on p. 52

20

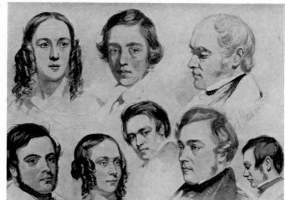

21

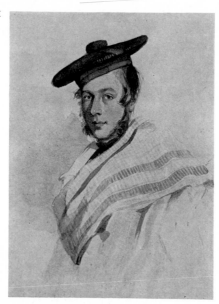

22

building business at Poplar and is said to have taken it over, though Carter's son Thomas was also a ship-builder so they may have been partners.

20 Family Portraits 1838
Watercolour heightened with white, $5\frac{3}{4} \times 8$ in, 14.5×20.4 cm
Inscr. right-hand side: 'Rd Dadd. 1838'
Exh: *Pre-Raphaelites to Post Impressionists*, Maas Gallery 1965 (37)
Prov: John Rickett.
Private collection

Most of these portraits seem to be of members of Dadd's immediate family, but it has not been possible to identify them all. His oldest brother Robert is at the bottom left, his father at the top right, and the top centre head is probably his youngest full brother George William. The head in the centre is presumed to be a self-portrait, and the one to the right is probably the second son Stephen, born 1816. There is no brother to account for the man in the bottom right-hand corner, unless this is actually Stephen. The girls are probably two of Dadd's three sisters, but the face at the bottom quite closely resembles that of the girl in Nos. 3, 4, and 18, about whom there is considerable confusion.

21 Portrait of a Young Man in Tam O'Shanter and Plaid 1838
Watercolour heightened with white, $6\frac{3}{4} \times 5\frac{1}{4}$ in, 17.1×13.3 cm
Inscr. on plaid, lower left: 'R Dadd 1838'
Private collection

There is no clue to the sitter's identity, but he might be one of Dadd's fellow students at the Academy Schools.

22 Still-Life with Knife and Jar 1838
Oil on millboard, 3×4 in, 7.7×10.1 cm
Inscr. bottom left: 'RD 1838'
Exh: *Victorian painting 1837–1889*, Agnew's 1961 (44)
Private collection

A label on the back in the handwriting of the grand-father of Horace Buttery, who cleaned the picture in 1906, reads: 'March 3rd 1839. Recd this Picture from Mr Rd Dadd, a student of promise at the Royal Academy'. It is not painted with a true miniaturist's technique, despite the small size and although Dadd was already using the technique in watercolour. The lethal looking knife blade, pointing straight out of the picture and threatening the spectator, may have been included as an exercise in painting, but is nonetheless a significant choice in the light of Dadd's subsequent history. A number of objects from this collection were later depicted in the watercolour 'Brutality' (No. 124), painted in Bethlem in 1854.

23 Still-Life with Bottles and Corkscrew 1834 or ? *c.*1838
Oil on board, $10\frac{1}{4} \times 8$ in, 26×20.3 cm
Inscr. bottom right: 'R. Dadd 183 ?' (date damaged and indistinct)
Prov: Christie's 18 November 1966 (14), bought by Maas Gallery. John Rickett.
Private collection

The date of this painting is illegible, though a reading

of '1834' has been suggested. If so it would be the earliest known oil painting by Dadd to survive, dating from the year in which the family moved to London from Chatham: a slightly later date seems more likely, however. Dadd had obviously had opportunity to study the Dutch still-life paintings which have influenced him here. The crumpled cloth from this, or perhaps another similar study, may have been remembered when he added a crumpled handkerchief as an accessory to the 'Portrait of a Young Man' painted in Bethlem in 1853 (No. 112).

24 Portrait of Augustus Hearn Gilbert 1839
 Watercolour heightened with white, oval,
 6⅝ × 5⅛in, 16.8 × 13.0cm
 Inscr: 'R^d Dadd 1839'
 Prov: John Rickett
 Private collection
The sitter is in the uniform of a ship's purser, and wears the Order of Isabella the Catholic on the left of his two decorations, and a medal awarded for taking part in action off Bilbao on the right. From this he has been identified as Augustus Hearn Gilbert, who was promoted purser on 1 September 1831, and was involved in action off the north coast of Spain during 1836–7. His association with the Dadd family is not yet known, nor where the picture was painted, but it was probably made before Gilbert's appointment to the *Curacoa* in April 1839.[2]

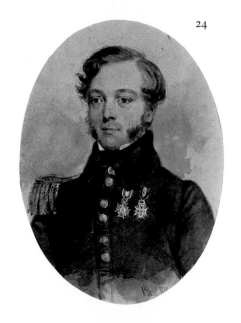

24

25 Portrait of John Phillip as 'Glorious Jock'
 1839
 Chalk, 12 × 9¼in, 30.5 × 23.5cm
 Inscr. bottom left: 'RD from J Phillip as
 Glorious Jock|1839'
 Exh: *Royal Academy Draughtsmen*, The British
 Museum 1969 (29) (exhibited as a 'Self Portrait'
 by John Phillip)
 Trustees of the British Museum, given by E. E.
 Leggatt *c.*1919
This drawing was first described in 1919 in the *Burlington Magazine* by Campbell Dodgson as 'a portrait of Dadd, drawn in 1839 by T. Phillips, R.A.',[3] and has more recently been thought to be a self-portrait by John Phillip; but it is clearly related to Dadd's pencil study of Phillip (No. 26). Both drawings might be sketches for one of the portraits 'in character' which Dadd painted of his friends while a student at the Academy Schools, described by John Imray (*see* p. 15): 'Glorious John' was a designation of John Dryden. If the inscription is in Dadd's hand, as it appears to be, 'from' must be taken to mean 'sketched from'. The words 'as Glorious Jock' seem to have been added later.

26 Portrait of John Phillip, Reading *c.*1839
 Pencil, 4½ × 3½ in, 11.4 × 80.9cm
 Prov: Capt. R. H. Dadd to 1972; by descent in
 the family of the artist's brother.
 Alister Mathews
See notes on No. 25. John Phillip 1817–1867, was a fellow student of Dadd at the Royal Academy Schools, and later his brother-in-law (*see* p. 14). A fairly recent inscription on the back reads 'Jock Phillip sketched by Rd. Dadd when about 24 yrs. old'.

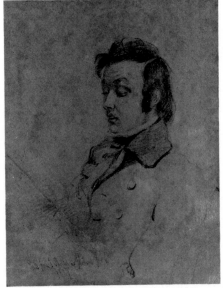

25

26

27 Portrait of John Dadd *c.*1837–9
Watercolour heightened with white, oval,
5 × 3¾ in, 12.6 × 9.5 cm (repr. on p.49)
Prov: By descent in the family of the artist's
brother.
Private collection

A note on the back made by a recent member of the
family reads: 'John Alfred Dadd 1829–95 | at age 10 |
Painted by R^d Dadd his half brother. | circa 1837', but
either the date or the age must be incorrect. John
Alfred Dadd, 1829–1895, was the youngest of the
artist's two half brothers. He learned pharmacy as an
apprentice to his half brother Robert and emigrated to
America in 1850, settling (as did his brother Arthur
John) in Milwaukee, where he later established his own
drugstore. He became one of the state's leading pharma-
cists, and was elected the first president of the Wiscon-
sin Pharmaceutical Association on its formation in
1880. His son Robert followed him in the business, but
died without issue in 1929. John Dadd's half sister
Mary Ann, who emigrated at the age of sixty-five, came
to live with him and his wife in about 1886 after spend-
ing ten years in Galveston, Texas.

***28 Study of a Head** *c.*1839
Oil
Exh: Royal Academy 1839 (93)
Whereabouts unknown

This work is known only from the Royal Academy
catalogue for 1839.

***29 Don Quixote** *c.*1839
Oil
Exh: Society of British Artists 1839
Prov: Bought by Tyrone Power 1839.
Whereabouts unknown

Cervantes' romance provided one of the most popular
literary sources in nineteenth-century painting. C.R.
Leslie exhibited a 'Dulcinea del Toboso' in the same
year, and two of Dadd's friends, John Phillip and J.
Gilbert, painted scenes from the same work in the two
years following. Dadd made his first sale with this pic-
ture, which was bought from the exhibition by the Irish
comedian Tyrone Power, a great patron of the Suffolk
Street Galleries. Power was drowned in a shipping
disaster while returning from New York in 1841, and
the painting does not seem to have been heard of since.

***30 Boy Reading** *c.*1839
Exh: Society of British Artists 1839
Whereabouts unknown

Mentioned in Bryan's *Dictionary of Painters and En-
gravers*.

***31 Toby Fillpot** *c.*1839
Oil, '2.4 × 2.0' (outside measurement of frame)
Exh: British Institution 1839 (332)
Whereabouts unknown

This work is known only from the catalogue of the
British Institution exhibition.

32 Head ?c.1837–40
Pencil with touches of red wash, 5½ × 4½ in,
14.0 × 11.5 cm
Inscr. bottom right: 'RD'
Fitzwilliam Museum, Cambridge, given by
C. Fairfax Murray, 1917

The head has been described as 'Norse or Irish', but
nothing is known about the subject or purpose of this
drawing. The garments are reminiscent of priestly
robes, and the small half-concealed picture, of an
icon: these, together with the insignia and the menac-
ing mask-like face, hold the suggestion of a participant
in some occult rite. From the style of the drawing it
seems likely to date from Dadd's early years at the
Academy Schools. It could have been intended for an
illustration to some literary work.

33 Portrait of a Man, possibly H. G. Adams
?c.1837–40
Oil on board, 6½ × 5¾ in, 16.5 × 14.6 cm
Prov: Mrs Caroline Adams to 1925, by descent
from H. G. Adams.
Victoria and Albert Museum

This picture was acquired in 1925 from the daughter-
in-law of H. G. Adams, together with a volume of MS
poems 'Walpurgis Night etc.' (No. 71). According to
Mrs Adams they had belonged to her father-in-law,
and 'as far as she knew R.D. used to visit him';[4] the
MS has the initials H.G.A. on the cover. H. G. Adams,
editor of *The Kentish Coronal* (No. 51), was evidently a
friend of the Dadds when they lived at Chatham and
probably also related to them, since a family letter of
1886 refers to 'our relations and friends the Adamses'.[5]
He was an apothecary, later becoming resident dis-
penser at the Rochester, Chatham and Strood Dispen-
sary, and also published several books including a
history of Rochester bridge, and an anti-slavery tract,
God's Image in Ebony, in 1854. The latter could be
significant in view of Dadd's references to the anti-
slavery movement in 'The Child's Problem' (No. 169):
this may have been a common interest between the
families. The portrait was in bad condition when it
was acquired, being very worn with much of the under-
painting exposed. The board on which it is painted has
red lacquer with traces of a floral decoration on the
back, and black lacquer under the paint, and may
originally have been a table mat or some other decora-
tive object. The tentative identification of the sitter as
H. G. Adams is based only on the circumstantial evi-
dence.

34 Portrait of Thomas Carter ?c.1838–40
Oil on board, oval, 5¼ × 4 in, 13.5 × 10 cm
Prov: By descent in the sitter's family.
Private collection

This portrait is believed to be by Dadd. According to
family papers, Thomas Carter was 'of Minster in
Sheppey and Chatham Royal Dockyard', died in 1867
aged eighty-two, and was buried at Gillingham.[5] He
also owned a shipbuilding business at Poplar. Robert
Dadd jun. was a friend of Carter's two sons Thomas
and James when they all lived at Chatham, and married
his daughter Catherine at Poplar in 1843. Another
daughter Elizabeth is the subject of at least one por-
trait by Richard Dadd (No. 18) and possibly others.

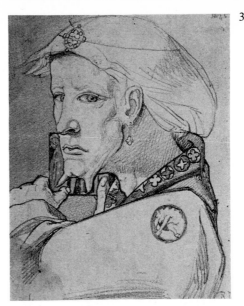

32

33

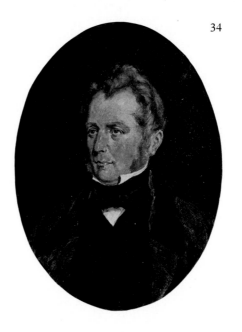

34

**35 Portrait of Elizabeth Carter née Yatman
(Chapman)** ?*c*.1838–40
Oil on board, oval, 5¼ × 4 in, 13.5 × 10 cm
Prov: By descent in the sitter's family.
Private collection

This portrait is believed to be by Dadd. Elizabeth
Yatman, the wife of Thomas Carter (*see* No. 34), died
in 1867 aged eighty. Her father James, a naval officer,
changed his name from Chapman to Yatman according
to the records of one branch of the family,[6] or from
Yatman to Chapman according to those of another.[5] He
came from Devon stock, but lived at Gillingham, and is
said to have died from wounds received while serving
on the *Victory* at Trafalgar. Elizabeth seems to have
been known as Yatman or Yatman Chapman at the time
of her marriage in 1808. Her mother was Elizabeth (or
possibly Amy) Greenaway; and her grandson Edward
Martin Dadd, the son of Robert and Catherine, re-
newed the Greenaway relationship in 1875 when he
married his distant cousin Frances, the sister of Kate
Greenaway the illustrator.

***36 Alfred the Great in Disguise of a Peasant**
c.1840
Oil on canvas
Exh: Royal Academy 1840 (450)
Whereabouts unknown

Scenes from the life of Alfred provided a natural and
popular choice of subject for history painting at this
time, and were included among the themes set for the
Palace of Westminster competitions over the next few
years. This picture was catalogued with the title:
'Alfred the Great in disguise of a peasant, reflecting on
the misfortunes of his Country', and the following
quotation from Hume's *History of England*: 'Alfred
himself was obliged to relinquish the ensigns of his
dignity, to dismiss his servants, and to seek shelter in
the meanest disguises, from the pursuit and fury of his
enemies.' It is Dadd's earliest known historical paint-
ing, and his first work to attract critical attention. The
reviewer of the *Art Union* wrote, 'There is much in this
picture that gives promise that the artist will attain a
high rank in his profession. The colouring is, perhaps,
raw, but there is a fine character in the composition,
and proofs of a reflective mind.'[7]

***37 Scene from 'As You Like It'** *c*.1840
Oil
Exh: Society of British Artists 1840
Whereabouts unknown

Mentioned in Bryan's *Dictionary of Painters and En-
gravers.*

38 Scene from Hamlet *c*.1840
Oil on canvas, 40¼ × 34½ in, 102.3 × 87.6 cm
(cut down)
?Inscr. on stretcher
Exh: British Institution 1840 (205): Liverpool
Academy 1840 (266); Guildhall 1964
Prov: R. G. Reeves to 1865; Christie's, March
1865. Lincoln Kirstein.
Mr and Mrs Paul Mellon, Upperville, Virginia

This is the only example of Dadd's early exhibited
paintings known to have survived, apart from the fairy
subjects, and is known to the writer only from a black-

and-white photograph. It was exhibited at the British
Institution with the quotation from Act III scene IV
'Ghost. Do not forget: this visitation| . . . Speak to her
Hamlet, etc.', and at Liverpool with the full quotation.
It shows a straightforward stage performance of the
scene in Gertrude's closet where the ghost appears to
remind Hamlet of his duty, with Charles and Ellen
Kean as Hamlet and Gertrude. Kean's playing in the
title role had aroused great interest when he took over
the part on his father's death, and Frith (and possibly
Dadd too) had been present at his first performance in
1837. The choice of this particular passage is significant
in the light of Dadd's subsequent history, showing that
the theme of haunting and the domination of a person's
actions by supernatural powers already held a fascina-
tion for him before it had begun to manifest itself in
his own life. The painting has been cut down and the
figure of the ghost eliminated, but in this context it
would almost certainly have been shown as represented
on the stage at Drury Lane. Dadd's great care in com-
position is already evident here: the sharp angles and
thrusting diagonals, reinforced by repetition and by
dramatic lighting, create a violent tension which is
focused towards the (now absent) ghost. The strong
sense of drama in all his work is clearly related to a
close interest in the theatre and theatrical techniques
from an early period.

***39 A Venetian Minstrel** *c*.1840
Oil, '2.7 × 2.3' (outside measurement of frame)
Exh: British Institution 1840 (417)
Whereabouts unknown

This work is known only from the catalogue of the
British Institution exhibition.

***40 Elgiva the Queen of Edwy in Banishment**
c.1840, Oil
Exh: Royal Manchester Institution 1840 (336)
Whereabouts unknown

Elgiva (or Aelfgifu), the wife of King Edwy (or
Eadwig), was said to have been separated from her
husband by Archbishop Odo on the grounds that they
were too near of kin: but Dadd probably knew a version
which transfers the responsibility to St Dunstan (who
had already quarrelled with Eadwig on account of the
same lady). The subject may had been suggested to
him by Dyce's 'St. Dunstan Separating Edwy and
Elgiva', which had been shown at the Academy the
previous year. Dadd's other illustration of English
history from 1840 also has a rather melancholy theme,
'Alfred the Great reflecting on the misfortunes of his
country'.

41 Portrait of George Dadd *c*.1840
Watercolour heightened with white, 4¾ × 3 in,
12 × 7.6 cm (repr. on p.49)
Inscr. on verso: 'Portrait of G. Dadd|by Rᵈ
Dadd -|aged 17'
Prov: By descent in the family of the artist's
brother.
Private collection

This portrait is on the back of a piece of paper which
has been cut from an academic pencil study of a head.
George William Dadd, 1822–1868, was the artist's
youngest full brother. He worked as a carpenter in the

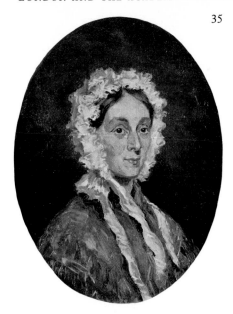

35

dockyard at Chatham, but became insane at the age of twenty and was committed to Kensington House asylum on 31 August 1843. He was transferred to Bethlem Hospital where he remained without recovering until his death from consumption aged nearly forty five. Like his brother he was very fond of Shakespeare, knowing many of the plays by heart, and would sometimes recite from them. He also had in the hospital a copy of Dickens's *The Old Curiosity Shop*, which he always kept somewhere near him when not actually reading it.[8]

42 Portrait of Robert Dadd jun. *c.*1840
Oil on board, oval, 15 × 13¼ in, 38.1 × 33.8 cm
Inscr. on verso: 1. (label) 'Robert Dadd 1813–1875 [*sic*]|Painted by his Brother RICHARD DADD|1817–1886|circa 1840.'; 2. 'Portrait Rob.ᵗ Dadd|by his brother Richard.'; 3. 'Mrs. Churchill|from|Catherine Dadd.|1890.'
Prov: By descent in the sitter's family.
Private collection

Robert Dadd, 1813–1876, was the artist's oldest brother. He was presumably apprenticed to his father, and ran a chemist's business at 54 Whitechapel High Street until 1859, when he took up a position with 'a firm', possibly as a representative. On 10 August 1843 he married, at Poplar, Catherine, the daughter of Thomas Carter (*see* 'Portrait of Thomas Carter,' No. 34, and also 'Portrait of Elizabeth Langley,' No. 18). One of his sons, Frank, became well known as a black-and-white artist, and another, Stephen Thomas, was trained as a wood engraver by John Greenaway, a cousin of the Carter family. The 'Mrs. Churchill' to whom this portrait was given was his eldest daughter, Marianne. Robert Dadd acted as a focal point for the rest of the family, and the letters exchanged between him and his half brothers in America, and later between his descendants and theirs, provide much information about their various fortunes.[5]

38

43 Portrait of 'Aunt Smith' *c.*1840
Oil on board, oval, 5⅞ × 4½ in, 15.0 × 11.3 cm (opening of mount)
By descent in the family of the artist's brother.
Private collection

A fairly recent inscription on the back reads: 'Mrs. Richard Smith (née Greenaway). Known in the Dadd family as "Aunt Smith". Richard Smith died in 1825 (born in 1778). "Aunt Smith" was probably born in or about 1780. Painted abt. 1840 by Richard Dadd brother of Robert Dadd (1813–1876).' The family papers from which this information was derived are less confident, showing only that 'Miss Greenaway, sister of Aaron Greenaway mar: one of the Smiths. Supposed to be Mr. Richard Smith . . .';[5] which does show, however, that she was a relative of Elizabeth (Yatman) Carter (*see* No. 35) and the great aunt of Kate and Frances Greenaway. The identification of the sitter as 'Aunt Smith' comes after the double relationship between Dadds and Greenaways had been formed, through the marriage of Robert Dadd with Catherine Carter in 1843, and in the next generation, of their son Edward with Frances Greenaway: there is therefore no particular reason to suppose that she was known by this name to the Dadds of Richard's generation. The date 1840 may have been

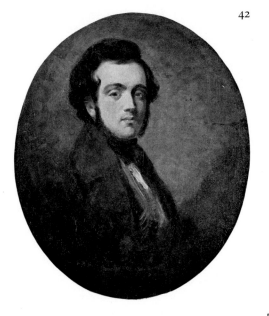

42

43

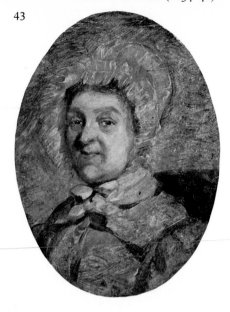

46

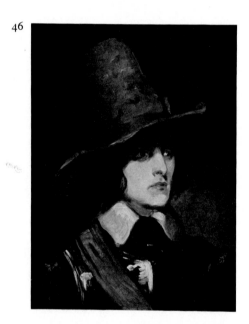

47

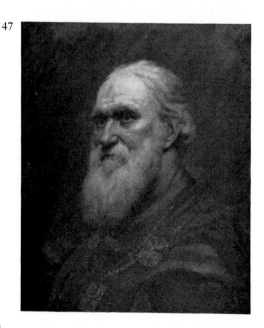

assigned only because the rest of the family portraits seem to date from about this time, but it is quite plausible.

***44 Portrait of Robert Dadd sen.** *c.*1840
Oil
Prov: In existence in 1934
Whereabouts unknown

An engraved portrait of Robert Dadd sen. published in *The Kentish Independent* in 1843, is described as being 'From an Original Painting, by his Son'.[9] A half-length watercolour portrait made by a member of the family in 1934, and inscribed 'From an oil head of Robert Dadd painted by his son Richard Dadd, circa 1840', is obviously copied from the same picture (the rest of the figure being probably taken from the miniature by John Turmeau, No. 242), but the original seems now to have disappeared.

***45 Portraits of his Friends in Character**
*c.*1838–40
?Oil
Whereabouts unknown

John Imray (*see* p. 15) retrospectively described how 'These friends, as well as the members of "The Clique", sat for their portraits to Dadd, who painted them in appropriate characters; one who had an oriental look, appeared as a Pacha; another, who made verses, was shown as the Poet with "his eye in a fine frenzy rolling"; a third, who was thin and bony, appeared as Cassius with his "lean and hungry look", and so on'.[10] Nos. 25, 26 and 46 are probably connected with these portraits.

46 Portrait of ?Augustus Egg ?*c.*1838–40
Oil on panel, 25 × 19 in, 63.5 × 48.3 cm
Prov: The Van Horne Collection, Montreal.
Mr and Mrs Paul Mellon, Upperville, Virginia

The painter Augustus Leopold Egg, 1816–1863, entered the Royal Academy Schools in 1835, and became a member of the Clique and one of Dadd's close friends (*see* p. 14). This picture, which has for many years been attributed to Dadd, bears a marked resemblance to known portraits of Egg, and seems likely to be a previously lost portrait of him 'in character'. John Imray has recorded that Dadd's friends sat to him for character portraits (*see* No. 45); and elsewhere there is a reference to William Bell Scott's recollection of a picture which he had not seen for more than twenty years, 'a portrait of Egg by his friend Dadd, "in a tall conical brown hat, like a Puritan, his complexion being almost colourless".'[11]

47 Portrait of an Old Man ?*c.*1838–40
Oil on canvas, 23 × 20 in, 58.5 × 50.8 cm
Inscr: 'R. Dadd. 18. .' (part of inscription illegible)
Mrs Doreen Wareing

Little is known about this picture, but judged from a photograph it seems likely to be either a copy of another work, or a portrait of someone in theatrical costume.

***48 Portrait of the Artist in a Scotch Bonnet**
*c.*1840–3
Oil
Whereabouts unknown

An engraved portrait of Dadd which was published in *The Kentish Independent* in 1843 is described as being 'from an Original Painting, by himself'[9]. It purports to show him 'aged 26', but this cannot be so unless he had painted it within the previous 27 days; and as the age attached to his father's portrait in the same publication is more than ten years out by any reckoning, there is no particular reason to be guided by this statement.

49

49 Bocaccio's Tales ?c.1840
Pen and ink, 5¾ × 7¾ in, 14.6 × 19.7 cm
Inscr. verso: 'Richd. Dadd from Bocaccio's tales'
Prov: Capt. R.H. Dadd to 1972; by descent in the family of the artist's brother.
Alister Mathews

There is no known finished picture for which this could be a study. It might have been made for one of the weekly meetings of the Clique (*see* pp. 14-15), perhaps not finished: the subjects chosen for this sketching society were described as being 'chiefly', but not exclusively, from Byron and Shakespeare, and the drawings were in pen and ink outline with thick shadow lines.[10] The arrangement of the group resembles that used by Maclise many years later in 'A Winter Night's Tale' (c.1867),[12] and both may have been based on some earlier work by Maclise, or may simply be one of many examples of the two painters' similar ideas on composition and design.

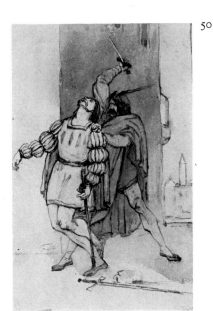

50

50 Scene of Murder ?c.1840-2 or early 1850s
Watercolour and brown ink, 9½ × 6⅛ in,
24.1 × 15.6 cm
Inscr. bottom right: 'DADD'
Alister Mathews

This picture seems likely either to date from around the time of the drawings for 'Walpurgis Night, etc.' (No. 71), which it quite closely resembles, or to be a sketch for some missing 'Passion' or other related watercolour from the period at Bethlem c.1852-6.

51 Frontispiece to The Kentish Coronal 1840
Etching, 5⅛ × 3⅛ in, 13.1 × 7.8 cm (plate)
Frontispiece to *The Kentish Coronal*, London, Simpkin and Marshall, 1841.
London Borough of Bromley Libraries

The Kentish Coronal; Consisting of Original Contributions, in Prose and Poetry, by Persons Connected with the County of Kent was edited by H.G. Adams, apothecary of Chatham and Rochester (*see* also 'Portrait of a Man', No. 33, and 'Walpurgis Night, etc.', No. 71). He had already published two poems locally, *The Ocean Queen* and *The Departure of the Israelites*, and wrote the first poem in this book, a sonnet called 'Our frontispiece' which is dedicated to the designer. The frontispiece must have been completed in 1840, the date of the Editor's preface, and may have been one of Dadd's first attempts in this medium. It incorporates many Kentish symbols, including hops, apples, a ship, the motto 'Invicta' and the badge of a white horse, and a scroll bearing the names of some of the famous sons of the county.

51

52

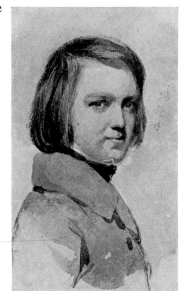

52 Portrait of the Artist *c.*1841
Watercolour heightened with white, 5 × 3⅛ in,
12.6 × 7.9 cm
Inscr. on verso: 'Rich^d Dadd at age 23.
Self portrait.' (? a recent inscription)
Prov: By descent in the family of the artist's
brother.
Private collection

This self-portrait is the original from which the etch-
ing, No. 53, is made. It is the only positively identified
self-portrait, and was taken to America by one of
Dadd's half brothers, being later sent back to England
to another member of the family.

53 Portrait of the Artist 1841
Etching, 5¼ × 4½ in, 13.3 × 11.4 cm (plate)
Inscr. lower right: 'R^d Dadd se ipse fecit.
|1841.'
Prov: Capt. R. H. Dadd to 1972; by descent in
the family of the artist's brother.
Alister Mathews

Dadd made this etching from his own watercolour
self-portrait (No. 52), but whether by accident or
design, has not reversed it in the process. He was ex-
perimenting with the technique of etching from around
1840 (*see* also *The Kentish Coronal*, No. 51, 'Water
Nymphs', No. 66, 'A Country Churchyard', No. 70),
and was a founder member of the Painters' Etching
Society in 1842 (*see* p. 17).

53

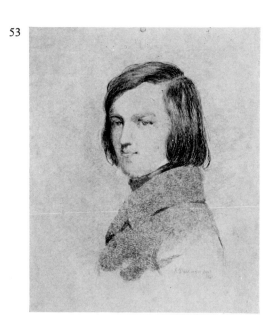

54 Portrait of the Artist *c.*1841
Oil on board, 7 × 5½ in, 17.7 × 14.0 cm
Exh: *Victorian Paintings, Drawings and Water-
colours*, Maas Gallery 1971 (11)
Prov: Maas Gallery 1970.
Alfred Essex

The origins of this self-portrait are not known, but it
seems to be related to the watercolour (No. 52) and
could have been painted at about the same time.

55 Portrait of the Artist ?*c.*1841
Oil on panel, 21½ × 17 in, 54.6 × 43.2 cm
Prov: Michael van Gelder of Uccle, Brussels, by
1914. Christie's 2 July 1971 (168).
Private collection

This painting has been known as a self-portrait by
Dadd since at least 1914. It seems to date from
about the same period as the watercolour (No. 52), and
the etching (No. 53) which it more closely resembles,
but is in a somewhat more romantic vein.

54

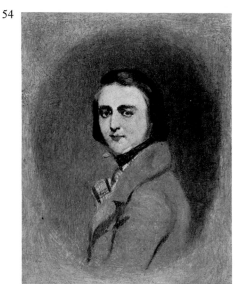

***56 Portrait of a Girl in a White Dress, Holding
a Rose** 1841
Oil on panel, 11½ × 8⅛ in, 29.2 × 20.6 cm
Inscr: 'R^d Dadd. 1841'
Exh: *Victorian Pictures*, Birmingham 1937 (75)
Prov: Mrs Gertrud Johnes in 1937.
C. R. Rudolph. Sotheby's 7 July 1965 (88).
Whereabouts unknown

The sitter has not been identified, but she seems to
have been well known to Dadd, since he could remem-
ber her features well enough to paint them recognisably
thirteen years later as 'Columbine' (No. 133), and also
clearly remembered this portrait of her, repeating the
gesture of her hand. Though closer to the 'Keepsake'

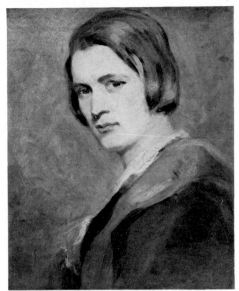

55

style of female portraiture than his watercolours of a few years earlier, it is still a natural and easy study by comparison with such works as, for example, his contemporary H. N. O'Neil's 'The Opera Box'.[13]

57 Titania Sleeping *c.*1841
Oil on canvas, 25½ × 30½ in, 64.8 × 77.5 cm
Exh: Royal Academy 1841 (207); *Art Treasures of the United Kingdom*, Manchester 1857 (477)
Prov: H. Farrer, bought from the Academy 1841.
Samuel Ashton in 1857; Thomas Ashton;
Col C. H. Wilkinson to 1960.
Miss V. R. Levine

The picture was exhibited at the Royal Academy with the quotation in the catalogue: 'There sleeps Titania sometime of the night|Lulled in these flowers with dances and delight'. The scene in which Titania is sung to sleep by her attendants is Act II scene 2 of *A Midsummer Night's Dream*, though the quotation from Puck's words is found in the preceding scene. The figure of Oberon can just be made out in the shadows of the cave, preparing to squeeze juice from the magic flower on Titania's eyelids. *A Midsummer Night's Dream* was among the most popular of Shakespeare's plays, and frequently illustrated.

This picture and its companion 'Puck' (No. 58) were the two which helped to establish Dadd's reputation as a fairy painter. Of 'Titania' when it was shown at the Academy, the reviewer of the *Literary Gazette* wrote: 'A small production and near the ground, but one that promises greater efforts, to the clever young artist. The conception of the fairy circle boasts of originality, even after the hundreds of times it has been painted; and we are glad to take this opportunity of noticing the merits of a pencil to which we owe a grateful compliment'.[14] The *Art Union*'s reviewer found 'a volume of poetry in this beautiful work; the production of an accomplished mind, and the result of matured thought and study.'[15] It was spoken of in 1843 as: 'the work which may even now be considered his most successful.'[16] The picture makes a good foil to the spectacular dazzle of 'Puck', with its more tender luminosity, but still depends for much of its effect on highly dramatic lighting. The composition is conceived as a spiral snail's-shell shape, set slightly obliquely to the surface plane of the picture, arching round from the left-hand side of the cave's mouth and swirling across the foreground through the trail of toadstools which are scattered over the grass, until it meets up with the dancing figures on the left. The tightness of the structure and the complete integration of the figures with the natural world of their surroundings creates, as in all Dadd's fairy paintings, the feeling of a self-contained microcosm, existing entirely on its own terms and in its own context. In this instance, however, the group of dancers is moving out of the picture and down a hill, and so intensely is the scene realised that they take with them the slightly chilling sense that they are moving out into the void of another dimension. Though the total picture is completely his own, Dadd has borrowed for it from several different sources. The basic structure, with the main group framed in a central recess, is a device learnt from Maclise who uses it often; and the framing arc of hobgoblins itself derives from the circle of putti in Maclise's 'Choice of Hercules'.[17] Titania and her

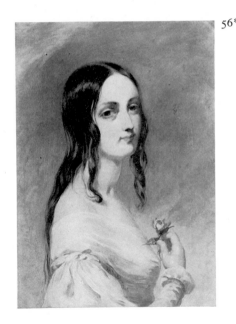

56*

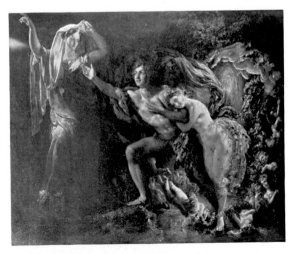

Daniel Maclise, 'The Choice of Hercules', 1931
The Hon. Christopher Lennox-Boyd

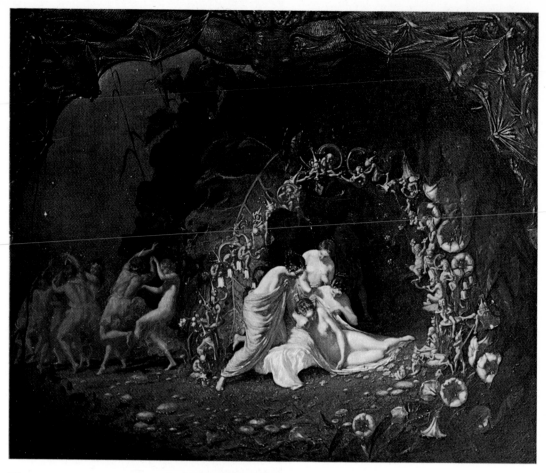

57

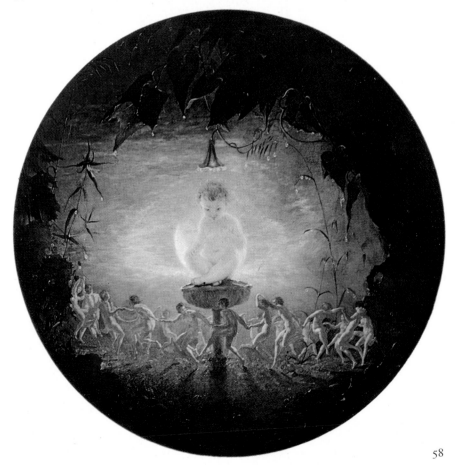

58

attendants are seen as a nativity group, the kneeling fairy on the left being given the pose of a shepherd from Giorgione's 'Adoration of the Shepherds' (known as 'The Beaumont Adoration' or 'The Allendale Nativity')[65]: while Titania herself must surely count Venus among her antecedents, and perhaps Giorgione's 'Dresden Venus'. In the strange and inventive proscenium arch, by which Dadd confirms that this is truly a theatrical work, the shape of the central monster flanked by bats owes much to similar shapes in the work of Blake and Fuseli. A particularly close parallel is found in a drawing by Fuseli for his 'Vision of the Madhouse' (now in the Kunsthaus, Zürich),[18] in which just such a figure with outstretched arms and batwing outline dominates the top of the composition; but Dadd is unlikely to have seen this, and the figure is omitted from the engraved version. However, it is just possible that the painting of the same subject in Fuseli's 'Milton Gallery', now lost, included this figure and was seen by Dadd before its disappearance. 'Titania', like 'Come into These Yellow Sands', was sufficiently successful to be very heavily used by Huskisson in his own version of the subject a few years later (No. 250).

Giorgione, 'Adoration of the Shepherds', c. 1510
National Gallery of Art, Washington

58 Puck 1841
Oil on canvas, 23¼ × 23¼ in, 59.2 × 59.2 cm
Inscr. bottom centre: 'R^d Dadd 1841'
Exh: Society of British Artists 1841 (603);
Art Treasures of the United Kingdom, Manchester 1857 (335)
Engraved: by G. Lizars, published in the *Art Journal* May 1864; Virtue's *Imperial Shakespeare*, 1873–6
Prov: H. Farrer, bought from the Suffolk Street Galleries 1841. Thomas Birchall of Ribblestone Hall in 1857 and 1864. John Rickett.
Private collection

This picture is a companion to 'Titania Sleeping' (No. 57) and was exhibited the same year: together they established Dadd's reputation as a painter of fairy subjects. Of 'Puck', the *Art Union*'s reviewer wrote 'A most happily conceived picture of the spirit that "wanders everywhere" . . . It is cleverly coloured too; and has, as it ought to have, the character of a dream'. He praised the drawing, particularly of the nude figure, 'a style in which excellence is still rare among us', and the poetical composition, but warned that Dadd must beware, 'and stop short of the boundaries which divide the imagination from the absurd.'[19]

This concept of Puck is taken from Reynolds's version of the same subject; probably not from the original, which was then in the collection of the poet Samuel Rogers, but from the engraving published by the Boydells at the Shakespeare Gallery[20], with which there is actually a closer resemblance in the child's features. Dadd may also have had in mind the little red-headed children of Reynolds's 'The Infant Academy' (now in The Iveagh Bequest, Kenwood). The use of the painted spandrels, as well as a number of features in the main composition, suggest that he might have known the work of Phillip Otto Runge, particularly perhaps, 'Morning'; though they do not harmonise in mood with the rest of the picture as do Runge's decorative borders. Dadd's treatment can be seen more in terms of a *trompe-l'œil* frame than a border, an approach which may have

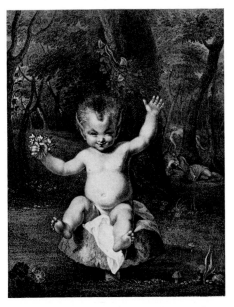

After Sir Joshua Reynolds, P.R.A., 'Robin Goodfellow' engraved by L. Schiavonetti, 1799

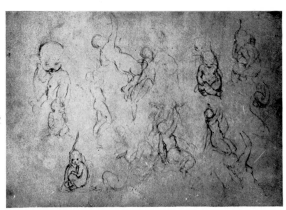

59

been influenced by the fact that his father and brother were gilders and frame makers. The figures in the spandrels seem to be based chiefly on ideas from the Sistine Chapel ceiling, though Dadd's art historical awareness and adaptation is elsewhere shown to be wide, and sometimes unexpected, and several sources may have contributed to their make up. The composition is essentially a theatrical one, and contains characteristic features of all his early fairy pictures. The scene is powerfully held together by dramatic lighting, and the figures are conceived as a part of the whole design and are closely integrated with their natural environment. The location is very precisely defined, again by the brilliant light which illuminates only the area in which the dancers are discovered. The flat ornamental border of foliage which frames the scene, confining and limiting it still further as though it were a stage set, is a device often used by Maclise. It can be seen in a very characteristic form in his 'Undine';[21] and a still closer comparison, though here the border is composed of icicles not foliage, is with Maclise's oval painting 'The Origin of the Harp',[22] which he exhibited in 1842 and may have been working on at the same time as Dadd was working on 'Puck'. The emphasis on surface pattern owes much to Maclise's influence too. Although the composition is based on circles, the ring of figures surrounding Puck is seen as a frieze, and the whole design is essentially flat, the depth being created through strongly contrasting light and shade. The use of a light source entirely at the back of the picture, leaving the foreground in heavy shadow, contributes much to the atmosphere of mystery and magic. The practice of underpainting with white, by which Dadd achieves much of the luminous quality in his work—here the moonlight seems to shine out almost from behind the canvas—may have been learned from Mulready. His painting of nude figures is also reminiscent of the style of Mulready, who was teaching at the Academy Schools while Dadd was a student.

59 Sketches for Puck *c*.1841
Pencil, 6½ × 10 in, 16.5 × 25.4 cm
Prov: Capt. R. H. Dadd to 1972; by descent in the family of the artist's brother.
Alister Mathews

These sketches for No. 58 show that Dadd originally intended Puck to hold a bow, and considered several different views including a three-quarters back view. The nearest pose to the one finally used is the second from the right at the top. The nude female figures sketched on the same page do not relate to any known finished painting.

60 Evening *c*.1841
Oil on panel, oval 9 × 7½ in, 23.0 × 19.0 cm
Prov: Maas Gallery 1972.
Patricia Allderidge

The scale of the figure in relation to the background places this among the fairy paintings. All the characteristics of style, lighting, colour, details of foliage, etc, relate it most closely to 'Puck' (No. 58), and it could almost be a study of one of the dancers from that picture. Some of the means by which Dadd achieves his effects in the more elaborate fairy paintings can be seen almost schematically in this relatively simple work. The

figure is isolated as if at the front of a stage by dramatic lighting, and by the near background of leaves and grasses which act like a stage side-scene: this gives her an air of existing only in the immediate present, and within a small tightly controlled setting, even though there is open landscape in the distance. The feeling is enhanced by the arrangement of overhanging grasses to reflect the shape of her body, and of other foliage to echo its individual lines, so that she becomes an integral part of the whole environment through her relationship with it in terms of design. The white underpainting by which Dadd achieves some of his most brilliant lighting effects can also be seen very clearly here.

61 The Fairys Rendezvous *c*.1841
Watercolour heightened with white,
9⅝ × 11½ in. 24.5 × 29.1 cm
Inscr. on the back by Robert Dadd: 'Sketch for a Picture—which has been painted by|my son Richard|Rob Dadd|The Fairys Rendezvous-|presented to Mr Clements|RD.'
Prov: William Clements, given to him by the artist's father; thence to Joseph Mayer; Mayer bequest to Bebington Corporation.
Walker Art Gallery, Liverpool, presented by Bebington Corporation 1971

Joseph Mayer, to whom this watercolour belonged, was a prominent Liverpool collector and benefactor. William Clements (1803–1886), who acted as his agent in London, was a friend of Robert Dadd who gave him a number of drawings and etchings by his son (*see* Nos. 66 and 70). Clements passed on at least some, including this, to Mayer. Immediately after the murder Clements wrote a series of letters to Mayer[23] keeping him informed of developments, in one of which he advised Mayer to 'Collect the Articles you meet with to illustrate the Drawings you have of Young Dadd'. Amongst Mayer's papers is a note in his own hand that 'Mr. Dadd the Father gave me a Drawing (through the hands of my Friend W. Clements) of Oberon and Titania a short time before he killed his Father': but no other works by Dadd from this collection have yet been traced, and it is not known whether 'The Fairys Rendezvous' is the one which he called 'Oberon and Titania'. It is slightly different from the surviving fairy paintings of this period, in that the fairies here have wings. They are still drawn as naturalistic human nudes, but are marginally closer to the pretty creatures of the nursery than Dadd's wild elementals of the *Midsummer Night's Dream* and *Tempest* pictures.

***62 Oberon and Titania** *c*.1841–2
Watercolour
Prov: Joseph Mayer in 1843.
Whereabouts unknown

See notes on 'The Fairys Rendezvous' (No. 61), which may have been the drawing which Mayer called 'Oberon and Titania'.

***63 When I Speak, Let no Dog Bark** *c*.1841
Oil
Exh: Society of British Artists, 1841
Whereabouts unknown

This work is mentioned in Bryan's *Dictionary of*

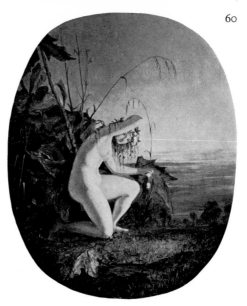

60

Painters and Engravers. The title is a near quotation from Act I scene I of *The Merchant of Venice*: 'As who should say, "I am Sir Oracle,|And when I ope my lips let no dog bark!"'. The context of the words make it uncertain whether this picture would be a Shakespearian scene or not.

***64 Ever Let the Fancy Roam** *c.*1841
 Oil, '4.0 × 3.4' (outside measurement of frame)
 Exh: British Institution 1841 (378)
 Whereabouts unknown

The British Institution catalogue contained the quotation: '"Ever let the fancy roam, etc."—Keats'. Although there is no certainty that this was a work of fantasy, it seems likely from the title and from what is known to have been the direction of Dadd's interests in this, the year of the first three fairy paintings. He seems to have been one of the first to paint a subject inspired by the poetry of Keats.

A full quotation of the first few lines of the poem, 'Fancy', is:

 'Ever let the Fancy roam,
 Pleasure never is at home:
 At a touch sweet pleasure melteth,
 Like to bubbles when rain pelteth;
 Then let wingèd Fancy wander
 Through the thought still spread beyond her:
 Open wide the mind's cage-door,
 She'll dart forth, and cloudward soar.'

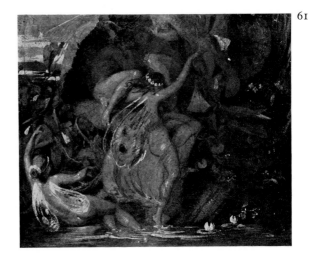

61

***65 Fairies Assembling at Sunset to Hold their
 Revels** *c.*1841
 Oil
 Exh: Royal Manchester Institution 1841 (184)
 Whereabouts unknown

Although this was only the first year that Dadd had shown his fairy paintings, the *Art Union*'s review of this picture opened with the words: 'Mr. Dadd is emphatically the poet among painters. . .'[24] No description of it is given but it is spoken of in much the same terms as the following year's 'Come unto these Yellow Sands' (which was also exhibited on one occasion as 'Fairies Holding their Revels on the Sea Shore at Night'): and 'Fairies Assembling at Sunset' could have been an earlier version of the same subject. The review goes on ' . . . He seems to paint in a dream; but it is a dream in which the images are all naturally arranged. His picture suggests a volume of thought as certainly as does a passage from Shakspere. He is, moreover, a master of professional "technicalities", and in drawing the nude figure he is surpassed by very few. He has a "walk in Art" entirely to himself, and no competitor is likely to approach him . . .'

66 Water Nymphs *c.*1841
 Etching, $4\frac{5}{16} \times 3\frac{13}{16}$ in, 10.9 × 9.8 cm (plate)
 Inscr. in margin by Robert Dadd: 'Designed &
 Etched by my son Richard|Robert: Dadd.|1 May
 1843|to Mʳ Clements'
 Prov: William Clements, given to him by the
 artist's father. Christie's 6 December 1973 (28).
 Christopher Mendez

For William Clements, to whom this picture was given, see p. 12 and notes on 'The Fairys Rendezvous' (No. 61). The date 1 May 1843 must be the date of the gift, since

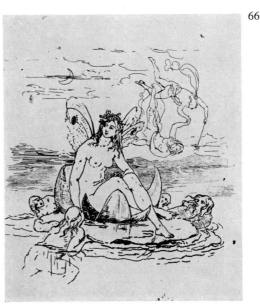

66

Dadd was still on his way home from the Middle East at that time. He is known to have been experimenting with etching as early as 1840, with the frontispiece to *The Kentish Coronal* (No. 51), but the earliest dated fairy pictures known at present are from 1841. This seems likely to have been an independent trial work, rather than being intended for a book illustration.

*67 Panels for Lord Foley, Scenes from 'Manfred' and 'Jerusalem Delivered'

c.1841–2

Whereabouts unknown

Around 1841 Dadd received a commission to provide a series of panels for 26 Grosvenor Square, the new residence of Henry, 6th Baron Foley (*see also* p. 17). According to one account they were purely fanciful, and he executed many designs taken from Byron's 'Manfred' and Tasso's 'Jerusalem Delivered'. The *Art Union* calls them his principal work; 'These evince the power and variety of his conceptions; they are more than 100 in number. His friend Mr. Parnell executed the decorations of the house, and produced most beautiful effects in combination with the studies of the artist.'[16] Frith says 'He had often astonished us; notably by a series of designs from Tasso, which, probably to this day, decorate Lord Foley's house . . .',[25] which suggests that these were more striking than the 'Manfred' series. In *The World* 1877, is a description of 'A scene from *Manfred* painted on a screen for Lord Foley; the Alpine mist or smoke about Manfred's head being composed of minute figures of men and women, explained by Dadd to be ideas formed and unformed, as their outlines were distinct or indistinct'.[26] This screen seems still to have been in Dadd's studio after his return from the Middle East. The Grosvenor Square house was destroyed to make way for the American Embassy, but the panels may have been removed long before this to one of the other Foley houses. Witley Court, Worcester, the family seat, was burnt down in the 1930s, but it is possible that at least some of the Dadd panels were dispersed at the sale of Ruxley Lodge, Surrey, in 1919. The sale catalogue shows over fifty unidentified and unattributed works described only in such terms as 'set of 8 panels in carved and gilt wood frames' 'two overdoor pictures in shaped oak gilt frames, Swiss scenery', etc.[27]

68 Come unto these Yellow Sands 1842

Oil on canvas, 21¾ × 30½ in, 55.3 × 77.5 cm
Inscr. on shell, bottom left: 'R Dadd 1842'
Exh: Royal Academy 1842 (527); Birmingham
Society of Artists 1842 (263); Liverpool
Academy 1843 (184); Royal Academy
Bicentenary Exhibition 1968–9 (239)
Prov: Edwin Bacon to 1967; John Rickett.
Private collection (repr. on p.69)

This painting was exhibited at the Royal Academy untitled, but with the quotation in the catalogue of Ariel's song from *The Tempest*, I, ii:

'Come unto these yellow sands,
And then take hands,
Curt'sied when you have and kissed,
(The wild waves whist)
Foot it featly here and there,
And sweet sprites the burden bear.'

At Liverpool it was titled 'Fairies Holding their Revels on the Sea Shore at Night', but carried the same quotation. It was 'one of the attractions of the exhibition at the Royal Academy, notwithstanding that it was placed where the mere crowd of gazers would pass it by unnoticed.'[28] The *Art Union*'s reviewer felt that it 'approaches more nearly to the essence of the poet than any other illustrations we have seen . . . The picture is fraught with that part of painting which cannot be taught—in short, the artist must be some kind of a cousin to the muse Thalia.'[29] The structure of the composition is very carefully worked out, based on a series of interlocking ellipses and circles. The figures also form linear arabesques across the surface of the picture, broken by the small triangle perched on top of the rock. Strong theatrical lighting defines, as in 'Puck', a circle within which the dancers are contained, and where they are held tightly together by the dramatic tensions which it sets up. The unusual colouring, predominantly pinks, blues and orangey reds, did not entirely please the reviewer, who warned Dadd to 'guard against the prevalence of the colour of the figures': but it plays an important part in creating the mysterious and homogeneous microcosm, which is at the heart of each of the fairy paintings. The abandoned spirit of the dancers within this highly controlled environment increases the atmosphere of heightened elation, which amounts almost to frenzy, and is strengthened by their air of total self-absorption. In the light of hindsight, knowing that this was the last picture painted before leaving for the journey from which he returned insane, it is tempting to see in it some evidence of an over-fevered imagination.

Dadd is again seen to have been looking closely at the work of Maclise, particularly at 'The Choice of Hercules'.[17] Some of the female figures owe their inspiration to the figure of Vice in this work (and probably also to the dancers in the background, now too dark to be clearly seen). The decorative swirls of putti have been borrowed too, and whether by accident or design, they tumble into a shape very like that of the floating loop of drapery in the same picture. Individually, they recall some of Poussin's putti, and there are perhaps echoes of his 'Triumph of Galatea' both here and in the female figures on the right of the aerial group. The group of three standing figures on the rock, which brings the composition to a climax at the exact centre of the picture, is deliberately suggestive of a Madonna with attendants, recalling 'Titania Sleeping' with its treatment of Titania and her fairies as a nativity scene. This, like Dadd's other fairy pictures, made its mark on his contemporaries; and some of its decorative features can be seen, carried to excess and producing very different results, in Paton's two *Midsummer Night's Dream* pictures of a few years later. It is difficult to be sure how much Paton and Dadd were simply influenced by common sources, but a more obviously deliberate use of Dadd's ideas is found in Robert Huskisson's 'Come unto these Yellow Sands' (No. 248), and at third hand, in H. Stanier's copy of Huskisson's work (No. 249).

69 Robin Goodfellow 1842
Drawn on wood, engraved by W. J. Green
Four designs for 'Robin Goodfellow' in *The Book of British Ballads*, edited by S. C. Hall, London 1842.

The first volume of *The Book of British Ballads* was published in 1842 under the editorship and general guidance of Samuel Carter Hall, one of whose less desirable achievements was to serve as the model for Mr Pecksniff in Dickens's *Martin Chuzzlewit*. Hall's aim is (fairly) clearly stated in the introduction: 'In illustrating the work [the editor] was ambitious so to apply the great and admitted capabilities of British Art, as to prove that the embellished volumes of Germany and France were not of unapproachable excellence, in reference either to design or execution. He believes himself warranted in stating, that as the work progresses he will be enabled to submit examples of the genius of a large proportion of the more accomplished artists of Great Britain—as exhibited in drawing upon wood'. In this the book is a foretaste of an increasingly prevalent type of production in which the work of a number of different artists, of varying styles and degrees of talent, is combined in one volume. Some of the contributors who were, or were to become, known for their illustrative work were John Tenniel (whose first commission this was), Kenny Meadows and John Gilbert. Others from Dadd's particular circle include Edward Mathew Ward, Thomas Joy, William Powell Frith and William Bell Scott. During the production of the book Hall would assemble the artists at his house, where he fed them on coffee and biscuits and read aloud each ballad before handing over the woodblocks to the person to whom it had been alotted: after which, at least when Kenny Meadows was present, they would adjourn in some disgust to a nearby tavern.[30] The pattern is the same for all the poems. Within an almost plain frame, of which three specimens are used throughout, picture and text are placed side by side in vertical columns and separated by a ruled line: only the head- and tailpieces are integrated with the text. 'Robin Goodfellow' is one of the shorter ballads, and Dadd has managed to represent nearly every verse by linking three small scenes into each of the tall narrow designs imposed by the format. He is the only person to use this solution, and his illustrations are in a more imaginative vein altogether than the rest, most of which show figures in medieval costume enacting scenes of high drama or pathos: though the difference is inevitable, since he was given the most fanciful poem as being the one best suited to his talents. In the two side slips and tailpiece he has produced a set of lively and inventive vignettes illustrating Robin's activities as told in the poem, and capturing the spirit of his tiresome and sometimes frightening, but not too malevolent pranks. The headpiece, perhaps the best of the four, shows the laughing Puck in the shadowy moonlit land from which he emerges to torment humankind. It is an eery place, peopled by foetal-looking, goggle-eyed elves and goblins; and there is more than a hint of cruelty in the giant dew-drops which imprison tiny frog-like creatures, and the spiky lettering of the title on which the body of an elf has been impaled. Though he had never drawn on wood before, Dadd's concern with dramatic lighting at this period translates well

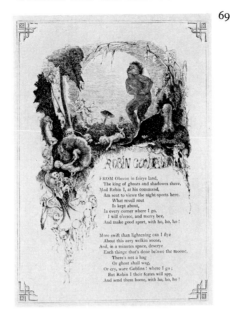

69

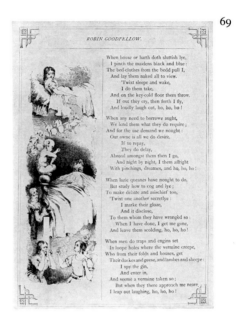

69

70

into the light and dark contrast of wood engraving, and he shows an understanding of the medium's potential which was not shared by all his friends who worked on the volume. He enjoyed the work, and only a few days before killing his father had written to Hall offering to illustrate another ballad for the second volume.

70 A Country Churchyard *c.*1842
Etching, $5\frac{1}{16} \times 6$ in, 12.8 × 15.3 cm (plate)
Inscr. in the margin by Robert Dadd: 'Beneath those rugged Elms that Yew Trees shade|Where heaves the Turf &c &c Gray's Elegy|drawn & etched by my son Richard|Robert Dadd| Presented to M.ʳ Clements'
Prov: William Clements, given to him by the artist's father. Christie's 6 December 1973 (29).
Christopher Mendez

For William Clements *see* p. 12, and notes on 'The Fairys Rendezvous' (No. 61). The design was probably made in connection with Dadd's membership of the Painters' Etching Society, founded in 1842 (*see* p. 17), one of whose first but abortive projects had been to illustrate the poems of Gray.

71 Walpurgis Night, The Piper of Neisse, The Devil's Bridge ?*c.*1842
Illustrated manuscript, 43ff., $8 \times 6\frac{1}{2}$ in, 20.4 × 16.5 cm
Prov: Mrs Caroline Adams to 1925, with 'Portrait of a Man' (No. 33).
Victoria and Albert Museum

This volume contains three manuscript poems with a total of 19 illustrations by Dadd in pen and ink. The text appears to be in his own handwriting and was probably composed by him, but there is no certainty. The book is labelled on the front cover: 'Illustrated Poems|HGA', and H. G. Adams, to whom it belonged, is known to have written and published several poems (*see* 'Portrait of a Man', No. 33, and *The Kentish Coronal*, No. 51). On the other hand Dadd too shows himself to have been fond of versifying, in his 'elimination' of 'The Fairy Feller's Master Stroke' (No. 193); and the first poem of the three here certainly deals with matters which were very close to his imagination. 'Walpurgis Night, a Lay of the Hartz Mountains' is something of a cross between 'Manfred' and 'Faust', the latter association strengthened by its opening with a verse from Shelley's 'Faust': 'The stubble is yellow, the corn is green, | Now to the Brocken the witches go; | The mighty multitude here may be seen | Gathering, wizard and witch, below'. Walpurgis Night is the eve of the feast of St Walburga (1 May), an eighth-century English nun credited with helping to convert the Germans to Christianity; and according to German legend it is the night when the witches and the devil hold a festival. The forty-one undistinguished but strenuous stanzas, tell the story of Henrich, a student who comes to Göttingen from the Rhineland and practises alchemy in search of the *elixir vitae*. Failing to find it he ventures out into the mountains on Walpurgis Night, pursuing forbidden knowledge through a howling tempest which has everyone else bolting their doors and praying. Here he faces a multitude of fiends, demons and other nameless horrors, amidst harrowing

shrieks, hollow groans, screams, and flashes of *ignus fatui*. A party of ghastly witches and wizards arrives in a deep ravine, and they start seething a 'mixture foul' in a large cauldron which happens to be there, dancing round it in a sight 'horrible to see'. One of them tempts Henrich with the information that this is the *elixir vitae* itself, and an owl, who is the devil in disguise, perches on his shoulder and advises him that the best way to get down is to leap. Henrich leaps, and is dashed to death on the rocks below. At home his father, the old Count Palatine, shows little interest when told that his son is missing, while his nine brothers merely remark that 'He was a bookworm' and his mother sips wine and lisps 'poor dear!'. There are seven outline illustrations which Dadd apparently intended to etch: the first is signed 'R.ᵈ Dadd invent. et fecit', and the rest 'R Dadd invenit'.

The second poem, 'The Piper of Neisse, a Legend of Silesia' is very much longer, and while it may not be great literature, is quite good entertainment. It tells of Willibald, a wandering piper who has settled in Neisse, and is in great demand for his powers to make even the oldest and least agile dance, when he plays his special music. His foster son Wido, a young painter, is pining with hopeless love for the daughter of the town's despotic mayor, but will not allow Willibald to trick her father by his piping into giving consent to their marriage. When the oppressed townsfolk finally set out to burn down the mayor's house, Wido persuades Willibald to charm them back home with his music, believing that the mayor in gratitude will give him his daughter's hand. The mayor promises the piper anything he asks, but goes back on his word, flings him into prison, and prepares to have him burned for witchcraft. Willibald dies peacefully in prison, after pointing out to Wido that it is no use counting on human goodness, as he said all along, and asking for his pipes to be buried with him. He is buried in unhallowed ground, and gets up nightly to play the magic tune, arousing all the dead from their graves and leading them in a dance round the town. Gradually they strike down all the most beautiful maidens with their phantom powers, until the townspeople rebel again and tell the mayor to let Wido marry his daughter or they will carry her off themselves. The mayor saves face by announcing that this was his intention all along; the couple are married, and Willibald returns for the last time to bring back the maidens, now restored to life. The last few lines give a flavour of the whole, as well, perhaps, as a clue to the authorship:

Now to immortalize this tale,
A goodly picture painted he,
Of which in Antwerp, Dresden, Basle,
And Lubeck—imitations be,
But none like the original
Of which, alas! no trace remains,
Though lovers of the art, have all
To find it ta'en exceeding pains.

There are twelve illustrations to this story, in the same style as the others but unsigned.

The last poem, 'The Devil's Bridge, a Swiss Legend' is only six stanzas long and is not illustrated. It tells the well-known legend of the Devil's Bridge over the Reuss, which was annually swept away by avalanches until the devil undertook to build a more durable one in

71

return for the soul of the first to cross it. The bridge was built, but the local inhabitants fulfilled their side of the bargain by sending a dog over first.

The dating of this volume is difficult. A date of 1842 is suggested because the illustrations seem to be related in the style and costume of the figures, to the work of Dadd's colleagues in *The Book of British Ballads* (No. 69): and in the third drawing for 'Walpurgis Night', which shows Henrich tossing in his bed and clutching the sheets as 'wild phantasies' come to worry his brain, the figure of Henrich is the same as one used by Joseph Noël Paton in the tailpiece for 'The Eve of St. John', which was published in the second series.[31] Paton did not join Hall's group of illustraters until at least 1843, after Dadd had left them, which might mean that the MS was still in circulation among them at this time: but a common source for both figures is also possible. It would be tempting to suggest that the work dates from after Dadd's return to England in 1843, when his recent travels in Germany and Switzerland would have aroused his interest in these tales; but it seems unlikely that his state of mind at that time would have allowed such prolonged writing about demons, fiends, and the devil, without a certain amount of personal involvement and probably some incoherence creeping in.

71

72 **Decorative Festoons** before 1843
Pen and ink and wash, $13\frac{1}{2} \times 8\frac{3}{4}$ in, 34.3 × 22.2 cm (irregular paper)
Prov: Capt. R.H. Dadd to 1972; by descent in the family of the artist's brother.
Alister Mathews

Since this drawing remained in the artist's family until recently, it can be presumed to date like the others from before his confinement. The purpose of the designs is not known, nor can any thematic link be found between the various components and the words 'diverses amours', 'Magnanimité' 'Magnificence' in the shield at the bottom. The left-hand festoon appears to include symbols of music, medicine, comedy, agriculture, archery and marine life: that on the right seems to be chiefly architectural, imperial and numismatic.

73 **Sketchbook** 1842–3
Pencil, $5\frac{1}{2} \times 8\frac{1}{8}$ in, 14.0 × 20.6 cm (size of page)
Victoria and Albert Museum

This is one of the sketchbooks which Dadd brought home from the journey through the Middle East which he made with Sir Thomas Phillips in 1842–3 (*see* pp. 18–22). It is probably similar to the one which he had with him in Bethlem and Broadmoor, on which he relied heavily for the rest of his working life: several watercolours show that the two covered some of the same areas, though there may have been more landscape in the other. This book contains 191 leaves, mostly with drawings on one side only, and often including colour notes. It does not begin until they reached Greece on 21 August, after over a month's travelling. After that it includes material from the whole of the rest of the journey as far as Malta on the way home, but shows nothing from Italy except for one stray picture of Venice made on the way out. The largest proportion of sketches is of figure studies and heads, sometimes a dozen or more to a page and often

72

fitted in with bits of landscape, architectural details, and anything else which may have left space. Numerous tiny boats, some only two or three centimetres high are also scattered throughout the book, which is sometimes turned round so that a few more can be squeezed in; and it is obvious from these that Dadd's childhood and youth beside the Medway had laid the foundation of an intense fascination for all shipping subjects. All the drawing is meticulous, precise, and sharply observed, despite the peculiar difficulty of sketching in the Middle East noted by Dadd and many others, that of either attracting hordes of people all trying to turn the pages to look at the pictures, or of being chased down the streets by angry crowds. Dadd lamented to both Frith and David Roberts, however, about his lack of time for drawing because of the long stages by which they travelled, generally not stopping until it was too dark to see. Some of the locations where the drawings were made are noted in his own hand, but many of the identifications are in the handwriting of Sir Thomas Phillips, who owned the book after Dadd's confinement in Bethlem.

The sketchbook has been broken up and the pages are now mounted in groups. The notes in Phillips's hand are identified: anything else quoted is in Dadd's own handwriting.

Mount 1

D.247–92
'Greeks of the Morea' (note by Phillips). 9 figures; colour notes.

D.248–92
'On the Gulf of Corinth' (note by Phillips). Landscape; 2 studies of fountains noted 'Style of Fountains in Greece'.

D.249–92
'Greeks of the Morea' (note by Phillips). 8 figures; 4 heads; mule; 5 other sketches; colour notes.

D.250–92
'Greeks' (note by Phillips). Head of 'Our Greek Servant'; 5 other heads and detail of headdress; 1 figure; colour notes.

D.251–92
'Greeks' ['of the Morea' crossed out] (note by Phillips). 9 figures; colour notes.

D.252–92
'Greeks' ['of the Morea' crossed out] (note by Phillips). Squatting figure smoking a pipe; 4 other figures; 5 heads; a two-masted ship; 2 other sketches; colour notes.

Mount 2

D.254–92
'Trunks yet in the Groves of the Academy' (note by Phillips). Ancient tree trunks.

D.255–92
'Athens' (note by Phillips). Head and shoulders of a man; 8 other figures and details; detail of footwear; 2 mules; colour notes.

73

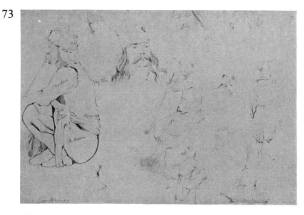

D. 250–92

73

D. 252–92

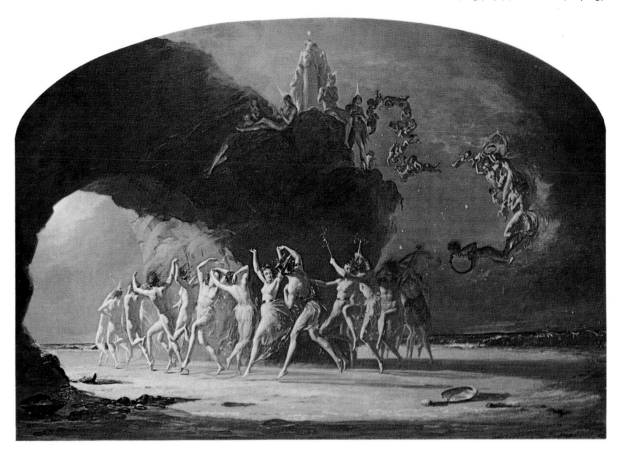

68 Entry on p. 64

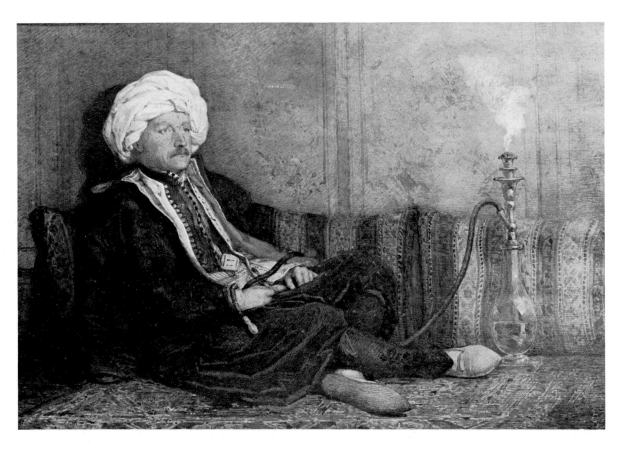

83 Entry on p. 75

73

D. 253-92

73

D. 257-92

73

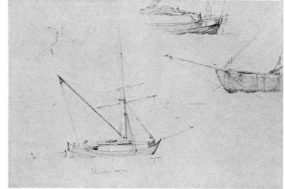

D. 113-92

D.253-92
'From the Olive Grove at Athens'. Olive trees.

D.257-92
Greece. Study of ancient masonry; head of an old man wearing a fez; bier and other details from a funeral procession (probably the burial of the bishop which was seen in Athens)[32]; colour notes.

D.256-92
'Athens' (note by Phillips). Architectural details; 13 figures, heads and details; colour notes.

D.258-92
2 studies of the head of 'A Grand Master of the Knights of Malta' (note by Phillips); 2 boats; landscape.

Mount 3

D.110-92
Possibly Smyrna. Head of a European girl; head of a man; girl in Turkish dress; 8 other figures and heads; colour notes.

D.112-92
Possibly Smyrna. 11 figures and heads; colour notes.

D.113-92
'Smyrna'. 'Tchernikes caique'; prow and stern of caiques; 2 other sketches.

D.109-92
Smyrna. 'Mosque of Yani Jami'; colour notes.

D.111-92
Buildings, possibly at Smyrna.

D.114-92
Seated man wearing a fez; seated woman; archway with figures (the last two drawn with the page turned the other way).

Mount 4

D.97-92
Constantinople. Seated woman; 2 Persian men, seated; Persian man, sleeping; colour notes.

D.98-92
Constantinople. Room in which the dervishes danced, with kneeling figure in the centre; kneeling dervish; head of a dervish; notes about the room and the dancing; colour notes.

D.99-92
Group of about 12 figures, seated and lying; colour notes.

D.100-92
Probably Constantinople. Shoreline with buildings; caique; ox cart; 2 figures (drawn with page turned the other way); colour notes.

D.101-92
Probably Constantinople. Seated Turk smoking a pipe; colour notes.

D.102-92
Constantinople. 'Sultans barge'; landscape; prow of a boat; colour notes.

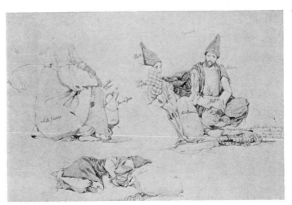

D. 97–92

Mount 5

D.133–92
Caria, Asia Minor. 'House of a Dere Bey at Koogez'; colour notes. (Dadd mentioned this in a letter to Roberts: 'Thence to Hoogiz [*sic* in printed version], where is a large ruinous house, which belongs to one of the Dere Beys: this was so picturesque that I made a sketch of it.')[33]

D.134–92
'Rhodes'. 14 figures, heads and other details; turkish eating and water carrying vessels.

D.135–92
Lycia, Asia Minor. Rock tombs, probably near Xanthus.

D.136–92
'Rhodes' (note by Phillips). Harbour scene, surrounded by 10 heads of men; colour notes.

D.137–92
'Mackry' (note by Phillips). View of houses with mountain scenery behind, at Macri (now Fethiye).

D.138–92
'Cyprus' (note by Phillips). View of coastline with note 'Marina [Larnica—crossed out] Cyprus Oct.'; 3 camels.

Mount 6

D.139–92
Houses at Beirut.

D.140–92
Beirut. 17 figures, heads and details.

D.141–92
Beirut. Street scene; camel (drawn with page turned the other way).

D.142–92
'Corn Market at Beyrout|28th Oct.r. 42' (*see* also No. 81); 5 figures (drawn with page turned the other way); colour notes.

D.143–92
'Coast of Syria' (note by Phillips). View of Jebeil; coastal view, with man in European dress (?Phillips) standing on the shore.

D.144–92
Syria. 14 figures and heads; castle overlooking water.

Mount 7

D.157–92
'Baalbec' (note by Phillips). Distant view of the temple of Jupiter; distant view of a mosque.

D.158–92
'Syria' (note by Phillips). 14 figures and heads; 5 boats (feluccas).

D.159–92
'Damascus' (note by Phillips). Balcony of a house; entrance to a courtyard (drawn with page turned the other way).

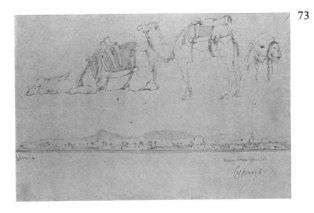

D. 138–92

D. 143–92

73

D. 160–92

73

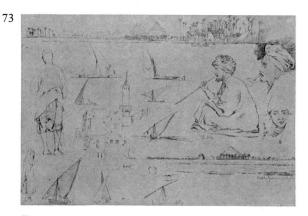

D. 200–92

73

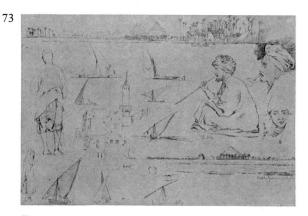

D. 204–92

D.160–92
Syria. 7 figures and heads; 1 felucca (with page vertical); 3 heads and detail; 2 feluccas (with page horizontal).

D.161–92
'Damascus' (note by Phillips). Courtyard, with houses, domes and minaret behind; colour notes.

D.162–92
'Syria' (note by Phillips). 11 figures and heads; archway, window and other architectural details; 1 felucca.

Mount 8

D.199–92
'Thebes' (note by Phillips). Architectural remains.

D.200–92
'On the Nile' (note by Phillips). Study of a boat moored (?the dahabeeyah in which they made the Nile trip);[34] 8 figures and heads; 1 small boat; group of 6 boats.

D.201–92
'Statues at Thebes' (note by Phillips).

D.202–92
'On the Nile' (note by Phillips). Scene with moored boat; 5 figures and heads; distant view.

D.203–92
'Medinet Abou' (note by Phillips). Ruined palace.

D.204–92
'On the Nile' (note by Phillips). 2 landscapes with pyramids, one of them noted 'One of the Pyramids at Dashur', with two flamingoes in foreground; 5 figures and heads; houses and minaret; 8 boats (some of them dahabeeyahs).

***74 Peter Martyr** 1842
Copy after Titian
Whereabouts unknown

In a letter to David Roberts Dadd wrote of his visit to Venice: 'I had just time enough to make a blot of Peter Martyr, and a picture of a miracle of St. Mark by Tintoretto . . .'[35] Titian's 'Peter Martyr' in the church of SS Giovanni e Paolo (destroyed by fire in 1867) was a work which Dadd would have been taught to revere at the Academy Schools, and may already have been known to him through engravings. It was regarded by Constable as 'the foundation of all the styles of landscape in every school of Europe' and spoken of by Turner as 'his divine picture of St Peter Martyr'.[36] In 1839 the *Art Union* had cited its qualities together with those of Tintoretto's 'Miracle of St Mark',[37] and Dadd was no doubt looking out for both. Nevertheless his particular interest in these two scenes of dramatic violence is significant, and the Titian was obviously still in his mind when he painted 'Dymphna Martyr' (No. 105), and possibly also 'The Death of Richard II' (No. 106), in Bethlem.

***75 The Miracle of St Mark** 1842
Copy after Tintoretto
Whereabouts unknown

See the notes on 'Peter Martyr' (No. 74). Dadd's letter to Roberts continues: 'I had just time enough to make a blot of . . . a picture of a miracle of St Mark by Tin-

toretto: the last one of the most fascinating works I ever beheld . . .'[35] This is the painting also known as 'The Miracle of the Slave' and 'The Miracle of the Hammer'.

76

76 Castalian Spring, Delphi 1842
 Watercolour, 10¼ × 7 in, 26.0 × 17.8 cm
 Inscr. on verso: 'Rich^d Dadd'
 Prov: Capt. R.H. Dadd to 1972; by descent in
 the family of the artist's brother.
 Alister Mathews

Dadd was at Delphi on 24 August 1842, and wrote of it to David Roberts: 'We visited the Castalian Fountain, and drank of its inspiring waters. Alas! how is this place changed! Where formerly the priestess raved out the oracle of the deity, now angry washerwomen rave out an intolerable jargon of abuse at each other. The waters, once deemed full of inspiration, are now full of frogs and water-cresses; and I think, from the repute in which the place is held by the people of the present day, that the goddess might be obliged to sell those same water-cresses for her living.'[38] A small and very hasty watercolour sketch of the same scene is in the sketchbook in the Victoria and Albert Museum (No. 73) on the back of f. 244 (the only use of colour in the book). It is possible that this version was made from it later, but more likely that the two were done on the same occasion.

77

77 Sketch of part of Athens 1842
 Pencil, 10¼ × 7 in, 26.0 × 17.8 cm
 Inscr. bottom right: 'Athens 4^th Sept^r'
 Prov: Capt. R.H. Dadd to 1972; by descent in
 the family of the artist's brother.
 Alister Mathews

This is one of four pencil sketches from the journey of 1842-3 which survive outside the sketchbook which is now in the Victoria and Albert Museum (No. 73). It does not seem likely to be a loose page from the sketchbook which Dadd had in Bethlem with him, which is described as 'small', and there may once have been many more of these slightly larger drawings. This and two of the others (Nos. 79 and 82) were taken to America by Dadd's half brothers (most probably by Arthur), and were returned this century to another member of the family.

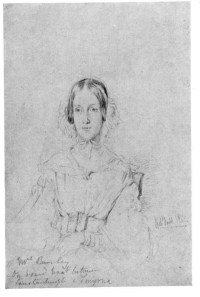

78

78 Portrait of Mrs ?Brimley 1842
 Pencil, 10¼ × 7 in, 26.0 × 17.7 cm
 Inscr. lower right, by Dadd: 'Rich^d Dadd
 1842.'; bottom left, by Sir Thomas Phillips:
 'M^rs Brimley [?Bumley, ?Burnley] on board
 boat between Constantinople & Smyrna'
 Private collection

During the early part of their journey to the Middle East, Dadd and Sir Thomas Phillips met and joined up with a Col Dawkins and his wife, and 'the wife of a Major (?)Brimley, the daughter of Sir George Berkley', all from Corfu.[39] Between Athens and Constantinople (that is, for much of September 1842), they formed an inseparable group. Phillips wrote of this to his brother, but unfortunately the lady's name is no more certainly legible in his letter than in the inscription here. There is at least one more drawing of her in Dadd's sketchbook (No. 73), at f. 116 and possibly f. 114v.

86

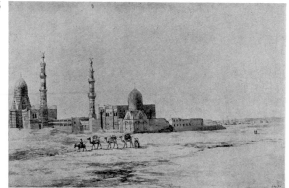

*87

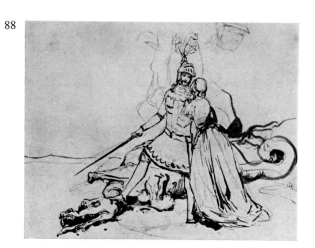

88

watercolour, which has the look of a hasty on-the-spot sketch, was made at the same time rather than being taken later from the sketchbook version. Dadd did not often have time for the use of colour on this journey, or for any prolonged periods of sketching at all; and he is said to have suffered the 'coup de soleil', which was later blamed for all his troubles, during a period of excessive work on a very hot day in Egypt. It may not be too fanciful to suggest that it could, at least, have happened on the occasion when this watercolour was painted, or at any rate during the week spent in Cairo.

***87 An Ancient Gateway in Rome** 1843 or c.1845
Watercolour, $7\frac{1}{2} \times 5\frac{1}{2}$ in, 19.0 × 14.0 cm
Inscr. across the bottom: 'An Ancient Gateway in the vicinity of St. Peters Rome'
Prov: E. J. Gibbons in 1898; in the family of E. J. Gibbons to 1965. Sotheby's 10 March 1965 (5), bought by Agnew.
Private collection (not exhibited)
This was possibly painted between 1 and 29 April when Dadd was in Rome on the way home from the Middle East with Sir Thomas Phillips, but may have been worked up later from his sketchbook. It seems to be from the same period as 'Bethlehem' (No. 101). In February 1843 he had written to David Roberts 'There is much pleasure in store for us yet at . . . Rome',[42] but by the time they arrived, his illness was already causing marked mental disturbance, and it is not known how much sketching he was able to do. The surviving sketchbook does not cover this part of the journey.

88 St George after the Death of the Dragon
1843
Brown ink and pencil, irregular paper, 7 × 9 in, 17.8 × 22.9 cm
Prov: Capt. R. H. Dadd to 1972; by descent in the family of the artist's brother.
Alister Mathews
This is a sketch for Dadd's entry for the competition to decorate the new Palace of Westminster, *see* No. 89.

***89 St George after the death of the Dragon**
1843
Chalk or charcoal cartoon, 10 × 15 ft
Exh: Westminster Hall 1843
Whereabouts unknown, probably destroyed
Controversy about how the new Palace of Westminster should be decorated had been rife before Dadd left on his journey to the Middle East in 1842, and while still in Palestine he had written to Frith 'What is done about the House of Lords ? Are they to be done by the painters, or who ?'[43] The competition for fresco designs was about to close by the time he arrived home at the end of May, but he immediately began work on a cartoon which he is variously said to have completed in 'a few hours', 'twenty three hours' and 'thirty two hours': there cannot, in any case, have been more than a few days left before the closing date. Many of his friends and family saw in it evidence of his insanity, and tried to stop him from submitting it, though Frith recalled 'the only evidence of eccentricity being the inordinate length of the dragon's tail, which one of the papers said was as long as O'Connell's (O'Connell had an enormous Irish

76

toretto: the last one of the most fascinating works I ever beheld . . .'[35] This is the painting also known as 'The Miracle of the Slave' and 'The Miracle of the Hammer'.

76 Castalian Spring, Delphi 1842
Watercolour, 10¼ × 7 in, 26.0 × 17.8 cm
Inscr. on verso: 'Richᵈ Dadd'
Prov: Capt. R.H. Dadd to 1972; by descent in the family of the artist's brother.
Alister Mathews

Dadd was at Delphi on 24 August 1842, and wrote of it to David Roberts: 'We visited the Castalian Fountain, and drank of its inspiring waters. Alas! how is this place changed! Where formerly the priestess raved out the oracle of the deity, now angry washerwomen rave out an intolerable jargon of abuse at each other. The waters, once deemed full of inspiration, are now full of frogs and water-cresses; and I think, from the repute in which the place is held by the people of the present day, that the goddess might be obliged to sell those same water-cresses for her living.'[38] A small and very hasty watercolour sketch of the same scene is in the sketchbook in the Victoria and Albert Museum (No. 73) on the back of f. 244 (the only use of colour in the book). It is possible that this version was made from it later, but more likely that the two were done on the same occasion.

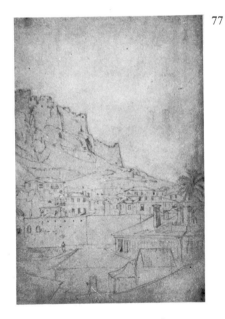

77

77 Sketch of part of Athens 1842
Pencil, 10¼ × 7 in, 26.0 × 17.8 cm
Inscr. bottom right: 'Athens 4ᵗʰ Septʳ'
Prov: Capt. R.H. Dadd to 1972; by descent in the family of the artist's brother.
Alister Mathews

This is one of four pencil sketches from the journey of 1842–3 which survive outside the sketchbook which is now in the Victoria and Albert Museum (No. 73). It does not seem likely to be a loose page from the sketchbook which Dadd had in Bethlem with him, which is described as 'small', and there may once have been many more of these slightly larger drawings. This and two of the others (Nos. 79 and 82) were taken to America by Dadd's half brothers (most probably by Arthur), and were returned this century to another member of the family.

78 Portrait of Mrs ?Brimley 1842
Pencil, 10¼ × 7 in, 26.0 × 17.7 cm
Inscr. lower right, by Dadd: 'Richᵈ Dadd 1842.'; bottom left, by Sir Thomas Phillips: 'Mʳˢ Brimley [?Bumley, ?Burnley]|on board boat between Constantinople & Smyrna'
Private collection

During the early part of their journey to the Middle East, Dadd and Sir Thomas Phillips met and joined up with a Col Dawkins and his wife, and 'the wife of a Major (?)Brimley, the daughter of Sir George Berkley', all from Corfu.[39] Between Athens and Constantinople (that is, for much of September 1842), they formed an inseparable group. Phillips wrote of this to his brother, but unfortunately the lady's name is no more certainly legible in his letter than in the inscription here. There is at least one more drawing of her in Dadd's sketchbook (No. 73), at f. 116 and possibly f. 114v.

78

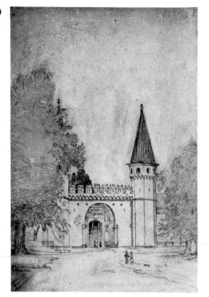

79

79 Sublime Porte, Constantinople 1842
Pencil, 10⅛ × 7 in, 25.8 × 18.0 cm
Inscr. bottom left: 'Gate from which is taken the
title of|Sublime Porte'; also inscribed with
colour notes
Prov: Capt. R. H. Dadd to 1972; by descent in the
family of the artist's brother.
Alister Mathews

This drawing shows the gate between the second court
and outer court of the Seraglio at Constantinople.
Thackeray wrote, two years after Dadd had been there:
'We passed out of the second court under THE SUB-
LIME PORTE, which is like a fortified gate of a German
town of the middle ages, into the outer court, round
which are public offices, hospitals, and dwellings of the
multifarious servants of the palace'.[40] He also de-
scribed his own attempts to sketch it, thwarted by the
officers of the court on account of the crowds which
gathered round. Dadd was in Constantinople from 14
to 27 September 1842.

***80 Frieze from the Tomb of Mausolus** 1842
Pencil sketches
Prov: Sent to Sir Stratford Canning, British
Ambassador to Turkey, 1842.
Whereabouts unknown

Dadd visited Bodrum, the ancient Halicarnassus, with
Sir Thomas Phillips in October 1842 (*see* p. 19). The
Castle of St Peter had been built there by the Knights
of St John in the fifteenth century, using materials
from the nearby tomb of Mausolus (called The
Mausoleum and accounted one of the seven wonders
of the ancient world). Fragments of bas-relief sculp-
ture showing the combat of the Athenians with the
Amazons were built into the walls of the castle, and had
been known for many years; they had even featured on
a Spode earthenware dish as early as 1808. In 1842 Sir
Stratford Canning was negotiating to obtain them for
the British Museum, and asked Phillips to inspect them
and report on the feasibility of removing them without
damage to the structure (a point on which the Turks
had shown a reasonable sensitivity). Dadd sketched the
four slabs in the outer face of the wall, but could not
get access to those in the rest of the fortress. Some more
drawings are in the sketchbook in the Victoria and
Albert Museum, ff. 272-4.

81

81 The Corn Market, Beirut 1842
Watercolour, 9⅜ × 7¾ in, 23.8 × 19.6 cm
Inscr. bottom left: 'Sketched at Beyrout in the
Corn Market Rich Dadd'
Prov: Presented by Sir Thomas D Barlow 1947.
*Whitworth Art Gallery, University of
Manchester*

Dadd spent one day, 28 October 1842, in Beirut, and
the sketchbook contains several drawings made there.
One (D.142-92), is identical with this except for the
figures and could have formed the basis for it, though
the watercolour has the look of being made on the spot.
Comparison suggests that the pencil sketch was made
first, and then the watercolour from exactly the same
place, some of the figures being transferred to the
second version.

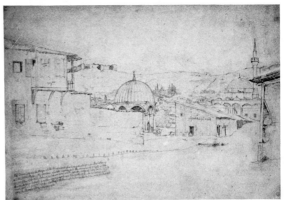

82

82 Sketch of an Eastern Town 1842
Pencil, 6¾ × 10 in, 17.2 × 25.4 cm
Prov: Capt. R.H. Dadd to 1972; by descent in
the family of the artist's brother.
Alister Mathews
This is one of the four pencil sketches surviving from
the tour of 1842–3 which do not come from the known
sketchbook (*see* No. 77). It contains detailed colour
notes. The town has not been identified.

**83 Portrait of Sir Thomas Phillips in Eastern
Costume, Reclining** 1842 (repr. on p.69)
Watercolour heightened with white, 6½ × 10 in,
16.5 × 25.4 cm
Prov: By descent in the sitter's family
Private collection
See No. 84.

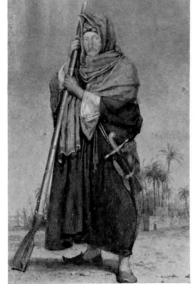

84

**84 Portrait of Sir Thomas Phillips in Eastern
Costume, Standing** 1842–3
Watercolour heightened with white,
9½ × 6½ in, 24.1 × 16.5 cm
Prov: By descent in the sitter's family
Private collection
These two pictures were painted during the tour of the
Middle East. Since there was little time for sketching,
and rarely any at all for the use of colour, they must
have been made during periods of comparative rest;
the first might have been painted at Damascus, Alex-
andria or Cairo, the second possibly during the boat
trip up the Nile. Although it was customary to adopt
eastern dress when travelling, and Dadd reported him-
self to be wearing a fez with handkerchiefs round it as
part of his travelling outfit,[41] there is definitely an air
of dressing up for the occasion in these two instances
and it is unlikely that Sir Thomas often appeared in
public clad like this.

***85 Entrance to an Egyptian Tomb** 1843
Watercolour, 6⅞ × 5½ in, 17.5 × 14.0 cm
Victoria and Albert Museum (not exhibited)
The scene is a tomb at Medinet Abou, near Thebes: an
identical view, on f. 212 of the sketchbook in the
Victoria and Albert Museum (No. 73), is identified in
Dadd's handwriting. The watercolour has the appear-
ance of being made on the spot, and the two versions
were probably sketched on the same occasion, the only
difference being that no figures appear in the pencil
sketch. Dadd was at Thebes with Sir Thomas Phillips
from 6 to 13 January 1843, visiting all the sites in the
neighbourhood.

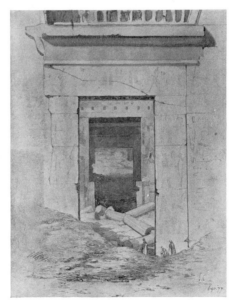

85*

86 Tombs of the Khalifs, Cairo 1843
Watercolour, 9½ × 14½ in, 24.1 × 36.8 cm
Victoria and Albert Museum (Circulation Dept)
Dadd visited the Tombs of Khalifs, outside Cairo,
between 24 and 30 January 1843, when he was staying
in Cairo on the way back from the expedition up the
Nile. There is a view nearly identical with this on f. 227
of the sketchbook in the Victoria and Albert Museum
(No. 73), without the string of camels or the figures on
the right, but including the two tiny figures which can
just be seen by a rock close up to the walls, near the
centre. The pencil sketch covers the tombs only, and
not the view of Cairo to the right, and probably this

86

*87

88

watercolour, which has the look of a hasty on-the-spot sketch, was made at the same time rather than being taken later from the sketchbook version. Dadd did not often have time for the use of colour on this journey, or for any prolonged periods of sketching at all; and he is said to have suffered the 'coup de soleil', which was later blamed for all his troubles, during a period of excessive work on a very hot day in Egypt. It may not be too fanciful to suggest that it could, at least, have happened on the occasion when this watercolour was painted, or at any rate during the week spent in Cairo.

***87 An Ancient Gateway in Rome** 1843 or *c*.1845
Watercolour, $7\frac{1}{2} \times 5\frac{1}{2}$ in, 19.0×14.0 cm
Inscr. across the bottom: 'An Ancient Gateway in the vicinity of St. Peters Rome'
Prov: E. J. Gibbons in 1898; in the family of E. J. Gibbons to 1965. Sotheby's 10 March 1965 (5), bought by Agnew.
Private collection (not exhibited)
This was possibly painted between 1 and 29 April when Dadd was in Rome on the way home from the Middle East with Sir Thomas Phillips, but may have been worked up later from his sketchbook. It seems to be from the same period as 'Bethlehem' (No. 101). In February 1843 he had written to David Roberts 'There is much pleasure in store for us yet at . . . Rome',[42] but by the time they arrived, his illness was already causing marked mental disturbance, and it is not known how much sketching he was able to do. The surviving sketchbook does not cover this part of the journey.

88 St George after the Death of the Dragon
1843
Brown ink and pencil, irregular paper, 7×9 in, 17.8×22.9 cm
Prov: Capt. R. H. Dadd to 1972; by descent in the family of the artist's brother.
Alister Mathews
This is a sketch for Dadd's entry for the competition to decorate the new Palace of Westminster, *see* No. 89.

***89 St George after the death of the Dragon**
1843
Chalk or charcoal cartoon, 10×15 ft
Exh: Westminster Hall 1843
Whereabouts unknown, probably destroyed
Controversy about how the new Palace of Westminster should be decorated had been rife before Dadd left on his journey to the Middle East in 1842, and while still in Palestine he had written to Frith 'What is done about the House of Lords? Are they to be done by the painters, or who?'[43] The competition for fresco designs was about to close by the time he arrived home at the end of May, but he immediately began work on a cartoon which he is variously said to have completed in 'a few hours', 'twenty three hours' and 'thirty two hours': there cannot, in any case, have been more than a few days left before the closing date. Many of his friends and family saw in it evidence of his insanity, and tried to stop him from submitting it, though Frith recalled 'the only evidence of eccentricity being the inordinate length of the dragon's tail, which one of the papers said was as long as O'Connell's (O'Connell had an enormous Irish

following, which was called his *tail* by the profane).'[44] In a contemporary review by Henry G. Clarke, there are (mainly scathing) comments on over 100 of the 140 entries, but Dadd's was not found to be of sufficient merit or demerit to be worth remarking on[45]. The *Times* for 6 September, however, after news of the murder had broken, showed more interest: 'It has been stated that the cartoon No. 14, representing "St. George after the death of the Dragon", was the composition of the unfortunate man who is supposed to have murdered his father in Cobham-park on the 28th ult. The statement is perfectly correct . . . It is of course little more than outline, and bears marks of haste in other respects, the composition being generally considered exaggerated. The chief figure, however, that of a female, who is represented leaning on the shoulder of St. George, is finely drawn. One of the unfortunate young man's sisters stood for this figure at his own earnest request. The motto chosen for the drawing is the word "Industria", probably in allusion to the short space of time occupied in its completion . . .' In fact, Dadd's entry seems to have boosted attendances during the last few days of the exhibition to a gratifying degree in terms of admission money, though with unforeseen consequences for the art world: '. . . the excitement in Westminster Hall upon youthful minds and arduous temperaments has had a severe morbid effect upon several of the other candidates, who have been consequently obliged to submit themselves to medical treatment'.[46]

90 Study of a Nude Boy 1843
Pencil, 12¼ × 7⅛ in, 31.1 × 18.1 cm
The Trustees of the British Museum
This is a study for the boy wearing a coral cap in the foreground of 'Caravan Halted by the Sea Shore' (No. 91).

91 Caravan Halted by the Sea Shore 1843
Oil on canvas, 35½ × 59½ in, 90.2 × 151.1 cm
Inscr. on rock, bottom right: 'Rich^d Dadd 1843'
Exh: Liverpool Academy, 1843 (358)
Art Treasures of the United Kingdom, Manchester 1857 (603)
Prov: Richard G. Reeves in 1857. Archduke Franz Ferdinand of Austria; sold in Vienna after his death. Sotheby's 9 December 1964 (133).
Miss V. R. Levine (repr. on p.80)
This picture was exhibited at Liverpool as 'Group of Water Carriers, Men and Camels, at a Spring on the Sea Shore at Fortuna, near Mount Carmel, Syria'; and at Manchester as 'The Water Carriers'. Dadd passed through Fortuna (Dor) with Sir Thomas Phillips sometime between 13 and 20 November 1842. No sketches used in this painting can be positively identified in the V. & A. sketchbook, but a study for the naked boy is in the British Museum (No. 90).
This is the only traced work to have been painted by Dadd between his arrival home from the Middle East and the murder of his father, a time when his illness was producing increasingly obvious symptoms of insanity in his daily life. It is cited by the *Art Union* for October 1843 as one of several paintings from this period being, 'strange to say . . . as admirable in design and execution as his earlier works . . . a work of rare and

singular merit'.[16] There is little in the meticulously arranged composition to indicate that Dadd himself was experiencing any loss of mental control, and its most striking characteristic is the pervasive air of calm. His rather different on-the-spot reaction to such a scene is recorded in a letter to Frith: 'The water-carriers (women) are very capital subjects for the brush; and they rush along with great celerity under pitchers of water of no small size, carrying the same upon the head on little pads made for the purpose. Their dress is a loose blue shirt with wide sleeves . . . You would, my dear Powell, indeed you would, have become perfectly rabid at the sight of their groups round the wells on the seashore, with, perhaps, a string of camels grunting and growling, the whole recommended to you by the overture of the sea roaring in . . . and covering the golden beach, which glitters dazzlingly bright, with long lines of whitish foam . . . At times the excitement of these scenes has been enough to turn the brain of an ordinary weak-minded person like myself . . .'.[47] The restful feeling, emphasised by the gentle lines, static grouping and soft colours, is very different from the bustle and stir of 'The Flight out of Egypt' (No. 104), in which the water-carriers are used again in a scene which is probably closer in spirit to the one described in the letter. The main group is arranged in a shallow pyramid, a design favoured elsewhere by Dadd as a means of occupying horizontal space, and creates a static frieze-like pattern. It also forms a crescent shape in plan, which follows the line of the shore and carries the whole composition through in a gentle curve from the two men seated apart in the foreground, to a far-off clump of trees on the right. The impression of empty space is enhanced by the low horizon viewed from a vantage point somewhere near ground level, causing the group to stand out against the wide expanse of bare sky with the impact of a set of cut-out figures. The glimpse of skyline beneath the camel's belly increases this effect. As always the setting is very precisely defined, seen from just offshore with the main area of interest enclosed between sea and mountains. Though the composition is highly contrived, the figures have obviously been taken from sketchbook studies. The rather unusual low-key colours, coral, soft blues and greens, and sandy browns and yellows, are found in a number of Dadd's works, and are used again in almost the same combination in 'Saul and David' (No. 123) eleven years later.

***92 Artists' Halt in the Desert** ?1843
Watercolour
Exh: *Art Treasures of the United Kingdom*, Manchester 1857 (283)
Prov: T. Birchall in 1857.
Whereabouts unknown
This picture is described in *A Handbook to the Watercolours . . . in the Art Treasures Exhibition*. It is not certain whether it dates from before or after Dadd's admission to Bethlem: it was one of three watercolours from the collection of T. Birchall to be exhibited at Manchester, and was said to be one of three works constituting 'the sole remaining record of impressions made by that eastern journey . . .'[48] which is not true, but suggests that the author did not know any of the Bethlem drawings. It is described as 'a most impressive

90

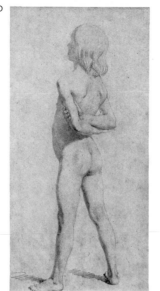

*97

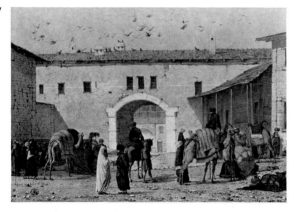

101

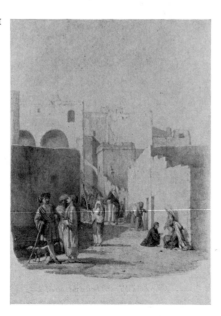

''moonlight halt''' and as having 'all the solemnity which the blue sky, and broad pale moon, and twinkling white stars are calculated to impress on an excited brain, calming its horror and lulling its rage to sleep.' It could have represented an episode on the excursion to the Dead Sea (*see* p. 20), when the party bivouacked for two hours after sunset and then crossed the wilderness of Engaddi by moonlight.

***93 Vale of Rocks** ?1843
Watercolour
Exh: *Art Treasures of the United Kingdom,*
Manchester 1857 (281)
Prov: T. Birchall in 1857.
Whereabouts unknown

This picture is mentioned in the handbook to the watercolours in the Manchester Art Treasures exhibition (*see* No. 92) as well as in the catalogue, but it is not described. Two of the three watercolours exhibited are said to have been records 'of impressions made by [the] eastern journey', but although 'Vale of Rocks' is not mentioned as such, this might be only because it did not contain figures and so was not identifiable with a specific episode as were the others.

***94 Dead Camel** ?1843
Watercolour
Exh: *Art Treasures of the United Kingdom,*
Manchester 1857 (282)
Prov: T. Birchall in 1857.
Whereabouts unknown

This picture was referred to in the *Handbook to the Water Colours . . . in the Art Treasures Exhibition* as 'full of gloomy madness',[49] and seems to be the work also mentioned in the *Handbook to the Gallery of British Painting . . .* as 'a ghastly little invention of desert-horror, framed in by demons such as his distempered brain alone could devise'.[48] It is known only from these two sources.

***95 Eastern Scene** ?1843
Watercolour
Whereabouts unknown

This is recorded by Bryan as 'Eastern Scene, Rocky Landscape'.[50] It could be 'The Island of Rhodes' (No. 100) which, without the evidence of the 1870 sale catalogue, would be presumed to have been painted during or straight after Dadd's journey of 1842–3.

***96 Portrait of Sir Thomas Phillips in a Monk's Cowl** 1843
?Watercolour
Whereabouts unknown

In *The World* 26 December 1877 there is an account of some of Dadd's strange behaviour after his return from the Middle East, amidst which 'A portrait of Sir Thomas Phillips in monk's cowl, and with strange owl-like eyes, was shown as the devil who could take any shape he pleased . . .'.[26] The parts of this article dealing with Dadd's early life are often very fanciful, and it is just possible that the portrait referred to merely showed Sir Thomas in his arab costume (*see* No. 84), if it existed at all: Dadd may, however, have alluded to it himself as portraying the devil.

***97 Caravanserai at Mylasa** 1845
Oil on panel, 8⅜ × 12 in, 21.2 × 30.5 cm
Inscr. bottom left: 'Caravanserai at Mylasa in
Asia Minor|RD [in monogram]|1845 Bethlehem
Hospital'
Exh: *Fine Art and Industrial Exhibition*, Hudders-
field 1883. Virginia Museum of Fine Arts,
Richmond, Virginia, 1963. Royal Academy,
Winter 1964–5 (119). Yale, April–June 1965
Prov: R. Rawlinson in 1883. Mrs Arthur Clifton
to 1961. Agnew.
Mr and Mrs Paul Mellon, Upperville, Virginia
(not exhibited)

This picture was exhibited at Huddersfield as 'Eastern
Inn Yard'. It has an inscription on verso: 'Memoran-
dum that I hereby declare that it is my personal know-
ledge that the picture of Mylasa in Asia Minor was
painted by Richard Dadd a prisoner in Bethlehem
Hospital. Cr. Smith, October 19th 1847 Caravanserei
Mylasa in Caria'. It has not been possible to trace any-
one associated with Bethlem who might have written
this, and the use of the word 'prisoner' rather than
'patient' suggests an outsider.

Dadd was at Mylasa with Sir Thomas Phillips in the
first week in October 1842. There is a different view of
the caravanserai on f. 125 of the sketchbook in the
Victoria and Albert Museum (No. 73), but this scene
must have been taken from the book which he had
with him at Bethlem. Painted within a year of his
admission to the hospital, it is the earliest known work
from the period after he had been acknowledged com-
pletely insane. On this account it is remarkable for
being one of the most naturalistic of all his paintings;
more so for example, than the 'Caravan Halted by the
Sea Shore' (No. 91) of two years earlier, and far more
than the hectic 'Flight out of Egypt' (No. 104) of a few
years later. The figures, however, are very static, partly
due to their all being shown in full profile, or full front
or back view, and there is already one indication of a
highly artificial feature which Dadd was often to use
elsewhere, almost, it sometimes seems, as a game. This
is the deliberate superimposing of one image directly
on another: here it is seen in the heads of the two
camels on the righthand side. It is interesting to note
that he dated his work with the name of the hospital
right from the start; whether as a gesture of defiance,
or because he knew that it would add to its interest, or
for some other reason, is not known.

***98 Avenue of Box Trees** 1845
Watercolour
Whereabouts unknown

This is described in the *Art Union* for May 1845 by a
visitor to Bethlem as 'an avenue of close box-trees,
terminated by the tall gate of a mansion. It is a marvel-
lous production – such as scarcely any of our living
painters could surpass.'[51] Though the trees are de-
scribed as box, it is possible that the subject is related in
some way to the magnificent avenue of lime trees at
Cobham Park which Dadd knew so well.

***99 A Castle Shattered by Lightning** 1845
Watercolour
Whereabouts unknown

This picture is described in the *Art Union* of May 1845

by a visitor to Bethlem: 'Two or three of his produc-
tions indicate the state of his mind. One describes a
castle shattered by lightning: underneath is written
"The wrath of God".'[51]

100 View in the Island of Rhodes ?1845
Watercolour, 9⅝ × 14⅞ in, 24.5 × 37.4 cm
Inscr. on verso: 'Vieuw [*sic*] in the Island of
Rhodes.|near the site of a castle of the Knights of
St John.|a part of which still remains in ruins.'
Prov: Sir Charles Hood to 1870. Christie's 28
March 1870 (310), bought by Vokins.
Victoria and Albert Museum (repr. on p.80)

Although undated, this picture is known to have been
painted in Bethlem Hospital because of its provenance
in the collection of Sir Charles Hood, and it appears in
the catalogue of his sale among the watercolours
painted between 1845 and 1856. It seems likely to have
been among the pictures which Dadd was working up
from his sketchbook in 1845, and which were described
by a visitor as being 'absolutely wonderful in delicate
finish'.[51] It is in any case likely to be an early work,
dating from before the beginning of the 'Passions' and
other figure compositions. If so, it provides evidence of
at least one style which Dadd used continuously all his
life, for he was still working towards the end in this
combination of washes, and very fine drawing and
stippling with the point of the brush, for watercolour
landscapes. It is one of the finest examples of all his
landscape work, though it has faded somewhat and
originally all the yellowish tone of the grass was prob-
ably nearer to the areas of brighter green which still
remain. During their travelling in 1842, Dadd and
Phillips were obliged to spend four days on Rhodes,
21–25 October, waiting for the steamer to take them to
Beirut; and Dadd must have had a rare opportunity for
detailed sketching and for absorbing the scenes into his
memory.

101 Bethlehem ?1845
Watercolour, 7½ × 5⅝ in, 19 × 14.2 cm
Inscr. across the bottom: 'At Bethlehem near the
Greek Convent of the Nativity of Christ.'
Prov: J. & W. Vokins, dealers. E. J. Gibbons,
given to him by his father in 1898. Sotheby's
10 March 1965 (4). John Rickett.
Private collection

Dadd visited Bethlehem on 22 November 1842 with Sir
Thomas Phillips and a party of officers from the
Vernon, *Beacon* and *Hecate* (*see* p. 20), in the course of a
hectic two-day round tour from Jerusalem, via Jericho
and the Wilderness of Engaddi. There could scarcely
have been much time even for sketching, and it is
likely that this watercolour, with its very fine and
delicate detail, was worked up later, probably in
Bethlem Hospital. The street scene, deceptively simple
at first glance, is composed as usual with great care. The
arrangement of the figures along the right-hand side of
the street, parallels a diagonal line which is made by the
tops of walls and other features: the central figure on
horseback forms the apex of a triangle, which is com-
pleted by the opposing diagonal of figures and shadows
on the left. One of Dadd's favourite devices, of exactly
repeating the same line throughout the smaller details,
can be seen here, for example, in the leg of the man on

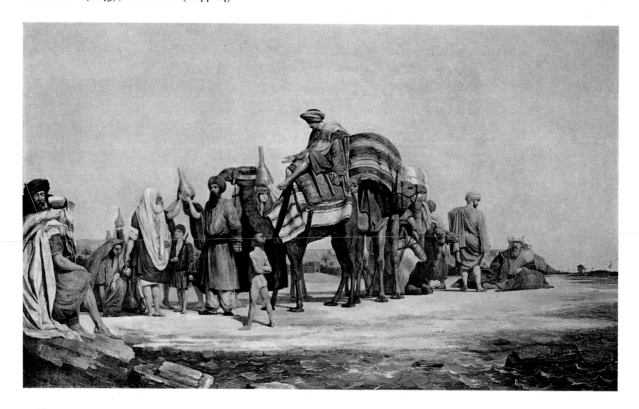

91 Entry on p. 77

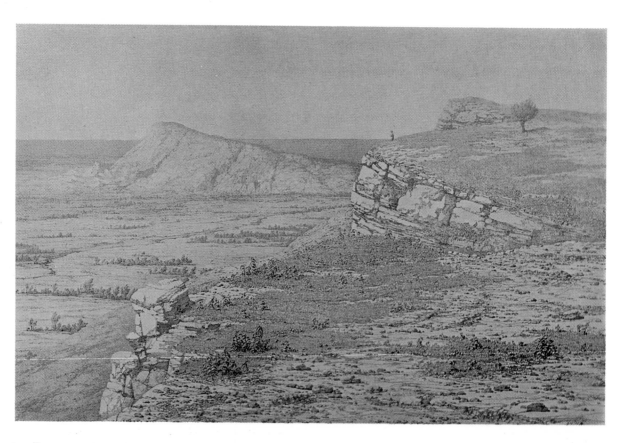

100 Entry on p. 79

102

the extreme left, a pole supporting a roof near the centre, the lance of the man on horseback, the leg and arm of the hooded figure, and the flowing headdress of the seated man on the right. The soft golden browns also echo and reflect each other across the picture.

102 The Fish Market by the Sea [?c.1849]
Oil on canvas, 39½ × 49½ in, 100.4 × 125.7 cm
Inscr. bottom left: 'Richard Dadd| . . .' (part of inscription concealed by the frame)
Prov: Ian Robertson in the 1930s.
Mr and Mrs Paul Mellon, Upperville, Virginia

The subject is the fisherfolk of Newhaven, a village near Edinburgh, made famous through the calotype studies of them by D.O. Hill and Robert Adamson in 1845. It is not known whether Dadd ever visited Newhaven himself, though a 'Mr. Dadd', probably his father, did so with David Roberts in 1841 (*see* p.12).[52] If not, the most likely source for this picture would be the calotypes themselves, though they would have to have been brought or sent to him in Bethlem, since they were not made until after his admission. This is one of his largest known pictures, 'The Flight out of Egypt', of about the same date, being exactly the same size but a complete contrast in design. Here Dadd looks back to the type of composition used in 'Caravan Halted by the Sea Shore', with a static and artificially posed group standing out sharply against the sky. He may have known Joshua Cristall's 'The Fish Market, Hastings', which also shows a (far more busy) scene on the open sea shore after the arrival of the fishing boats; and also Dutch fish market scenes such as de Witte's 'Adriana van Heusden and her Daughter, at the New Fish Market in Amsterdam', and remembered them when painting both this and the next picture.

103 Fish Wives 1849
Oil on canvas, 23¾ × 19⅜ in, 60.4 × 49.2 cm
Inscr. bottom left: 'Richard Dadd 1849'
Mr and Mrs Allen Staley

This picture is obviously related in subject to 'The Fish Market by the Sea' (No. 102) and probably shows the fisherwomen of Newhaven selling the catch in the streets of Edinburgh, where they walked with the heavy baskets strapped to their backs. Dadd could have seen this for himself if it were he, and not his father, who accompanied David Roberts to Scotland in 1841 (*see* No. 102);[52] but at any rate he would probably have heard it described by either his father or Roberts. If it is painted from memory or from one of his own sketches, then this picture must have been in circulation outside the hospital within a few years of its completion, and have been known to the designer of a prattware pot-lid which shows an identical scene: but it is possible that both are taken from a third source, such as an engraving; or that Dadd took his idea from the pot-lid.

David Hill, Newhaven fisherwomen (calotype) 1845
National Portrait Gallery

Prattware pot-lid

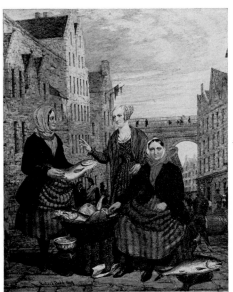

103

104 The Flight out of Egypt 1849–50

Oil on canvas, 39½ × 49¾ in, 100.3 × 126.4 cm
Inscr. in cartouche bottom centre: 'Richard
Dadd|1849–50'
Prov: Sacheverell Sitwell c.1930, bought from
the Army and Navy Stores. The Leicester
Galleries in 1947.
Tate Gallery, bought from the Leicester
Galleries 1947

This painting was found in the picture frame depart-
ment of the Army and Navy Stores, where it might
have been for any length of time since the stores were
opened in the 1870s. So far as is known Dadd gave it
no title, and the present one is obviously not the whole
answer, if any part of it. There seem to be a number of
irreconcilable activities going on in different areas,
linked only through the design. In the bottom right-
hand corner is a very ambiguous reference to a Holy
Family group which seems to include both the baby
and the older child Jesus, the latter identified only
through association with the glowing star on the shield
behind his head (*see also* 'Mother and Child', No. 178):
while in front of them sits a youth with his legs drawn
up in the pose of Michaelangelo's 'Doni Madonna'. Just
to the right of the centre, a soldier raises his hand in
the exact gesture of the elder Horatius from David's
'Oath of the Horatii', and there are probably other such
(apparently) arbitrary visual allusions to famous works.
In the foreground the boy butted by a goat has more
recent antecedents, and seems to derive from the fairy
soldier attacked by a snail in Huskisson's 'There Sleeps
Titania' (No. 250), which Dadd could have seen en-
graved in the *Art Journal*; though possibly both might
be taken from some common source. Much of the
activity seems to come from various different parts of
Dadd's Middle East journey: the mounted arabs who
are causing so little concern on the left, recall the war-
like group whom his party had encountered near
Jericho (*see* p. 20): the remainder of the scene could be
based on recollections of an encampment at the
beginning of the Hadj, the annual pilgrimage to Mecca,
which was setting out just after Dadd left Damascus;
or of a complete village returning from its summer
quarters in the hills to winter in the plains, a scene
which he described from Asia Minor and probably
also saw in Syria (which seems to be the setting here).
Despite the apparent confusion the design is very care-
fully worked out. On the left a group forms a circle
round the two women and the boy in blue. On the
right the figures are massed along the side of a stream
which sweeps round the outer edge of the circular
group, and are also linked into it by the soldiers who
span the two groups, to form a wide ellipse. Many
other patterns and shapes are interlocked across the
surface, which is far more crowded than anything
which Dadd seems to have attempted before, and un-
like anything else which he is known to have painted in
Bethlem. The composition is surprisingly similar in
many ways to Maclise's late work, particularly the
frescoes 'The Meeting of Wellington and Blucher',
and 'The Death of Nelson': surprisingly, because work
had not yet begun on these huge and swarming pro-
ductions, and Dadd's anticipation of their layout can
only be coincidence, stemming from the fact that his
ideas on design were at times almost uncannily closely

aligned to those of Maclise. The composition is quite
unusual altogether for Dadd, who generally prefers to
group his figures in a shallow space to make a flat, frieze-
like design. However there is a compromise here, and the
spatial arrangement of some of the foreground figures
has been flattened in varying degrees, and quite in-
dependently of the rest of the picture, to produce some
very curious relationships between individuals. The
most striking example is the woman on the left with
her hands on the shoulders of the boy in blue. Although
her feet must be well in front of the palm tree, her
head is behind the trumpeting soldiers, who stand
behind the tree. On this side there seems to be a great
deal more space at ground level than in the air, which
might also account for the shortage of horses among
the mounted group even though there appear to be
nearly enough legs to go round. On the right-hand side
there exists another ill-defined relationship; between
the arab flourishing a scimitar, and just about every-
body else in the immediate vicinity. It would be use-
less to speculate on the purpose of his gesture, as on so
much else in the narrative context of the picture. The
roman soldiers in particular seem to have strayed in
from another world altogether, which may be why
they are being so studiously ignored, though it might
seem hard to ignore the vivid scarlet of their cloaks. Their
wholly incongruous presence, the strange ridged veins
on their forearms, the heavy emphasis on the central
figure and the almost surrealist obscuring of his face
with a drinking vessel, the insistent placing of the palm
tree itself in the exact centre of the composition, all
these features seem explicable only in terms of some
private obsession. This is undoubtedly the most in-
consequential of Dadd's surviving paintings, and is
probably of the type seen by a visitor in 1848, who
described him as painting 'with all the poetry of
imagination and the frenzy of insanity – in parts
eminently beautiful, but other parts, in madness, with-
out method'.[53] This is not quite a fair assessment, since
there is obviously a great deal of method; but it is
doubtful whether even a full explanation by Dadd him-
self would have made it wholly accessible to us. The
beauty lies in many individual passages of painting,
particularly in some of the robes in the left hand half
of the picture, and in the stream and rocky foreground;
and in the pure vibrant colouring, the quieter harmony
of the more brown-toned fabrics on the right and the
desert wastes behind, and the extraordinary but con-
vincing sea green of the sky.

Jacques Louis David, 'The Oath of the Horatii', 1784
Musée du Louvre, Paris

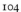

*105 **Dymphna Martyr** 1851

 Watercolour, 14¼ × 10¼ in, 36.2 × 26.0 cm
 Inscr. bottom left: 'Dymphna Martyr'; bottom
 right: 'Rich^d Dadd 1851'
 Exh: *The Victorian Romantics*, Leicester Galleries
 1949 (37)
 Prov: Gilbert Davis to 1959.
 Henry E. Huntington Library and Art Gallery,
 San Marino, California (not exhibited)

St Dymphna, patroness of the insane, was the daughter
of an Irish pagan king and Christian mother. Her
father wishing to marry her after his wife's death, she
fled with her chaplain Gerebernus to Gheel in Belgium
where the king caught up with them, had Gerebernus
killed, and himself beheaded his daughter. Their relics
were rediscovered in the thirteenth century, and in-
vocation to St Dymphna was 'found to be efficacious
in cases of insanity.' Gheel rapidly became a centre for
pilgrimage with a convent and hospital, and to this day
a unique colony exists there for care of the mentally
disturbed.[54] It is not known where Dadd would have
got hold of the story, but he might have become
acquainted with it while passing through Belgium with
Sir Thomas Phillips in 1842: it would now have
obvious attractions for him.

The picture is a strange amalgam of seemingly in-
congruous components. The subject, and elements in its
treatment, may have been suggested by memories of
Titian's 'Peter Martyr' which Dadd had copied in

105*

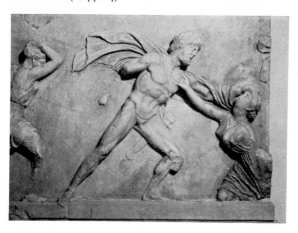

Greek and Amazon, from the frieze of the Mausoleum,
c. 350 B.C.
The British Museum

Venice (*see* No. 74). The figures in the background, and
most of the background itself, look as if they have been
inspired by Dürer engravings, but the figure second
from the left stands in a pose derived from Michael-
angelo's 'Dying Captive', while the pose and grouping of
the two chief protagonists are taken almost direct from
the Greeks and Amazons frieze of the Mausoleum which
Dadd had admired and sketched at Bodrum (*see* No.
80). This is the earliest known watercolour figure com-
position from Bethlem, and is somewhat uncharac-
teristic in style: but there may have been others like it
which have not survived. The writing of the inscription
seems intended to imitate medieval script.

106 The Death of Richard II 1852
Watercolour, $14\frac{1}{2} \times 10\frac{1}{2}$in, 36.8×27.3cm
Inscr. bottom right: 'Sketch of the Death of
Richard 2^{nd} in Pomfret Castle.|—1852—
by. Richard Dadd. Bethlehem Hospital.'
Prov: Mrs Robert Frank in 1970.
Private collection

106

The scene is taken from the last act of Shakespeare's
Richard II and shows Richard set upon by Exton and
armed servants. Having killed one servant, the King is
about to kill another before being finally struck down
by Exton. As with so many of the dramatic 'sketches'
it is played out at the front of a shallow area, and the
heavy open door on the left brings the action forward
in the manner of a piece of stage scenery. This is one of
Dadd's most actively violent pictures, the taut oppos-
ing diagonals of the triangle-based composition creating
an air of great energy and tension. The obsessionally
placed central figure with raised axe is reminiscent of
the soldier drinking at the centre of 'The Flight out of
Egypt', though here he forms a pivotal point for the
whole composition. The ruff-like folds into which the
tunics are gathered may also contain an element of
obsessionalism in view of Dadd's preoccupation with
the device elsewhere, though here it is reasonable in
simple terms of costume. His fondness for spurs is
also seen in other works, and as the King would be
unlikely to have been wearing spurs in prison, their
inclusion here may owe something to this private en-
thusiasm. In the priapic angle of the sword there may
be a piece of rare (for Dadd) sexual symbolism. The
clear colours, yellow and buff, blue, lilac, and scarlet,
are all within Dadd's normal range, though they are
combined here to produce a brighter than usual effect.
The quantity of scarlet is quite rare, and provides
another link with 'The Flight out of Egypt'.

**107 Polyphemus Discovered Asleep by the
Shepherds of Sicily** 1852
Watercolour, 10×14in, 25.5×35.5cm
Inscr. bottom right: 'Sketch of|Polyphemus|
discover'd asleep|by the Shepherds of|Sicily.
Richard Dadd.|—1852—'
Exh: *Victorian Art*, The Emily Lowe Gallery,
Hofstra University, 1972 (68)
Prov: N. G. Ley to 1970. Sotheby's
19 November 1970 (193).
Forbes Magazine Collection, New York

Polyphemus, a son of Poseidon, was one of the race of
one-eyed giants known as the Cyclopes who kept sheep
and goats on the island of Sicily. In the *Odyssey* he is

107

represented as a bloodthirsty monster, who captured
Odysseus and some of his companions with intent to
devour them a few at a time. Odysseus intoxicated him,
and while he slept, put out his eye with a sharpened
stake or a firebrand. Polyphemus also appears in Sicilian
legend as something of a figure of fun, the unsuccessful
rival to the shepherd Acis for the love of Galatea, and
in this role he features in the idylls of Theocritus.
Dadd's gentle pastoral comes closest to the Theocritan
image, and this deliberate choice against a ready-made
scene of gruesome horror, makes an interesting com-
parison with the scenes of violence which he was also
painting at this time.

108 Robin Hood 1852
 Watercolour, 13⅝ × 9¾ in, 34.6 × 24.8 cm
 Inscr. top right: 'Sketch of Robin Hood. R^d
 Dadd.|1852.'
 Exh: Isaacson Gallery, New York, 1961–2
 Mr and Mrs Paul Mellon, Upperville, Virginia
Numerous ballads commemorate the life and adven-
tures of Robin Hood, and there is no indication as to
which story Dadd is illustrating here: but he is known
to have been acquainted with 'The Ballad of Robin
Hood and Guy of Gisborne', published in the same
volume of S. C. Hall's *Book of British Ballads* for which
he had illustrated 'Robin Goodfellow' (No. 69). Even if
this did not directly inspire the picture, the memory of it
probably suggested the subject. Unless the scene is the
shooting match between Robin and Guy, the second
character seems most likely to be Little John, who
appears in this ballad as well as in many others. 'The
Death and Burial of Robin Hood' is also in the Hall
collection, but there is no episode in it which could be
associated with this scene. In Robin, we see the first
use of a favourite pose which Dadd employed many
times, e.g. for Abishai in 'Saul and David' (No. 123),
for Oberon in 'Oberon and Titania' (No. 172), for
Othello in 'Jealousy' (No. 113). Throughout his work
there can be seen repetitions of the same poses and
small gestures, a reminder that in his isolation Dadd
had to hoard every scrap of visual material that he
could get hold of. The cascading water of the stream
on the left is also a feature which he painted several
times, first of all in 'The Flight out of Egypt' (No. 104),
and later in 'Negation' (No. 179).

109 Jesus Christ Walking on the Sea 1852
 Watercolour, 10¼ × 14⅛ in, 26.1 × 35.9 cm
 Inscr. bottom left: 'Sketch of Jesus Christ|
 Walking on the Sea. by. Richard Dadd. 1852.'
 Victoria and Albert Museum
This picture is one of a group of the earliest (surviving)
watercolours from Bethlem, in which Dadd illustrates
stories from various sources. It is not known how far
his convictions about Egyptian mythology would have
affected his more conventional religious beliefs, and
impossible to guess from looking at the subjects, such
as this, which have a Christian iconography. Much of
the picture's very delicate tonality is due to fading, and
traces of the original blue of sky and sea can be seen at the
edges where an earlier mount has protected them. This
must have caused some shift of emphasis in the design,
though the intention is still clear, and the pink and blue
robed figures probably stand out more sharply than

108

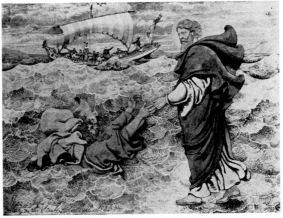

109

before against the textured surface of the near mono-chrome grey sea. By placing them in the trough of a wave, Dadd has provided his favourite compositional device of a natural barrier to isolate the main figures from the distant landscape, indicating their exact place within a very small range. The scene has much in common with his many sea pieces, particularly in the viewpoint, looking directly towards a distant shoreline, and in the attention which has been lavished on the exotic boat. A very similar vessel can be found on f. 156 of the sketchbook in the Victoria and Albert Museum (No. 73), even to the hooded figure standing in the stern, and probably Dadd had another drawing of it in the book which he had with him in Bethlem.

110

110 A Hermit 1853
Watercolour, $14\frac{1}{8} \times 10\frac{1}{8}$ in, 35.9 × 25.4 cm
Inscr. top left: 'Sketch of.|a Hermit—by|
Richard Dadd—|Bethlem Hospital|1853.'
Prov: S. E. Lucas to 1961, Christie's 17 March
1961 (25) bought by Maas Gallery.
*Trustees of the Cecil Higgins Art Gallery,
Bedford*, bought 1961

Though lacking the immediate dramatic impact and psychological tensions of the 'Passions' and some other of the more action-packed watercolours, this scene is characterised by a strong and carefully built up sense of atmosphere. The figure of the hermit reclines in peaceful harmony with his environment, his body gently embraced by the rocks. The broad thick folds of his robe echo the solid shapes and rough textures around him, and the darker golden brown harmonises with the ochre background. His oblique pose forms a triangular shape, completed by the boulder against which he is leaning, which reflects and fits into the angled niche behind his head, identifying him still more closely with his surroundings. The softness of line and colour, the relaxed pose and distant expression, the unspecified setting, all contribute to a sense of timelessness. In contrast, the hard-edged precision of hour-glass, crucifix and skull bring a sharp reminder of the finity of earthly life, in an atmosphere of eternity. At the foot of the cross a few fresh flowers add the only touch of living colour, and they too will soon die and turn to brown. The mood of this picture is similar to that of 'Melancholy' (No. 130), of 1854: and there is obviously no chronological progression, in either direction, between such gentle tranquil studies and the scenes of violence and aggression which Dadd painted both before and after it.

111 The Ballad Monger 1853 (repr. on p.89)
Watercolour, $10\frac{1}{16} \times 14\frac{1}{16}$ in, 25.5 × 35.7 cm
Inscr. bottom right: 'The Ballad Monger.
A Reminiscence|Sketch by Richard Dadd 1853.
Bethlem Hospital'
Exh: Tokyo Institute of Art Research 1929.
Romantic Art in Britain, Philadelphia Museum of
Art 1968 (202)
Trustees of the British Museum, Bequeathed by
Sir Edward Marsh through the National Art
Collection Fund, 1953

As with all the 'reminiscences' this picture seems to draw for its subject on a real remembrance of things seen. The colourful world of ballads and ballad sellers

appealed to Dadd's imagination, an interest shown elsewhere in his illustration of ballad subjects (Nos. 108, 134, 151), and many of the ballad sheets shown here, e.g. 'Jim Crow', 'Lovely Nan', 'Judy Calaghan', 'The Honest Snob', 'Go it ye Cripples', would have been well known to him as a boy[55]. They may be presumed to be all genuine, and there is probably nothing sinister in his selection of titles, though 'The Assassin' is obviously open to suspicion. The two boys nearly always appear in scenes associated with his childhood, and may be intended for younger brothers or perhaps for Dadd himself and a companion: the right-hand figure of this pair is used, in an identical pose, in 'Polly of Portsmouth' (No. 134). The simple scene of street life is designed as carefully as usual, but where diagonal lines and a strong central figure are often used in the watercolours to create tension and violence, they are used here in a flat frieze-like composition for more peaceful ends. The would-be buyer, though centrally placed at the apex of a shallow triangle, shares the main role with the sleeping ballad seller whom he is about to wake; the action – or perhaps it should be called the inaction – passing back and forth between them in a diagonal interplay. On the right-hand side the small boy's full back view, uncompromisingly solid, offers a minor contrast to the zig-zag exchanges of the main group. This is one of the finest examples of Dadd's broader watercolour style, with its delicately controlled washes and sharply observed drawing. There is a slightly disturbing element in the central figure, which comes partly from the inexplicable way he balances on a piece of turned wood; but also, perhaps, from the fact that his pose is taken from the Adam of Michelangelo's 'Creation', reversed and stood on end.

112 Portrait of a Young Man ?Dr Charles Hood
1853 (repr. on p.89)
Oil on canvas, 24 × 20 in, 60.9 × 50.7 cm
Inscr. left-hand side, on edge of seat:
'Richard Dadd.|1853.'
Exh: *Victorian Pictures*, Birmingham 1937;
Victorian Romantics, Leicester Galleries 1949 (64)
Private collection

The sitter has not been identified, but because of Dadd's circumstances the possibilities are few. Among the most likely are Dr Charles Hood and G. H. Haydon, the two young men whose sympathetic personalities were first felt in Bethlem Hospital in 1853 (*see* p. 30). Comparison with a known portrait of Hood (No. 252) shows considerable resemblance except in the colour of the hair, and in this highly idiosyncratic image, such a minor detail need not necessarily rule Hood out: moreover, Dadd is unlikely to have seen a great deal of him during his first extremely busy year. No portrait of Haydon has yet been found for comparison, and all other candidates are highly speculative. The garden setting is purely fanciful, the criminal patients' access to the outdoor world being confined to an exercise yard. The distant background is probably compiled from memory and from the sketchbook, and contains a feature which Dadd often included in imaginary landscapes, a castle on a hill top: the line of poplars is seen again in the 'Passions' sketch 'Love' (No. 114) of the same year. The design centres around a giant sunflower (*see also* 'Pope's House' No. 189), its huge leaves

providing the embossed texture which he so often explores. Here the texture is seen from both sides, and the underside shows clearly that his treatment of the sea's surface as a series of pits and hollows (as in the 'Pilot boat' and elsewhere), is closely related to this leaf pattern. The solid garden seat appears as dependable as the sitter, and around it clings another plant whose leaf form is often seen in Dadd's work, a crisp strong ivy. The foliage is sprinkled with dew drops, last seen in the early fairy paintings, and soon to reappear at their most profuse in 'Oberon and Titania'. One droplet runs across a leaf near the top of the picture, trailing a stream of fine pearls behind it, in one of those small feats of virtuoso painting which Dadd often tosses off almost casually. The handkerchief lying on the seat might have been recalled from an early still-life, e.g. No. 23, while the fez, besides adding a delicately restrained splash of vivid red to the predominant green and brown of the colouring, is associated with memories of the Middle Eastern journey on which he himself wore just such a piece of headgear. Against the rich and densely detailed background, the sitter's simple dignity is accentuated by the sombreness of his clothing: behind, the radiant sky seems to symbolise his own radiant calm. The pose is relaxed and tranquil, yet there is about the whole image that intensity which is so characteristic of Dadd's work. In this painting he shows himself perhaps closer to the Pre-Raphaelites than anywhere else. It invites comparison with the portrait of Ruskin by Millais,[56] also set in landscape and painted the same year; and with the work of Frederick Sandys, particularly his portrait of the Rev. James Bulwer.[57]

113 Sketch to Illustrate Jealousy 1853
Watercolour, 13¾ × 9½ in, 35.0 × 24.1 cm
Inscr. top left: 'Sketch to illustrate Jealousy.|
Othello. Shakespeare's Play—|Iago. Sweet
Desdemona Oh! cruel|Fate that gave thee to the
Moor—|by Richard Dadd. Bethlem Hospital.
London. 1853.'
Exh: M. Knoedler & Co., New York City, 1964
Prov: Mrs Robert Frank. Robert Isaacson.
Lincoln Kirstein.
*American Shakespeare Theatre, Stratford,
Connecticut*

So far as can be judged from the survivals, the series 'Sketch to Illustrate the Passions' was started in 1853, but Dadd did not begin to date them with the day and month until December so the earliest cannot be put into sequence with any certainty. Of the eight surviving from the first year three, 'Jealousy', 'Love' and 'Hatred' are scenes from Shakespeare, and although there are later examples which carry Shakespearian quotations, none of the others actually depicts any scene from a play. 'Jealousy' shows Act III scene 3 of *Othello*, in which Iago plays on Othello's already aroused jealousy with alleged evidence of Desdemona's unfaithfulness with Cassio, and 'Love' is the balcony scene from *Romeo and Juliet*, though neither of the quotations which appear in the titles is exact. Both are presented as straightforward illustrations of the action, though not as actual representations on stage.

In these two very similar interpretations, the word 'sketch' in the title can be taken to mean a scene from a

113

114

115

play, and the choice of play in both cases is a fairly obvious one, being entirely concerned with the theme which is being illustrated. Neither has been given the full title 'Sketch to Illustrate the Passions', though 'Love' is called 'Sketch for the Passions', suggesting that there was already some intention of making a series. In style and treatment they are similar to the Shakespearian subject of the previous year, 'The Death of Richard II', and the whole 'Passions' series may have begun, without much premeditation, as a development from this type of 'sketch'. It seems likely that the Shakespearian subjects were among the first to be produced, and that the others followed from them, keeping essentially to the same format. Nearly all the later examples, even where they take the form of contemporary genre scenes, are seen in theatrical terms, using a dramatic scene to illustrate the theme.

114 Sketch for the Passions. Love 1853
Watercolour, 14 × 10 in, 35.6 × 25.4 cm
Inscr. top right: 'Sketch for the Pas[sions]|
LOVE—Romeo & Juliet|Romeo—My life, my love,|my soul, adieu. Vide|Shakespeare's.
Play—|Richard Dadd|Bethlem Hospital. 1853'
Exh: M. Knoedler & Co., New York City, 1964
Prov: Sir Charles Hood to 1870. Christie's 28 March 1870 (329), bought by Pocock. Mrs Arthur Clifton to 1961. Lincoln Kirstein.
American Shakespeare Theatre, Stratford, Connecticut
See notes on 'Jealousy' (No. 113).

115 Sketch of the Passions. Hatred 1853
Watercolour, 12¼ × 10⅛ in, 31.1 × 25.7 cm
Inscr. top right: 'Sketch of the Passions—Hatred|Murder of Henry 6th by Richard Duke of Gloster|See how my sword weeps the poor king's death.|Vide Skakespeare's [*sic*] Play.|—Richard Dadd.—|1853'
Prov: Sir Charles Hood to 1870. Christie's 28 March 1870 (330), unsold. Given to Bethlem Hospital by Mrs Wormald in 1924.
Board of Governors of The Bethlem Royal Hospital and The Maudsley Hospital
This was one of the drawings which was not bought at Sir Charles Hood's sale in 1870 (*see* 'Brutality' No. 124). It is probably among the earliest of the 'Passions' sketches, dating from before the establishment of the full title 'Sketch to Illustrate the Passions', and shows the murder of Henry VI by Richard of Gloucester in the last act of *Henry VI* part 3. Some details in the composition, Gloucester's left arm, and the body of the king, are taken from figures in the painted frame of Huskisson's 'There Sleeps Titania' which Dadd must have seen engraved in the *Art Journal* of 1848 (*see* No. 250). The angle of the sword, pointing threateningly out of the picture, is reminiscent of the knife in the early 'Still Life' (No. 22), painted in 1838 long before anyone could have interpreted its prophetic quality. The two characters are wearing the traditional stage costumes of the period for these roles, but there the unreality ends, and this clearly represents a scene very like the killing in which Dadd himself had been involved, and with which he still closely identifies. The Duke is almost certainly a physical self-portrait, whether intentional or

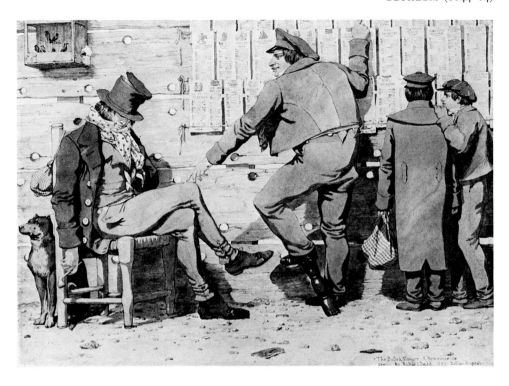

111 Entry on p. 86

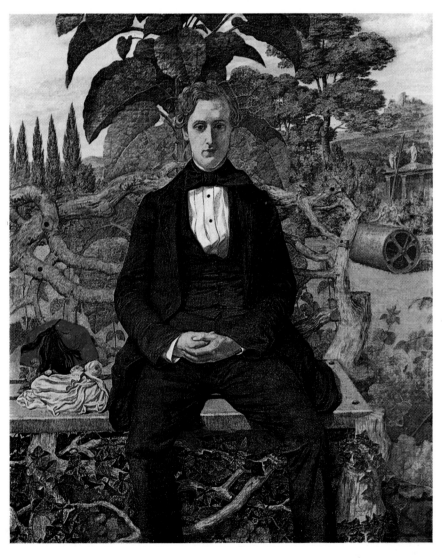

112 Entry on p. 87

not, and certainly a psychological self-portrait: and it is more than coincidence that his name should be Richard. The tremendous ferocity with which this picture is charged is heightened by the purity and control of the drawing, the delicate modulations of colour, and the spine-chilling choice of blues and mauves. Everything is deliberate and calculated, with no more hint of sudden impulsive violence in the action, than in the depiction of it. It is one of Dadd's most frightening pictures, and leaves the feeling that it could only have been conceived by someone who had experienced, and could still experience, the emotion which it portrays. To find him at work on it, knowing his history, must have been one of the most unnerving sights faced by the staff of Bethlem Hospital.

116

116 Sketch for Poverty 1853

Watercolour, $13\frac{1}{2} \times 10$ in, 34.9×25.3 cm
Inscr. bottom left: 'Sketch for Poverty by|
RICHARD. DADD. 1853—|Bethlem Hospital.
London.'
Prov: Sir Charles Hood to 1870. Christie's 28
March 1870 (330*), bought by White.
Christie's 11 July 1972 (107), bought by Manning
Gallery.
Private collection

There is no certainty that this should be classed among the true 'Passions' sketches, though it was listed among them as a late addition at the sale of Sir Charles Hood's pictures in 1870. It was then called 'Blind Fiddler', no doubt through association with Wilkie's famous picture of that title. Although Dadd played the violin himself this seems to be the only time that he painted it, though many other musical instruments feature in his work. The old man resembles his father.

117 Sketch to Illustrate Splendour and Wealth 1853

Watercolour, 14×10 in, 35.6×25.4 cm
Inscr. in cartouche, bottom left: 'Sketch to
illustrate|Splendour & Wealth—subject|
Cleopatra dissolving a pearl—|a seed—Rich^d
Dadd Bethlem Hospital 1853'
Prov: Sir Charles Hood to 1870. Christie's 28
March 1870 (327), bought by Holl.
Newport Museum and Art Gallery

117

The picture illustrates a legend in which Cleopatra dissolved one of her pearl ear-drops in a cup of wine, which she then drank, in order to impress Mark Anthony with her riches. The incident is supposed to have taken place at a banquet given in his honour. The story is not in Shakespeare and it is not certain from which source Dadd would have taken it; but it was well known, and he probably also knew Reynolds's portrait of 'Kitty Fisher as Cleopatra Dissolving the Pearl' (in which the gesture of the hand with which she drops the pearl is, possibly by coincidence, identical with the one used here). The atmosphere of splendour and wealth is conveyed in the opulent folds of the drapery, the fruit laden dish and luxuriant urn of flowers, and in a greater variety and richness than usual in the colouring; though all the colours, yellow and gold, coral pink, blues, mauve and some green, are taken from Dadd's normal range. As with the 'Sketch for Poverty', with which this picture makes a contrast-

ing pair, there is no certainty that it comes truly within the series of 'Sketches to Illustrate the Passions'; but it is obviously closely related to them, and was classed among them at the sale of Sir Charles Hood's pictures in 1870.

118 Sketch to Illustrate the Passions. Treachery
1853
Watercolour, 14 × 9¾ in, 35.6 × 24.8 cm
Inscr. in cartouche, bottom left: 'Sketch to illustrate the Passions|Treachery. by Rich^d Dadd—Bethlem Hospital London. 1853.'
Exh: *English Drawings and Watercolours 1550–1850 in the Mellon Collection*, Pierpont Morgan Library, New York 1972, and Royal Academy 1973 (149)
Prov: Sir Charles Hood to 1870. Christie's 28 March 1870 (328), bought by Gladwell. Mrs Arthur Clifton to 1961. Durlacher Bros 1962.
Mr and Mrs Paul Mellon, Upperville, Virginia

118

Unless he intends just to create a generalised atmosphere of Chinese treachery, Dadd has not supplied much clue as to what is taking place in this picture, and in terms of narrative content it is as baffling as, for example, 'Insignificance' (No. 135). The setting too has much in common with 'Insignificance', with its large door, and uncompromisingly English brickwork and doorstep. A Chinese figure appears also in 'The Fairy Feller' (No. 190), and there is almost certainly another in 'The Flight out of Egypt' (No. 104), lurking behind the negro figure in the foreground group; but it is not clear whether they played any part in Dadd's delusional beliefs about persecution, or whether he simply used them as stock characters. Shortly before his admission to Bethlem the first war with China of 1839–42 had been fought, and 'incidents' were still continuously being reported in the papers, so it would not be surprising if he should have absorbed some anti-Chinese feelings; but here at least they seem to have been treated fairly lightheartedly.

119 Sketch to Illustrate the Passions. Idleness
1853
Watercolour on brown paper, 14⅜ × 10⅛ in, 36.5 × 25.7 cm
Inscr. top left: 'Sketch to illustrate the Passions| Idleness—Idleness is the Mother of Vice.|by Richard. Dadd. Bethlem Hospital London Dec^r 20^th 1853'
Prov: Sir Charles Hood to 1870. Christie's 28 March 1870 (325), bought by Holl.
Victoria and Albert Museum

119

This is another of the watercolours showing a familiar street scene, a family of idle layabouts lounging outside an inn. It is hard to believe that the hideous old woman who dominates the centre did not exist somewhere in real life, and she may be some well-known local character remembered from Dadd's childhood or youth. The basket which she holds is also vividly recalled, with its pieces of red, white and blue patchwork and trinket boxes adding a touch of bright colour to the muted pinkish browns and dull yellows. The picture is very carefully designed, but without appearing over-contrived or stiff. The legs of the boy seated on the ground, angled to echo the corner of the paper,

120

121

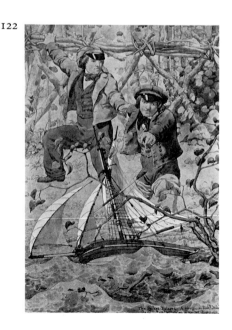

122

terminate the group abruptly in the bottom left-hand corner, while in the opposite corner the sickle's hook sweeps back and round to draw the composition together. The pose of the younger boy balances that of the man, their left legs nearly aligned, and the arc of his hand as it pursues a fly reflects in miniature the sickle curving towards the man's head. The visual harmony of the group is built up through careful repetitions; the diagonal of the lower boy's supporting arm is repeated in the woman's shoulder, the man's hat, his left trouser leg, the roof of the house, the smaller boy's right arm; the boy's hand on the ground reflects the man's foot, his own right foot opposes it; the curve of his right thigh is repeated in the curve of the woman's shawl, and so on.

The sign of the 'Jolly Beggars' hanging above their heads is a nice piece of irony, for there is nothing jolly about these people, whose idleness seems to be turning them sour rather than vicious. The precise significance of the full title is not clear, and the quoted proverb: 'Idleness is the Mother of Vice' remains at the level of a pertinent observation, rather than finding any definite expression in the picture. Vice is certainly a credible association to make with any of these unwholesome looking characters, but it is not actually made here. One or two of the other 'Passions' sketches, e.g. 'Vaulting Ambition' (No. 126), and 'Insignificance' (No. 135) have titles which seem to have explained themselves to Dadd's own satisfaction, but not quite to ours.

120 Sketch to Illustrate the Passions. Gaming
1853
Watercolour, 14⅜ × 10⅛ in, 36.7 × 25.7 cm
Inscr. bottom left: 'Sketch to illustrate the Passions|Gaming—by Richard Dadd—|Bethlem Hospital. London. 1853'.
Prov: Sir Charles Hood to 1870. Christie's 28 March 1870 (320), bought by White.
Visitors of the Ashmolean Museum, Oxford, presented by William King 1938

The subject, and to some extent the costume, suggest that Dadd may have been thinking of Dutch paintings such as De Hooch's 'The Card-Players', or the card-playing groups in some of Jan Steen's works. The colour is stronger and more varied than in many of the 'Passions' sketches, though all the colours are found in other works in different combinations, and the scene is brightly lit, too brightly, for a room which obviously has small leaded windows, but this gives scope for one of Dadd's most satisfying talents, that for rendering highlights on the smaller areas of white fabric, with bold crisp shadows.

121 Juvenile Members of the Yacht Club 1853
Watercolour, 14 × 10⅛ in, 35.6 × 25.7 cm
Inscr. bottom right: 'Sketch of| Juvenile Members|of the Yacht [originally misspelt 'Yatcht'] Club by|Richard Dadd 1853|Bethlem Hospital.'
Prov: S. E. Lucas to 1961. Christie's 17 March 1961 (24), bought by Agnew (with 'The Packet Delayed'). Sotheby's 15 March 1967 (32), bought by Colnaghi.
Mr and Mrs Paul Mellon, Upperville, Virginia
This picture is related to 'The Packet Delayed' (No. 122)

which Dadd painted in January of the following year, in which the two boys appear again who are seen here blowing into the sails of their model yacht. They are also seen in several other watercolours, and obviously represent memories of Dadd's childhood. Here the past associations are still more overtly stated, as the background shows a view behind Chatham, where the hill climbs up towards the dockyard fortifications known as the Lines. The composition is unusual for Dadd, being one of only two or three watercolours in which he sets the figures directly against a distant landscape, without the intervention of any screening device in the near background to define their exact position; and it is also one of few in which he does not show the whole figure. The angled viewpoint is curious, and the background is now so faded that it is difficult to make out the precise intention; the more so, without a detailed knowledge of the local topography. Some of the cows in the bottom left-hand corner are also rather curious, and can be compared with the bull calf in No. 168. The foremost animal here (which seems to be developing the feet of a camel) has the same misshapen head as the calf, while its neighbour is shown in very much the same stance, but appears rather surprisingly to be performing a balancing act on its front legs. In the unnatural drawing of animals, while in Bethlem, Dadd shows more than in any other area the loss which he sustained through not having access to models. Possibly he had not studied them very closely in the past and had few suitable sketches in his book, which emphasises his extreme dependence on this book and on his visual memory of things which he knew well. The Elizabethan ruff worn by the left-hand boy shows a wholly inexplicable sartorial obsession which can be found in other drawings, most strikingly in the 'Passions' sketch 'Suspense or Expectation' (No. 149).

122 The Packet Delayed 1854
Watercolour, $14\frac{1}{2} \times 10$ in, 36.8×25.4 cm
Inscr. bottom right: 'The Packet Delayed. A Sketch by Richd Dadd|Jany 17th—1854—Bethlem Hospital London—'
Prov: S. E. Lucas to 1961. Christie's 17 March 1961 (24), bought by Agnew (with 'Juvenile Members of the Yacht Club').
Trustees of Sir Colin and Lady Anderson

This child's eye view of a shipping subject is seen with the cool detachment which Dadd always brings to scenes remembered from his own past. The boys, recognisable in a number of other watercolours (e.g. 'Juvenile Members of the Yacht Club', No. 121, 'Suspense', No. 149, 'The Balladmonger', No. 111), might be two of his brothers, or Dadd himself and a companion. Perhaps because he paints them out of his own experience, treating them as his contemporaries, his children have no trace of the sentimentality with which other Victorian painters so often viewed them. The close-up study of choppy water in the foreground, swelling to engulf the branch of a tree, is a fine example of the power of Dadd's visual memory to evoke images which he could not have seen for many years. The play of light on the crests of the ripples is an effect which always fascinates him, and can be seen also in 'Venice' (No. 170), 'Jesus Christ Walking on the Sea' (No. 109), and elsewhere.

123 Mercy. David Spareth Saul's Life 1854
Oil on canvas, 27×22 in, 68.5×56.0 cm
Inscr. top left: '[RICHA]RD. DADD. 1854.' (part concealed under frame); verso (now covered in relining): 'Mercy. David spareth Saul's life.|1st Samuel. Chapr. 26.|by Richard Dadd.|1854.'
Exh: *Victorian Painting*, Agnew's 1961 (43); *Romantic Art in Britain*, Philadelphia Museum of Art 1968 (203); *Victorian and Edwardian Decorative Art. The Handley-Read Collection.* R. A. 1972 (B122)
Prov: Sir Charles Hood to 1870. Christie's 28 March 1870 (331), bought by Holl. Mrs Clifton to 1961. K. J. Hewett. Mrs R. Frank. Charles and Lavinia Handley-Read to 1971.
Thomas Stainton (repr. on p.100)

This is one of several paintings, e.g. 'Contradiction. Oberon and Titania' (No. 172), 'Negation' (No. 179), in which Dadd illustrates a one-word abstract theme, rather in the manner of the 'Passions' sketches. The subject of David sparing Saul had been exhibited by John Martin in 1835, and was engraved among his illustrations to the Bible.[58] The scene shows David staying the hand of Abishai from killing the sleeping Saul, after they have come into the trenches of Saul's encampment by night. Dadd used the figure of Abishai again in a similarly dominant position for Oberon in 'Oberon and Titania', begun in the same year, almost as if he wished to demonstrate his ability in two completely contrasting types of composition. Here the design is simple and dramatic, the action self-contained in a way which is familiar from other works. The rocky wall of the trench cuts off the protagonists like actors at the front of a stage, and at the sides they are framed between a spear planted at Saul's head on the left, and the inclined edge of the trench against which leans another spear shaft on the right. The central figures are almost enclosed in the circle of Saul and his sleeping men, but stand above the prostrate forms in a position of powerful ascendancy. Within this simple structure the flowing movement of the garments creates its own rhythms and patterns, into which the finely wrought detail is, as always, carefully integrated. Even a virtuoso passage such as the hem of David's robe, falling from his outstretched arm in sinuous folds, is seen to melt into a gentle arc which is taken up by the wavelike robes of the sleeping figure behind. Unlike some of Dadd's most intricate paintings, however, the composition does not become enmeshed by surface pattern, or take on the flat, frieze-like appearance which is characteristic of them. Although small, the picture has a monumental quality. There are none of the strong tensions which in earlier works were set up by dramatic spotlighting, the whole scene being evenly bathed in bright but soft moonlight. Though there is potential violence in the scene, it has been mitigated in a visual as well as a narrative context. David's easy stance and light gesture contains no force, and only the left hand tightly gripping a spear betrays the power which underlies his authority. The clear colours are similar to those used in 'Caravan Halted by the Sea Shore' (No. 91) ten years before, and the extreme sensitivity of Dadd's palette is seen in his handling of this very personal range of sea-greens, blues, pinks and creamy browns.

[93]

124

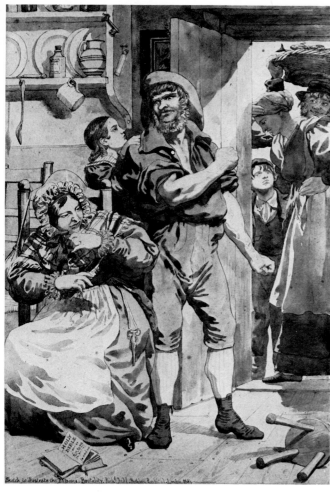

124 Sketch to Illustrate the Passions. Brutality
1854
Watercolour on brown paper, 14¼ × 10 in,
36.2 × 25.4 cm
Inscr. bottom left: 'Sketch to illustrate the
Passions. Brutality. Rich^d Dadd. Bethlem
Hospital. London. 1854'
Prov: Sir Charles Hood to 1870. Christie's 28
March 1870 (326), unsold. Given to Bethlem
Hospital by Mrs Wormald in 1924.
*Board of Governors of The Bethlem Royal
Hospital and The Maudsley Hospital*

This is one of the three watercolours belonging to Sir
Charles Hood which did not find buyers at his sale,
and so can be presumed to be one of the two which
his daughter Mrs Wormald gave to Bethlem Hospital
in 1924. The others were 'Hatred' (No. 115), now also
at Bethlem, and 'Malice' (No. 144), whereabouts un-
known. The setting is a cottage interior such as Dadd
could have remembered from his childhood in Chat-
ham; the scene too, of a fisherman ill-treating his
family, was probably familiar to anyone accustomed to
wandering round the more picturesque parts of the
town. The Bible, which has fallen to the ground as the
frightened woman raises her arm to protect herself,
suggests that this is a Sunday event. Amongst the ob-
jects on the shelves in the top left corner are some which
Dadd had painted in a still-life study in 1838 (No. 22);
the key and phial hanging from nails, the knife, now
reversed and with its handle protruding instead of the
blade, and a blue and white jug just visible on the top
shelf which is, perhaps, an amalgam of the jug and jar
in the earlier picture. The little group framed in the
doorway and highlighted by the bright sunlight out-
side is particularly attractive, and a fine example of
Dadd's handling of his broader style, with washes of
colour and quick firm strokes of shadow. The muted
pinky browns and blues, with touches of dull yellow,
are characteristic of several of the watercolours which
are on brown paper.

*125

***125 Sketch to Illustrate the Passions. Pride** 1854
Watercolour, 14½ × 10¾ in, 36.8 × 27.3 cm
Inscr. bottom right: 'Sketch to illustrate the
Passions. Pride.|By that sin fell the Angels how
then shall Man &c. Shakespeare. by Richard
Dadd Bethlem Hospital. April 1854'
Exh: Walker's Galleries 1946 (19); Bristol, 1947
(108)
Prov: Dr R. Hemphill to 1966. Christie's 22
February 1966 (150).
Whereabouts unknown

The quotation in the sub-title of this work comes from
Act III scene 2 of *Henry VIII*, but actually refers to
ambition, not pride: 'I charge thee, fling away ambi-
tion:| By that sin fell the angels; how can man then,|
The image of his Maker, hope to win by't?' The sub-
ject of the picture is not Shakespearian. Dadd's mis-
quotation here and elsewhere suggests that he did not
have a copy of the plays in Bethlem with him, though
obviously knowing them very well; or at any rate, that
he did not refer to them in detail for his work.
This picture is known to the writer only from a black-
and-white photograph. There seems to be an air of
exaggerated burlesque about it which is not found in

other works; and the fairy-tale castles in the distance, make it the only open-air subject among the water-colours which does not contain a realistic landscape background taken from the sketchbook.

126 Sketch to illustrate the Passions. Ambition 1854

Watercolour, 14½ × 10 in, 36.8 × 25.4 cm
Inscr. bottom left: 'Sketch to illustrate the Passions—Ambition|Vaulting Ambition mocking the meat it feeds. on. by Richard Dadd April 13.th 1854|Bethlehem Hospital London'
Exh: Walker's Galleries, 1946 (16)
Prov: H. C. Green to 1961; Sotheby's 18 October 1961 (33) (with 'Avarice'). Agnew's in 1964.
John Hewett

The symbolism of this scene is obscure, though there is a suggestion of family portraiture in the air, and an inconclusive feeling that it may refer obliquely to some situation from Dadd's past. The composition is an unusual one, the two main figures standing in an undefined spatial relationship with the rest of the picture. In the distant background is an evocative Mediterranean landscape taken from the sketchbook, a more extended view than the usual glimpse which is seen over rocks or round the edge of buildings. In the near background are figures in Greek costume who seem also to have been taken from first-hand sketches. The women gather round a fountain of a type which Dadd had drawn in the V. & A. sketchbook, and labelled 'Style of Fountains in Greece', and which appear on the same page as a landscape sketch noted by Phillips 'on the Gulf of Corinth' (*see* No. 73, Mount 1, D248–92). The reference in the inscription shows a confusion of two Shakespearian quotations. 'Vaulting ambition, which o'er leaps itself' is found in *Macbeth*: the second part comes from *Othello* and refers to jealousy: 'It is the green-eyed monster which doth mock|The meat it feeds on.'

127 Sketch to Illustrate the Passions. Agony— Raving Madness 1854

Watercolour on brown paper, 14 × 9⅞ in, 35.5 × 25.3 cm
Inscr. bottom left: 'Sketch to illustrate the Passions. Agony—Raving Madness.|by. Richard Dadd. Bethlem Hospital London. May 2.nd 1854'
Exh: Bethlem Royal Hospital, 7–13 August 1913
Prov: in Bethlem Hospital in 1913.
Board of Governors of The Bethlem Royal Hospital and The Maudsley Hospital

An exhibition of works by insane patients from various institutions was arranged at Bethlem Hospital in 1913, in connection with the 17th International Medical Congress. Six works by Dadd owned by the hospital were included of which this, the only one which can now be identified, was illustrated in the *Daily Mirror*, 9 August 1913. Of the seven other watercolours now at Bethlem, four were bought for the hospital by Mrs Farnham, a Governor, in 1916; two were given in 1924 by Mrs Wormald (*see* 'Brutality', No. 124, and 'Hatred', No. 115); one was given by a former physician superintendent, Dr W. H. B. Stoddart, in 1935, having been 'picked up' in the Caledonian Market. Except for those mentioned, they cannot now be distinguished.[59]

126

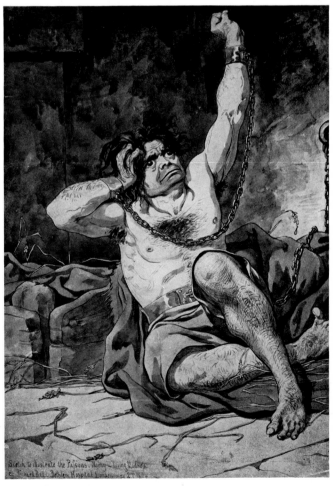

127

In depicting 'Madness' Dadd might in theory have painted a straightforward portrait of one of his companions: he was certainly aware of their potential, and in the encounter with Gow during his early days in the hospital (*see* p. 34) had commented that in Gow's drawings of the patients 'those fellows look mad, every one of them'. But this would not have fitted into the overall pattern of the 'Passions' sketches, with their theatrical overtones; and instead he has chosen what at first appears to be the standard stereotype of a chained lunatic lying on straw, in a scene which could not have been found at Bethlem Hospital for many years before his own admission. It is an image which might have come from a book such as Bell's *Essays on the Anatomy of Expression in Painting*,[60] which he probably knew as a student. He may also have had in mind Caius Gabriel Cibber's two famous figures of 'Raving and Melancholy Madness', formerly over the gateposts of the old Bethlem, but by now reclining discreetly veiled in the entrance hall.[61] Nevertheless Dadd makes in this picture a very personal and moving statement, out of his own inner knowledge of the subject; one which is implicit in the title. His madman is not, as Cibber and Bell and the rest of the world see him, fighting against his chains, which hang loose and relatively useless from his wrists; he is struggling impotently to free himself from the agony of his own tormented and tormenting mind. This, as much as 'Hatred' (No. 115), is a psychological self-portrait, but showing a different aspect of Dadd's experience.

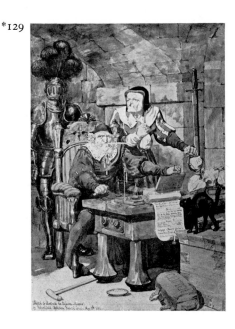

*128

*129

***128 Sketch to Illustrate the Passions. Drunkenness** 1854
Watercolour [?c.14 × 10 in]
Inscr. bottom left: 'Sketch to illustrate the Passions by Rich^d Dadd. Bethlem Hospital London May 6^th 1854.|Drunkenness.'
Exh: Walker's Galleries 1946 (18)
Whereabouts unknown

This picture is known to the writer only from a black-and-white photograph. Though the costume this time is contemporary English, the subject seems, like some other of the 'Passions' series, to have been influenced by Dutch seventeenth-century tavern scenes; particularly, perhaps, by Jan Steen's tavern interiors, some of which Dadd might have seen in the Royal Collection.

***129 Sketch to Illustrate the Passions—Avarice** 1854
Watercolour, 14½ × 10¼ in, 36.8 × 26.0 cm
Inscr. bottom left: 'Sketch to illustrate the Passions—Avarice.|by Richard Dadd. Bethlehem Hospital London. May 12^th 1854.'
Exh: Walker's Galleries 1946 (17)
Prov: H. C. Green to 1961. Sotheby's 18 October 1961 (33) (with 'Ambition'). Ernest Brown & Phillips in 1964.
Whereabouts unknown

This picture is known to the writer only from a black-and-white photograph. Although at a narrative level it is apparently a rather commonplace view of the subject of avarice, it is enlivened by some deft touches, particularly in the faces of the old couple, distorted by a lifetime's greed and ill-will, as they turn with sudden suspicion towards the light from an invisible window.

The suit of armour, which appears in other pictures, adds to the atmosphere of general mistrust with the suggestion of a figure lurking behind the chair. This is one of several of the 'Passions' sketches which may show the influence of Dutch paintings in the subject matter.

130 Sketch to Illustrate the Passions. Melancholy 1854 (repr. on p.100)

Watercolour, 14⅜ × 10in, 36.5 × 25.5cm

Inscr. bottom left: 'Sketch to illustrate the Passions. Melancholy.|by.Richard Dadd. Bethlehem Hospital. London. May 30ᵗʰ 1854.'

Prov: Dr Isobel Simpson to 1964. Sotheby's 15 July 1964. John Rickett.

Private collection

This simple sketch of a pilgrim lost in meditation by the sea is one of the gentlest of all the 'Passions' drawings, and one of the finest examples of Dadd's ability to create mood through design and colour. The figure rests against an outcrop of rock, his body melting in a soft relaxed curve into its semicircular outline. His lightly balanced staff, the only straight line in the composition, reinforces the languid gesture of his right arm. Behind, the tall cliff is bare and featureless except for a ruined castle on its summit, the sea washes through an empty arch, the landscape is deserted. The golden brown of his robe isolates the pilgrim against the greys and browns of his surroundings and the slate blue of the sea, without isolating him from the melancholy atmosphere of which he forms a part. If his face were invisible, there could still be little doubt as to its expression.

131 Settling the Disputed Point 1854

Watercolour, 10 × 14⅜in, 25.4 × 36.5cm

Inscr. lower left: 'Settling the disputed|Point. A Sketch|by Richard Dadd.|Bethlem Hospital| London June 13. 1854'

Prov: The Fine Art Society to 1973

Mr and Mrs Paul Mellon, Upperville, Virginia

This is one of few among Dadd's pictures which might be described as an absolutely straight genre scene, making no pretence to illustrate an episode from literature or history, or any abstract theme. It is related through some of the minor details, as well as in general tone, to 'A Curiosity Shop' (No. 132), which was painted nine days later, though neither the composition nor any of the figures is literally repeated. The two figures embracing are reminiscent of the group similarly framed in a doorway in 'Brutality' (No. 124), though the latter is more stylishly treated. There is a lack of resolution about the handling of parts of this picture which is rare for Dadd: he seems to have tried to combine two of his watercolour styles which are usually kept separate, one relying on controlled washes and bold shadows, the other on stippling and hatching. By comparison with the other figure compositions of this period the outlines are also indistinct; the still-life collection of boots and shoes, and the tankards on the floor on the right, are more characteristic in finish and stand out accordingly. Dadd always shows great interest and care in painting footwear, and it may be significant that his great friend Humby was a fashionable bootmaker (*see* Appendix, note 71.)

131

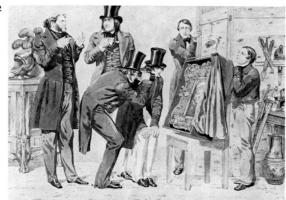

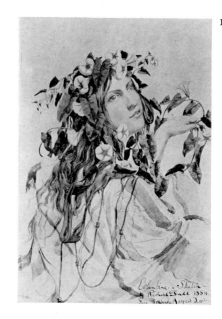

132 A Curiosity Shop 1854
Watercolour, 10⅛ × 14¼ in, 25.7 × 36.2 cm
Inscr. bottom left: 'Sketch of A Curiosity Shop.
by Richard Dadd.|Bethlehem Hospital. London.
June 22nd 1854.'
Prov: Sir Charles Hood to 1870. Christie's 28
March 1870 (315), bought by Holl.
Trustees of the British Museum

In its literal interpretation of the 'curiosity' in the title, this slightly bizarre scene takes on the character of a visual pun. There may also be some, rather heavily veiled, social comment: it is close in idea to Maclise's 'Salvator and his Patron' of 1835, in which a hypercritical second-hand dealer peers closely at a painting which the destitute young artist holds up to him. Dadd could have known the original, and might have been reminded of it by an engraving in the *Art Journal* in 1848.⁶² In some of the details this watercolour is related to 'Settling the Disputed Point' (No. 131), and also compositionally, in the flat disposition of the figures across, and nearly filling, a horizontal space. Various elements in it can be found scattered throughout the rest of Dadd's work: the figure with his hands on his knees adopts the same pose as the ostler in 'The Fairy Feller's Master-Stroke' (No. 190), while the figure of the man with binoculars contains echoes of the central figure in 'The Balladmonger' (No. 111): a plumed helmet like the one on the left is seen in several other drawings, for example 'Pride' (No. 125), and 'Battle or Vengeance' (No. 143): swords and daggers proliferate in many works; and the goblet standing on the table is almost identical with that in 'Disappointment' (No. 139). The wearing of spurs seems to have had some significance for Dadd and they sometimes appear, as here, in situations where they hover on the borderline of incongruity: one would hesitate, however, to single out any one item as being more incongruous than another in this curious context. The figure standing at the back of the central group, holding a pair of spectacles, resembles

Dadd's own early self-portraits, particularly the etched version (No. 53), and there is a feeling that all the characters may be portraits.

133 Columbine 1854
Watercolour, 14¼ × 9⅞ in, 36.2 × 25.1 cm
Inscr. bottom right: 'Columbine a Sketch|by
Richard Dadd 1854|June Bethlehem Hospital
London'
Hamish Miles

The shortage of any sort of models, and the complete absence of women, in Bethlem must often have caused Dadd to fall back on his memory of faces, but 'Columbine' is one of the few examples for which a real life prototype can be found. The 'Girl in a White Dress' (No. 56) whom he had painted in 1841 was almost certainly in mind here, even to the gesture of the right hand in which previously she had held a rose. Though Columbine was a stock character in harlequinade or pantomime, the title of this picture seems little more than a pretext to recapture the remembrance of a fresh and characterful young face, though the fact that her head is wreathed in convolvulus and not columbine might make even this pretext look a little thin: but she is wearing among the blue ribbons in her hair a leadline (used for taking depth soundings at sea), which cannot similarly be explained in terms of faulty botany, so it may be that the whole picture is full of private allusions which have now been lost. Dadd admired women who were 'free from affectation', as he described the women of Asia Minor to David Roberts, and who walked upright 'without mincing', conveying 'a notion of truthfulness of character, a thing more to be prized than all the boarding-school accomplishments . . .'.⁶³ Her apotheosis as this spirited Columbine, who could hardly be further from the despised boarding-school miss, suggests that the original sitter may have been someone whom he had admired in earlier years.

134

134 Polly of Portsmouth and Joe The Marine
1854
Watercolour, 9½ × 13½ in, 24.1 × 34.3 cm
Inscr. bottom right: 'Polly of Portsmouth and
Joe the Marine—A Sketch. by|Richard Dadd
Bethlehem Hospital London. July 4ᵗʰ 1854'
Prov: Mrs E.A.F. Martin to 1964. Sotheby's
9 December 1964 (15). Alister Mathews.
John Hewett

The subject is taken from a popular ballad *Poor Joe the
Marine*, but Dadd's memory is not quite accurate and
although the story was set in Portsmouth, the girl was
Polly of Portsea⁵⁵. Nor has he illustrated any recogni-
sable episode in the song, which tells of Joe's marriage
to Polly and his immediate departure to be killed in
battle, in a sequence far too rapid to allow the accumu-
lation of children shown here. The background to this
picture is actually Chatham, looking down towards the
Medway. Through a gap in the lines (the fortifications
which protected the dockyard area), there can be seen
the parish church of St Mary as it appeared in Dadd's
day (*see* also 'Reminiscence of the River Medway', No.
166), while over the top is glimpsed a ship's mast behind
the chimney. The street-posts are the barrels of old
cannon, as described by Dickens in *The Uncommercial
Traveller*, and the sentry in the distance could almost
have come from the same book: 'The one red-coated
sentry . . . was a mere toy figure, with a clock-work
movement. As the hot sunlight sparkled on him he
might have passed for the identical little man who had
the little gun, and whose bullets they were made of
lead, lead, lead.'⁶⁴ The boys who lean over the side of
the bridge are almost an inseparable part of Dadd's
childhood reminiscences and appear in several other
sketches, notably in 'The Balladmonger' (No. 111)
where the boy on the right leans on his companion's
shoulder in exactly the same attitude. In 'Reminiscence
of the River Medway' the figure at the end of the jetty
stands in an identical pose to that of the left-hand boy.

**135 Sketch to Illustrate the Passions. Insig-
nificance or Self Contempt** 1854
Watercolour on brown paper, 14 × 9⅞ in,
35.6 × 25.3 cm
Inscr. bottom left: 'Sketch to illustrate the
Passions. Insignificance or|Self Contempt—
Mortification—Disgusted with the|world—he
sinks into himself and Insignificance.—Richard
Dadd. Bethlehem Hospital. London. July 12ᵗʰ
1854.'
Prov: *See* note on 'Agony—Raving Madness'
(No. 127).
*Board of Governors of the Bethlem Royal
Hospital and The Maudsley Hospital*

135

This appears at first sight to be one of the least com-
plicated of the 'Passions' sketches, with its elegantly
simple image of a baggy little man set against the clean
hard lines of a large door; but the only thing really cer-
tain about it is that the figure is a caricature of J.M.W.
Turner, whom Dadd would have remembered from
his student days at the Academy Schools. This may
have no more significance than that Turner provided a
suitably shabby-looking model for Dadd's purpose; but
that purpose is far from clear. Everything seems to be
plainly set out: the untidy little figure is clearly an

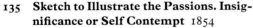

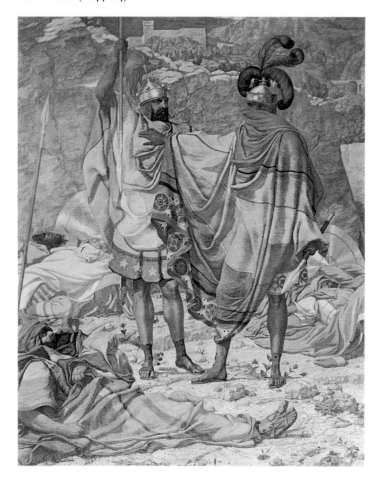

123 Entry on p. 93

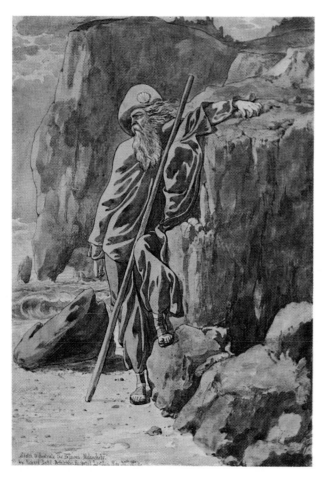

130 Entry on p. 97

artist, for he carries his portfolio, and he is about to enter the house of Mr Crayon, a drawing master who lets furnished apartments for a single gentleman. The most obvious interpretation is that the figure is Mr Crayon himself, and that Dadd is simply bewailing the lot of the artist, who is reduced to giving drawing lessons and letting rooms to earn his living. It would not quite explain why he is portrayed as a dwarf, but this could be just a visual reinforcement of his insignificance. If so, then the use of Turner to represent the artist must be merely a matter of convenience; but it is hard to reconcile any straightforward interpretation with the impassioned outburst of the sub-title, in which Dadd's usually meticulously neat script suddenly breaks down into a rapid cursive hand, as though emotion has temporarily carried him away: 'Insignificance or Self Contempt–Mortification–Disgusted with the world–he sinks into himself and Insignificance.'

Although there is little evidence of it, it is known that Dadd did suffer from a loss of control over his normal powers, both of reasoning and of expressing himself; but because of the complete control which he shows over the media and techniques of his profession it is always a shock to remember this, and that there may sometimes be no rational explanation for elements in his work. This picture may be one of those in which his meaning is simply not accessible to anyone but himself.

136 Sketch to Illustrate the Passions. Self Conceit or Vanity 1854
Watercolour on brown paper, 14 × 9¾ in, 35.6 × 24.9 cm
Inscr. bottom right: 'Sketch to illustrate the Passions. Self-conceit or|Vanity. by Richard Dadd. Bethlehem Hospital. London|July. 19.ᵗʰ 1854.'

Prov: *See* note on 'Agony–Raving Madness' (No. 127).
Board of Governors of The Bethlem Royal Hospital and The Maudsley Hospital

Although this picture has the appearance of being a Shakespearian subject there is no indication that this is intended, nor can any specific scene from a play be identified; but it may have been inspired by the character of Malvolio in *Twelfth Night*. The theme of 'Vanity' is reinforced by the peacock in the background, echoing the almost luminous peacock's feather in the man's hat.

137 Lucretia 1854
Watercolour, 12 × 10 in, 30.5 × 25.4 cm
Inscr. bottom left: 'Lucretia–a Sketch|by Richard Dadd 1854|July 24.ᵗʰ Bethlehem Hospital London.'
Prov: *See* note on 'Agony–Raving Madness' (No. 127).
Board of Governors of The Bethlem Royal Hospital and The Maudsley Hospital

This picture was painted only one month after 'Columbine' (No. 133), and there is an obvious relationship between the two. The brown and purple colouring is repeated from the earlier work, though used here more densely and almost unrelieved by any lighter tones except in the face and hair; and there is a feeling that the same model has inspired both, even though the original 'Girl in a White Dress' might not be recognisable without the intermediate 'Columbine' to provide a link. Dadd probably knew Guido Reni's 'Lucretia' in the Dulwich College Gallery, and a pastiche of that work may also have been in his mind.[65] In other pictures he shows a fondness for portraying exaggeratedly hooked noses, but they are generally intended to produce a grotesque effect; the features of this rather unexpected 'Lucretia' seem to suggest a private preoccupation, not quite related to the subject.

136

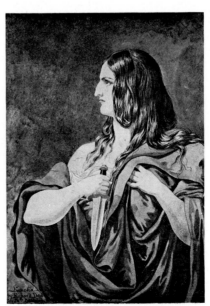

137

138

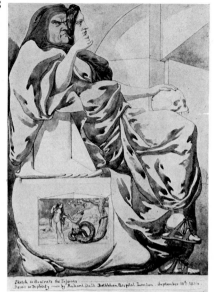

139

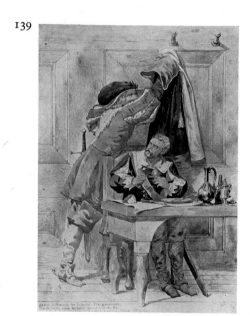

140

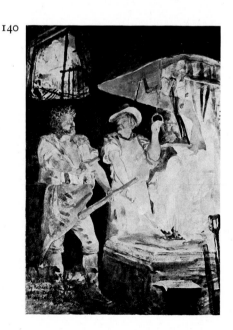

138 Sketch to Illustrate the Passions. Deceit or Duplicity 1854

Watercolour, $14\frac{3}{8} \times 10\frac{1}{4}$ in, 36.5 × 26.0 cm
Inscr. across bottom: 'Sketch to illustrate the Passions|Deceit or Duplicity – by Richard Dadd Bethlehem Hospital. London. September 15th 1854.'
Prov: *See* note on 'Agony – Raving Madness' (No. 127).
Board of Governors of The Bethlem Royal Hospital and The Maudsley Hospital

Although the general purport of this sketch is clear, its full interpretation remains baffling. It seems that an ugly old harridan, already approaching death, as symbolised by the skull beneath her hand, is deceiving the world behind the mask of a beautiful young girl: but Dadd could be suggesting that in a world full of deceit and duplicity, even a beautiful young girl will be found to be already corrupt beneath her mask. The little vignette of Eve and the serpent might, except for its unexpected placing on the end of the seat, be taken for a rather obvious reinforcement of the theme of duplicity; until one recognises in the head of the serpent, the features of Dadd's father. Nothing is clarified by the undefined location in what appears to be some sort of vault, or by the strange chair which looks as though it might be a fantastic essay in paper sculpture. Dadd has invented some rather unusual looking chairs in other pictures, e.g. 'Night and Day' (No. 188), and 'Cupid and Psyche' (No. 180), all equally inexplicable. The greenish yellow of the predominant colouring, while not unpleasant itself, symbolises the unattractive theme.

139 Sketch to Illustrate the Passions. Disappointment 1854

Watercolour, $14\frac{1}{4} \times 10\frac{1}{4}$ in, 36.2 × 26.0 cm
Inscr. bottom left: 'Sketch to illustrate the Passions. Disappointment . .|There's many a slip between the cup and the lip.|by. Richard Dadd. Bethlehem Hospital. London. October 7th 1854.'
Prov: *See* note on 'Agony – Raving Madness' (No. 127).
Board of Governors of the Bethlem Royal Hospital and The Maudsley Hospital

The apparent triviality of this scene makes it seem inappropriate to a series illustrating 'The Passions', for all that has happened is that one man has caused another to spill his wine. As a very exact illustration of the quoted sub-title: 'There's many a slip between the cup and the lip', it recalls a certain type of thought disturbance in which the individual cannot interpret a conceptual idea except in concrete terms, and will, for example, always explain a proverb in its literal sense without being able to grasp the abstract or general significance. It is possible that Dadd suffered at times from this form of disorder, though there is no real evidence for it elsewhere, and very definite evidence that he did *not* suffer from it all the time. In some of the other 'Passions' drawings the influence of Dutch seventeenth-century painting can be seen, particularly in the card-playing scenes; and here the cloak can be compared with a cloak hanging from similarly massive pegs in Pieter de Hooch's 'The Card-Players', from which picture the hat and part of the costume

might also derive. The objects on the table also suggest memories of Dutch tavern scenes.

140 Sketch to Illustrate the Passions. Anger
1854
Watercolour, 14¼ × 10¼ in, 36.2 × 26.0 cm
Inscr. bottom left: 'Sketch to illustrate|The Passions. Anger|by Richard Dadd. Oct.ʳ 17ᵗʰ| 1854. Bethlehem|Hospital. London'
Prov: *See* note on 'Agony–Raving Madness' (No. 127).
Board of Governors of The Bethlem Royal Hospital and The Maudsley Hospital

The blacksmith's forge was an obvious choice for painters, such as Joseph Wright of Derby, who specialised in strong dramatic lighting, and Dadd had probably studied examples and may even have worked on the subject himself before he was confined in Bethlem. This almost impressionistic sketch is something of a rarity, at least amongst his surviving work, though it has much in common stylistically with 'Grief or Sorrow' (No. 142) which was painted the following month; and shows that however insistently he may have used high finish and fine detail, he did not depend upon it exclusively for effect. The narrative content has never been satisfactorily elucidated. A partial explanation, though far from convincing, might be that the man on the left who holds a broken shaft has broken it in the paroxysm of his anger. The figure who stands almost concealed behind the glare of the fire is also rather mysterious. The small scene in the top left-hand corner is presumably a view into a neighbouring forge.

141 Sketch to Illustrate the Passions. Murder
1854
Watercolour, 14¼ × 10¼ in, 36.2 × 26.0 cm
Inscr. bottom left: 'Sketch to illustrate the Passions|Murder. Cain murders Abel.|by Richard Dadd Oct.ʳ 24. 1854|Bethlehem Hospital. London.'
Prov: *See* note on 'Agony–Raving Madness' (No. 127).
Board of Governors of The Bethlem Royal Hospital and The Maudsley Hospital

It is interesting to see that in depicting 'Murder', a subject about which he knew a good deal, Dadd should have chosen to use the archetypal murder story of Cain and Abel which requires no specialised knowledge. He was not reluctant to show his own version elsewhere, e.g. in 'Hatred' (No. 115) and 'The Death of Richard II' (No. 106), but it is obvious that he did not seize every passing pretext to reenact the scene. The picture belongs to a number of watercolours from the last few months of 1854 in which he seems to have been trying out a looser style, and is perhaps the most successful in this group.

142 Sketch to Illustrate the Passions. Grief or Sorrow 1854
Watercolour, 14 × 10 in, 35.6 × 25.4 cm
Inscr. lower left: 'Sketch to illustrate|the Passions|Grief or Sorrow|by Richard. Dadd–| Bethlehem Hospital|London|Nov.ʳ 7ᵗʰ |1854'
Prov: *See* note on 'Agony–Raving Madness' (No. 127).

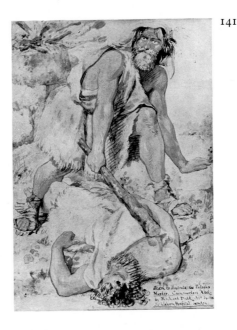

141

142

Board of Governors of The Bethlem Royal Hospital and The Maudsley Hospital

This picture alone out of the 'Passions' series comes near to an abstract treatment of the subject, rather than showing characters acting out a living 'sketch'. It is also the only one entirely in monochrome. It is full of highly charged emotional atmosphere, built up through the dramatic lighting, and melancholy tonality, the sorrowful yearning attitude of the sightless woman, and the surging movement in her garments and in the trees which carries her grief upwards as if on a wave. The untended look of the ghostly transparent trees in the foreground adds to the sense of desolation.

[103]

143 Sketch to Illustrate the Passions. Battle or Vengeance 1854
Watercolour, $14\frac{1}{4} \times 10$ in, 36.2 × 25.4 cm
Inscr. bottom left: 'Sketch to illustrate the Passions. Battle|or Vengeance. by Richard Dadd. Bethlem Hospital.|London Dec.^r 4^th 1854'
Prov: *See* note on 'Agony–Raving Madness' No. 127).
Board of Governors of The Bethlem Royal Hospital and The Maudsley Hospital

This watercolour has faded, and must originally have presented a more vivid scene than now, but it is still full of action and the clash of combat. The movement is carried vigorously forwards by the thrusting spears and flowing eagle banner, countered by the strong opposing lines of the figure who dominates the foreground, and reversed by the broken angles of his victim on the right. Dadd's fondness for painting armour and weapons can be seen throughout his work, and must have originated in the general interest in medievalism which was growing around the time when he was a student: but after his confinement in Bethlem he generally paints it, as here, without reference to any specific episode from medieval history and apparently for its own sake. His equation of 'Battle' with 'Vengeance' in the title is not entirely clear.

***144 Sketch to Illustrate the Passions. Malice** ?*c*.1853–55
Watercolour, [?*c*.14 × 10 in]
Prov: Sir Charles Hood to 1870. Christie's 28 March 1870 (321), unsold.
Whereabouts unknown

This work is known only from the catalogue of Sir Charles Hood's sale in 1870. It was unsold, but was not given to Bethlem Hospital by Hood's granddaughter with the other two unsold pictures from this sale (*see* 'Brutality', No. 124).

***145 Sketch to Illustrate the Passions. Despair** ?*c*.1853–55
Watercolour, [?*c*.14 × 10 in]
Prov: Sir Charles Hood to 1870. Christie's 28 March 1870 (317), bought by Johnson.
Whereabouts unknown

This work is known only from the catalogue of Sir Charles Hood's sale in 1870.

***146 Sketch to Illustrate the Passions. Senility** ?*c*.1853–55
Watercolour, [?*c*.14 × 10 in]
Prov: Sir Charles Hood to 1870. Christie's 28 March 1870 (318), bought by Ryder.
Whereabouts unknown

This work is known only from the catalogue of Sir Charles Hood's sale in 1870.

***147 Sketch to Illustrate the Passions. Ingratitude** ?*c*.1853–55
Watercolour, [?*c*.14 × 10 in]
Prov: Sir Charles Hood to 1870. Christie's 28 March 1870 (324), bought by Flower.
Whereabouts unknown

This work is known only from the catalogue of Sir Charles Hood's sale in 1870.

148 Sketch to Illustrate the Passions. Recklessness 1855
Watercolour, 14 × 10 in, 35.6 × 25.4 cm
Inscr. bottom right: 'Sketch to illustrate the Passions. The Recklessness.|by. Richard Dadd. Bethlehem Hospital. London. March 19^th |A.D. 1855'
Prov: Sir Charles Hood to 1870. Christie's 28 March 1870 (322), bought by Addington.
Trustees of the British Museum

The carefree mood of the subject is marked by a much lighter tonality than in many of the watercolours, with light yellows and greys picked out with red in the costume, and a very pale rocky landscape bathed in bright sunlight. For the man seated on the ground on the right, Dadd has re-used the pose of one of the boys in 'Idleness' (No. 119), but in reverse.

149 Sketch to Illustrate the Passions. Suspense or Expectation 1855 (repr. on p.109)
Watercolour, $14\frac{1}{2} \times 10\frac{1}{4}$ in, 36.8 × 26.0 cm
Inscr. bottom left: 'Sketch to illustrate the Passions. Suspense. or Expectation.|by. Richard Dadd. Bethlehem Hospital London–June 2^nd 1855.'
Exh: *Loan Exhibition of English Watercolours and Drawings*, Worcester, 1938
Prov: Sir Charles Hood to 1870. Christie's 28 March 1870 (319), bought by White.
E. Holland-Martin, by descent from Robert Holland-Martin

This is the most vividly evocative of all Dadd's reminiscences of childhood, and could perhaps only have been drawn by someone whose own memories of children and their games had not been overlaid by an adult's-eye view. The faces of the children betray their various reactions to this scene of breathless suspense with the whole-hearted intensity unique to childhood: the oldest boy, brave and devil-may-care as he applies the touch-paper regardless of the consequences, the others slightly more apprehensive, but determined not to show it; the girls unashamedly keyed up to screaming point by the delicious thrills of mingled terror and delight; the baby not quite sure what it is all about, but carried along on the general wave of excitement. The lack of either sentimentality or nostalgia in such pictures owes much to Dadd's isolation, in which he had little opportunity to develop the changing views which would inevitably have come with age, had he lived in a world inhabited by children. In painting childhood scenes he was forced to work directly from his own experience, and his models could only be his own former self, his brothers and sisters and companions, seen as he had known them through the eyes of a contemporary. The gardens have all the familiarity of former playgrounds, and in the distance, part of the town of Chatham mounts the hill behind the houses. It is tempting to see members of the Dadd family portrayed in the little group, though not necessarily in their correct chronological relationship: the eldest boy Robert, perhaps, lighting the toy cannon, Stephen at the top of the clothes post, and Dadd himself in the middle. The girls could be Rebecca and Maria Elizabeth; the other two, any of the younger children. The smallest child is reminiscent of C. R. Leslie's portrait of

his son playing with a wooden horse and cart, in 'A Scene in the Artist's Garden' painted in 1840.[66] In the Elizabethan ruffs which two of the boys are wearing with their reefer jackets, Dadd shows again that strange obsession which is seen in 'Juvenile Members of the Yacht Club' (No. 121), 'The Child's Problem' (No. 169), and elsewhere, for which no satisfactory explanation can be found.

143

150 The Death of Abimelech at Thebez 1855
Watercolour, 14½ × 10 in, 36.8 × 25.4 cm
Inscr. across the top: 'Death of Abimelech at Thebez – Draw thy sword, & slay me, that men say not of me. A woman slew him. – Judges. IX. v LIV. – by Richard Dadd. Bethlehem Hospital. London|August 28ᵗʰ –|1855'
Exh: *The Victorian Romantics*, Leicester Galleries, 1949 (33)
Prov: Sir Charles Hood to 1870. Christie's, 28 March 1870 (303), bought by White. Sir Osbert Sitwell in 1949.
Sir Sacheverell Sitwell

148

The date of this watercolour is the anniversary of Dadd's murder of his father, possibly a coincidence but the choice of subject is appropriately violent. It shows the episode in which Abimelech the son of Gideon, having destroyed his seventy brothers and the entire population of Shechem, has been felled while attacking the beseiged tower of Thebez by a piece of millstone thrown down by a woman. He is seen being dispatched by his armourbearer, in response to the plea quoted in the inscription. Dadd seems to have been attracted to the massacre-filled *Book of Judges*, and also illustrated a 'Jael and Sisera' (No. 155), now lost. His knowledge of David's 'Oath of the Horatii' has already been shown in 'The Flight out of Egypt' (No. 104): here he uses the gesture of the Horatii themselves, though reversed, in the two figures with outstretched arms, and the angled spear behind them is probably from the same source. Little else of the neo-classical ideal shows in this busy scene. There seems at times to be a deliberate effort to confuse, especially in the legs of the right-hand group, though this may be simply due to over-elaboration in the design; and there is also some failure to fit all the figures into the shallow space with complete conviction, though the surface design is effectively achieved. Dadd's obsession with ruffs seems to have got the better of his historical sense, in the frills which garter the legs of the soldiers on the right, though they do not appear visually incongruous amidst the rest of the decoratively exotic costume. The predominant steely blue colouring reflects the warlike action, and illustrates Dadd's skill in using colour to intensify the mood of his pictures. It can be contrasted with the blue in another watercolour, 'Hatred' (No. 115), which is used to achieve a different effect.

150

151 Crazy Jane 1855 (repr. on p.109)
Watercolour, 14⅛ × 10 in, 36.0 × 25.6 cm
Inscr. top left: 'Sketch of an idea for Crazy
Jane.|by Richard Dadd. Bethlehem Hospital.
London [August *expunged*]|September 6th 1855.'
Exh: *British Romantic Painting*, Paris, 1972 (95)
Prov: *See* note on 'Agony–Raving Madness'
(No. 127).
*Board of Governors of The Bethlem Royal
Hospital and the Maudsley Hospital*

The subject is taken from the ballad 'Poor Crazy Jane',
which tells its story in the form of an encounter be-
tween a passer-by and a poor wandering mad girl:

'Why fair maid in every feature
Are such signs of fear expressed!
Can a wandering wretched creature,
With such horror fill thy breast.
Do my frenzied looks alarm thee,
Trust me sweet, thy fears are vain,
Not for Kingdoms would I harm thee,
Shun not thou poor Crazy Jane.'

Jane then tells how she has been driven out of her wits
by her false lover's desertion, ending with the verse:

'Now forlorn and broken hearted
And with frenzied thoughts beset,
On that spot where last we parted,
On that spot where first we met
Still I sing my lovelorn ditty
Still I slowly pace the plain,
While each passer by in pity
Cries God help thee Crazy Jane.'

Crazy Jane was a popular ballad figure, and also
appears in 'The Ghost of Crazy Jane', and (briefly) in
'The Vision', and probably elsewhere.

With the same feeling which he shows for the outcast
and hopeless in the 'Passions' sketch 'Want' (No. 157),
Dadd has captured the mood of the subject in one of
his most lyrical compositions. The figure reaches up-
wards and across the paper in a yearning diagonal
movement, carried within a thrusting spearhead shape
formed by the branch in her right hand, and the
straws which dangle from her left: but she is held
down, helplessly earthbound, by the bulky solidity of
her own form. The weight of darker colour in the skirt
serves as an anchor, its tonality forming a continuous
horizontal band with the distant trees; while the
buoyant lightness of the upper part of the picture, with
its floating drapery and wind-tossed straws, expresses
her struggle to be free. The sense of desolation is
heightened by the melancholy blue green landscape
with its derelict crumbling castle, and by the black
birds (? ravens) which are its only other inhabitants;
but the figure of Jane stands alone in isolation against
the wide expanse of sky, dominating the background
so that her own mood imposes itself definitively on the
scene. The cool purity of blue and primrose epitomises
Dadd's feeling for colour in its most sensitive vein, and
all the details, such as the broken ears of wheat, the
bunch of feathers tied with ribbon, the tendrils of con-
volvulus twining round the branch, are delicately
drawn. The figure is obviously drawn from a male
model, and the face is recognisable again as Medea in
'The Flight of Medea with Jason' (No. 153), suggest-
ing that Dadd could sometimes get his fellow patients
to model for him.

152 Hunting Scene (called **The Flight**) 1855
Watercolour, 12¼ × 6½ in, 31.1 × 16.5 cm
(cut down)
Inscr. bottom left, but the first part cut off and
attached as a tab in the centre: 'Richard Dadd.
Bethlehem Hospital Lond[o]|n. September. 27th
1855.'
Exh: *Watercolours from the Cecil Higgins Art
Gallery, Bedford*, Agnew's 1962 (42)
*Trustees of The Cecil Higgins Art Gallery,
Bedford*, purchased 1957

This watercolour has probably been cut down from
c.14 × 10 in, this being the normal size of the figure
compositions from this period, which it closely re-
sembles stylistically. It could have been one of the
'Passions' sketches, but the type of the figures is also
consistent with non-Passions works from the same date
such as 'Medea and Jason' (No. 153). The highly arti-
ficial counterbalancing of the horses' heads has already
been seen in 'Dymphna Martyr' (No. 105): and, as in a
of number of Dadd's more crowded scenes, there is a loss
spatial definition in the over-complicated surface design.

***153 The Flight of Medea with Jason** 1855
Watercolour, 14¼ × 10¼ in, 36.2 × 26.1 cm
Inscr. bottom right: 'Sketch of the Flight of
Mēdēa with Jason – Chief of the Argonauts.| by
Richard. Dadd. Oct.r 16th 1855. Bethlehem
Hospital. London.'
Victoria and Albert Museum (not exhibited)

In several ways this picture is related to the 'Hunting
Scene' (No. 152) painted only three weeks earlier, the
most obvious comparison being in Jason's features and
headdress. The man at the back leans with his arms
outspread in the attitude of one of the shepherds in
'Polyphemus' (No. 107), and the huge rock round which
he is peering derives from the same source. A similar
attitude is used, again in association with a large
boulder, in 'Arab Ambush' (No. 187). Dadd here com-
bines his preference for the action to be defined at the
front of the stage, with a distant view of landscape and
a fortified town, probably taken from the sketchbook,
which is seen over the top of the rocks. This type of
composition is characteristic of a number of the
'Passions' sketches and other works where an outdoor
setting is used, the figures being placed at the front of
the picture against a natural screen which closes off the
near foreground. The landscape setting is similar to
that of 'Recklessness' (No. 148), with which the pic-
ture has other affinities.

***154 A Fallen Warrior** 1855
Watercolour, 14 6/16 × 10¼ in, 36.4 × 26.1 cm.
Inscr. bottom right: 'Sketch of a Fallen Warrior.
by. Richard Dadd. Bethlehem Hospital London.
Oct.r 18th|1855 [on line above]|This end
downwards'
Victoria and Albert Museum (not exhibited)

The subject seems to be little more than a pretext for a
really large and dominant specimen of the shields which
Dadd was so fond of painting; and he himself may have
had doubts as to its total success, when he added the
hint 'This end downwards'. He had recently finished
'The death of Abimelech' (No. 150), and the subject
may have suggested itself as a result of that work.

*155 **Jael and Sisera** *c.*1845–56
Oil
Prov: Sir Charles Hood to 1870. Christie's 28
March 1870 (332), bought by Holl.
Whereabouts unknown

The story comes from the *Book of Judges*. Sisera was
captain of the host of Jabin, King of Canaan. After
losing his entire army Sisera fled for refuge to the tent
of Jael, the wife of Heber, who killed him while he
slept by hammering a tent peg through his temples.
This picture may date from around the same time as
'The Death of Abimelech' (No. 150), which story also
comes from *Judges*. It was one of the three oil paintings
by Dadd belonging to Sir Charles Hood, and must have
been a fairly substantial work since it made 32 gns at
his sale in 1870, as against 19 gns for 'Saul and David'
(No. 123).

156 **The Grotto of Pan** 1856
Watercolour, 10 × 7 in, 25.4 × 17.8 cm
Inscr. bottom left: 'The Grotto of Pan. A Sketch|
by. Richard Dadd. Bethlem. Hospital. London|
April 21. 1856'
Prov: Sir Charles Hood to 1870. Christie's 28
March 1870 (305), bought by Vokins. By descent
in the present owner's family from *c.*1875.
Private collection

This picture shows Silenus, Pan and a shepherd. From
the point of view of subject matter it seems to be an
isolated example, like 'Columbine' (No. 133) and other
works of pure fancy which run parallel to the 'Passions'
series. It is known to the writer only from a black-
and-white photograph, but in style and finish seems
to be closest to 'Murder' (No. 141), of 1854. The
grouping of the figures is very like that used in
'Idleness' (No. 119), and there are other similarities
including facial resemblances to suggest that Dadd had
either the earlier work, or some common source, in
mind.

157 **Sketch to Illustrate the Passions. Want** 1856
Watercolour, 14 3/16 × 10 3/16 in, 36.1 × 25.9 cm
Inscr. top right: 'Sketch. to illustrate the
Passions.|Want. the Malingerer. by Rich^d Dadd|
Bethlehem Hospital London Nov^r 26^th 1856.'
Prov: Sir Charles Hood to 1870. Christie's 28
March 1870 (323), bought by Holl.
Victoria and Albert Museum

Although there may have been others which have now
disappeared, this picture dates from later than the
main bulk of the 'Passions' series. It is rather different
in character, and instead of a dramatic sketch in which
the theme is illustrated by action, like a charade,
it records a scene which symbolizes the state of 'Want'
itself. In the compassionate observation of this group
of fellow outcasts, Dadd shows a mood which has
not often been apparent in his work so far; and in
the distant view of the Medway at Chatham is a wistful
glimpse of the much loved place from which he him-
self is now an outcast. Some of his most delicate draw-
ing is to be found in this work, not only in the exquisite
background, but in details such as the battered pan
lying in the road. The cool colours, greeny blues and
pale mushroom, show a range which he uses in-
creasingly from this time on, often for small landscapes

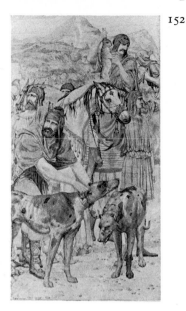

152

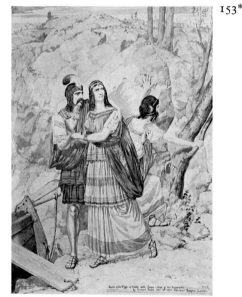

153*

154*

156

157

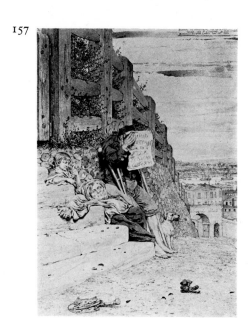

worked up from his sketchbook. Here, there is a touch of brighter colour in the man's blue waistcoat, and the red coat of the tiny dockyard sentry standing in the gateway, which emphasises the wan, hopeless atmosphere of the rest of the scene. On the paper which the man holds before his face is printed, in reinforcement of the theme: 'GOOD CHRISTIANS [illegible] . . ON TO A POOR FORLORN OUTCAST', (the 'S's being printed back to front). Almost hidden among the pebbles of the foreground are nine symbols, including the following:

$\oplus \; \leftmoon \; ♀ \; ♂ \; ⊙$

This is a rare occasion when we see the intrusion into his pictures of Dadd's preoccupation with the occult. The most easily recognisable signs probably represent the planets Earth, Moon, Venus, Mars, Saturn or Jupiter, and Sun; though some can also be used for the elements, and have other esoteric meanings as well.

***158 Charles II and Nell Gwyn** 1845–c.1856
Watercolour
Prov: Sir Charles Hood to 1870. Christie's 28 March 1870 (314), bought by Holl.
Whereabouts unknown

This is one of thirty three works by Dadd which were sold after the death of Sir Charles Hood, formerly physician to Bethlem Hospital. They are described as 'Painted between 1845 and 1856', but one or two are known to be later.
In 1842 Egg had painted 'Pepys's Introduction to Nell Gwynne' which Dadd would certainly have known, and E. M. Ward painted 'Charles II and Nell Gwynne' in 1854, which he might have read about: but in any case subjects from this period were popular, and Dadd himself used characters in cavalier costume in other scenes.

***159 Marius at Carthage** 1845–c.1856
Watercolour
Prov: Sir Charles Hood to 1870. Christie's 28 March 1870 (313), bought by Ryder.
Whereabouts unknown

The Roman general Gaius Marius landed at Carthage after being beaten by Sulla in 88 B.C. Ordered to leave the country, he sent a message to the Roman Governor 'Tell the praetor you have seen Gaius Marius a fugitive sitting among the ruins of Carthage'. This picture was among the thirty three belonging to Sir Charles Hood at his death in 1870 (see No. 158), but nothing more is known about it.

***160 View in Switzerland** 1845–c.1856
Watercolour
Prov: Sir Charles Hood to 1870. Christie's 28 March 1870 (306), bought by Richardson.
Whereabouts unknown

This work is known only from the catalogue of Sir Charles Hood's sale in 1870 (see No. 158). No other work is known to have existed which depicts scenes from this, the first part of Dadd's journey of 1842–3.

149 Entry on p. 104

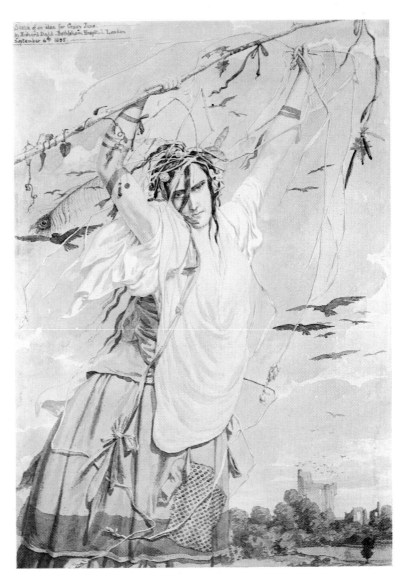

151 Entry on p. 106

*161 **Classical Composition** 1845–c.1856
 Watercolour
 Prov: Sir Charles Hood to 1870. Christie's 28
 March 1870 (304).
 Whereabouts unknown

This work could be the 'Finished Sketch of an Artificial
Composition' ('Landscape with Bull Calf', No. 168);
otherwise it is known only from the catalogue of Sir
Charles Hood's sale (see No. 158).

*162 **A Sea Piece** 1845–c.1856
 Watercolour
 Prov: Sir Charles Hood to 1870. Christie's 28
 March 1870 (302), bought by Holl.
 Whereabouts unknown.

This is known only from the catalogue of Sir Charles
Hood's sale in 1870 (see No. 158), though it could
possibly be 'Shipping in a Fresh Breeze' (No. 163),
for which there is no date or provenance.

163 **Shipping in a Fresh Breeze** ?c.1852–60
 Watercolour, 14½ × 19 in, 36.8 × 48.2 cm
 Prov: Alister Mathews to 1966.
 Private collection

Though undated, this picture seems likely to have been
painted at Bethlem during the 1850s, and is among the
most realistic of all Dadd's sea pieces. It is full of life,
movement and colour, quite different in character from
the static, timeless 'The Pilot Boat' (No. 173), and even
from the equally lively but more insubstantial 'Dia-
donus' (No. 183), though closest to this in manner. The
vantage point is characteristic and precise, a position
far out at sea and looking towards the coast, and in the
distance to the left can be glimpsed one of the steep-
sided rock faces which appear more and more insis-
tently in the later works. The foremost boat has the
name 'Industry. Portsmouth' carved on the stern,
possibly a clue to identifying the distant coastline, with
its low smooth hills and the suggestion of a naval build-
ing to the fore. To the left is a man-of-war, and the
small fishing-boat has its name, the *Fanny*, on the sail.

164 **Composition** 1857
 Watercolour, 6⅞ × 9⅞ in, 17.5 × 25.2 cm
 Inscr. bottom left: 'Composition: Sketch.
 Rich^d Dadd.|Bethlem Hospital. London. May 7^th
 1857.'
 Exh: Colnaghi's March 1971 (102)
 Prov: Christie's 18 January 1972 (96).
 Alister Mathews

Around 1857 and 1858 Dadd seems to have been
working on a series of small watercolour landscapes,
some worked up directly from the sketchbook and some
imaginary but using details from the same source. This
is one of the earliest known at present. The castle set
high on a hill is a recurrent theme in his backgrounds,
for example 'Portrait of a Young Man' (No. 112), 'Reck-
lessness' (No. 148), 'Melancholy' (No. 130), 'Jason and
Medea' (No. 153), and is probably influenced by
memories of Rochester castle from his boyhood. The
piece of masonry seen here immediately on the right of
the keep is the exact shape of the ruined curtain wall at
Rochester, as it would have been seen end-on by some-
one standing at the foot of the old bridge. A similar
shape occurs in the castle in 'Crazy Jane' (No. 151).

165 **Sketch to Illustrate the Passions. Patriotism**
 1857
 Pen and ink and watercolour, 14 3/16 × 10 3/16 in,
 36.1 × 25.9 cm
 Inscr. bottom left: 'Sketch to illustrate the
 Passions. Patriotism. by Richard Dadd.
 Bethlehem Hospital. London May 30^th 1857.
 St. George's in the Fields.' (Other inscriptions
 form part of the picture)
 Prov: Sir Charles Hood to 1870. Christie's 28
 March 1870 (316), bought by John Forster.
 Victoria and Albert Museum, Forster bequest

This picture was bought at the sale of Sir Charles
Hood's pictures by John Forster, the friend and bio-
grapher of Dickens. Forster would probably have
known Hood through his association with the Commis-
sioners in Lunacy (see p. 36),[67] and is likely to have had
a particular interest in Dadd. The main part of the
'Passions' series seems to have ended in 1855, though
one dates from 1856, and it is not known why Dadd
should have revived it in this isolated example. The
subject is humerous but is based on the 'siege opera-
tions' or military manoeuvres at Chatham, in which the
town garrison took part and the neighbourhood turned
out to watch: (Dickens gives a vivid account of the
event in *The Pickwick Papers*). Plans of the fortifica-
tions and details of the campaign were published in
advance,[65] and Dadd must have studied many of these
in his time: there is no doubt that his family took a
great interest in the manoeuvres, and his brother
Stephen had gone down from London specially to watch
them on the day of the murder.

The title at the bottom of the plan is: 'A General Plan
of the CITY OF OLABOLIKA and its environs at the
time of The Siege by Commander in Chief. Field
Marshal. Prince Plaiatit. and its defence by Com-
mander of all the Forces. Archduke Bighrogue de
Bighead'. Some of the place names are at the level of
popular board games of the period, such as 'Fort
Sosorri', 'Biggenuph Island', and 'The Honble. Mr.
Quibble's House'; though 'Bastardy, a small Fishing
village', 'Drudge's Sneer Rivulet', 'The Bad Gal's
Bluff' and 'The Harlot' are not so likely to have ap-
peared in this context: but many of them obviously
have a personal significance, notably the 'Lunatic
Asylum called Lostwithal', and also 'The Heights of
Delusion', 'Bay of Victimsall', 'Fatal Truth Batteries',
and 'Grand Swindle Cathedral'. Others may have auto-
biographical associations, such as 'The Spendthrift
Brother', and 'Headland called Rival's Taunt'. The
text in the bottom left corner describes the engage-
ments fought during the campaign, and shows that
Dadd was still capable of sustaining a long and coherent
passage of inventive prose. There are few signs of
wandering from the subject, though towards the end
the ideas take on a rather inflated and inconsequential
tone, which was probably to be found from time to
time in his ordinary conversation. At intervals the
Devil creeps into the text without apparent justification,
together with the theme of 'victimisation'; and again
this probably gives an idea of Dadd's conversational
style, with sudden breaks to pursue some private and
seemingly irrelevant preoccupation. (Dr Hood des-
cribed him as 'rambling and becoming incoherent'
when he got on to subjects which excited him).[69] In

the top right-hand corner, above the 'Angel Rock & Lighthouse', is a 'Scale for abolishing the difficulties of proportion'.

166 Reminiscence of the River Medway at Chatham 1857

Watercolour, 7 × 10 in, 17.7 × 25.4 cm

Inscr. top right: 'Reminiscence of the River Medway at Chatham – Scene from the Sun|Quay – Yarmouth Bloater-Boat departing. &c. by Richard Dadd: Bethlehem Hospital.|St. George's in the Fields. London. July 20th 1857. Juvat ire per undas.'

Prov: (Probably) Sir Charles Hood to 1870. (Probably) Christie's 28 March 1870 (309), bought by Holl. Mrs D. Cuthbert to 1964. Christie's 8 December 1964 (183).

John Baskett

This is probably the watercolour sold after the death of Sir Charles Hood, and formerly in his collection, which is described as 'On the Medway'. Since Dadd is so meticulous about noting an original sketch when he has used one, usually with the precise date, it seems safe to assume that this is truly as the inscription describes it, a reminiscence. Comparison with the view from the present Sun Pier, close to the site of the old Sun Quay, shows that if this is so Dadd must have had a truly re-markable visual memory. The view is down river to the dockyard, and along Chatham Reach towards Upnor on the far bank, a vivid evocation of a scene which he must have drawn and painted many times in his youth, but could not by this time have seen for at least fourteen years. The parish church of St Mary, in which Dadd's father and mother had been married and he and all his brothers and sisters were baptised, is shown almost exactly as it appeared when the family lived at Chatham (though it has been altered considerably since then). The large Noah's Ark vessels in the distance are the old convict hulks, the same from which the convict Mag-witch escaped in Dickens's *Great Expectations*. They were moored in the Medway just below Chatham, but here they may be placed a little too far up the river. Dadd's strong feeling for shipping subjects is seen in many works, but this is the only known study of the original source of this lifelong fascination.

167 Reminiscence of Mountain Scenery in Caria 1857

Watercolour, 6⅞ × 10⅛ in, 17.5 × 25.7 cm

Inscr: 'Reminiscence of Mountain Scenery, in Caria, near Mylasa. From a Sketch made on the spot in 1842. Rd Dadd. Bethlehem Hospital. St. George's in the Fields. London. August. 28th 1857'

Prov: Sir Charles Hood to 1870. Christie's 28 March 1870 (311), bought by Holl.

Mr and Mrs Paul Mellon, Upperville, Virginia

This is the first of several watercolours painted in Bethlem which are specifically noted by Dadd as having been worked up from sketches made during the tour of 1842–3. Other related watercolours from around the same time also use sketchbook material, but are not given locations and are clearly imaginary compositions. Dadd travelled through Caria in Asia Minor in October 1842, and was at Mylasa on 6 or 7 October. Although

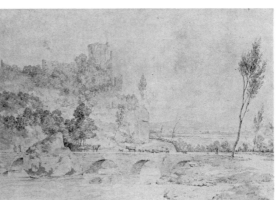

164

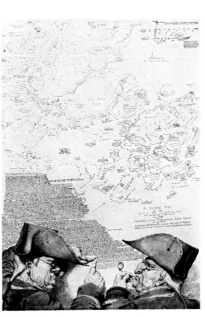

165

166

167

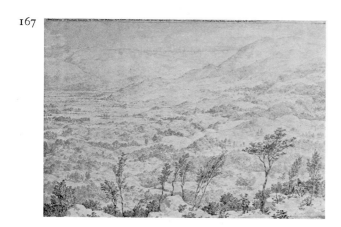

*168

one might have expected the group of travellers in the foreground to represent his own party, Sir Thomas Phillip's letters make it clear that this part of the journey was, unusually, made with a cavalcade of eight horses (*see* p. 19). However, much of the travelling was by mule as shown here, and it is tempting to think that at least the young man in European costume on the extreme right is intended for Dadd himself.

***168 Landscape with Bull Calf** 1857
Watercolour heightened with white, $6\frac{7}{8} \times 10\frac{1}{8}$ in, 17.4×25.7 cm
Inscr. top left: 'Finished sketch of an artificial composition. Rd Dadd. Bethlehem Hospital. London. St. George's in the Fields. Sept. 22nd 1857.'
Prov: Grenville L. Winthrop to 1943; bought in London, June 1935.
Fogg Art Museum, acquired as part of the Grenville L. Winthrop bequest 1943
(not exhibited)

This whole scene is fraught with uncertainty, but seems to be compiled out of elements from different parts of the sketchbook: the lacy trees in the foreground and glowing snow-capped peaks behind, are obviously remembrances of scenery from the journey of 1842–3. Perhaps the mountains contain some memory of the 'Masicyths range of snow mountains', which Dadd recorded as being 'enough to make one leap out of one's skin' when first seen in 1842 (*see* p. 20). The young bull calf, with its misshapen nose and horse's legs, owes some of its impact to rarity value, as well as to its slightly startled air of having materialised *in situ* rather than arriving by natural means. Dadd was rarely very convincing when his drawing ventured farther into the animal world than cats, which he could still see in the hospital, and a small dog of mixed origins. Cows may never have been among his best subjects; but after 1843 they were as alien to his environment as dragons, and it is not surprising that when they do appear in the Bethlem drawings, there is often a touch of the bizarre about them.

169 The Child's Problem 1857
Watercolour heightened with white,
$6\frac{3}{4} \times 10$ in, 17.1×25.4 cm
Inscr. top left: 'The Child's Problem. A Fancy Sketch. by Richard Dadd. Decr 18th 1857. Bethlehem Hospital. London. St. George's in the Fields.'
Prov: Dr R. C. Neville to 1955; by descent from his great grandfather Charles Neville, head attendant at Bethlem Hospital and then Broadmoor; presumed to have been given to him by the artist.
Tate Gallery, presented by Dr R. C. Neville 1955
This is overall one of the most incomprehensible of Dadd's watercolours, though most of the details can be understood independently. The moralising element in Victorian painting leads us to look to the background details for reinforcement of the main theme, but here no such consistency can be seen: nevertheless they are very deliberately chosen, which gives rise to a feeling of dissatisfaction at being unable to understand them fully. This quality of unreasonableness, together with the slightly bizarre attitude, and wholly disrup-

The problem

tive presence, of the child, makes an attractive little genre scene into something rather more disturbing. The title refers quite literally to the position on the chess board, which represents a very simple composed problem: 'White to play, and mate in two'; a problem simple enough, in fact, to be solved or even set by a child.[70] (Chess was a popular pastime in Bethlem Hospital, but there is no evidence as to whether Dadd played or not.) On the wall at the back, one picture shows the symbol and slogan of the Anti-Slavery Society, a kneeling slave and the words 'AM I NOT A MAN AND A BROTHER'; while that on the right, bearing the title 'THE BLACK FEREE. Remarkable Fast Slaver. Commanded by Capt.n S. Nigger B.[?.]' is plainly another reference to the same subject. Dadd might be expected to show sympathy with captives of all kinds; and it is also probable that his family had always been interested in the anti-slavery cause, as his brother Robert certainly was later on[71] (see also 'Portrait of a Man', No. 33). The statue of Ceres is reminiscent of the kneeling nude in 'Evening' (No. 60) which he had painted while still a student, and any female nude would, for obvious reasons, have to be drawn from memory or from engravings at this period. It also recalls the famous statue of 'Narcissus', long believed to be by Michaelangelo (now in the V. & A.)[72]. On the table are some delicate still-life details, two small touches in particular recalling that this is a scene of childhood – the walnutshell boat to the left, and the pawn lurking under a walnutshell hat in the centre. Even the fruit-knife seems unusually harmless. The child on the other hand is distinctly unnerving, with his unfocused stare, and quite inexplicable as to costume

except on the grounds that Dadd seems to have been attracted to ruffs; while the role of the sleeping old man is as mysterious as his headgear. The plant-holder on the extreme left is closely related to more elaborate constructions in 'Oberon and Titania' (No. 172), on which Dadd was still working at this time, and the plants rather improbably sprouting from it are also to be found in that picture. He seems to have had some trouble with the perspective in several places, which is partly responsible for the levitating chess-board. The colouring shows one of his favourite ranges, coral pinks, cold grey blue, and sandy yellow; and although he often achieves a very delicate tonality, the paleness here has a peculiar intensity of its own, like a face drained of colour under stress.

170 Reminiscence of Venice 1858
Ink, watercolour and bodycolour on buff paper, 6$\frac{15}{16}$ × 10$\frac{1}{8}$ in, 17.6 × 25.7 cm
Inscr. top left: 'Reminiscence of Venice. from a sketch made on the spot in 1842. by Rd. Dadd. Bethlehem Hospital. St George's in the Fields. Feby 15th 1858.'
Exh: *The Victorian Vision of Italy*, Leicester Museums and Art Gallery, 1968 (92); *Venice Rediscovered*, Wildenstein, 1972 (13)
Prov: Sir Charles Hood to 1870. Christie's 28 March 1870 (307), bought by Holl. G. Railland to 1934.
Laing Art Gallery and Museum, Newcastle upon Tyne, purchased 1934

Dadd was in Venice for about a week in August 1842, leaving on 10th, and must have made the sketch for this picture during that period. A single stray drawing of Venice, quite different from this, is found on f.243 of the V. & A. sketchbook (No. 73), which does not otherwise cover Italy at all; and Dadd may have had other drawings in Bethlem with him from the first month of the journey. It is characteristic that his 'reminiscence' of the city should express itself in the smoothly curved hulls and fragile rigging of her shipping, and in the play of light on ruffled water, rather than in architectural riches. It is an intensely personal study, full of reflective tenderness. In this as in the other views and landscapes which he worked up from the sketchbook, many years after he had passed out of the world in which they existed, Dadd makes no attempt to recapture the actuality of the colours. He uses a uniformly cool and delicate tonality, with washes of pale blue and grey, sometimes as here, on buff paper and highlighted with white, so that they seem truly to be seen through the gentle haze of memory, while the outlines still retain all their sharpness and clarity. On the stern of the boat in the near right foreground, the *Santa Anna*, a pentacle is drawn after the name: this may be another example of Dadd's inclusion in some of his works of occult symbols, without apparent relationship to the picture (e.g. in 'Want', No. 157).

***171 Street Scene in Bodrum** 1858
Watercolour heightened with white, 7 × 10$\frac{1}{8}$ in, 17.8 × 25.7 cm
Inscr.: 'Street-scene in Boudroon. the Birthplace of Herodotus. From a sketch made on the spot on Monday. Sept 9th 1842 by Richard Dadd.'

Bethlehem Hospital. St Georges in the Fields. London. April 5th 1858'
Prov: Sir Charles Hood to 1870. Christie's 28 March 1870 (312), bought by Holl. Durlacher Bros. to 1966.
Private collection (not exhibited)

Despite Dadd's care in dating all his work, he is wrong about the date of the original sketch from which this picture was worked up, which he gives as 'Monday. Sept. 9th. 1842', (and similarly mistakes the month in dating another sketch of Bodrum on f. 127 of the V. and A. sketchbook). It is clear from Sir Thomas Phillips's letters that on 9 September (a Friday) he and Dadd were crossing from Greece and that they were in Bodrum on 9 October, which was, however, a Sunday. This is one of a series of watercolour landscapes and views dating from around 1858, which are taken from sketches made during the Middle Eastern journey of 1842–3. The figure in the foreground with his hands behind his back has already been seen, in the earliest oil known to have been painted in Bethlem 'Caravanserai at Mylasa' (No. 97), and the camel also looks familiar from that work.

172 Contradiction. Oberon and Titania
1854–8 (repr. on p.120)
Oil on canvas, oval, 24 × 29$\frac{1}{2}$ in, 61.0 × 75.0 cm
Inscr. on leaf, bottom left: 'Rd Dadd. 1854–1858'; on verso: 'Contradiction. Oberon & Titania. Midsummer Night's Dream. Act. 2. Scene 2. Painted for W. C. Hood. Esqre MD. &c. by Rd Dadd. A.D. 1854–58'
Exh: *Jubilee Exhibition*, City of Bradford Corporation Art Gallery 1930 (468); *Victorian Painting*, Mappin Gallery, Sheffield 1968; *Collectors Choice*, Ferens Art Gallery, Hull 1970 (49)
Prov: Sir Charles Hood to 1870, given to him by the artist. Christie's 28 March 1870 (332A), bought by Holl. Arthur Crossland. Thomas Laughton to 1964. Sotheby's 18 March 1964 (42).
Private collection

This picture was painted for Dr William Charles Hood, the young physician superintendent of Bethlem Hospital whose arrival at the end of 1852 transformed the lives of all the patients (*see* p. 30 and No. 252). Except for a few watercolours, Dadd probably worked almost exclusively on it from 1854 to 1858. The scene represented is the quarrel of Oberon and Titania over Titania's refusal to give up her Indian changeling boy to Oberon to be his page, which actually takes place in Act II scene 1 of *A Midsummer Night's Dream*, and not Act II scene 2, as Dadd has quoted it. On the right Demetrius and Helena have strayed in ahead of cue, although properly they should not enter until the fairies have left. Act II scene 2 contains the scene which Dadd had already painted as 'Titania Sleeping' in 1841; and the play, as well as being the most popular of Shakespeare's works at this time, was a fruitful source for all painters of fairy subjects including Reynolds, Fuseli, and even Landseer[73]. Henry Howard had painted a 'Contention of Oberon and Titania' in 1832 (*see* p. 13), and Joseph Noël Paton painted the same subject for his diploma work in 1846, and exhibited a later version at the Royal Scottish Academy in 1850. It is likely that Dadd would have heard of the success

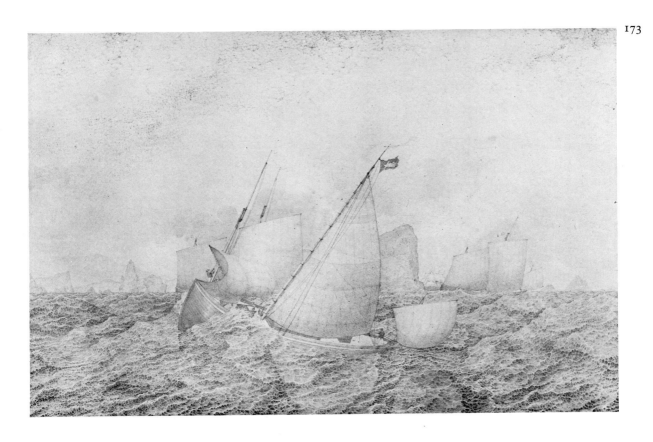

*171

174

*175

of this and also Paton's 'Reconciliation of Oberon and Titania' of 1847, and may have chosen to paint the same passage in defiance of Paton's apparent usurpation of his own former position, as the leading fairy painter of his generation.

Although very different in mood from the earlier fairy subjects, 'Oberon and Titania' is not so far removed from them in terms of composition, and particularly in the features which Dadd had borrowed from Maclise, as might at first appear. A decorative border of foliage still frames the main action, now clinging more closely than ever to the flat surface of the picture, and the recessed alcove which in 'Titania Sleeping' took the form of a cave, becomes the very heart of the picture. The surface pattern is now so elaborate that the design is intricately woven like a tapestry across the whole canvas; but the tightly interlocking shapes are preserved from congestion by endless variations in scale and texture and colour, and by the meticulous precision of the delicate details, each layer of the composition standing out in sharp relief against the layer behind. Within the oval framework there appears a device often used by Maclise, and which Dadd himself was to use again in 'The Fairy Feller', that of raising some of the groups of figures by means of platforms, to maintain a coherent surface. The prodigality of Dadd's imagination in this work seems to be inexhaustible, and besides the obvious inventiveness of the design and of the main characters and their costumes, a host of tiny creatures teem through the foreground and background. In the bottom half of the picture are many kinds of elves and sprites, including soldiers with bows and spears and gleaming shields, a centaur, and fairies with gossamer wings and flowing robes. On the right next to Demetrius and Helena, a party of soldiers are loading a fir cone on to a snail's back, a hint that Dadd had studied the engraving in the *Art Journal* of Huskisson's 'There Sleeps Titania' (No. 250), in which fairy soldiers fight a snail; and further to the right some of the grasses have been tied and plaited into knots. At the bottom left a struggle is going on to prevent Titania from being shot by a grotesque archer, surrounded by hoardes of watchers peering round and over the leaves. Nearer the centre Titania herself, a hulking amazon in contrast to her dainty predecessor of 1841, has trampled a flower underfoot together with its fairy occupant, setting off a flurry of activity in the area. These are just a few of the larger and more obvious figures in the lower half: but many more pursue each other, or merely lurk, amongst the foliage. In the upper part of the picture, a group of revellers including a faun, with musical instruments, are dancing across the top platform carrying the body of a deer, while other fantastic creatures disport themselves on and around the exquisite inventions which lie somewhere between architecture and still-life. Just behind Titania's head is one of the elves who, when Oberon and Titania quarrel, 'for fear, Creep into acorn-cups and hide them there'. Behind Oberon, himself a Syrian sheik like the one whom Dadd had described in his letter to Frith (*see* p. 20), are some of his attendants; and in the distant background, almost in another world, are far-off hills and some kind of fortress. Some of the plants have been brought from the earlier *Midsummer Night's Dream* pictures, including the grasses which

bow their dew-laden heads across the top, convolvulus, and fat toadstools scattered over the ground; others, such as honeysuckle, solomon's seal, harebells and violets, and many more, are new. Also borrowed from the earlier works are the dew drops, now multiplied until they seem to have been poured from a bucket to run down every surface, lying thickly over the leaves, trickling from grass and flower petals, clinging to Helena's gown and hat and sprinkling her foot, and dropping from the wing tips of the fairies. A photograph of Dadd at work on this picture (*see* frontispiece) shows that, as with 'The Fairy Feller', he worked out the whole design and then completed tiny areas at a time; and it can also be seen that in this case he worked upwards from the bottom right-hand side. The picture itself shows some evidence of this method in one or two of the larger leaves, where sections painted at different times show slight variations in colour.

173 The Pilot Boat 1858–9
Watercolour, $11\frac{1}{8} \times 17\frac{3}{4}$ in, 28.2 × 45.1 cm
Inscr. bottom right: 'The Pilot Boat. R.d
Dadd Bethlem Hospital London St. George's in the Fields April 1859. incepit 1858.'
Prov: Sir Charles Hood to 1870. Christie's 28 March 1870 (308), bought by Holl.
Tate Gallery, purchased 1930
Dadd's treatment of the sea in this picture is a development and refinement of the one which he used in 'Christ Walking on the Sea' (No. 109). It is a uniquely personal technique, through which he seems to achieve an almost mystical rapport with the subject: the delicately textured surface is not so much stippled, as scooped out of the water by the brush. Thousands of tiny dimpled hollows and troughs flow together, their crests building up to create wider patterns and rhythms, the swell of large waves and the ripple of small: the result conveys with great vividness, an impression of movement passing across the surface of a vast and static mass of water. Although the boats are shown in realistic detail the scene has an unreal, almost hallucinatory atmosphere: they too are static, trapped as if frozen into the icy blue monochrome of their surroundings; they are as motionless as the grey rocks which mistily reflect their colour, and sometimes their outline too. A characteristic of many of Dadd's pictures is the feeling that all movement, and even time itself, has been suspended by the intensity of his observation, and this is felt here more completely than in any other of the watercolours. In this, however, it is unlike most of his seapieces, which are generally by contrast full of life and immediacy.

174 A Dream of Fancy 1859
Watercolour heightened with white, $3\frac{7}{8} \times 5\frac{3}{4}$ in, 9.9 × 14.6 cm
Inscr. bottom centre: 'A Dream of Fancy. R.dDadd. Bethlem Hospital 1859.'
Prov: G. H. Haydon, probably given to him by the artist; given by Haydon to Myles Birket Foster. Sotheby's 2 November 1966 (198). John Rickett.
Private collection
On a piece of paper associated with the drawing is an

autograph note by the steward of Bethlem Hospital, G. H. Haydon: 'Birket Foster Esq. With Mr. Haydon's compliments'. (Haydon was an amateur draughtsman himself, and the friend of many artists.) In the light of his own work it is easy to see why this delicate little landscape should have been coveted by Birket Foster, who also, significantly, admired the work of J. F. Lewis and the stippled and minutely detailed hedgerow studies of W. H. Hunt.
Dadd used this title again for a completely different subject 'Songe de la Fantasie' (No. 192), and clearly he would himself have thought 'dreamlike' an appropriate description for these delicate watercolours of his later Bethlem period and the years at Broadmoor. This example comes halfway between scenes such as 'Venice' (No. 170), worked up directly from original sketches, and the purely visionary creations such as 'Port Stragglin' (No. 181). While obviously imaginary, it still has the appearance of an identifiable piece of landscape, and may be put together from material in the sketchbook even though having no specific location.

***175 The Good Samaritan** before 1859
Oil on canvas, c. 5 ft. × 10 ft.
Prov: In Bethlem Hospital until 1930.
Whereabouts unknown
This painting hung on the staircase at Bethlem Hospital. The subject was probably chosen as an answer to Hogarth's 'Good Samaritan' on the great staircase of St Bartholomew's Hospital, but Dadd's version was a far more modest affair, and was certainly not a 'fresco' or even a mural, as has been occasionally suggested. It was already hanging in 1859 when it was seen by G. A. Sala and mentioned in the *Illustrated London News*, as 'a vigorous though unfinished painting.'[74] It can be seen indistinctly in an old lantern slide in the hospital's archives. In 1935 a former physician superintendent of Bethlem gave its size from memory as 'about 10 feet by 5 ft.':[75] he understood that it had been left behind when the hospital moved in 1930, but nothing is known of it by the present occupants of the building, the Imperial War Museum.

***176 Richard III after Killing his Nephews**
?before 1859
Whereabouts unknown
H. T. Dunn in *Recollections of Dante Gabriel Rossetti and his Circle*, 1904, records a description by George Augustus Sala of a number of criminal patients whom he had seen in confinement, including Dadd. Amongst the pictures which he was alleged to have seen were one of Job suffering from a plague of boils (*see* No. 177), and 'Richard III, after having slain his two nephews. He was depicted as holding up his sword high aloft, and catching in his mouth the blood drops as they fell'. Allowing for the general level of inaccuracy shown in this whole account, and Sala's interest only in the sensational aspects of Dadd's work, as well as the effects of time on Dunn's memory, it is possible that this picture was actually the Passions sketch 'Hatred' (No. 115). Dunn says that Sala had just come back from a visit to Broadmoor, and his chronology would place the occasion around 1863 (which happens to be the year before Broadmoor was opened for male patients). However, he was obviously unaware that Dadd had ever been in

Bethlem; and as Sala made an extended tour of Bethlem in October 1859 for a long article which he published about the hospital in *The Illustrated London News* of March 1860,[74] it seems more likely that this was the occasion when he saw Dadd. Moreover, on present evidence Dadd was no longer working on violent figure compositions of this kind by the time he got to Broadmoor.

***177 Job Suffering from a Plague of Boils** ?1859
Watercolour
Whereabouts unknown

This was one of the two pictures described by G.A. Sala after his visit allegedly to Broadmoor, but more probably to Bethlem (*see* notes on 'Richard III after Killing his Nephews', No. 176). According to this account Dadd occupied much of his time 'in making designs of the wildest and most ghastly character'; which, considering that he had by now painted 'Oberon and Titania' and was working on 'The Fairy Feller' and several delicate little landscape watercolours which are also unmentioned, shows the general direction of Sala's interest in him. Allowing for this, a grain of salt may perhaps be added to his report that 'the boils were depicted in every stage, and in the most microscopic manner, and he seemed to take a delight in painting them, licking his brush over an extra ulcerous one.'

178 Mother and Child 1860 (repr. on p.122)
Oil on canvas, $19\frac{1}{2} \times 13$ in, 49.5×33.0 cm
Inscr. bottom left: 'R. Dadd. 1860.'
Exh: *Victorian Painting*, Agnew's 1961 (46);
Victorian and Edwardian Decorative Art,
The Handley-Read Collection, R.A. 1972 (B123)
Prov: S.E. Lucas to 1961. Christie's 17 March 1961 (111), with 'Negation'. Mrs Robert Frank.
Charles and Lavinia Handley-Read.
Thomas Stainton

It is not known whether Dadd had ever painted this subject before, nor whether he ever did so again; and there is considerable ambivalence about the iconography. Although the picture is obviously intended to be read at one level as a 'Madonna and Child', there is no certainty that it was specifically painted as such. His habit of superimposing one image on another or juxtaposing two images, so as to confuse the interpretation, has been seen before, most notably in 'The Flight out of Egypt' (No. 104); and here he seems to have left the question deliberately open, as to whether anything more than the chance alignment of the sun's aureole has transformed a mother and child into a madonna and child. The picture has an extreme purity which is characteristic of all Dadd's best work, and the subordinate details, observed here with exceptional sharpness and clarity, are carefully integrated into a restrained design. The almost stern simplicity of the pose is softened by the luxuriance of intricately draped fabrics, the delicacy of the plants offsetting the figure's ample solidity; in the background a pillar emphasises her upright posture, its fluted base picking up the lower tier of her dress; the ivy twines into sinuous curves to echo the hem of her shawl, while the ruffled sea reflects the colour and texture of her skirt. In the puffed out feathers of the never-to-be-forgotten bird, a single patch of darker tonality gives emphasis to the

pure clear colours. There is a strong feeling of Nazarene influence in this picture, particularly in the colouring, and Dadd is known to have visited the studio of Overbeck when he was in Rome in 1843,[76] and was leaning towards Germanic ideas before that date. The child is comparable with the children painted by P. O. Runge, especially, perhaps, the baby in 'The Hulsenbeck Children'.

179 Negation 1860
Oil on canvas, $20 \times 13\frac{1}{2}$ in, 50.8×34.3 cm
Inscr. bottom left: 'Rd Dadd. 1860.';
verso: 'Negation|Rd Dadd.|1860'
Prov: S.E. Lucas to 1961. Christie's 17 March 1961 (111) with 'Mother and Child'. Mrs Robert Frank.
Mr and Mrs Paul Mellon, Upperville, Virginia

This picture belongs to a group, e.g. 'Contradiction. Oberon and Titania' (No. 172), and 'Mercy. David Spareth Saul's Life' (No. 123), which illustrate a one-word abstract idea, but differs in apparently having no external narrative theme. The 'Negation' of the title seems to lie simply in the child's refusal, or his mother's refusal on his behalf, of a proffered fruit. The painting is known to the writer only through a black-and-white photograph. It appears to be related to 'Mother and Child' (No. 178) of the same year; the seated girl with a jug is probably inspired by the same model, whether real, imagined or from some pictorial source, and the children too have something in common. Much of the detail echoes earlier works: the meticulously observed foreground and rocky stream can be traced back to 'The Flight out of Egypt' (No. 104); the tall grasses on the cliff edge, and sparkling drops of water which roll down the jug's side, have been seen as long ago as the first fairy paintings; the features of the right-hand girl can be found in the face of one of the lady's maids in 'The Fairy Feller's Master-Stroke' (No. 190) and also, to some extent, of the ostler. Dadd's preoccupation with ever more complicated folds, flounces, and drapery, can be seen in the women's huge shawl collars and soft dresses: but sometimes his insistent precision produces a more artificial, almost stylised pattern, as seen here in the regularly fluted gathers of the child's frock and the skirt of his mother. This is perhaps related to the obsessional interest in neat frills and ruffs, which often, and sometimes inappropriately, adorn his figures.

180 ?Cupid and Psyche ?c.1853–60
Oil on board, $6\frac{3}{4} \times 4\frac{7}{8}$ in, 16.2×12.4 cm
Visitors of the Ashmolean Museum, Oxford,
presented by E.R. Meatyard 1939

The subject of this puzzling picture has been identified as Cupid and Psyche, though Dadd himself does not seem to have made this entirely clear. In the legend, which appears in Apuleius's *The Golden Ass*, Cupid falls in love with Psyche, a King's daughter, and visits her nightly but remains invisible and forbids her to see him. Stealing a look one night, she spills hot oil from the lamp on his shoulder, and he leaves her.
The stone balustrade and the plants which appear over its top, and the handling of the softly draped fabric, would suggest a date of around the same period as the 'Mother and Child' (No. 178) of 1860, though the gold

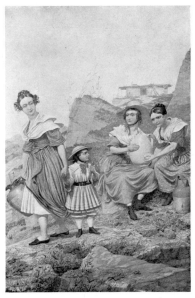

179

vessel recalls the amphora in 'Splendour and Wealth' of 1853 (No. 117), in which there is also a diamond-patterned floor. That work also contains a couch with ornate supports, though nothing so fantastic as the single foot which so unexpectedly emerges here, exactly repeating the position of ?Psyche's own foot. In the arrangement of the drapery Dadd seems to have recalled his early fairy painting 'Titania Sleeping' (No. 57), in which he has created a very similar shape but in reverse, in the drapery on which Titania is resting.

181 Port Stragglin 1861

Watercolour, $7\frac{1}{2} \times 5\frac{1}{2}$ in, 19.0 × 14.0 cm
Inscr. bottom left: 'R^d Dadd 1861';
verso: 'General View of Part of Port Stragglin –
|The Rock & Castle of Seclusion.|and the|
Blinker Lighthouse in the Distance.|not sketched
from Nature.|by R^d Dadd. 1861|Jan^y Finit.';
top and bottom edges on verso: 'Not a bit like it.';
'[. ?.] style sit[?]. very'; 'What a while you are!';
'Of course it is!!'; 'I don't like it. No'
Trustees of the British Museum, Given in
memory of Robert Ross 1919

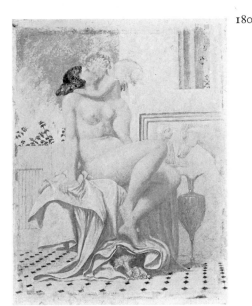

180

The inconsequential remarks which Dadd has written on the back of this picture carry an additional sense of strangeness for being found associated with a work whose essence lies in its perfect control. It is perhaps the most poetical, the most intensely visionary of all his watercolours. Much of its character is found in contrasting effects: the fugitively delicate colour is pinned down by minutely sharp and precise drawing; the vast and brutally solid expanse of rock and fortress dominates a cluster of tiny houses and frail spiky masted ships, but all are bathed in the same softly luminous haze which leaves, in the words of Laurence Binyon, an enduring impression of an extraordinary tenderness;[77] the whole town is a vision of pure fantasy, but realised with the certainty of one who has walked its streets and bridges and quaysides.

The precipitous rockface is a powerful symbol in many of Dadd's later drawings, though it does not always carry the same meaning: here it seems to stand for his own isolated seclusion in the impregnable fortress of his asylum. Despite the obviously truthful assertion that it is 'not sketched from nature', the scene is distilled from many half-recognisable elements. The rock and parts of the town are probably based on memories of things seen during his travels, while the cluster of buildings at the foot of the rock, with a stack of timber on the left, is reminiscent of the dockyard area of Chatham. Much of the shipping too, including the large fully rigged men-of-war, could have been seen on the Medway. The Blinker Lighthouse, similar in idea to the 'Angel Rock and Lighthouse' of 'Patriotism' (No. 165), may be inspired by the Eddystone Lighthouse, which he could have seen during visits to the Plymouth area, where the family had connections. Robert Ross, who greatly admired this picture in which he had a part share through his association with the Carfax Gallery, was keenly interested in Dadd and his work. He visited Broadmoor sometime after Dadd's death in order to learn more about him.[78]

181

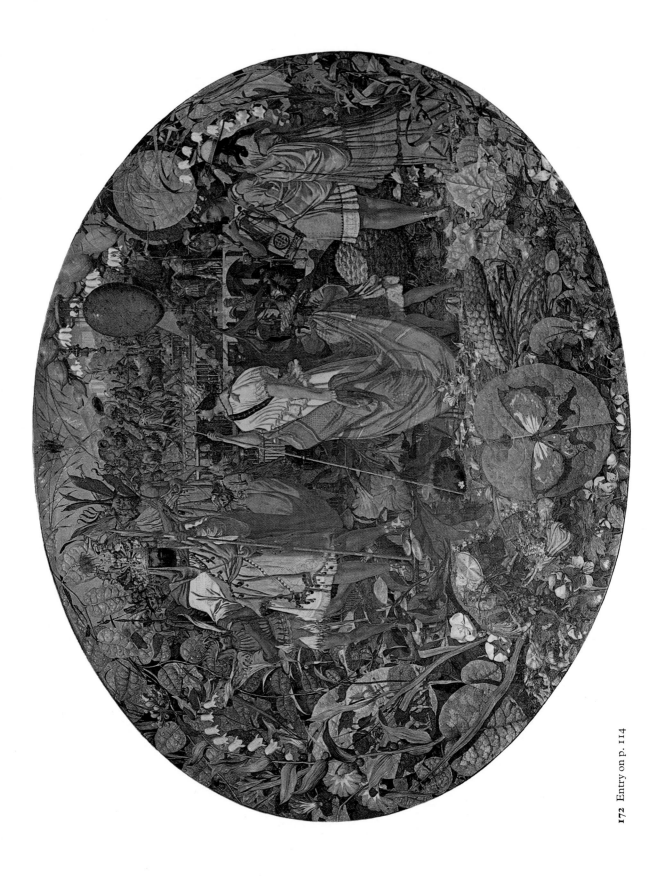

172 Entry on p. 114

***182 Sailing Ships** 1861

Oil on panel, 7¾ × 21 in, 19.7 × 53.3 cm

Inscr. bottom left: 'R^d Dadd 1861'

Exh: Virginia Museum of Fine Arts, Richmond 1963 (162): Royal Academy Winter Exhibition 1964–5 (132); Yale 1965

Prov: Mrs Arthur Clifton to 1961.

Mr and Mrs Paul Mellon, Upperville, Virginia (not exhibited)

This painting is known to the writer only from a monochrome photograph, but it appears to be a companion to 'The Diadonus' (No. 183), and like 'The Diadonus' it is something far more than just a marine painting. In an atmosphere of frozen calm, the hard flat surface of the sea holds all movement in suspense. As in 'Venice' (No. 170) and other pictures, the surface is delicately textured in a pattern of scooped-out hollows, but here its rigidity matches the rigid unreality of the spectral ships. The whole image haunts the imagination like a passage from Coleridge's 'Ancient Mariner', a faithful record of the haunting of Dadd's own imagination by the subject of ships and the sea, throughout his long incarceration.

183 The Diadonus 1861 [? and 1862]

Oil on panel, 7⅞ × 21⅛ in, 20.0 × 53.8 cm

Inscr. bottom left: 'R^d Dadd. 1861'; verso, centre: 'The Diadonus advancing backwards & giving|a heavy lurch to windward. wind due|– NORTH.–'; verso, bottom right: 'Richard Dadd |Bethlem Hospital|Feb^ry 1862.'

Private collection

This appears to be a companion picture to 'Sailing Ships' (No. 182), making with it a pair of calm sea and rough sea studies. The rather jocular inscription may be a skit on more conventional marine paintings recalled by Dadd from his youth, but the picture itself is a serious, almost mystical evocation of the subject about which he felt so deeply. Though a work of pure imagination, it has nevertheless the vitality and immediacy of actual experience: the sea, driven by the gale, breaks furiously over half-submerged rocks in the foreground, while in the middle distance ships of many kinds – and to the right of centre, the warship Diadonus – stand-to or are driven with the wind. Their frailty contrasts with the stability of the massive rocks, and the fort seen on the horizon to the right; and in the afterglow of sunset, which throws a veil of pale rose across the sky, they are like the phantom vessels of a dream.[79]

182*

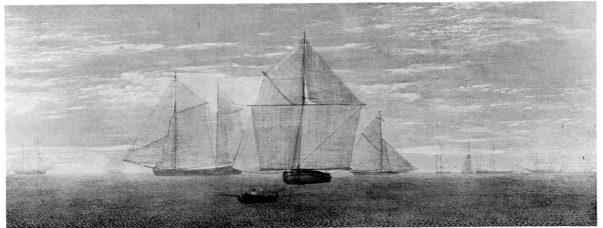

183

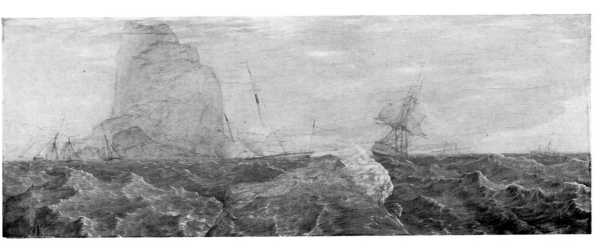

178 Entry on p. 118

184

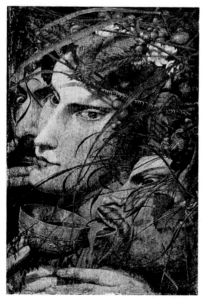

184 Bacchanalian Scene 1862
Oil on panel, 14 × 9½ in, 30.4 × 24.1 cm
Inscr. on verso: 'Est suum cuique dunc dictum|
Transupra et ecce sinistrum|Simile similibus
addendum|Daemoni date debendum m m m
[trailing off in a series of decreasing 'm's]|1862'
Private collection

The support of this picture seems to be a utilitarian
wood panel which might have been part of a door, and
is painted on the back either in connection with its
former use, or to counter-balance the tension from the
picture surface and prevent warping.

The painting was formerly known as 'Circe'. The sub-
ject is obscure, but the head of the satyr seems to be a
reference to Rubens's 'Triumph of Silenus' in the
National Gallery. The latin verse can be translated
(allowing for some confusion in the last line): 'Each
man then has his own unlucky fate both here and
beyond – like must be added to like and one's due paid
to the appointed spirit'.[80] It is repeated round the bowl
of the goblet. The first part at least is in keeping with
Dadd's fatalist philosophy as he had already explained
it for Dr Wood (*see* p. 22), saying that he could not
separate himself from what appeared to be his fate, and
also: 'Now the author of this act [the murder] is un-
known to me, although, as being the cat's-paw, I am

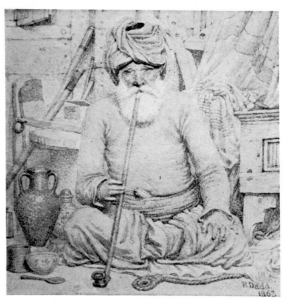

185

held responsible.' Stylistically the painting is closest to 'The Fairy Feller's Master-Stroke' (No. 190) and 'Oberon and Titania' (No. 172), and has almost the appearance of being a detail out of some larger work: though the arrangement of the grasses which, as in 'The Fairy Feller', define the picture plane, leaves no doubt that it is complete. It is a picture full of mystery and enchantment.

185 A Turk 1863
> Watercolour, $2\frac{1}{2} \times 2\frac{1}{2}$ in, 6.4×6.4 cm
> Inscr. bottom right: 'R Dadd.|1863'
> *Tate Gallery*, presented in memory of H. B.
> Hagreen by his children

Nothing quite comparable with this in size and texture is known from the rest of Dadd's eastern subjects, though in content it has affinities with 'Eastern Letter Writer' (No. 186) of the same year, and stylistically it resembles the Egyptian 'Fantasies' (Nos. 194-5) of 1865. The colours too, coral, and palest yellow-buff and blue, with a tiny speck of red in the top of the fez which shows through the swathed turban, have all been seen before, but have rarely been used with quite this degree of delicacy. Several studies of similar seated figures can be found in the V. & A. sketchbook (No. 73), and there must have been others in the book which Dadd had with him in Bethlem and from which this must have been directly taken.

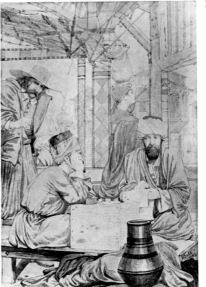

186*

***186 Eastern Letter Writer** 1863
> Watercolour, $11\frac{3}{4} \times 8$ in, 29.8×20.3 cm
> Inscr. on end of bench, bottom right:
> 'R. Dadd-|1863-'
> Prov: Mrs Robert Frank.
> Whereabouts unknown

Date and subject place this watercolour in a series with 'A Turk' (No. 185), the main figures probably being taken directly from the sketchbook. There is also a study of a letter writer on f. 93 of the V. & A. sketchbook (No. 73).

187 Arab Ambush 1864
> Watercolour, $14\frac{3}{4} \times 11\frac{3}{4}$ in, 37.4×29.8 cm
> Inscr: 'Rd Dadd. 1864.–|Bethlehem
> Hospital|St George's in the Fields'
> Prov: Mlle M. C. Berger to 1962.
> *Private Collection*

The figures in this picture seem to look forward to the two Egyptian 'Fantasies' of 1865 (Nos. 194-5); but in style it has more of the solidity of the 'Passions' sketches as well as much of their familiar background material, in which there are links with work from as far back as 'Polyphemus' (No. 107). The boulder with hands pressed against it also recalls, besides 'Polyphemus', the 'Flight of Medea with Jason' (No. 153), and the vegetation is to be found in several earlier works, for example 'Landscape with Bull Calf' (No. 168). On the face of it, the picture seems to be something of an isolated retrospective work; but this reinforces the belief that a great deal of Dadd's work is still missing, and that more of it would probably show him working throughout his life in various different styles concurrently, to a far greater extent than can now be seen.

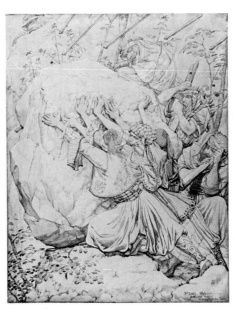

187

188

189

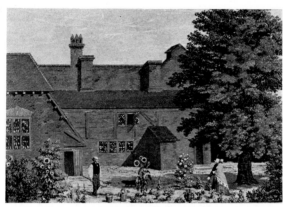

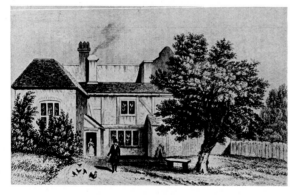

Pope's House, Binfield, from Dugdale's,
England and Wales Delineated, 1854

188 Night and Day 1864
Watercolour, segmental, 5¾ × 13⅝ in,
14.7 × 34.6 cm
Inscr. bottom right: 'R^d Dadd. 1864.'
Visitors of the Ashmolean Museum, Oxford,
purchased 1939

This work is dated from the year of Dadd's removal
from Bethlem to Broadmoor, and might have been
painted in either hospital. Though the central figure
(perhaps showing the influence of Blake) plainly repre-
sents Time, and the groups on either side symbolise
Day and Night, it is not certain whether any further
allegory is intended. The figure of the girl with cymbals
on the left was used thirteen years earlier for the palm-
bearing angel in 'Dymphna Martyr' (No. 105), and is
also reminiscent of some of the fairies in 'Oberon and
Titania' (No. 172).

189 Pope's House (known as The Gardener)
before 1864
Oil on millboard, 8¼ × 12 in, 20.9 × 30.5 cm
Exh: *The Victorian Romantics*, Leicester
Galleries 1949 (65); *Victorian Painting*,
Agnew's 1961 (47); *Collectors' Choice*, Ferens
Art Gallery, Hull 1970 (48)
Prov: Given to Mr Shields by G. H. Haydon,
steward of Bethlem Hospital, c.1880; by descent
to his son Arthur E. Shields. J. Bomford in 1949.
Tom Laughton to 1964. Sotheby's, 18 March
1964 (41).
Private collection

The picture was given in the 1880s by G. H. Haydon,
steward of Bethlem Hospital, to Mr Shields, whose
family firm had supplied the hospital with furniture for
over sixty years, and was found in a locked box after
his death. According to his son, 'When I first found it
there was an old faded label on the back stating it was
by Dadd and "Pope's house at Twickenham"';[81] but
it is in fact taken from an engraving of Pope's house at
Binfield, published in Thomas Dugdale's *England and
Wales Delineated*.[82] The proximity of Binfield to
Broadmoor may be coincidence, since the picture must
have been painted before Dadd left Bethlem in order to
have come into Haydon's possession; though the
approaching move to Broadmoor was known several
years in advance and Dadd could have become in-
terested in the locality beforehand. The view of the
house is almost identical with that in the engraving,
with some correction to the perspective, though the
orderly garden, in which most of the plants are growing
in pots, and the figures in the foreground, are Dadd's
own invention. The colouring is naturalistic. The
figure of 'the gardener' is interesting, since he closely
resembles Dadd's father, and his association here with
sunflowers may have some symbolic significance.
During the height of his illness in France, Dadd appears
to have been much pre-occupied with the sun, and also
with identification of his father (*see* p. 26): and an
exaggeratedly large sunflower plant also features,
dominantly, in the 'Portrait of a Young Man' (No. 112).
The picture seems to hark back stylistically to some of
the works of Mulready, and may be compared with his
'The Farrier Shop'.[83]

190 The Fairy Feller's Master-Stroke

quasi 1855–64 (repr. on p.131)

Oil on canvas, 21¼ × 15½in, 54.0 × 39.4cm

Inscr. on verso: 'The Fairy Feller's|Master-
Stroke-|Painted for|G. H. Haydon. Esq^{re}|by
R^d Dadd|quasi–1855–64'

Exh: Ashmolean Museum, Oxford 1935–37 (as
'A Fantasy'): *British Romantic Painting*, Paris,
1972 (93)

Prov: G. H. Haydon from 1864, given to him by
the artist. Alfred Morrison of Fonthill; by descent
to his daughter Lady Gatty, and to her daughter
Lady Sassoon.

Tate Gallery, presented by Sir Siegfried Sassoon
in 1963, in memory of the painter's great-
nephews Julian, Edmund and Stephen Gabriel
Dadd.

In a recently discovered MS poem (No. 193) Dadd
explains how he came to paint this picture for 'an
official person', evidently G.H. Haydon the steward of
Bethlem Hospital; who, after seeing 'Oberon and
Titania' (No. 172), expressed a wish for something
similar for himself. Either that or (Dadd is not quite
sure), Haydon had a friend who wrote fairy poetry, and
asked for a sketch to illustrate some verses, from which
the whole thing grew. The date 'quasi' 1855–64 seems
to be explained in the opening lines of the poem. Dadd
says that this all happened 'Half twelve, that's six, 'tis
more | Perhaps . . .' years ago: but this was written in
1865, which would have made it ten years ago if the
1855 date were correct. It is probable that he genuinely
could not remember when he had begun the painting,
and so, being meticulously precise over dating, added
the 'quasi' to what was only an estimation. However,
in 1855 there would not have been much of 'Oberon
and Titania' (which is dated 1854–8) ready for Haydon
to covet: and anyway it is unlikely that these two ex-
tremely complicated paintings were being carried on
simultaneously for a long period. It is possible, then,
that the date should really be 1857 or 1858–64.

In the same poem Dadd elucidates the subject and
identifies all the characters. The fairy woodman (the
'feller') in the centre foreground, clothed from top to
toe in leather, raises his axe to strike a hazel nut; the
rest of the characters are 'Fays, gnomes, and elves and
suchlike', who have gathered to settle some dubious
point known only to themselves, but are now watching
to see whether he will split the nut with one stroke. In
the centre is a white-bearded old man, the arch
magician, a patriarch with 'triple crown of subtle
might'. The crown looks like a reference to the Pope,
reinforced by the gesture of his right hand as if in
blessing; but Dadd explains this as a command 'Except
I tell you when, strike if you dare'. In his outstretched
left hand he holds a 'large little club', for hitting small
fairies over the head. Along the brim of his hat are
dancers in Spanish costume on the right, and on the
left Queen Mab in a car of state drawn by female
centaurs, with a gnat as coachman, Cupid and Psyche
for pages, and 'some strapping fairy footman' behind.
The group below the patriarch are: on the left two
eavesdropping elves, a fairy dandy making a pass at a
fairy nymph, and the crouching squinting figure of a
pedagogue, a critic whose 'business is to teach to do. |
Do it himself? Oh! no! tis you.'; directly below, in

pink, a politician 'with senatorial pipe', and seated on
his right a well shod clod-hopper with a satyr's head, a
'modern fay'. In the group to the right of the Fairy
Feller are an ostler from the fairy inn, watching intently
with hands on knees; behind him a dwarf monk, more
likely to attain the nether regions than heaven, and
well acquainted with inns and ostlers; above these two,
a good-humoured ploughman makes sage remarks to
the indifferent 'Waggoner Will', whose head appears
just below the axe. To the right and slightly above this
group are two fairy men-about-town who live by their
wits. To the far side of the magician stand two ladies'
maids, one holding a mirror, the other with a broom in
one hand and her favourite hawkmoth perched on the
other: their bulging calves and tiny feet, and the huge
breasts of the girl on the left, shaped like the pointed
end of the hazel nuts and straining against her bodice,
provide an overtly erotic element which is extremely
rare in Dadd's work, and is emphasised by the pre-
sence of a leering satyr whose head appears just by the
elbow of the crouching pedagogue, peering under the
skirts of the right-hand girl. Below and to the left are a
pair of rustic lovers, Lubin, a tanner and 'Chloe or
Phyllis' a dairymaid; further down are two dwarfs, the
man being a conjuror who at present is taking odds on
whether the nut will be split, and to his right is a spider
who is a master weaver and employs lesser spinners.
Directly above the magician, Oberon and Titania
watch the scene, watched in turn by an old lady in a
scarlet cloak: and above and reading from left to right
are the childhood favourites, soldier, sailor, tinker,
tailor, ploughboy, apothecary, thief, the apothecary
looking somewhat like Robert Dadd sen. Over to the
left are a dragonfly trumpeter (who looks very like a
grasshopper), assisted by 'a tatterdemalion and a
junketer, Holiday folk'; and below the dragonfly an elf
peeps through the grasses at the spectator, showing
apparently by his hat that 'Of the Chinese Small Foot
Societee, He's a small member'. The 'pendants' which
trail from the patriarch's crown and wind about the
picture 'represent vagary wild, | And mental aberration
styled.|Now unto nature clinging close | Now wildly
out away they toss. . . .': their purpose is to bring grace
to the picture, but eventually they are tied down to a
stem. Dadd asks the benefit of the doubt over the size of
the nuts, as he does not know what size fairies grow to.

This painting is the most completely fantastic of all his
works, having no external narrative source. Its atmos-
phere is one of trancelike intensity, which holds all the
figures motionless and isolated, not only from the
spectator, but from each other. Dadd's own account in
the MS poem of how the picture was actually con-
ceived, goes far to define if not to explain the quality of
this atmosphere. He says that imagination would not be
deliberately invoked; so he gazed at the canvas and
thought of nothing, until pure fancy began to give form
to the cloudy paint which he had already smeared
over it: and there is certainly a feeling that all the
characters have been, not so much invented, as con-
jured out of the shades by the sheer effort of concen-
trated observation. The sense of each one as a powerful
presence in his or her own right is only confirmed by
the detailed explanation of who they all are; and
although this is interesting and amusing it is also in a
way irrelevant, in that it neither adds to nor detracts

from their independent existence. Although Dadd lightly suggests that the design and composition simply grew on the canvas, 'Now minus and just here perhaps –plus', it is of course one of the most intricate and carefully worked out of all his creations, conforming to many of his previous practices but with new and highly inventive variations. The flat decorative border used in 'Oberon and Titania' and in the earlier fairy pictures, is here replaced by the enmeshed timothy grasses which sweep diagonally across the surface of the picture, and which frame it also at the sides and back. We peer through them, as if into a glass-fronted box: but at the top left-hand corner the grasses from the front rise to meet those from the back like their own reflections in a mirror, flattening the space between into a mysterious no-man's-land where the ordinary rules no longer apply. Scale and perspective shift, constantly and fluently, from one part of the picture to another, adding to the impression that we are looking in on an enchanted world. Within this shallow but ambivalent box-like structure, many subsidiary compositions are all linked into the major design. In the lower half of the picture the figures are grouped independently into an oval; those at the top, helped out by a few daisies, form a less symmetrical ellipse; the brim of the patriarch's hat, extended by grasses on the left-hand side, makes a boat-like shape which carries the whole of the upper part of the picture; the two pairs of larger figures counterbalance each other on either side; flowers and grass make their own independent arabesques; a vertical line can be traced down the exact centre of the picture from the tinker's grinding wheel to a plane fruit lying below the Feller's left foot; the four corners are closed off by diagonals; these are just a few of the elements of surface pattern which can be found in endless combination and permutation, within the main design. This follows a serpentine path from the bottom right-hand corner backwards and forwards across the picture, ending at the top left with the dragonfly's long bugle. As it climbs the path recedes by means of a series of platforms, on which the main figures are grouped; while extra-terrestrial devices such as the leaf supporting Oberon and Titania are effortlessly superimposed, defying the very concept of a three dimensional world. The grey-green colouring with its dull leaden gleam produces a slightly congested effect, offset by the clearer colour in the dresses. This also helps to strengthen the impression of a world existing in another dimension, where time has been solidified. The figure of the patriarch, and the flowing line of his hat, seem to have been suggested by Blake, particularly such works as 'The House of Death' and some of his 'Book of Job' illustrations. A few of the figures are familiar from Dadd's earlier works: the two girls are recognisably the 'lazy queanes' from 'Robin Goodfellow' (No. 69), and the two elves and the stance of the Fairy Feller himself come from the same source; the Fairy Feller also, at least in his hairstyle, has a look of Dadd in his early self-portraits; the ostler's features can be found in 'The Flight out of Egypt' (No. 104), his pose in 'A Curiosity Shop' (No. 132); the men-about-town are also characteristic Dadd types: but overall this picture has no real precursors anywhere in his work. Even the technique is unfamiliar, particularly in the pebbled ground and some of the plane fruits, which

are built up to an embossed finish with tiny individual lumps of paint. The picture is incomplete, and some of the hazel nuts, the Feller's axe, and a part of the swirling pendants are only sketched in. From this it can be seen that Dadd's method of tackling such a complicated painting was to work out the whole design in considerable detail in monochrome, and to finish small sections at a time, completely and independently: also that, at least sometimes, he worked from foreground to background, and at all points in between.

A part of the initial idea for this picture may have come from Dadd's recollection of a poem called 'To the Grasshopper' by John Brent, which had been published in the *Kentish Coronal* for which he had designed the frontispiece in 1841 (No. 51). Besides a reference to the 'bugle-winding Gnat', which may have become transformed into the (alleged) dragonfly, the poem contains the lines 'Deep shade thou lovest, and the arching grass,| With glimpse of fairy folk the stalks between'.

191 Portrait of Charles Neville after 1853
Chalk and charcoal, oval, 27 × 21 in,
68.6 × 53.4 cm
Prov: By descent from the sitter to his great grandson
Dr R.C. Neville

Charles Neville came to Bethlem Hospital as head attendant in 1853 from Colney Hatch Asylum, where he had worked with Dr Charles Hood who now came to Bethlem as Physician Superintendent. When the new criminal lunatic asylum was opened at Broadmoor in 1864 he transferred there, and it is not known whether this portrait was drawn in Bethlem or Broadmoor.[84] Neville also owned 'The Child's Problem' (No. 169), which may have been given to him by Dadd. This portrait is Dadd's only known attempt in this medium and style, and cannot be considered entirely successful.

192 Songe de la Fantasie 1864
Watercolour on ivory board, 15 1/16 × 12 3/8 in,
38.3 × 31.4 cm
Inscr. top left: 'Songe de la Fantasie.|
R^d Dadd Nov^r 1864.'
Prov: 'EWB', *c.*1864, given to him by the superintendent of Broadmoor.
Fitzwilliam Museum, Cambridge, found in the museum in 1947, provenance unknown

A label on the back of this picture reads: 'Painted by R^d Dadd | an artist of | great promise who | murdered his father & was | imprisoned at Bedlam: | EWB saw him there at | work on "Saul in the Trenches | he was then removed | to Broadmoor, & Dr. Meyer | gave this to EWB (the | actual picture *not* an engraving)'. 'EWB' has not yet been identified, but he must have visited Bethlem around 1854, the year in which Dadd finished 'Mercy. David Spareth Saul's Life', which is obviously the 'Saul in the Trenches' mentioned here. The visitors' book for that period does not show anyone with these initials. Dr John Meyer (1814–70) was the physician superintendent of Broadmoor Hospital, holding the post from its first establishment until his death (which was hastened by a blow received from a patient in 1866).

Dadd painted this replica of 'The Fairy Feller's Master-Stroke' within four months of his arrival at

Broadmoor, having left behind the not quite finished painting at Bethlem for G.H. Haydon. Clearly he was still very much involved with the picture, and the following January wrote the poem in which he 'eliminates' its meaning (No. 193). The watercolour might have been made at the request of someone such as Meyer, either for himself or for 'EWB', or Dadd may just have been reluctant to leave the subject with which he had lived for so many years, and had never finished. It is a remarkably faithful reproduction in general terms, and most of the differences of detail are minor variations attributable to the fact that he was working from memory and in a different medium. Some, however, such as the fact that the grasses are now in flower, and the great proliferation of calligraphic swirls across the surface, as well as the completely different colour and tonality, suggest that he did not intend to make a literal copy but rather a translation into another style and mood. The change in the name would seem to bear this out, indicating that it is intended to look like, as well as to be, a dream or memory of the original. This title was evidently one which appealed to Dadd, as he had already used it for a small landscape, 'A Dream of Fancy' (No. 174). 'Wandering Musicians' (No. 211) is the only other work known to have been produced in both oil and watercolour, and in that case the two versions are truly identical.

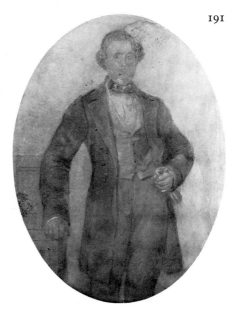

193 Elimination of a Picture & Its Subject – Called the Feller's Master Stroke 1865
Autograph manuscript, signed and dated:
'Rd Dadd. Broadmoor, Jany 1865.'
Written in a notebook, 24ff., 7⅝ × 4⅝ in,
19.3 × 11.7 cm
Prov: The Rt Hon. The Lord Margadale of
Islay to 1972. Christie's 20 December 1972 (183).
Sarah and Alistair McAlpine

In this long, rambling and sometimes incoherent poem Dadd explains the action in his painting 'The Fairy Feller's Master-Stroke' (No. 190) and digresses on a number of subjects, some tenuously related to it, and some which seem to have slipped in while no one was looking. While he is describing the picture and the characters in it the sense emerges quite clearly, even through some patches of rather tortured syntax, and a full identification has been given in the notes at No. 190: but elsewhere, although it is usually obvious what he is talking about, it is not always so certain what exactly he is saying about it. Little of the verse holds together for very long under close scrutiny, even where the meaning is obvious, though a good deal of it could fairly be described as bad rather than mad: but some of the wilder passages suggest that he has become so involved in personal preoccupations that the medium has simply got out of control. The provenance of the notebook shows that it was formerly kept together with the painting, though the poem was written after Dadd had moved to Broadmoor and left the picture behind with Haydon. It might have been sent to Haydon, or the two may have been united by a later owner, but there is no way of telling whether it was written for Dadd's own satisfaction, or at the request of someone else; nor why he chose to write in verse, though he seems to have shown some inclination for this many years before (*see* Walpurgis Night' etc., No. 71). The

192

use of the word 'elimination' in the title is open to speculation, and it could be suggested that Dadd intended something significant by it, perhaps trying to convey that by explaining, he was somehow eliminating the picture from his mind: but in view of his fondness for punning and word play shown elsewhere, for example in one of his early letters to Frith, a likely explanation is that it is a play on some word such as 'illumination', or 'elucidation'. It could even be a simple mistake. Because of the poem's length, and the combination of triviality and incomprehensibility which is intermingled throughout with the more interesting passages, it is only possible here to include a few quotations to give the flavour of the whole. (For about half its length the text is set out conventionally: after that, probably to economise on space, the lines run on, but are still identified by capital letters for the beginning of each new line.) The opening lines, beginning an account of how and when the picture came to be painted, provide an example of the more straightforward style:

> Half twelve, that's six, 't'is more
> Perhaps, exact that's gone before
> Behoves not here to say,
> How many years away
> Have welled up and flowed on
> Slow passing till they're gone.
> But some such time has fled
> Since regular business led
> To where a canvas glowed
> With fays, ...

A little further on Dadd recounts how, having been asked by Haydon for a fairy painting and having a canvas already prepared:

> I thought on nought – a shift
> As good perhaps as thinking hard.
> Fancy was not to be evoked
> From her etherial realms
> Or if so, then her purpose cloaked
> And nuzzling the cloth, on which
> The cloudy shades not rich,
> Indefinite almost unseen
> Lay vacant entities of chance,
> Lent forms unto my careless glance
> Without intent, pure fancy 't'is I mean
> Design and composition thus –
> Now minus and just here perhaps – plus –
> Grew in this way – and so – or thus,
> That fairly wrought they stand in view
> A Fairy band, much as I say, just so 'tis true.

The description of all the characters in the picture begins with a typical passage, in which the words seem suddenly to run out of hand, and as suddenly return to their previous pedestrian level:

> But to the common mind
> The meaning thus, let's find –
> For idle pastime hither led
> Fays, gnomes, and elves and suchlike fled
> To fix some dubious point to fairies only
> Known to exist, or to the lonely
> Thoughtful man recluse
> Of power a potent spell to loose
> Which binds the better slave to worse
> Swindles soul, body, goods & purse
> T'unlock the secret cells of dark abyss

> The power which never doth its victim miss
> But may egorge when truth appears
> When fail or guns or swords or spears
> For some such end we may suppose
> They've met since day hath made its close ...

The subject of victimisation was one which always excited Dadd, and can be seen to rear its King Charles head in the long, and generally far better balanced, text in the picture 'Patriotism' (No. 165). Occasional epigrammatic passages stand out amidst the surrounding chaos, such as this which comes shortly after an exceptionally banal section about the arch magician and his habit of hitting fairies on the head with his club:

> 'Tis so – no doubt, but even Almighty Power
> Suffers defeat each day & every hour
> As unforeseen some little trifling thing
> Cheats of a stave, another song we sing

In general the descriptions of the characters are the most lucid parts of the poem, and the biographical information about them, while doing little to deepen an understanding of the picture, is often entertaining and sometimes tinged with satire:

> The Politician next, with senatorial pipe.
> For argument or his opinion ripe.
> A First chop Englishman at that sort of chaff.
> To hear him talk, Lord! how 't'would make you laugh.
> For fairy politics differ so very wide
> From human governments complete divide.
> He's pondering matters now as if his vote,
> Ought to be given ere 't'is smote.
> The nut – I mean –

Occasionally, there is a dim light thrown on Dadd's thoughts about problems which do not relate specifically to his own state of mind. Here he refers, though somewhat obliquely, to the subject of life in Bethlem without women: he is talking about the head of the satyr who is seen near the foot of one of the lady's maids and looking under her skirt:

> ... under the leg
> Of one of those maids, behind his back,
> A satyr peeps; at what, it doth not lack,
> An explanation. At such a book,
> His right to look,
> I care not to dispute.
> Such secrets surely some must know.
> All are not saints on earth below.
> Or if they are they know the same.
> Or are shut out from natures game.
> Banished from natures book of life,
> Because some angel in the strife,
> Had got the worser fate.
> And they close their eyes, that gate –
> By which reminders enter.
> And in a paradise of fools contented live.

Quite the best part of the poem is found in two passages in the last page. The first is perhaps more coherent than usual because it is concerned with a purely pictorial effect, in which there is no human participation: it is a description of the calligraphic swirls which are drawn across the surface of the picture:

> Turn to the Patriarch & behold
> Long pendents from his crown are rolled,
> In winding figures circle round
> The grass and such upon the mound,

They represent vagary wild
And mental aberration styled.
Now unto nature clinging close
Now wildly out away they toss,
Like a cyclone uncontroll'd
Sweeping around with chance-born fold
Unto the picture brings a grace
Which else was wanting to its face
But tied at length unto a stem
Shews or should do finitam rem-

The ending of the whole poem is undoubtedly Dadd's own master-stroke. One of the strongest impressions left at the first reading is that, setting aside some of the more muddled interpolations, it gives a remarkably detached and objective, if rather trivial, description of the picture quite unrelated to the atmosphere which emanates from the painting itself; telling little about it which could not have been said by any third party who happened to know who all the characters were. But just as the reader is deciding that though the explanation may be interesting and amusing, it really makes little difference to the wholly mysterious impact of 'The Fairy Feller's Master-Stroke', Dadd turns about to say exactly the same himself, in a final quatrain of outstanding elegance:

But whether it be or be not so
You can afford to let this go
For nought as nothing it explains
And nothing from nothing nothing gains.

The last lines could almost be an echo from *King Lear*: 'Can you make no use of nothing, nuncle?' 'Why no, boy; nothing can be made out of nothing'.

194 Fantasie Egyptienne 1865
Watercolour on pale blue-green paper heightened with white, 10 × 7 in, 25.5 × 17.8 cm
Inscr. bottom right: 'Fantasie Egyptienne. par Monsr Rd Dadd. Broadmoor. Berks. Sepr 2nd 1865.'
Prov: Sotheby's 23 November 1966 (263).
Private collection

This and the following watercolour (No. 195) are the only two known works on coloured paper except for the figure compositions on brown paper of the 1850s. The soft misty effect seen in both of them is achieved partly through the very delicate tonality of pale blue, red brown, and sepia and partly by the use of a miniaturist's stipple technique on a slightly enlarged scale, as if it is seen through a magnifying glass; but there is also a minute precision and accuracy in all the drawing, and the combination of these two qualities makes up the unique dreamlike atmosphere. The boats in the harbour, with the butterfly sails of a felucca in the background are particularly sharply observed, as are the architectural details, and probably come direct from the sketchbook. In the V. & A. sketchbook (No. 73), which Dadd did not have with him in Bethlem, are many similar studies. The small craft whose prow can be seen beached against the steps is one for which Dadd had a special affection, and its wide, generous curves are to be found more fully displayed in 'Venice' (No 170). The central character, who bears some resemblance to Sir Thomas Phillips in one of his eastern outfits (No. 83), is given emphasis by the vertical lines of the meticulously rendered brickwork against which

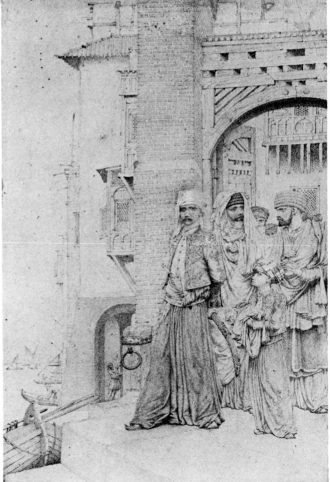

194

he is placed. He is singled out still more specifically by the oars of the boat, which point directly to him from the bottom left-hand corner; and behind him the composition recedes along the same diagonal, traced through the lines of the drapery in the costumes of the other figures. Dadd's habit of writing in French on some of his pictures had been recorded during his earliest days at Bethlem (see p.29), but it is not known whether he continued to do so all his life, or whether the two surviving specimens from Broadmoor show a revival of the practice.

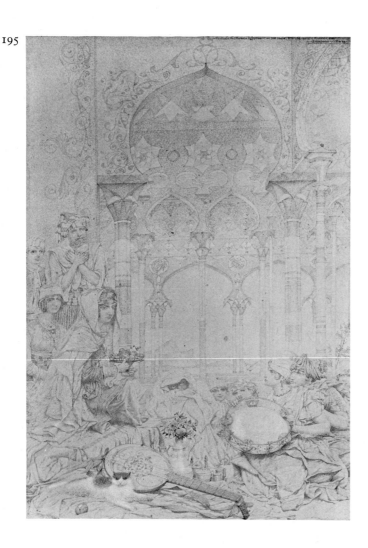

195

195 Fantasie de L'Hareme Egyptienne 1865
Watercolour on pale blue-green paper,
heightened with white, $10\frac{1}{8} \times 7$ in,
25.7×17.9 cm
Inscr. top right: 'Fantasie de l'Hareme
Egyptienne – par Monsr Rd Dadd – quasi –
Octobre – 1865 – | – Broadmoor – Berks –'
Visitors of the Ashmolean Museum, Oxford,
purchased 1935

[Notes supplied by Mr Ian L. Phillips] Here we seem to have passed in imagination into the palace whose gateway appears in the 'Fantasie Egyptienne' (No. 194), completed in the previous month. The eye is immediately taken by an architectural *capriccio*, a fantastic complex of lotus-columned screens pierced and decorated with wilfully sinuous arabesques, a hall whose Moorish arches frame a distant view of a rocky coastline with a sailing boat of the Nile. Beneath this exotic canopy sits a gathering of figures from the harem. To the left sits the Elect of the Harem, holding before her a dish of fruit as she gazes dreamily towards a slave-girl who clasps a tambourine. Behind her to the left is a girl in an embroidered dress, with fair hair curled in ringlets of an early Victorian fashion. Most cryptic of all, the crouching shrouded figure in mid-foreground, with dusky face half-concealed, gazes fixedly at us, the unseen intruders in this private world. The exotic atmosphere of the picture is supported by the mass of rich draperies, together with the grouping of flowers, musical instruments, and – not least of all – the magnificent Persian cat, the luxurance of its fur brilliantly suggested by deft touches of white gouache.

196 The Crooked Path 1866 (repr. on p.133)
Watercolour, $19\frac{1}{2} \times 14$ in, 49.5×35.5 cm
Inscr. bottom left: 'The Crooked Path. by.
Richd Dadd. Broadmoor. Berks. Septr
[?]Lues ab[?al] sinistro [. . .] iosi'
(Inscription damaged)
Trustees of the British Museum

Dadd's increasing preoccupation with high crags and sheer rockfaces can be seen in much of his later work, where they often appear in the background. Here, as in 'The Temple of Fame' (No. 199), the almost unscalable path seems to symbolise an almost unattainable goal, which must be fought for and can only be won at the expense of others. The scene could also represent, in the combat between Roman and Medieval soldier, something of his belief in the pre-eminence of the ancient world over the modern; and the utter defencelessness of all the participants against their hostile, or at any rate indifferent, environment would be in keeping with his belief expressed elsewhere, that each man has

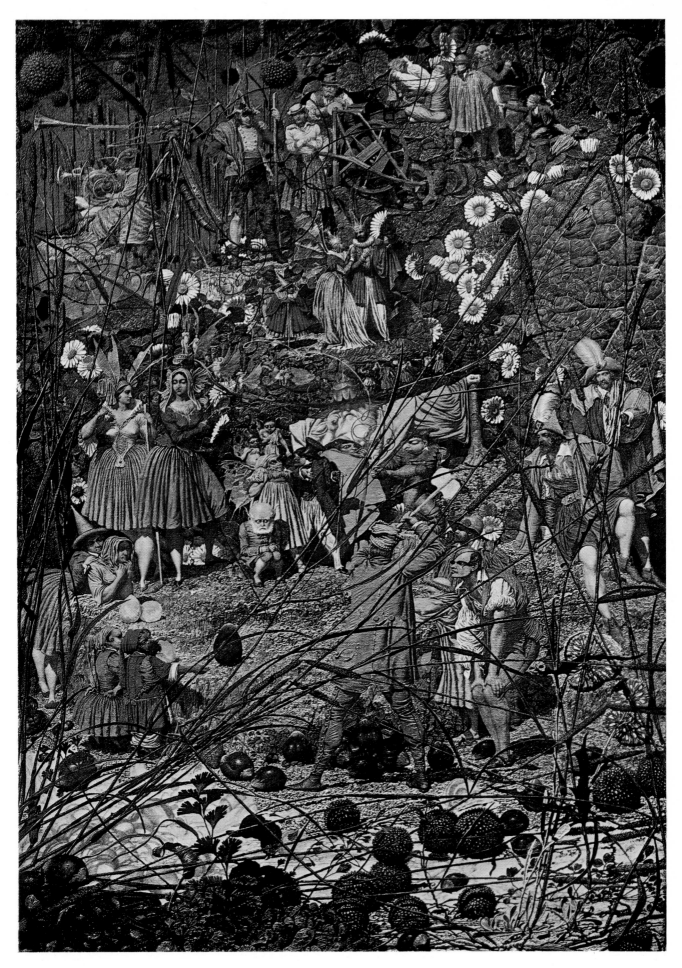

his own predestined fate. Dadd's full meaning is un-likely now to be elucidated: but the picture, with its exquisitely precise drawing and melting colour, con-veys very strongly the feeling that it comes from some spiritual inner world into which he has retreated.

The drawing was probably seen during Dadd's life-time by Frederick Goodall at a meeting of the Chalco-graphic Society, who recorded it in his autobiography as 'The difficult path' together with a rather inaccurate description.[85] (It is always possible that he saw another similar work, but Goodall's recollections of other, verifiable, events are generally found to be erroneous.)

197

197 Leonidas with the Woodcutters 1873
Watercolour, $7\frac{1}{8} \times 5\frac{1}{8}$ in, 18.1×13.0 cm
Inscr. bottom left: 'Leonidas. with. the. Wood
Cutters. vide. Glover's. Poem.'
bottom right: 'Rd Dadd. 1873'
Victoria and Albert Museum, Forster bequest

This picture shows an episode in the story of Leonidas, king of Sparta in the fifth century B.C., as told in the blank verse poem *Leonidas* by Richard Glover (1712–85). It illustrates the lines: 'Melissa, pointing, spake: | I am their leader. Natives of the hills | Are these, the rural worshippers of Pan, | Who breathes an ardour through their humble minds | To join you warriors,'. The poem is in nine books and not classifiable as light reading, and Dadd's choice of a passage from Book VII indicates the depth of his interest in English literature as well as classical history. The rigid poses of the soldiers are very close to those used in 'Fantasie Egyptienne' (No. 194), though the grouping is slightly different, helping to give the scene a similarly static, dreamlike atmosphere. The colour range is taken from that of the sketch for the Broadmoor drop-curtain (No. 198), chiefly the golds and the green and brown tones of the background, though here it is used more densely and to produce a richer effect in spite of the picture's overall delicacy. The sheer cliff face on the right recalls the same work. This tendency to reproduce similar colour schemes and images over a short period is very characteristic of Dadd, so that his watercolours can often be dated to within a month or two of each other independently of the inscriptions.

198

198 Sketch for the Broadmoor Theatre Drop-Curtain 1873
Watercolour, $12\frac{1}{16} \times 16\frac{5}{8}$ in, 30.7×42.4 cm
Inscr: 'Composition. Rd Dadd. Broadmoor.
Berks. 1873.'
Exh: *British Romantic Painting*, Paris 1972 (96)
Victoria and Albert Museum

This imaginary composition may have originated as an independent work, but seems to have been used later as the basis for the drop-curtain which Dadd painted for the Broadmoor theatre (No. 199). The figures are in historical costume, though no particular scene can be identified, and it may represent an earlier design which was subsequently developed into 'The Temple of Fame'. The colouring, particularly in the golden galley and the relatively rich green in the background, is warmer than in many of Dadd's late watercolours which often have a more bluish tone.

196 Entry on p. 130

207 Entry on p. 135

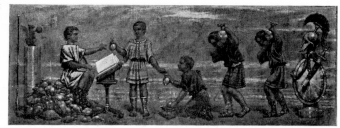

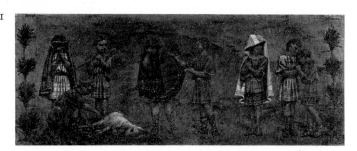

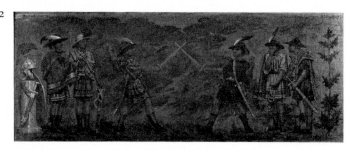

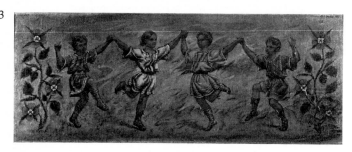

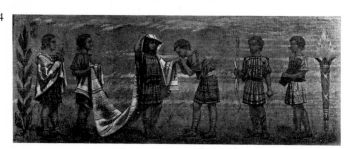

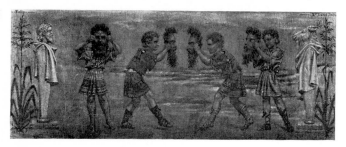

***199 The Temple of Fame** *c.*1874
Stage drop-curtain
Destroyed
Painted for the Broadmoor theatre

The decorative panels painted for the Broadmoor theatre stage (Nos. 200 to 205) are dated 1874, and the curtain had certainly been painted by 1877. It is described in *The World* for 26 December of that year: 'The drop-scene is a masterpiece, and exhibits all the lurid imaginative power that might be looked for from a "mind o'erthrown." It represents the temple of Fame; an elegant Greek edifice standing on a single peak, which soars high into the clouds of a wild and stormy sky. Crowds press onwards and upwards by a series of winding stairs and platforms, but upon the crag-summit there is foothold for but one at a time; and he who outstrips his fellows at first and wins the ascent is in danger of being overtaken, displaced, and hurled down the sheer straight precipice into the angry waves of a tumultuous sea. In the foreground is a wide terrace, paved with marble–it might be the Piazzetta of Venice–which is the starting-point for all who climb. It is crowded with figures–some eager, some apathetic, some pointing with feelings of envy or contempt to those who are already on the rise, while new arrivals are making for the shore in triremes and galleys under oar and sail. In all this work–meritorious, nay, painfully excellent–there is but one fault–no single figure is perfectly drawn. Some detail is wrong–arm, leg, hand, head . . .'[26] The curtain and other stage scenery painted by Dadd survived into the 1930s, but were 'superseded many years ago' according to information obtained from Broadmoor in 1945.[86]

Panels from the Broadmoor Stage 1874
Oil on hessian, each 14 × 36¼ in, 35.6 × 92.1 cm
Broadmoor Hospital, painted for the theatre

200 Avarice
Inscr. top left: 'Avarice.'; top right: 'R.ᵈ Dadd. 1874.'

201 Grief
Inscr. top left: 'Grief.'; top right: 'R.ᵈ Dadd. 1874.'

202 Hatred
Inscr. top left: 'Hatred.'; top right: 'R.ᵈ Dadd. 1874.'

203 Joy
Inscr. top left: 'Joy.'; top right: 'R.ᵈ Dadd. 1874.'

204 Love
Inscr. top left: 'Love.'; top right: 'R.ᵈ Dadd. 1874.'

205 Folly
Inscr. top left: 'Folly.'; top right: 'R.ᵈ Dadd. 1874.'

The men's recreation hall at Broadmoor contained a stage on which visiting players, members of the staff, and some of the patients themselves, provided entertainments, and for which Dadd painted the scenery (*see* 'The Temple of Fame,' No. 199). These six frieze-like panels, removed from the front of the stage, are all

that survive of the theatre decorations apart from the sketch for the drop-curtain (No. 198). The greater freedom at Broadmoor gave him many opportunities to work in media which he had not been able to use during all the time at Bethlem, and even after so many years, he was able to respond with new styles adapted to different circumstances. The format of these panels may owe something to memories of his work on the decorative panels for Lord Foley's house (No. 67) while still a student. The subject matter derives primarily from Pompeian wall friezes depicting cupids at play, including some who hold masks before their faces, whether remembered from his own visit to Pompeii or studied later in engravings: but secondary sources may also have played a part, such as the panels by Caldara at Hampton Court which show cupids playing, and in this case the tudor rose in 'Joy' could also indicate a link with memories of Hampton Court. Dadd's panels, showing children playing and apparently performing charades, have a freshness and spontaneity which is unexpected at this period, when his figure drawing was becoming increasingly remote, suggesting that they may have been inspired by real children, perhaps the families of members of the hospital staff. This possibility is supported by the recollection of Sir Hugh Orange who, as a child, watched Dadd working on the mural in his father's house (No. 214); so evidently he did have some opportunity to see such children. Although the subjects repeat some of those illustrated in the earlier 'Passions' series, this is altogether a more relaxed approach, and the interpretation is also more symbolic.

*206 Murals, Broadmoor Theatre c.1874
Formerly at Broadmoor Hospital: painted over
The description of Dadd's work for the theatre at Broadmoor in *The World*, 26 December 1877, mentions his wall paintings: 'He has adorned and beautified the asylum-walls; above all, upon the asylum theatre he has lavished much decoration of a curiously florid kind, quaint arabesques, and lines painted in a medley of vivid colours.'

207 Portrait of Dr William Orange 1875
Oil on canvas, 27 × 22 in, 68.5 × 55.9 cm
(opening of mount, oval, 22½ × 17¾ in,
57.2 × 45.1 cm)
Inscr: 'Rich.^d Dadd. Pinx.^t 1875. –'
Prov: The picture has remained in the hospital since it was painted.
Broadmoor Hospital (repr. on p.133)
Dr William Orange, 1833–1916, was deputy superintendent of Broadmoor from its opening until he succeeded Dr John Meyer as superintendent in 1870. He acquired a world-wide reputation in his field, but retired in 1886, the year of Dadd's death, having never fully recovered from an attack made on him by a patient in 1882. During the early 1880s Dadd also painted for him a mural in the hall of his official residence ('Flora', No. 214). The scale and the vivid realism of this portrait come as something of a surprise amidst the small watercolours which are practically all we know of Dadd's later work: the handling and finish, however, remain uncompromisingly those of a miniaturist in their meticulous precision. The background has been retouched.

208 A Fishing Fleet in a Storm 1877
(repr. on p.144)
Watercolour, 5¹¹⁄₁₆ × 3⅞ in, 14.4 × 9.8 cm
Inscr. bottom left: 'R.^d Dadd.|Nov.^r 1877.'
Exh: *English Drawings, Watercolours and Paintings*, Colnaghi 1973 (45)
Prov: Dr John Adair to 1973. Christie's 12 June 1973 (55), bought by Colnaghi.
Patricia Allderidge
This is one of the few works dating from the last decade of Dadd's life: he probably worked on it with a magnifying glass, as he is known to have done with another miniature painted at about the same time (*see* No. 209). With its storm tossed boats and angry surf this is a very different image of the sea from the one seen in 'The Pilot Boat' of twenty years earlier, full of lively movement and even, though it is now rather faded, of colour. A faint pink blush can still be seen in the sky and there are traces of the once stronger blue and green of sky and sea, enlivened by sharp touches of red and blue in the jackets of the sailors and the boats' pennants. The sea, as in several other watercolours, is painted in a microscopic stipple technique with the point of the brush: but instead of scooping out pits and hollows, as elsewhere, the tiny specks of colour here combine to build up lumps of foam and flying spray, as it whips from the crests of waves. In the far distance is a hilly shoreline, against which the sails of yet more tiny frail boats can just be made out. By 1877 Dadd had been cut off from the sea for more than thirty years; but in this fragile scene he provides a complete (perhaps his last) distillation of a subject which had haunted him all his life.

*209 Medieval Scene c.1877
Miniature on ivory
Whereabouts unknown
A visitor to Dadd in Broadmoor wrote in *The World*, 26 December 1877: '. . . upon the narrow table . . . lies an exquisitely-executed painting on ivory, only a few inches square, the subject allegorical – a fair maiden in medieval attire, with a basket of flowers in her hand, is crowning her knight; in the foreground jewelled mead, in the distance the walls and towers of an old-world town. Every detail is given with a marvellous minuteness and finish which could have been attained only by the use of the magnifying-glass he hands to enable his visitor to inspect this work of art.'[26]

*210 Atalanta's Race c.1877
Oil on canvas, 'moderately large'
Whereabouts unknown
Atalanta, a beautiful huntress, required her suitors to race with her: those who lost had to die. Melanion, as he raced, threw down three golden apples given to him by Aphrodite, and won as Atalanta stopped to gather them.
This painting is described in *The World* for 26 December 1877, by the correspondent who visited Dadd in Broadmoor. The race is 'depicted in a manner strikingly unconventional and original'. Dadd had seen Poynter's version of the same subject illustrated in the previous year's Academy catalogue, but was able to cite scholarly arguments for his own interpretation. 'His is a more ambitious treatment than mine. He depicts the race as

occurring in the stadium. I, you will observe, place it in a forest-glade. Probably both interpretations will pass muster. The myth of Atalanta's race could not have been founded upon a single instance; it must have been a constantly-recurring event, and is the type of a series of courtships . . . It is earlier than the siege of Troy; and it is conceivable that in those simple times maidens were often sued and won in this exciting fashion . . . Mr. Poynter's picture belongs to the historic period; mine to the heroic . . . [his] is in truth a royal and imposing picture. Mine is more simple and pastoral; yet my Melanion is a descendent of the gods, Atalanta is a king's daughter; the king and his guards wear the greaves and helmets of the Homeric epoch . . .'.[26]

211 **Wandering Musicians** c.1878
Oil on canvas, 24 × 20 in, 61.0 × 50.5 cm
Exh: *British Romantic Painting*, Paris 1972 (94)
Prov: Mrs Arthur Clifton to 1961. Agnew's in 1961, as 'A Greek Pastoral'; Sotheby's 15 July 1964, as 'Greek Shepherds', bought by Agnews. M.D.E. Clayton-Stamm. Christie's, 25 March 1966 (105), as 'Wandering Musicians'.
Trustees of the Vaughan-Lee Family Trust

The subject of this picture is in some doubt, as can be seen from its various titles. The names of the idyllic poets, Theocritus, Bion, and Moschus, with the Spartan poet Tyrtaeus, appear on the broken frieze in the bottom right-hand corner, suggesting that it might be a pastoral scene, possibly derived from one of the idylls of Theocritus. A previous owner believes the setting to be the island of Cos (which Dadd passed close by in 1842, though he did not land there): and the seventh idyll describes a scene with a shepherd on Cos. Dadd's own title for the watercolour version, 'Italian Rustic Musicians' (No. 212) opens the possibilities more widely: but whatever the subject, the mood of the painting is essentially idyllic. Apart from the portrait of Dr Orange and the panels from the stage, no other oils are at present known which date from later than 1862: the much paler tonality seen here may therefore be an isolated example, but it does seem to follow a trend which can be seen in the later watercolours, though the browns, blues, yellows and greens are in Dadd's normal colour range. The distant wooded valley stretching away to the right is a rare feature in Dadd's figure compositions after his confinement. The figures are generally isolated against a very near backdrop, and where there is landscape in the background it is often closed in by, or glimpsed over the top of, hills. Only when there is open water, is there any sense of freedom on a scale such as this. The open views from the terraces at the back of Broadmoor may have begun to compensate for the twenty years' close imprisonment of Bethlem.

212 **Italian Rustic Musicians** 1878
Watercolour, c.9¾ × 7¾ in, c.24.7 × 19.7 cm
Inscr: bottom left: 'Italian Rustic Musicians|Light from the Left.'; bottom right: 'R. Dadd. 1878.'
Prov: Richard Wyndham.
Sir Sacheverell Sitwell

There is nothing to indicate whether this is the original or a replica of the painting 'Wandering Musicians'

(No. 211). The note 'Light from the Left' may have had some esoteric meaning for Dadd; there is evidence elsewhere for his concern with the classical belief in the left as the unlucky side, in the poem on the back of 'Bacchanalian Scene' (No. 184), and possibly in the (damaged) inscription on 'The Crooked Path' (No. 196).

213 An Arab 1880
Watercolour, 10¾ × 6¾ in, 27.3 × 17.0 cm
Inscr. bottom left: 'R^d Dadd. 1880'
Prov: Dr John Adair to 1973. Christie's
12 June 1973 (56).
Dr Raymond Levy

This, one of the latest known dated works, shows Dadd still using material from his Middle Eastern travels of thirty-seven years before. Although he still had his sketchbook, there is an indistinctness about the figure, lost in its voluminous robes, which suggests that he did not work here directly from a sketch. The muted, near monochrome browns of the colouring integrate figure and landscape, so that the arab seems a part of his environment even while dominating it by his stillness. The sense of timelessness makes this not so much a study of an individual, such as can be seen in the surviving sketchbook, as a representation of some element in the arab character which Dadd has chosen to express his own mood. The air of faintly aggrieved resignation reflects what he is known to have felt towards the end of his life, and the drawing contrasts strongly with his earliest approach to Middle Eastern subjects, when the colour and turbulence of the scene excited his imagination. A comparison can also be made with the 'Passions' drawing 'Grief or Sorrow' (No. 142), in which a monochrome treatment of a figure seated in very similar pose creates a quite different atmosphere of emotional intensity. The broader style is more like that used at Bethlem in the 50s than the one which we associate with the later watercolours, and particularly those painted at Broadmoor. On the back are pencilled 'doodles', which seem to be related to the wall pattern in 'Fantasie de l'Hareme Egyptienne' (No. 195), in which the pentacle (or star of David) appears seven times.

***214 Flora** early 1880s
Mural, *c.*10ft × 6ft
Formerly at Broadmoor Hospital: painted over before 1945

In 1946 Sir Hugh Orange, son of Dr William Orange the medical superintendent of Broadmoor from 1870 to 1886, wrote of this work: 'In the early eighties Dadd was allowed to occupy himself by painting a fresco [*sic*] about 10ft high and say 6 feet broad, to cover a wall in the hall of the superintendent's house – The subject, (chosen I believe out of compliment to my mother whose name was Florence) was a large figure of Flora, bearing flowers and fruits, – It was full of detail, some critics thought it was too full of detail. I am no art critic, but I admired the work, and am sorry to have recently learned from Dr Hopgood [*sic*] that it had been effaced by one of his predecessors, in the course, I expect, of some structural alterations – I used to see Dadd at work on this when I was at home from school during the time when he was occupied on it; but I never had any conversation with him. He was, of course, accompanied by an attendant. He was a man of mild and dignified appearance, evidently absorbed in his work and taking pleasure in it.'[87]

215 Tlos in Lycia 1883
Watercolour, 10 × 16 in, 25.4 × 40.6 cm
Inscr. on verso: 'View of the Ancient City of Tlos in Lycia a Province|of Asia Minor. The foreground purely fanciful and|much of the middle distance. Mt Gragus [? Cragus] is to the left|at the top of the drawing. The columns towards the left|and bottom are part of a Greek Public Building probably|a Stadium or Paloestra [?Palaestra] and the Building in the Centre|of the drawing is supposed Roman – the sketch made| about 1842 – Richd. Dadd 1883.'
Exh: *The Victorian Romantics*, Leicester Galleries, 1949 (35)
Leeds City Art Galleries, bought from The Leicester Galleries 1949

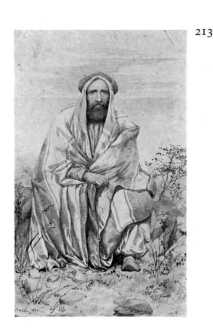

213

215

During their travels in Asia Minor in 1842 Dadd and Sir Thomas Phillips visited the area of southern Turkey around Tlos, Macri (Fethiye) and Xanthus in the second and third weeks in October, and the sketch for this picture must have been made at that time. In the V. & A. sketchbook (No. 73) is a drawing of some of the Lycian rock-cut tombs (Mount 5, D135–92), but nothing which can be identified with the landscape here, which Dadd must have sketched only in his other book. It is his latest known work, painted within three years of his death at Broadmoor, and shows that he kept and used the Middle Eastern sketchbook right up till the end of his life, that is for more than forty years. It shows also that he continued to work up sketches directly from it, as well as using it for background material in purely imaginary compositions. The inscription is the longest and most precise in a considerable output, and is very much in character with the description in *The World*, 1877 of his detailed, almost pedantic exposition of his interpretation of 'Atalanta's Race' (*see* No. 210). The microscopically fine treatment is comparable with the background of 'Italian Rustic Musicians' of five years earlier, and it seems likely that other works in this style would have been painted at Broadmoor and have now disappeared. This stippling technique is one which he had used all his life, but is best known from the period *c*.1857 onwards when he seems to have turned back increasingly to landscape subjects. The picture seems unexpectedly large for this late period, yet another reminder that we really know relatively little about the true pattern of Dadd's work over the years, from the scattered survivals which have so far come to light.

***216 ?Decoration on Chairs** 1884

A letter to the Superintendent of Broadmoor dated 9 July 1884, from a Mr E. K. Purnell, offers Dadd money for 'doing' some chairs: 'You were so sternly careful that I should not overpay Mr Dadds [*sic*] on the former occasion when he did some chairs for me that I hope you will let me be a little more liberal this time. You then named 10/. . . It has been most kind of you to

allow the chairs to be done by him.'[88] Dadd was only paid 10s. on this occasion too. There is no indication as to what he had done, and he could have been merely touching up some damaged decoration, though it seems more likely that he had painted the chairs with his own designs. A member of the staff of Broadmoor Hospital recalls that there were also some fire buckets decorated by Dadd, but these cannot now be found.

Series of panels after 1864
Scraped through a white ground on glass,
25 × 14½ in, 63.5 × 36.8 cm
Broadmoor Hospital

217 **Cook**

218 **Male Head**

219 **Female Head**

220 **Wine or Water Carrier**

221 **Turnkey**

222 **Troubadour**

223 **Scribe**

224 **Priest** (so-called, subject uncertain)

225 **Jester**

226 **Housekeeper**

227 **Girl with a Lily**

This series of glass panels, of which the technique seems intended to simulate etching, is the only surviving evidence of Dadd's versatility at Broadmoor, where he is described as turning out Christmas decorations, diagrams and illustrations for lectures and entertainments, and anything else that might be required. It is not clear what purpose they may have served, or whether he simply took a fancy to decorate some windows, possibly in the theatre or one of the day rooms. They show a firm assurance in a very different medium and style from those of his known previous work, one which could hardly be further removed

217

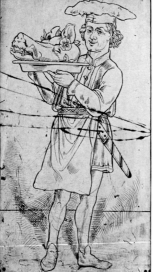

218

219

220 221 222 223 224 225 226 227

228

from the delicate little watercolours on which he was concentrating at Broadmoor. Some of the figures have the look of pantomime characters but the faces, with their heavy-lidded melancholy eyes, seem to contain an element of portraiture. Sometimes the same face seems to have been used for more than one study, for example the cook and the scribe; the housekeeper, and the girl in a flower-decked bonnet. It is not certain what medium was used for the white ground, though there is a tradition in the hospital that it was a whiting block, of the type used for cleaning doorsteps.

228 Coachman after 1864
Watercolour, 24¾ × 17¾ in, 62.9 × 45.1 cm
Broadmoor Hospital
This and the next two watercolours may be some of the works referred to in *The World*, 1877:[26] 'At Christmas-tide a few hours suffice to produce a host of humerous cartoons, comical street-figures . . .'.

229 Sailor after 1864
Watercolour, 24 × 16½ in, 61.0 × 41.9 cm
Broadmoor Hospital
See 'Coachman' (No. 228).

229

230 Crossing Sweeper after 1864
Watercolour, 23¾ × 17 in, 60.3 × 43.2 cm
Broadmoor Hospital
See 'Coachman' (No. 228).

***231 Sailing War Ships in a Rough Sea** n.d.
Oil on canvas, 30 × 50 in, 76.2 × 127.0 cm
Signed
Prov: Bonham's 18 January 1968 (210).
Whereabouts unknown

***232 A Turk Smoking a Waterpipe** n.d.
Watercolour, 14 × 10 in, 35.6 × 25.4 cm
Prov: A. Horley & Son, Maidenhead, 1 April 1971 (67).
Whereabouts unknown

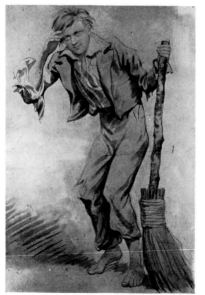

230

Attributed Works

Attributed to DADD

233 Portrait of a Woman
Watercolour on ivory, $3\frac{7}{8} \times 3$ in, 9.8×7.6 cm
Prov: Capt. R. Johnes to 1970; Christie's 3
March 1970 (121).
Mrs Caroline Annesley
The sitter is 'said to be the housekeeper at Bethlehem
Hospital', but there was no one on the staff of Beth-
lem with that designation, and the Matron was con-
cerned solely with the female patients. If it were a por-
trait of anyone at Bethlem, the setting would be purely
imaginary, since Dadd was not allowed out of the male
criminal wing in which he was confined. He is known
to have painted at least one miniature on ivory at
Broadmoor, but at present nothing else comparable
with this portrait is known from his hand.

Attributed to DADD

***234 The Prince's Birthday,** copy after Jan Steen
Watercolour, $12\frac{5}{8} \times 14\frac{1}{2}$ in, 32.0×37.0 cm
Private collection (not exhibited)
For the attribution of this work to Dadd, *see*
Christopher Lloyd, 'A New Drawing by Richard
Dadd', in *Master Drawings*, Vol. IX, no. 1.

Attributed to DADD

***235 Studies of Heads**
Oil on canvas, $9 \times 6\frac{1}{2}$ in, 22.8×16.5 cm
Prov: N. G. Ley to 1970. Sotheby's 19 November
1970.
Whereabouts unknown

Attributed to DADD

***236 Castle on Cliff, Overlooking a Lake**
Watercolour, $14\frac{1}{2} \times 9\frac{1}{4}$ in, 36.8×23.5 cm
Prov: Sotheby's 7 April 1965 (78).
Private Collection (not exhibited)

Attributed to DADD

***237 Group of Figures**
Watercolour, $8\frac{1}{2} \times 9$ in, 21.6×22.8 cm
Trustees of The British Museum (not exhibited)

Attributed to DADD

***238 A Seated figure on Horseback**
Pencil and watercolour on tan paper
10×8 in, 25.4×20.3 cm
Mr and Mrs Paul Mellon, Upperville, Virginia
(not exhibited)

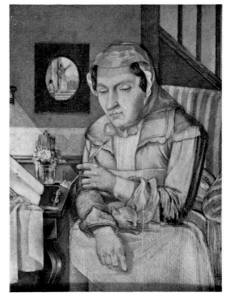

233

239

BOYDEN

239 Stephen and Rebecca Dadd and their Sons
1817
Watercolour on ivory, 7 × 5in, 17.8 × 12.8 cm
Private collection, by descent in the sitters' family
A label on the back identifies Stephen Dadd, aged 60, and his wife Rebecca (wrongly called Sarah), aged 51, at the two outer edges of the group, with their three sons; George William, aged 26, standing; Robert (father of Richard), aged 28, seated centre; and Stephen John, aged 31, seated in profile. The group is said to be 'Painted by Boyden. London. 1817'. Some of the birth and death dates and other information on the label are wrong, so it is clearly not reliable; but the date of 1817 seems reasonable, and anything much later would be impossible since the eldest son Stephen, a naval surgeon, was buried at Stoke Damerel near Plymouth in April 1818. In 1817 (the year of Richard Dadd's birth), Stephen and Rebecca Dadd were living at Plymouth where he held the post of timbermaster in the naval dockyard, and where his wife died in January 1822. Robert Dadd (and probably also George) was living in Chatham.

240

Artist unknown

240 Portrait of Stephen Dadd
Wax medallion, round, 3½ in, 8.9 cm
Private collection, by descent in the sitter's family
Richard Dadd's grandfather, Stephen (*c.*1757–1835), was employed in the Royal Naval dockyard, in which service he worked his way steadily up. From assistant converter in the shipwright's department, he became Foreman of the Yard at Chatham in 1802, moving to the Sheerness yard as assistant to the Master-Ship-wright in 1813 and to Plymouth in the same post in 1815. In 1816 he became Timber Master, a post with responsibility for handling all questions relating to the receipt of timber, its conversion and stowage. He returned to Chatham as Timber Master in 1824, and was superannuated on a pension of £450 in 1830 at the age of 73. His gravestone in Gillingham churchyard records that he was 'employed in the public service in the Chatham, Sheerness and Plymouth Dockyards during sixty years'. Stephen Dadd's brother, Robert, was a ship's carpenter who served at Trafalgar, and settled and died near Plymouth after his retirement.[89]

Artist unknown
241 Portrait of Robert Dadd, sen.
Wax medallion, round, 3½ in, 8.9 cm
Private collection, by descent in the sitter's family
Robert Dadd (*c*.1789–1843) was the second son of
Stephen and Rebecca Dadd, born when they were
living in the village of Brompton between Chatham
and Gillingham. He was baptised 5 February 1790. He
served his apprenticeship with a Chatham chemist
called Turner, and set up business on his own at 293
High Street (later renumbered 148) in 1811 or 1812,
under the sign of a Golden Mortar. The shop continued
to flourish under various proprietors until it was
demolished *c*.1902. In 1834, before October, he moved
to London where he had bought the business of Mr A.
Picnot, bronzist and watergilder of Suffolk Street, Pall
Mall East. He was killed by his son Richard at Cob-
ham Park, Kent, on 28 August 1843, when he was 54.
See also the Introduction, *passim*.

241

JOHN TURMEAU
242 Portrait of Robert Dadd, sen. 1836
Watercolour, 7 × 5½ in, 17.8 × 14.0 cm
Inscr: 'J. Turmeau 1836'
Private collection, by descent in the sitter's family
This portrait was painted when the sitter was 47, two
years after he had moved with his family from Chat-
ham to London. The artist John Turmeau (1777–1846)
was a miniaturist living and working in Liverpool from
1799, where he also had a print shop, and was one of the
founders of the Liverpool Academy. He exhibited in
London until 1836, but the portrait may have been
painted in Liverpool, where Robert Dadd had friends
and where he is known to have visited at least once, on
his return from a tour of Scotland with David Roberts
in 1841.[52] Turmeau was also a friend of the family, and
immediately after Robert Dadd's death in 1843 William
Clements (*see* p. 12) wrote in a letter to Joseph Mayer:
'See Turmeau and read the account to him. Miss D.
thought of him when she saw me and on taking leave,
requested me to inform him of this tragical event.'; and
in his next letter: 'Let me know how friend Turmeau
was affected, I fear it would have a serious effect upon
him.'[23] It is tempting to look for his influence in Dadd's
early portraits, but Turmeau's normal method of
modelling, with fine cross hatching, is quite different
from Dadd's style in the small watercolour portraits of
around 1838, and any comparison could only be made
with the few earlier examples (e.g. No. 3).

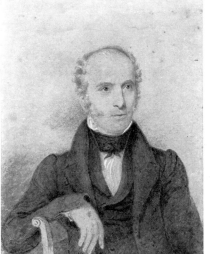

242

Attributed to JOHN PHILLIP
243 Portrait of Mary Ann Dadd
Oil on panel, 5 × 4½ in, 12.7 × 11.4 cm
Private collection, by descent in the sitter's family
A label on the back identifies this as being a posthumous
portrait of Mary Ann Dadd, the first wife of Robert
Dadd and mother of Richard, 'by her son-in-law John
Phillip R.A.'. The reason for this attribution is not
known, and the writer of the label had little knowledge
of the sitter, leaving blank the dates of her birth and
death and her place of birth. Mary Ann Dadd died
when her daughter Maria Elizabeth, John Phillip's
future wife, was three years old, and Phillip did not
become known to the family until thirteen years later.
Since the portrait must have been taken from an earlier

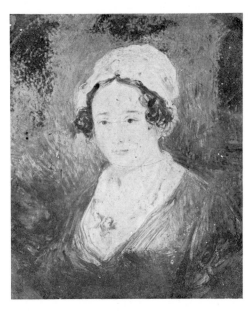

243

208 Entry on p. 135

original, it seems more likely to have been painted by Dadd: and it descended in the family of Robert Dadd jun., together with other portraits by Richard. However, it is impossible to say without further evidence which, if either, of these attributions is correct. Mary Ann Dadd was the daughter of Richard and Sarah Martin of Gillingham. She was born in 1790, married Robert Dadd at Chatham on 5 November 1812, and died at Chatham on 27 June 1824 aged thirty-four.

W.P. FRITH

244 Self Portrait 1838
Oil on canvas, 23½ × 19½ in, 59.7 × 49.5 cm
Exh: *Frith Exhibition* Harrogate, and White-
chapel Art Gallery, 1951
National Portrait Gallery, given by the artist's
daughters, the Misses Frith

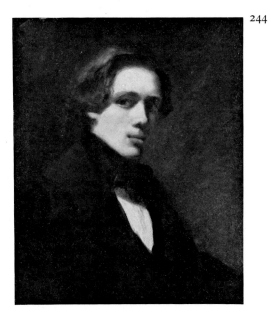

244

William Powell Frith (1819–1909) came to London from Harrogate in 1835 and trained first of all at the drawing school of Henry Sass in Charlotte Street, entering the Academy Schools with Dadd in 1837. He was one of the closest to Dadd in the circle of friends who made up The Clique (*see* p. 14), and devotes a whole chapter to him in vol. III of *My Autobiography and Reminiscences*, publishing in full a letter which Dadd wrote to him from the Middle East. During their student days and for many years afterwards Frith painted literary genre subjects from Dickens, Sterne, Goldsmith, Shakespeare, Molière and other favourite authors, but is now best known for his large panoramas of contemporary life, 'Ramsgate Sands', 'Derby Day', 'The Railway Station', 'The Salon d'Or, Homburg', etc. He was the most successful as well as the longest-lived member of The Clique, and the great popularity of his work epitomises in many ways the climate of Victorian taste in which Dadd would have had to make his way, had he not been so fortuitously removed from it. Frith became A.R.A. in 1845 and R.A. in 1853. A portrait of Dadd wearing a fez appears in the left-hand side of 'Derby Day', (identified by Ian Phillips).

AUGUSTUS EGG

245 Portrait of W.P. Frith
Oil on canvas, 11¾ × 9½ in, 9.8 × 24.2 cm
Harrogate District Council

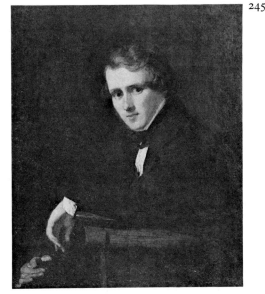

245

For the sitter, see 'Self-Portrait' by W.P. Frith (No. 244). The artist, Augustus Leopold Egg (1816-1863) entered the Royal Academy Schools in 1835 after a year at Sass's drawing school, and became one of a group with Dadd, Frith and Phillip when they joined him there in 1837. His friendship with Frith lasted the rest of his life, and he was also a friend of Dickens. The son of an eminent gunsmith, Egg was the only member of the circle with private means sufficient to make him independent of painting for his living. Like the others he began with literary scenes, and of his twenty-eight paintings exhibited at the Royal Academy, seven were subjects from Shakespeare and five from other works of fiction, while nine were familiar incidents in history; though he is now most highly regarded for his paintings of contemporary life, such as the three canvases comprising 'Past and Present', and 'The Travelling Companions', in which he was influenced by sympathy for the Pre-Raphaelite movement. In subject matter, and to some extent in style, he was closest to Dadd of all the group. He became A.R.A. in 1848 and R.A. in 1860.

246

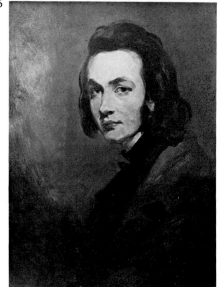

247

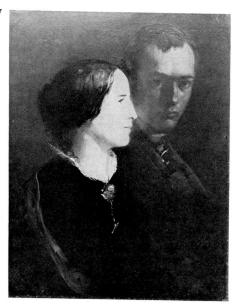

John Phillip

246 Self Portrait 1840
Oil, 13½ × 10½ in, 34.3 × 26.7 cm
Exh: Aberdeen, 1890 (35 or 39); *Centenary Exhibition*, Aberdeen Art Gallery, 1967 (7)
Aberdeen Art Gallery

John Phillip (1817–1867) was born in Aberdeen, the son of poor parents. By a determined effort he got himself to London, and was a pupil of T.M. Joy before joining the Academy Schools with Dadd and Frith in 1837. He returned to Aberdeen in 1840 to practise as a portrait painter, but came back to London in 1846. In 1851 he lived for a time in Seville; and although his biographer James Dafforne[90] says only that he went to Spain on advice because his health 'showed evident symptoms of giving way', it may be that the root cause was the incipient insanity of his wife, Dadd's sister (*see* p. 14 and No. 247). From that time on he exhibited Spanish subjects in a new and vigorous style, inspired by the colourful life of the country and by his discovery of the work of Velasquez, earning himself the name 'Phillip of Spain'. He continued to live in London, making a return trip to Spain in 1856–7; but the few printed sources for his life scarcely mention his marriage or the connection with the Dadd family at all, let alone its tragic end or the two children who survived it. Phillip had considerable success with his Spanish paintings, and was elected R.A. in 1859.

John Phillip

247 The Artist and his Wife
Oil on canvas, 29¼ × 24¼ in, 74.3 × 61.6 cm
Inscr: 'J. Phillip'
Exh: Aberdeen, 1888 (249) and 1890 (8); *Centenary Exhibition*, Aberdeen Art Gallery 1967 (11)
Prov: Francis Edmond Esq. LL.D to 1887.
Aberdeen Art Gallery, acquired 1887

For John Phillip, *see* No. 246. Phillip married, perhaps c.1846, Richard Dadd's youngest sister Maria Elizabeth (1821–1893), who became insane and was confined in an asylum in Aberdeen (*see* also p. 14). Mrs E.M. Ward, reminiscing about John Phillip, says: 'I remember his wife coming to a ball at our house (after I was married), and thinking her very distraught and peculiar. Shortly afterwards she went completely mad, and as the crying of her youngest child annoyed her, she made frantic efforts to strangle it.'[91] The Wards were married in 1848, which is the year in which Mrs Panton, Frith's daughter, was born, who also recollected Phillip's wife as 'a charming and beautiful young married woman'.[92] Mrs Panton was obviously a precocious child, and clearly recalls from the age of three another of Dadd's sisters, who was her governess; so her memories of Phillip and his wife quoted on p. 14 could be from around the same date and could suggest that Maria Phillip showed signs of mental disturbance soon after 1850. Another possibility is that it happened around 1856, just before Phillip's second visit to Spain. Mrs Panton believed, at the time of writing her reminiscences (published 1908) that 'she is still alive, being "taken care of" in some remote district of Scotland . . .' but in fact she died 1 October 1893.

ROBERT HUSKISSON
248 Come Unto These Yellow Sands *c.*1847
Oil on panel, 13¾ × 18 in, 34.9 × 45.7 cm
Engraved: *The Art Union*, 1 November 1847,
engraved by T. A. Prior
Prov: S. C. Hall in 1847.
Maas Gallery

Little is known about Robert Huskisson apart from a
story told by Frith to illustrate his total lack of educa-
tion, and Frith's assertion that his early death cut short
a brilliant career;[93] but he exhibited at the Royal
Academy in the 1840s and up to 1854, and illustrated
some of the works of Mrs S. C. Hall. His 'Come Unto
These Yellow Sands' obviously derives a great deal
from Dadd's, and shows the influence which Dadd had
on other fairy painters even in his short period of
activity. Huskisson's picture is very different in mood,
however; there is none of the sharp brilliance of Dadd's
lighting nor the tensions of his composition; the figures
are soft in outline, and tend, as does the colouring, to-
wards the sweetly pretty. For the figures he has also
borrowed heavily from Frost's 'Sabrina',[94] and to some
extent from Paton's published illustrations to *The
Tempest*.[95] It may be significant, in this context, that
Huskisson's speciality according to Frith was making
copies of old master's and 'others' of extraordinary
exactness. Dadd's work was obviously known to
Huskisson, and possibly vice versa; and comparison
between them, and Paton too, who also knew Dadd's
work, is interesting in showing the very different results
achieved by these painters working with much the same
material and at the same time.

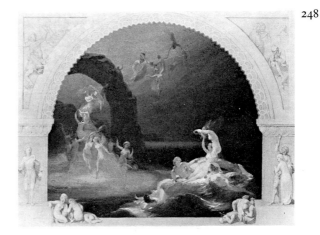

248

H. STANIER
249 Come Unto These Yellow Sands
Oil on board, 10 × 12¼ in, 25.4 × 31.1 cm
Inscr. on label on verso: 'Come unto these
yellow sands. Vide Midsummer Nights Dream.
H. Stanier'
Prov: John Rickett.
Private collection

This picture shows an example of Dadd's influence at
third hand, Stanier's version of Ariel's song being a
straight copy of Robert Huskisson's (No. 248), which
was itself derived from Dadd's. The popularity of this
sort of fairy painting was such that it did not really
matter what was being illustrated, as can be seen from
the label which attributes the subject to the wrong play.
H. Stanier might have been Henry Stanier, who was
born in Birmingham and exhibited at the Suffolk
Street Galleries between 1860 and 1864.

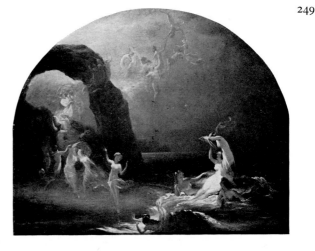

249

After ROBERT HUSKISSON
250 There Sleeps Titania 1848
Engraving by Fred Heath in *Art Journal*, October
1848, from the painting then in the possession of
S. C. Hall.

Huskisson's painting 'There Sleeps Titania' was ex-
hibited at the Royal Academy in 1847, where it was
'hung most advantageously . . . and attracted very great
attention'.[96] As in his scene from *The Tempest* (No.
248) Huskisson shows the lasting popularity and
influence of Dadd's fairy painting during this decade,
both in his choosing again to repeat one of Dadd's
subjects, and in his obvious borrowings from 'Titania

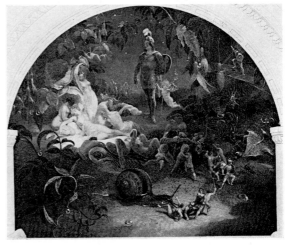

250

Sleeping' (No. 57) of 1841. The spotlighted main group, the figure of Oberon standing in the shadows behind, the dancers at the back of the picture, and the setting of the scene within a proscenium arch are the more obvious features for which he is indebted to Dadd; but the atmosphere is altogether more relaxed, and the colouring (in the original painting) much sweeter. Pink fuschia and a slightly pinkish tinge in the light round the Titania group, produce a sugary effect which is quite alien to the mood of Dadd's work; and in the soft tangle of bodies which surrounds Titania, Huskisson shows himself closer to Paton and others in his approach to fairy painting, as a vehicle for deploying groups of lush nudes lying about in sensuous abandon. It is interesting that Dadd saw this engraving in Bethlem. Possibly it was sent to him deliberately by someone aware of his likely interest in the subject, or perhaps he saw the *Art Journal* anyway from time to time; but having seen and evidently examined it closely, he in turn borrowed some elements back for use in his own later work. In the 'Passions' sketch 'Hatred' (No. 115) the poses of both protagonists owe something to figures seen here in the painted frame; the boy butted by a goat in the foreground of 'The Flight out of Egypt' (No. 104) is almost certainly related to the soldier here attacked by a snail; and in 'Oberon and Titania' (No. 172) the idea of a giant snail, and of the many fairy soldiers with their shields, probably originated in memories of this scene: even the profusion of dew drops may have been to some extent a response to Huskisson's giant globules, a sort of retaliation for Huskisson's exaggerated appropriation of his own dew drops in the first place. Although all these instances individually may seem slight, together they add up to more than coincidence; and the only source which Dadd could have known was in the engraved version, since the original was not painted until several years after his own confinement in Bethlem.

251

George Richmond

251 Portrait of Sir Thomas Phillips
Chalk and charcoal, $23\frac{1}{2} \times 17\frac{1}{2}$ in,
59.7×44.5 cm
Private collection, by descent in the sitter's family
Sir Thomas Phillips (1801–1867) was born at Llanelli in Monmouthshire, the son of the manager of an iron works who later acquired coal-mining interests in the area. Trained as a solicitor, he became town clerk and then mayor of Newport. During his mayoralty in 1838 chartists attacked Newport and Phillips was shot twice while preparing to read the riot act, but the rising was put down and he became a national hero overnight. He was knighted in 1839. He had previously been admitted to Gray's Inn, but had had to return home to help his father; but in 1840 he settled in London, where his younger brother, Benjamin, was already a successful surgeon living in Wimpole Street, and was called to the bar in 1842. He had several times toured in Europe and now decided, before beginning practice, to make the long tour of the Mediterranean areas and Egypt on which he took Dadd as a companion and commissioned artist in 1842–3 (*see* pp. 18 to 22). During the journey he wrote nineteen immensely long letters to his brother Benjamin's family, containing a step by step itinerary and description of things seen, but they are strictly

travelogues and contain no information about Dadd's illness. There seems to have been no reason, apart from Dadd's insanity, for any rift between them. In one of the few references to him in the letters, Phillips speaks of him as: 'obliging, good tempered, sufficiently informed on general subjects to make an agreeable companion, possesses considerable knowledge of art & loses no opportunity to improve himself'.[97] Phillips went on to a very successful career as an advocate practising in parliamentary committees, and took an increasingly active interest in promoting Welsh education.[98]

CHARLES FRÉCHOU

252 **Portrait of Dr Charles Hood** 1851
Oil on canvas, Oval, 28¾ × 23¾ in, 73.0 × 60.3 cm
Inscr. left-hand side: 'Charles Fréchou.
Paris. 1851.'
Given to Bethlem Hospital by the grand
daughters of Dr Hood
*Board of Governors of The Bethlem Royal
Hospital and The Maudsley Hospital*

William Charles Hood (1824–1870) was the son of a doctor, born in Lambeth and educated at Brighton. He was admitted to Trinity College, Dublin, but trained at Guy's Hospital, qualifying in 1845 and taking his M.D. at St Andrews the following year. He was resident physician to a private asylum, Fiddington House, Devizes, followed by a year as joint superintendent of the new Middlesex County Asylum at Colney Hatch, before his appointment as first resident physician superintendent to Bethlem Hospital in 1852 at the age of 28 (*see* p. 30). He worked tirelessly for ten years to reform the hospital, and was particularly concerned about conditions for the criminal patients. He was closely involved in planning the new Broadmoor Hospital. He resigned from Bethlem on being appointed Lord Chancellor's Visitor in Lunacy in 1862, but in 1868 was elected Treasurer of Bridewell and Bethlem (these two Royal Hospitals were administered jointly from 1557 to 1948), and was knighted the same year. He died of pleurisy at the Treasurer's House, Bridewell, at the age of 46. Hood's influence on Dadd's life in Bethlem, as on the lives of all the patients, was wholly beneficial; but he seems to have had a particular interest in Dadd, who painted 'Oberon and Titania' (No. 172) for him, and probably also painted his portrait (No. 112). He formed a large collection of Dadd's work. The watercolours sold at Christie's after Hood's death were listed as: 'A Seapiece', 'The Death of Abimelech', 'A Classical Composition', 'The Grotto of Pan', 'A View in Switzerland', 'Venice', 'The Pilot Boat', 'On the Medway, Chatham', 'The Island of Rhodes', 'Mountain Scenery in Caria', 'Boudron, the Birthplace of Herodotus', 'Marius at Carthage', 'Charles II and Nell Gwyn', 'The Curiosity Shop'; and the 'Passions' drawings 'Patriotism', 'Despair', 'Senility', 'Suspense', 'Gaming', 'Malice', 'Recklessness', 'Want', 'Ingratitude', 'Idleness', 'Brutality', 'Splendour', 'Treachery', 'Love', 'Hatred', and 'Blind Fiddler'. There were three oils, 'Jael and Sisera', 'Mercy: David and Abishai in the Tent of Saul', and 'Scene from The Midsummer Night's Dream' ('Oberon and Titania').[99]

252

Family Tree

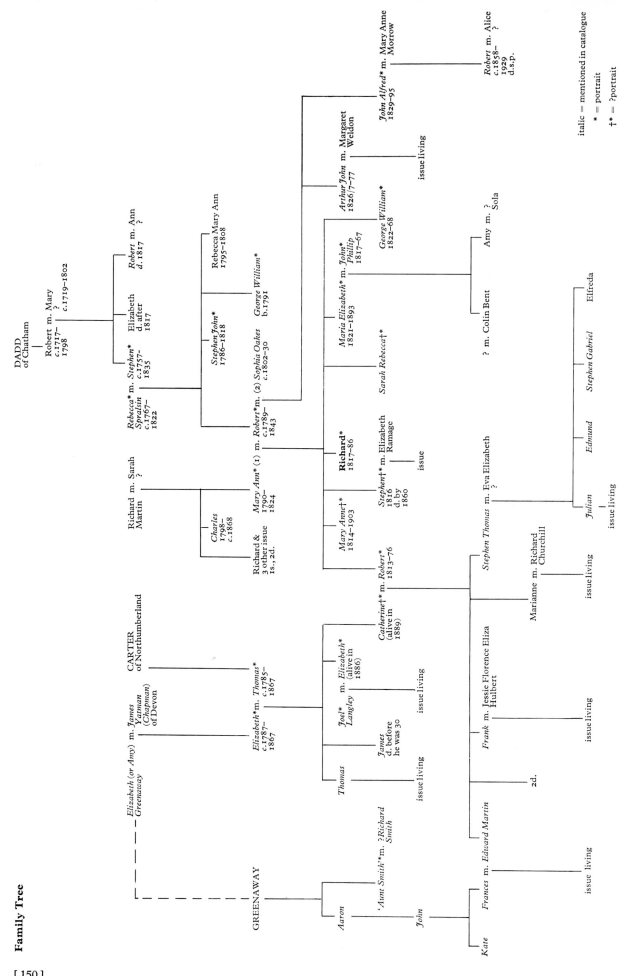

Notes and References

INTRODUCTION

1 *Art Union*, October 1843, p. 267.
2 The main sources used for biographical and other information in this section are: registers of St Mary's Church, Chatham; registers of St Mary's Church, Gillingham and gravestones in the churchyard; directories and guidebooks for Chatham, Rochester and Cobham; Admiralty records in the Public Record Office; index of dockyard officers in The National Maritime Museum.
3 [1st, 2nd, 3rd, etc.] *Annual Report of the Chatham an Rochester Philosophical and Literary Institution*, 1828, etc. *Rules and Regulations of the Rochester and Chatham Commercial and Mathematical School*, 1832.
4 Letters, Robert Dadd jun. to John and Arthur Dadd in Milwaukee, 11 January 1860, and to Arthur Dadd in Milwaukee [late 1871 or early 1872], Dadd family papers, private collection.
5 The move to London has previously been dated to about 1836. Robert Dadd does not appear in the London Post Office directories until 1838, but is shown at Suffolk Street in Robson's *London Directory* for 1836 (containing information for 1835); the *Annual Report* of the Chatham . . . Philosophical and Literary Institution shows that he had left Chatham by October 1834. He voted in Chatham in January 1835 according to the Poll Books, but presumably returned to do so: he had not voted in June 1834.
6 Letters, David Roberts from Edinburgh 9, 16 and 29 September, and from Glasgow 22 September 1841, to his daughter in London; extracts kindly supplied to me by Helen Guiterman. Miss Guiterman thinks that the 'Mr Dadd' referred to in the letters is more likely to be Richard, but at present there is no conclusive evidence either way.
7 The friendship with Turmeau, Clements, Mayer and Josi is shown in four letters from Clements in London to Mayer in Liverpool, dated 1, 5, 6, 11 September 1843, Mayer Papers, Acc. 2528, Liverpool City Libraries. I am very grateful to Edward Morris of the Walker Art Gallery for bringing these letters to my attention.
8 *Art Union*, September 1839, p. 130.
9 Archives of the Royal Academy.
10 Henry Howard, ed. Frank Howard, *A Course of Lectures on Painting Delivered at the Royal Academy of Fine Arts*, 1848.
11 W. P. Frith, *My Autobiography and Reminiscences*, III, 1888, Ch. IX, 'Richard Dadd', pp. 177–95. A letter to Frith from Dadd, written on board the *Hecate* Man-of-War Steamer lying off Jaffa, 26 November 1842, is printed in full pp. 182–95.
12 W. P. Frith, *op. cit.*, I, pp. 62–3.
13 Mrs J. E. Panton, *Leaves from a Life*, 1908, pp. 105–6.
14 Mrs E. M. Ward, ed. Elliott O'Donnell, *Mrs E. M. Ward's Reminiscences*, 1911, pp. 39–40.
15 William Bell Scott, ed. W. Minto, *Autobiographical Notes of the Life of William Bell Scott*, 1892, I, pp. 109–11.
16 S. C. Hall, *Retrospect of a Long Life*, 1883, pp. 328–9.
17 *Art Union*, October 1843, pp. 267–8, also quoting an article from the *Pictorial Times*.

18 Archives of the Royal Academy. *Art Union*, December 1839, p. 177, and December 1840, p. 194.
19 Ed. G. C. Williamson, *Bryan's Dictionary of Painters and Engravers*, 1903.
20 *Art Union*, February 1839, p. 7.
21 *Ibid.*, May 1840, p. 77.
22 *Ibid.*, July 1842, p. 161.
23 *Ibid.*, March, April, May 1842, pp. 60, 82, 105.
24 Byron to Moore, 25 March 1817, quoted in Peter Quennell, *Romantic England*, 1970, p. 146.
25 For this and other information I am very grateful to the Rev. Arthur Evans, who kindly allowed me to see the MS of his book on Sir Thomas Phillips which is still in preparation.
26 Except where other sources are indicated, details of the journey are taken from nineteen letters written home by Sir Thomas Phillips to his brother Benjamin, 1 August 1842 to 9 May 1843, private collection.
27 *Art Union*, October 1843, pp. 268–9, letter to David Roberts, Athens 4 September 1842.
28 *Ibid.*, pp. 270–1, letter to David Roberts, Fort Manuel, Malta 24 February 1843. The *Art Union* version relates Dadd's remarks about wandering the streets and drinking in the sights to Alexandria; Dr Senelick's transcript (see Appendix p. 39) shows that they refer to Cairo.
29 Quoted in Andrew Wilton, catalogue of the exhibition *Classical Sites & Monuments*, British Museum 1971, Introduction [p. 3].
30 *Art Union* October 1843, pp. 269–70, letter to David Roberts, Damascus 5 November 1843.
31 M. A. Titmarsh [W. M. Thackeray], *Notes of a Journey from Cornhill to Grand Cairo*, 1846, 2nd ed., pp. 207–213.
32 Sir Thomas Phillips, *Wales: the Language, Social Conditions, Moral Character, and Religious Opinions . . .*, 1849, Appendix, Note G, 'On Excited Feelings in Religious Worship', pp. 590–2.
33 *The World*, 26 December 1877, 'Her Majesty's Pleasure, The Parricide's Story', pp. 13–14.
34 Casebooks, archives of The Bethlem Royal Hospital.
35 *Art Union*, October 1843, p. 268.
36 William Bell Scott, *op. cit.*, p. 172.
37 Mrs J. E. Panton, *op. cit.*, pp. 5–6. Frederick Goodall, *op. cit.* note 65, p. 230.
38 William Wood, *Remarks on the Plea of Insanity*, 1851, pp. 41–2. Wood records that at his request Dadd furnished him with 'a long and rambling account of the ideas that had, from time to time, occurred to him', but quotes only the part relating directly to the murder.
39 *A Handbook to the Gallery of British Paintings in the Art Treasures Exhibition, Being a Reprint of Critical Notices Originally Published in The Manchester Guardian*, 1857, pp. 126–7.
40 Mrs E. M. Ward, *op. cit.*, pp. 37–9.
41 This information was originally published in the *County Chronicle*, 12 September 1843, and other newspapers; William Clements wrote to Joseph Mayer, 11 September, 'the account of the Eggs & Ale is strictly true' (Mayer Papers cited at note 7).
42 Reports of the murder and associated details, the inquest,

and subsequent events, are in many national and local newspapers for September 1843; the fullest accounts of the murder and inquest are in the *Kentish Independent*, 2 September, the *Maidstone Journal and Kentish Advertiser*, 5 September, and the *Maidstone Gazette and Kentish Courier*, 5 September; of Dadd's escape to France and arrest, in *The Times*, 11 and 12 September, and the *Kent Herald*, 14 September.

[43] Mayer Papers cited at note 7. Casebooks, archives of The Bethlem Royal Hospital.

[44] Mayer Papers.

[45] Bill for transport and treatment, Melun 24 May 1844, Home Office Papers, H.O. 45., Bundle 1085, Public Record Office.

[46] *Art Union*, 1 May 1844, p. 122.

[47] Reports of the remand and committal proceedings are in local newspapers for early August 1844; the fullest account of the first hearing is in the *Kentish Independent*, 3 August 1844; of the second, in the *Rochester, Chatham and Strood Gazette*, and the *Maidstone Journal*, both 6 August.

[48] 3 & 4 Victoria c. 54, *An Act for Making further Provision for the Confinement and Maintenance of Insane Prisoners*, 1840. This empowered the Home Secretary to issue a warrant to transfer any prisoner to an asylum, before or after trial, on his being certified insane by two physicians or surgeons and two justices of the peace. Had Dadd been tried and found 'not guilty by reason of insanity', he would have been admitted by royal warrant under an Act of 1800. Either way, the name 'Criminal Lunatic' would have been a misnomer for him as for many others in the department: only those who had become insane *after* conviction should technically have been so-called.

[49] The main sources for background to Dadd's life in Bethlem are: *General Report of the Royal Hospitals of Bridewell and Bethlem*, 1846, etc.; *Report of the Commissioners Appointed . . . to Continue the Inquiries Concerning Charities* [The Charity Commissioners' Report], 32nd Report, part VI, pp. 385–614, Mr Martin's Report on Bridewell and Bethlem, 1840; archives of The Bethlem Royal Hospital, especially records of the Criminal Lunatic Department 1816–64.

[50] *The Quarterly Review*, vol. 101, 1857, pp. 361–2.

[51] *Art Union*, May 1845, p. 137.

[52] *The Report of the Commissioners in Lunacy to the Secretary of State on Bethlem Hospital*, 1852.

[53] *Sale Catalogue*, Christie's, 28 March 1870. The annotated catalogue, containing names of purchasers, prices, etc., was discovered by John Hudson of Christie's, and I am very grateful to him for this and for much other material.

[54] W. M. Rossetti, *Some Reminiscences of William Michael Rossetti*, 1906, I, pp. 269–70.

[55] Information about the early days at Broadmoor can be found in the *Illustrated London News*, 24 August and 7 September 1867, pp. 208–9, 271, 273: *The World*, 26 December 1877, pp. 13–14.

[56] Archives of Broadmoor Hospital.

[57] The numbered markers have now been removed from the graves, but it is possible to identify the approximate position of Dadd's, no. 337, from a plan.

[58] Letter from Mary Ann Dadd to Catherine (Carter) Dadd, Galveston, Texas, 31 January 1886, Dadd family papers, private collection.

[59] *Art Union*, May 1845, p. 137.

[60] W. P. Frith, *op. cit.*, III, pp. 97–9. That this was actually Dadd is confirmed by another version of the story, told in Goodall (*loc. cit.* note 65): 'Some of his artist-friends went to see him, and sat down to a meal with him and other inmates. He knew his friends perfectly well. Without a word of warning he jumped up to one of the inmates near, seized him with both his hands, held his head, and turned round to the artists who had come to visit him, and said, "Hasn't he got a capital head to paint?"'.

[61] *Art Union*, February 1848, p. 66.

[62] Copy letter, J. E. Johnson to Sir Alexander Morison, Bridewell Hospital 5 May 1856, Bridewell and Bethlem Letter Book 1856–9, archives of Bridewell Royal Hospital.

[63] Letter, William Cox, to Joseph Gillott at Birmingham, Hen and Chickens Hotel, Birmingham 28 March 1870, private collection.

[64] Edmund Yates, *Edmund Yates, his Recollections and Experiences*, 1884, II, p. 104.

[65] Frederick Goodall, *The Reminiscences of Frederick Goodall R.A.*, 1902, pp. 228–33.

[66] *A Handbook to the Water Colours, Drawings, and Engravings, in the Art Treasures Exhibition . . .*, 1857, pp. 12–14.

[67] Information communicated to me by an owner of this book.

[68] Dadd family papers, private collection.

[69] I am very grateful to David Greysmith, to whom these transcripts were originally sent, for passing them on to me.

[70] Sir John Gardner Wilkinson, *Manners and Customs of the Ancient Egyptians*, 3 vols., 1837. Sir Thomas Phillips's collection of guide books for the journey is almost certain to have included Wilkinson's other great work, *The Topography of Thebes and General Survey of Egypt*, Alexandria, 1835.

[71] Humby was a fashionable bootmaker, brother-in-law of Augustus Egg, and a lover and patron of art. Dadd, Frith, Egg, Reynolds the engraver, and other painters often dined with him, and having collectively taken exception to a dead white wall in Humby's dining room, Dadd and Egg painted on it at Dadd's suggestion 'a view of Vesuvius, with a Festa going on, figures dancing, mandolins, vines, and all that sort of thing!', see W. P. Frith, *op. cit.*, III, pp. 125–6. In his letter to Frith from the Middle East, Dadd added the postscript: 'I've so many friends I forgot to mention Humby and Egg. Tell 'em they're bricks.'

[72] This version of the story appeared in the earlier newspapers; but later accounts and the Mayer papers seem to indicate that Dadd made his enquiries about a passport, and also obtained one, very shortly before the murder.

[73] Phillips acquired at least one of Dadd's sketchbooks, which is now in the V. & A. Since these affairs would probably have been settled by the following August, when Dadd was admitted to Bethlem, he may originally have acquired them all and have given back the book which Dadd had in Bethlem and Broadmoor: at least he must have agreed to the arrangement. As Roberts appears to have been dealing with matters concerning Dadd's Middle Eastern work, it may be he who thought of taking the sketchbook to him.

[74] This is obviously the screen mentioned in *The World* (see No. 67), and presumably the one described in the *Art Union*, October 1843, p. 268 as: 'a large folding screen, carefully canvassed, on which he noted down his thoughts – as artists note them – with their pencils.'

[75] Quoted and discussed in Jeremy Maas, *Victorian Painters*, 1969, p. 150.

[76] John Imray, *op. cit.* p. 14.

[77] Graham Reynolds uses this expression in discussing Turner's watercolours, in his introduction to the exhibition *English Drawings and Watercolours 1550-1850 in the Collection of Mr and Mrs Paul Mellon*, Royal Academy 1972, p. xiv.

[78] 'The visions of the soul, being perfect, are the only true standard by which nature must be tried . . . Sometimes landscape is seen as a vision, and then seems as fine as art; but this is seldom, and bits of nature are generally improved by being received into the soul . . .': quoted in Geoffrey Grigson, *Samuel Palmer's Valley of Vision*, 1960, p. 19.

[79] *Art Union*, October 1841, p. 171.

CATALOGUE

1 Letters, Elizabeth Langley to R. G. Hazle, Broadmoor Hospital, 27 May 1879 and 1 December 1885, and various notes by Hazle and others, 1885–6, archives of Broadmoor Hospital.

2 I am very grateful to Alan Pearsall of the National Maritime Museum, who identified the sitter and provided all the information for this entry.

3 Campbell Dodgson, 'Recent Acquisitions for Public Collections – XII', in *Burlington Magazine*, July 1919, p. 62.

4 Note in the records of the Victoria and Albert Museum.

5 Dadd family papers, private collection.

6 Information supplied by a descendant of Joel and Elizabeth Langley.

7 *Art Union*, May 1840, p. 77.

8 Casebooks, archives of The Bethlem Royal Hospital.

9 Published as a special supplement to the *Kentish Independent*, 9 September 1843, with a view of the scene of the murder.

10 John Imray, 'A Reminiscence of Sixty Years ago', in *Art Journal*, 1898, p. 202.

11 Quoted by Geoffrey Grigson in 'Artist, Madman and Murderer' (a review of David Greysmith, *Richard Dadd*), in *The Guardian*, 5 July 1973.

12 Richard Ormond, catalogue of the exhibition *Daniel Maclise 1806–1870*, National Portrait Gallery, 1972, no. 110, p. 102 (repr.).

13 Repr. in Graham Reynolds, *Victorian Painting*, 1967, pl. 17.

14 *Literary Gazette*, 15 May 1841, p. 315.

15 *Art Union*, May 1841, p. 78.

16 *Ibid.*, October 1843, p. 267.

17 Richard Ormond, *op. cit.*, no. 63, p. 59 (repr.).

18 Repr. in Frederick Antal, *Fuseli Studies*, 1956, pl. 26a: catalogue of the exhibition *La Peinture Romantique Anglaise et les Préraphaélites*, Petit Palais, Paris 1972, no. 118.

19 *Art Union*, April 1841, p. 68.

20 *Midsummer-Night's Dream. Act 2. Scene 2. A Wood – Robin Good-Fellow*, painted by Sir Joshua Reynolds P.R.A., engraved by L. Schiavonetti, published 29 September 1799 by J. and J. Boydell at the Shakspeare Gallery, Pall Mall, and 90 Cheapside. Many other versions were published, including one engraved by S. W. Reynolds, one engraved by Charles Heath and published by R. Jennings in 1827, and one published by George Virtue in the 'Cabinet Gallery' series. All except the Boydell engraving are called 'Puck'.

21 Richard Ormond, *op. cit.*, no. 80, p. 74 (repr.).

22 *Ibid.*, no 79, p. 73 (repr. p. 70).

23 Mayer papers cited at Introduction, note 7.

24 *Art Union*, October 1841, p. 171.

25 W. P. Frith, *op. cit.*, III, p. 178.

26 *The World, loc. cit.*

27 *Catalogue* of the sale by Castiglione and Scott of the contents of Ruxley Lodge, Claygate, Surrey, 14 October 1919 and six days following.

28 *Art Union*, October 1842, p. 235.

29 *Ibid.*, July 1842, p. 161.

30 S. C. Hall, *op. cit.*, pp. 328–9. W. P. Frith, *John Leech, his Life and Work*, 1891, II, pp. 103–5, quoted in Percy Muir, *Victorian Illustrated Books*, 1971, p. 35.

31 Ed. S. C. Hall, *The Book of British Ballads*, second series 1844, p. 292 (pagination continuous with first series).

32 *Art Union*, October 1843, p. 269, letter to David Roberts, Athens 4 September 1842. Letter, Sir Thomas Phillips to his brother Benjamin, Constantinople 16 September 1842, private collection.

33 *Art Union*, October 1843, p. 270, letter to David Roberts, Damascus 5 November 1842.

34 Phillips describes the boat in a letter to his brother dated On the Nile, Upper Egypt 2 January 1843, private collection.

35 *Art Union*, October 1843, p. 268, letter to David Roberts, Athens 4 September 1842.

36 Quoted in Leslie Parris, catalogue of the exhibition *Landscape in Britain c.1750–1850*, Tate Gallery 1973, p. 22.

37 *Art Union*, September 1839, p. 129.

38 *Ibid.*, October 1843, p. 269, letter to David Roberts, Athens 4 September 1842.

39 Letter, Sir Thomas Phillips to his brother Benjamin, Constantinople 27 September 1842, private collection.

40 M. A. Titmarsh [W. M. Thackeray], *Notes of a Journey from Cornhill to Grand Cairo*, 2nd ed. 1846, p. 98.

41 W. P. Frith, *op. cit.*, III, p. 183.

42 *Art Union*, October 1843, p. 271, letter to David Roberts, Fort Manuel, Malta 24 February 1843.

43 W. P. Frith, *op. cit.*, III, p. 194.

44 *Ibid.*, p. 180.

45 Henry G. Clarke, *A Hand-Book Guide to the Cartoons now Exhibiting in Westminster Hall . . .*, 1843.

46 *Literary Gazette*, 1843, p. 608, quoted in T. S. R. Boase, 'The Decoration of the New Palace of Westminster, 1841–1863', in *Journal of the Warburg and Courtauld Institutes*, vol. 17, 1954, p. 327.

47 W. P. Frith, *op. cit.*, III, pp. 186–7.

48 *A Handbook to the Gallery of British Paintings in the Art Treasures Exhibition . . .*, 1857, pp. 126–7.

49 *A Handbook to the Water Colours, Drawings, and Engravings, in the Art Treasures Exhibition . . .*, 1857, pp. 12–14.

50 Ed. G. C. Williamson, *Bryan's Dictionary of Painters and Engravers*, 1903.

51 *Art Union*, May 1845, p. 137.

52 'We had a very fair passage but did not get to Newhaven until past midnight on Monday . . .', letter from David Roberts to his daughter, 9 September 1841, *see* Introduction, note 6.

53 *Art Union*, February 1848, p. 66.

54 Mary Sharp, *A Traveller's Guide to Saints in Europe*, 1964. Grace Goldin, 'A Painting in Gheel', in *Journal of the History of Medicine and Allied Sciences*, vol. XXVI no. 4, October 1971, pp. 400–12.

55 I am grateful to Leslie Shepard for information about ballads, and for kindly sending me a copy of *Poor Joe the Marine*.

56 Repr. in Jeremy Maas, *Victorian Painters*, 1969, p. 197: catalogue of the exhibition *La Peinture Romantique Anglaise et les Préraphaélites*, Petit Palais, Paris 1972, no. 183. I am grateful to Ian Phillips for this suggestion.

57 Repr. in Jeremy Maas, *op. cit.*, p. 218.

58 Richard Westall and John Martin, *Illustrations of the Bible by Westall and Martin*, 1835, II, pl. 59.

59 *Bethlem Hospital, Report of Resident Physician for the Year Ending 31st December, 1913*, 1914, p. 15. Bethlem Sub-Committee Minute Books, archives of The Bethlem Royal Hospital. Letter from Dr W. H. B. Stoddart, 31 December 1935, Dadd family papers, private collection.

60 Charles Bell, *Essays on the Anatomy of Expression in Painting*, 1806, 'Madness', pp. 153–7.

61 These figures, still in the possession of Bethlem Hospital, were carved for the gateposts of the second hospital building which stood at Moorfields 1676–1815. They came to symbolise the hospital and its purpose. Their most famous literary reference is in Pope's *Dunciad*, Book I, ll. 29–32, and they are also mentioned by Wordsworth in *The Prelude*, Book VII, ll. 132–3.

62 *Art Journal*, August 1848, p. 252.

63 *Art Union*, October 1843, p. 269, letter to David Roberts, Damascus 5 November 1842.

[64] Charles Dickens, *The Uncommercial Traveller*, Ch. XXIV, 'Chatham Dockyard'. Ch. XII, 'Dullborough Town' is also about Chatham, and there are descriptions of the town in *The Pickwick Papers*.

[65] I am grateful to Richard Cork for pointing out the use of the Giorgione shepherd in 'Titania Sleeping', and also the possible reference to Guido Reni's 'Lucretia'.

[66] Repr. in Graham Reynolds, *op. cit.*, pl. 6.

[67] Forster became Secretary to the Lunacy Commissioners at the end of 1855, and resigned to become a Commissioner in November 1861.

[68] An example of these sketch maps with an outline of the operations, 15 June 1837, is preserved amongst other Chatham material in a volume of pamphlets in the British Museum, pressmark 10368.e.5.

[69] Casebooks, archives of The Bethlem Royal Hospital.

[70] I am very grateful to Leonard Barden and the late Hugh Alexander, who examined the position on the chess board for me and (quite independently) supplied the information that it is a composed problem, with the solution: 1. Q–Q8, K–B3; 2. Q–B7 mate. As a result of my passing on this information, it has been published elsewhere without acknowledgement and I apologise for allowing this to happen. Mr Barden thought the quality of the problem 'banal': Mr Alexander thought it 'rather poor', but not so poor if it was set by Dadd himself and not by a serious problem composer.

[71] In a letter to his brothers in Milwaukee, January 1866. Robert Dadd jun. expresses his views on slavery at some length: '. . . whoever comes within its baneful influence becomes at once brutalised, ferocious, and unreasoning . . .'; Dadd family papers, private collection.

[72] I am grateful to Simon Wilson for this suggestion.

[73] In 1851 Landseer exhibited at the R.A. (157) 'Scene from "A Midsummer Night's Dream", Fairies attending – Peasblossom, Cob-Web, Mustard-Seed, Moth, etc.' with the quotation of Puck's epilogue: 'If we shadows have offended . . .'

[74] *Illustrated London News*, 24 March 1860, 'A Visit to the Royal Hospital of Bethlehem', p. 291.

[75] Letter from Dr W. H. B. Stoddart cited at note 59.

[76] Letter, Sir Thomas Phillips to his brother Benjamin, Florence 9 May 1843, private collection.

[77] Laurence Binyon, 'A Note on Richard Dadd', in *Magazine of Art*, Washington, February 1937, pp. 107, 125, 128.

[78] Information kindly supplied by Giles Robertson. Professor Robertson mentions a family story of Ross's speaking about an altarpiece, 'Suffer Little Children to Come unto Me', on his return from this visit. No such work is now known or recalled at Broadmoor, and it is possible that Ross was referring to the panels at the front of the stage.

[79] Part of the entry for this picture was supplied by Ian Phillips.

[80] Derryan Paul kindly made this translation for me. Miss Paul comments on Dadd's latin: 'Dunc' – not apparently found in classical or medieval latin; suggested reading 'tunc'. 'Transupra' – the same; perhaps intended as an equivalent to 'ultra'. 'Daemoni date' – the grammatical gender of 'daemon' is masculine, but assuming that 'date' is intended to qualify 'daemon' the author seems to have envisaged his spirit as being feminine: if the last line is read as 'Daemoni datum debendum' this would mean 'like must be added to like as a gift due to the spirit.' (There is no doubt, however, that Dadd actually wrote 'date', whatever he may have meant.) Another classicist, without knowing the origin of the poem, commented that it seems to be written in caballistic latin.

[81] Letter, Arthur E. Shields to Messrs Spink and Sons, 9 July 1946. I am grateful to Ian Phillips for lending me a copy of this letter.

[82] Thomas Dugdale, *Curiosities of Great Britain. England and Wales Delineated, Historical, Entertaining & Commercial, Alphabetically Arranged* [1854–60], I, p. 181 (a previous edition ?1845). Ian Phillips first identified this engraving as being the source of Dadd's painting.

[83] Repr. in catalogue of *A Loan Exhibition of Drawings, Watercolours, and Paintings by John Linnell and his Circle*, Colnaghi's, 1973, pl. XLIV.

[84] Attendants in the criminal wards were employed only in that department, while Neville was on the staff of the main hospital, which might suggest little contact with Dadd while he was at Bethlem. However, as head attendant he may have had some duties in the criminal wing.

[85] Frederick Goodall, *op. cit.*, p. 231.

[86] Copy letter, Dr J. S. Hopwood, medical superintendent of Broadmoor Hospital, to Sir Hugh Orange, 9 August 1945, archives of Broadmoor Hospital.

[87] Letter, Sir Hugh Orange to Ian Phillips, 12 February 1946. ¡I am grateful to Mr Phillips for lending me this letter.

[88] Letter, E. K. Purnell to Dr Orange, 9 July 1884, archives of Broadmoor Hospital.

[89] Admiralty records, particularly ADM 22 and ADM 42, Public Record Office. Index of dockyard officers, National Maritime Museum (extracts relating to Stephen Dadd kindly supplied by Alan Pearsall, Custodian of Manuscripts). Copy, will of Robert Dadd of Stoke Damerel, Devon, proved 11 April 1817, Devon Record Office (I am grateful to the County Archivist P.A. Kennedy for locating this will for me).

[90] James Dafforne, *Pictures by John Phillip. R.A. . . . with Descriptions and a Biographical Sketch of the Painter*, [1877].

[91] Mrs E. M. Ward, *op. cit.*, pp. 39–40.

[92] Mrs J. E. Panton, *op. cit.*, pp. 5–6.

[93] W. P. Frith, *op. cit.*, I, 1887, pp. 148–9.

[94] William Edward Frost, 'Sabrina', exhibited at the R.A. 1845, engraved by P. Lightfoot for the Art-Union of London 1849.

[95] J. Noël Paton, *Compositions from Shakespeare's Tempest*, 1845.

[96] *Art Journal*, October 1848, p. 306.

[97] Letter, Sir Thomas Phillips to his brother Benjamin, Athens 3 September 1842, private collection.

[98] *See* Introduction, note 25.

[99] *Sale Catalogue*, Christie's, 28 March 1870, nos. 302–332A. *See* Introduction, note 53.

Bibliography

Primary Sources For Richard Dadd's life and background

MANUSCRIPTS, ETC.

Baptism and marriage registers of St Mary's church, Chatham.

Baptism and burial registers of St Mary's church, Gillingham.

Gravestones in St Mary's churchyard, Gillingham.

Bishop's Transcripts for Stoke Damerel, and copy of the will of Robert Dadd of Stoke Damerel, in Devon County Record Office.

Index of dockyard officers in the National Maritime Museum (for Stephen Dadd's career).

Dockyard pay-books in the Public Record Office: ADM/22/52; ADM/42/79, 92, 93, 247; ADM/106/3005 (for careers of Stephen Dadd and other members of the family).

Rochester Diocesan Chapter Minutes 1827–31 (for Dadd's attendance at school).

Archives of the Royal Academy: registers of students, of professors and visitors, and of prizewinners.

Letters from Sir Thomas Phillips written during his Middle Eastern tour, to his brother Benjamin at 17 Wimpole Street, 1 August 1842 to 9 May 1843, private collection.

Letters to David Roberts from Dadd, Stephen Dadd, and Sir Thomas Phillips (*see* Appendix, pp. 39-40).

Letters from David Roberts to his daughter 1841, and to S. C. Hall 1843, private collections.

Letters from William Clements to Joseph Mayer, 1, 5, 6, 11 September 1843, in Mayer Papers, Acc. 2528, Liverpool City Libraries (a family friend's account of events around the time of the murder).

Home Office records in the Public Record Office: Entry Books, H.O./43/65, 66 (letters from Home Office officials to the Clerks to the Rochester Magistrates about the conduct and progress of Dadd's case, September 1843–May 1844): Registered Papers (O.S.), H.O./45/1085 (account for Dadd's maintenance in France).

Archives of The Bethlem Royal Hospital, especially casebooks, records of the Criminal Lunatic Department, Bethlem Sub-Committee minute books, prints and photographs.

Archives of Broadmoor Hospital (only a few letters about Dadd survive).

Dadd family papers, private collection (for subsequent history of the family, and some genealogical information).

PRINTED SOURCES (newspaper reports of the murder etc. vary in accuracy; it is advisable to look at several versions for each event).

Adam, H. L., *The Story of Crime from the Cradle to the Grave* [*c.* 1908] (contains a photograph of the Broadmoor theatre with Dadd's stage panels *in situ*).

[1st, 2nd, 3rd, etc.] *Annual Report of the Chatham and Rochester Philosophical and Literary Institution*, Chatham, 1828, etc. (information about Robert Dadd sen.'s activities as geologist and museum curator).

The Art Union [continued from July 1848 as *The Art Journal*], October 1843, pp. 267–71 and p. 272 (the fullest contemporary biographical source, including three letters written to David Roberts from the Middle East); January, May, September 1844; May 1845; February 1848; May 1864; also from 1839 on, *passim*, for background news of the art world.

Bagshaw, Samuel, *History, Gazeteer and Directory of the County of Kent*, I, Sheffield, 1847.

Boyle's Fashionable Court and Country Guide, and Town Visiting Directory, 1841, 1843 (for Lord Foley's residence).

Brindley, Robert, *The Plymouth, Stonehouse and Devonport Directory*, Devonport, 1830 (description of the Plymouth dockyard).

The Canterbury Journal, 2 September 1843.

Catalogue of the Art Treasures of the United Kingdom Collected at Manchester in 1857, 1857.

Catalogue, Royal Manchester Institution, 1840, 1841.

Clarke, Henry G., *A Hand-book Guide to the Cartoons now Exhibiting in Westminster Hall . . .*, 1843.

Collings, T., *A New and Complete History of the County of Kent*, 1834.

The County Chronicle, Surrey Herald and Weekly Advertiser for Kent, Sussex . . . etc., 5, 12 September 1843; 6 August, 3 December 1844.

The Dover Chronicle, 9, 23, 30 September 1843; 27 July, 3, 17 August 1844.

The Exhibition of the Liverpool Academy, at the Exhibition Rooms, Post-Office Place, Liverpool, 1840, etc.

The Exhibition of the Royal Academy, 1839, etc.

Fordham's Kentish Advertiser, Weather Almanack and Chatham Directory, Chatham, 1842.

Frith, William Powell, *Further Reminiscences* [vol. III of *My Autobiography and Reminiscences*], 1888, pp. 182–95 (a letter from Dadd from the Middle East printed *in extenso*).

General Report of the Royal Hospitals of Bridewell and Bethlem . . ., 1846, etc.

A Handbook to the Gallery of British Paintings in the Art Treasures Exhibition. Being a Reprint of Critical Notices originally Published in the 'Manchester Guardian', 1857, pp. 126–7.

A Handbook to the Water Colours, Drawings, and Engravings, in the Art Treasures Exhibition, Being . . . etc., 1857, pp. 12–14.

The History and Antiquities of Rochester and its Environs [*the Vicinity*, in later editions], W. Wildash, Rochester, 1817 and 1833 (good description of Chatham and the dockyard).

Household Words, a Weekly Journal Conducted by Charles Dickens, no. 386, 15 August 1857, pp. 145–50 (contemporary description of Bethlem Hospital after Hood's reforms).

The Illustrated London News, 2, 9, 16 September 1843; 3, 10 August 1844.

The Kent Herald, Canterbury, 14, 21 September 1843.

The Kentish Gazette, Canterbury, 6, 13 August 1844.

The Kentish Independent, Gravesend, 2 September 1843 (one of the fullest accounts of the murder and inquest, with other information), 9 September 1843; 3 August 1844 (fullest account of the remand proceedings).

Maidstone Gazette and Kentish Courier, 5 September 1843; 30 July, 6 August 1844.

Maidstone Journal and Kentish Advertiser, 5 September 1843 (one of the fullest accounts of the murder and inquest, with other information), 12 September, 17 October 1843; 6 August 1844 (fairly full account of the committal proceedings).

The Pictorial Guide to Chatham, [*c*. 1860].

The Pictorial Guide to Cobham, 1844 (includes a list of the paintings in Cobham Hall).

Pigot's Commercial Directory, for Kent, 1823, 1824, 1826, 1840.

The Poll of the Electors for a Member of Parliament to Represent the Borough of Chatham . . ., Chatham, 1832, 1834, 1835.

Post Office London Directory, 1838, etc.

The Quarterly Review, vol. 101, 1857, pp. 361–2 (description of the criminal lunatic department at Bethlem).

Report of the Commissioners Appointed . . . to Continue the Inquiries Concerning Charities . . ., [*The Charity Commissioners' Report*], 32nd report, part VI, 1840, pp. 385–614 (report on Bridewell and Bethlem Hospitals, containing a description and plan of the criminal lunatic department).

Report of the Commissioners in Lunacy to the Secretary of State on Bethlem Hospital, together with a Copy of the Evidence . . ., 1852, and *Observations of the Governors upon the Report of the Commissioners in Lunacy . . .*, 1852 (evidence as to treatment in the hospital before Hood's reforms, and the governors' reply to criticism).

Robson's London Directory, 1836, etc.

The Rochester, Chatham and Strood Gazette, 5, 12 September 1843; 30 July, 6 August 1844 (fullest account of the committal proceedings).

Rules and Regulations of the Philosophical and Literary Institution, Established 1827, Rochester, 1828.

Rules and Regulations of the Rochester and Chatham Commercial and Mathematical School, Instituted in 1827, Chatham, 1832.

Sala, George Augustus, 'A Visit to the Royal Hospital of Bethlehem', in *The Illustrated London News*, 24 and 31 March 1860, pp. 291–3 and 304–5 (contemporary description of Bethlem after Hood's reforms, illustrated).

The Times, 1 September 1843 (least accurate account of the murder), 2, 6, 7, 11, 12, 26 September 1843.

Wood, William, *Remarks on the Plea of Insanity*, 1851, pp. 41–3 (contains Dadd's own account of his beliefs relating to the murder).

The World, 26 December 1877, pp. 13–14 (contains a long report of an interview with Dadd, the main source for his life in Broadmoor; details of his early life unreliable).

Wright's Topography of Rochester, Chatham, Strood, Brompton . . ., 1838.

Secondary Sources for Dadd's life and background, and other related reading. (The memoirs of his contemporaries are outstandingly unreliable; any 'facts' about his early life should be checked against primary sources).

Allderidge, Patricia, *Richard Dadd*, 1974.

Antal, Frederick, *Fuseli Studies*, 1956.

Ayrton, Michael, 'British Drawings', in *Aspects of British Art*, ed. W. J. Turner, 1947, pp. 48–50.

Binyon, Laurence, 'A Note on Richard Dadd', in *Magazine of Art*, Washington, February 1937.

Boase, T. S. R., 'The Decoration of the New Palace of Westminster, 1841–1863', in *Journal of the Warburg and Courtauld Institutes*, vol. 17, 1954.

Boydell, John and Joshua, *A Collection of Prints, from Pictures Painted for the Purpose of Illustrating the Dramatic Works of Shakspeare, by the Artists of Great-Britain*, 2 vols., Shakspeare Gallery, 1803.

Bryan, M., ed. G. C. Williamson, *Dictionary of Painters and Engravers*, 1903.

Catalogue of the exhibition *David Octavius Hill 1802–1870 and Robert Adamson 1821–1848*, The Scottish Arts Council, 1970 (includes calotypes of Newhaven Fisherwomen).

Catalogue of the exhibition *Fact & Fancy, Drawings and Paintings by Sir Joseph Noël Paton R.S.A., 1821–1901*, The Scottish Arts Council, 1967.

Catalogue of the exhibition *Shakespeare in Art* (introduction by W. Moelwyn Merchant), The Arts Council, 1964.

Dafforne, James, *Pictures by John Phillip, R.A. . . . with Descriptions and a Biographical Sketch of the Painter*, [1877].

Dictionary of National Biography, 1885, etc.

Dunn, H. T., ed. Gale Pedrick, *Recollections of Dante Gabriel Rossetti and his Circle*, 1904, pp. 57–9 (records G. A. Sala's account of Dadd in Bethlem or Broadmoor).

Frith, William Powell, *My Autobiography and Reminiscences*, 3 vols., 1887–8, *passim* but especially I, pp. 62–3, III, pp. 97–9 and Ch. IX (a mine of lively information and gossip about the Victorian art world, including a chapter on Dadd by his closest friend).

Goodall, Frederick, *The Reminiscences of Frederick Goodall R.A.*, 1902, pp. 228–33 (amiable if woolly-minded recollections of Dadd).

Graves, Algernon, *The British Institution 1806–1867, A Complete Dictionary of Contributors and their Work . . .*, 1908.

Greysmith, David, *Richard Dadd: The Rock and Castle of Seclusion*, 1973.

Grigson, Geoffrey, *Samuel Palmer's Valley of Vision*, 1960.

Hall, Samuel Carter, *Retrospect of a Long Life: from 1815 to 1883*, 1883, pp. 327–9 (recollections of Dadd as a young man by an older contemporary).

Hamilton, Jean, *The Sketching Society 1799–1851*, Victoria and Albert Museum, 1971.

Hardie, Martin, *Water-Colour Painting in Britain*, vol. III, 'The Victorian Period', 1968.

Hill, David Octavius and Adamson, Robert, 'Calotypes by D. O. Hill, R.S.A. and Robert Adamson. Edinburgh: MDCCCXLIII to MDCCCXLVIII' (two vols. in the Victoria and Albert Museum; vol. II contains Newhaven Fisherwomen calotypes).

The Hill/Adamson Albums, Times Newspapers Limited, 1973 (includes Newhaven calotypes).

Hood, W. Charles, *Suggestions for the Future Provision of Criminal Lunatics*, 1854.

– *Criminal Lunatics, a Letter to the Chairman of the Commissioners in Lunacy*, 1860.

Howard, Henry, ed. Frank Howard, *A Course of Lectures on Painting Delivered at the Royal Academy of Fine Arts*, 1848.

Howgego, J. L., catalogue of the exhibition *David Roberts and Clarkson Stanfield*, Guildhall Art Gallery, 1967.

Hutchison, Sidney C., *The History of the Royal Academy*, 1968.

– 'The Royal Academy Schools, 1768–1830' in *Walpole Society Volume 38*, 1962.

Imray, John, 'A Reminiscence of Sixty Years ago', in *The Art Journal*, 1898, p. 202 (recollections of The Clique).

Jameson, Anna, *Companion to the most Celebrated Private Galleries of Art in London*, 1844.

Maas, Jeremy, *Victorian Painters*, 1969.

Munk, William, *The Roll of the Royal College of Physicians of London 1518–1825*, 3 vols., 2nd ed., 1878, and vol. IV, *1826–1925*, 1955 (biographies of the various physicians associated with Dadd).

Ormond, Richard, catalogue of the exhibition *Daniel Maclise, 1806–1870* at the National Portrait Gallery and the National Gallery of Ireland, Arts Council of Great Britain, 1972.

Panton, Mrs J. E., *Leaves from a Life*, 1908, pp. 5–6, 105–6 (recollections about two of Dadd's sisters by Frith's daughter)

Partridge, Ralph, *Broadmoor; A History of Criminal Lunacy and its Problems*, 1953.

Paton, Joseph Noël, *Compositions from Shakespeare's Tempest*, 1845.

Phillips, Charles Palmer, *The Law Concerning Lunatics, Idiots & Persons of Unsound Mind*, 1858.

Quennell, Peter, *Romantic England, Writing and Painting 1717–1851*, 1970.

Reitman, Francis, *Psychotic Art*, 1950 (this and other works on 'psychotic art' are useful chiefly to establish that the subject is not relevant to Dadd).

Report of the Capital Punishment Commission; together with the Minutes of Evidence and Appendix, H.M.S.O., 1866 (the evidence of Dr Charles Hood, Sir George Bramwell and others illustrates some contemporary views on insanity and criminal responsibility).

Reynolds, Graham, *Victorian Painting*, 1966.

– 'British Artists Abroad, V, Roberts in Spain, Egypt & Palestine', in *Geographical Magazine*, XXI, no. 10, 1949.

Rickett, John, 'Rd. Dadd, Bethlem and Broadmoor' in *The Ivory Hammer* [Sotheby's Yearbook], II, 1964.

Ritson, Joseph, *Fairy Tales, now First Collected: to which are Prefixed Two Dissertations: 1. On Pygmies. 2. On Fairies*, 1831.

Rossetti, William Michael, *Some Reminiscences of William Michael Rossetti*, 1906, I, pp. 269–70 (an account of seeing Dadd in Bethlem).

Saunders, Frederick W. T., 'A Business History of Chatham High Street, Mainly from the Year 1838 to the Year 1961', 4 vols., [?1962] (typescript, copies in B.M. and Chatham Public Libraries).

Scott, William Bell, ed. W. Minto, *Autobiographical Notes of the Life of William Bell Scott*, 1892, I, pp. 110–11, 172 (recollections of Dadd by a contemporary).

Searight, Rodney, catalogue of the exhibition *The Middle East, Watercolours and Drawings by British and Foreign Artists and Travellers, 1750–1900, from the Collection of Rodney Searight Esq.*, Leighton House, 1971.

Shee, Sir Martin Archer, *Address to the Students of the Royal Academy; Delivered before the General Assembly, on the Distribution of the Gold Medals 10 December 1837*, 1838.

Shepard, Leslie, *John Pitts, Ballad Printer of Seven Dials, London, 1765–1844*, 1969.

Survey of London, vol. XX, Trafalgar Square and Neighbourhood, L.C.C., 1940 (covers Suffolk Street and the National Gallery).

Titmarsh, Michael Angelo [William Makepeace Thackeray], *Notes of a Journey from Cornhill to Grand Cairo*, 1846 (contains descriptions of many places and events which Dadd must have seen two years earlier).

Walker, Nigel and McCabe, Sarah, *Crime and Insanity in England*, 2 vols., 1968 and 1973 (excellent historical perspective on criminal lunacy).

Ward, Mrs E. M., ed. Elliott O'Donnell, *Mrs. E. M. Ward's Reminiscences*, 1911, pp. 37–40 (recollections of Dadd and his sister).

Wilkinson, Sir John Gardner, *Manners and Customs of the Ancient Egyptians*, 3 vols., 1837.

Wilton, Andrew, catalogue of the exhibition *Classical Sites & Monuments*, The British Museum, 1971.

Yates, Edmund, *Edmund Yates: his Recollections and Experiences*, 1884, II, p. 104 (recalls Dickens's interest in Dadd).

List of Lenders

**Index to ownership of works in catalogue but not
included in the exhibition**

Acknowledgements

This exhibition and catalogue have been made possible only by the help and encouragement of many people over a number of years. The owners who have lent to the exhibition are acknowledged elsewhere, but I wish also to record my most grateful thanks to them for much kindness and patience, and for the great generosity with which they have given me access to their pictures. My especial thanks are due to Ian Phillips, who has placed at my disposal the materials and experience of nearly thirty years' work on Dadd; and to Alys Rickett, who kindly allowed me to use the research material collected by her late husband, John Rickett. Numerous private individuals and the staff of institutions have helped in locating pictures and manuscripts, supplying information and opinions, and in various other ways: in particular I thank Patricia Barnden of the Paul Mellon Centre, London; David Carritt; Beverly Carter, secretary to the Paul Mellon Collection in Washington; Julian Doyle; Edward English of Broadmoor Hospital; Naomi Evetts of the Liverpool Record Office; Charlotte Frank; Helen Guiterman; Edward Holland-Martin; John Hudson of Christie's; Dr Richard Hunter; Lincoln Kirstein; Jeremy Maas; H. L. Mallalieu of Christie's; Alister Mathews; Edward Morris of the Walker Art Gallery; Gabriel Naughton and other members of the staff of Thomas Agnew & Sons; John Page-Phillips; Andrew Patrick of the Fine Art Society; Leslie Parris of the Tate Gallery; Alan Pearsall of the National Maritime Museum; Richard Raymont, formerly of Broadmoor Hospital; Barbara Riddell of Chatham Public Libraries; Eileen Robinson of The Shakespeare Centre, Stratford-upon-Avon; Dr Michael Rose; Prof. L. P. Senelick; Leslie Shepard; Sir Sacheverell Sitwell; Trevor Smith; Dudley Snelgrove; Stephen Somerville of Colnaghi's; Allen Staley; Dr Ronald Stewart; Paul Thomson and other members of the staff of Sotheby's. In 1971 I received a grant towards the cost of research from the Paul Mellon Centre for Studies in British Art, which since that date has also undertaken a great deal of photography for me, and I am extremely grateful for this assistance.

Ruth Rattenbury and Pauline Key of the Tate Gallery have, respectively, organised the exhibition and designed the catalogue: my gratitude and admiration for their professional skill can only be adequately expressed, by acknowledging them as co-authors of the whole work.

Index

Catalogue numbers are in bold type, page numbers in roman.
Reference is to the catalogue text, not to pictures as such.
The first number after each of the works is that of the main catalogue entry.